BALLROOM MARFA

BALLROOM MARFA

THE FIRST TWENTY YEARS

CONTENTS

INTRODUCTION

PROLOGUE

STERRY BUTCHER

The building that now houses Ballroom Marfa was variously an auto body shop, a grocery store, and a dance hall.

Before the internet was widely available in our region, before Marfa Public Radio, before YouTube or smartphones or laptop computers, there was the *Big Bend Sentinel*. Published every Thursday, the *Sentinel* was pored over, dissected, and digested in every corner of the community, by ranchers and teachers, border patrol agents and teenagers working the Dairy Queen.

Our readers readily cornered us reporters at the *Sentinel*'s office downtown—or anywhere we happened to be in town—with any worrisome rumor, pressing criticism, or potential news item. We covered it all, from serious legislation issues and testy county commissioners meetings to lost dogs and hundredth birthdays.

My first outreach to Ballroom stemmed from a trio of tips we'd received from concerned Marfans. The gist: those new art folks are renovating that building to put in a topless bar. I laid this sizzling gossip on Virginia Lebermann. "Is it true?" I asked. "A topless bar? In the middle of Marfa?" There was silence on the line for one beat . . . two . . . three, and then came a great whoop of laughter. "*Tapas!* Tapas," she sputtered, and then whooped again. "We were thinking we might have a tapas bar as part of the gallery, but a topless bar might be a good idea if this little art deal doesn't work out."

This was, I think, the best first conversation I've ever had with anyone. □

THE CREATIVE HORIZON

FAIRFAX DORN

"The unexplainable thing in nature that makes me feel the world is big fat beyond my understanding—to understand maybe by trying to put it into form. To find the feeling of infinity on the horizon line or just over the next hill." —Georgia O'Keeffe

In the fall of 2001, I had exhausted my hopefulness about New York City. The paintings I wanted to paint there had somehow eluded me. The people, the parties, the culture—all felt dry and brittle, and when towers started falling, I looked instinctively for an exit. I turned to Texas, my home state, hoping I would find a familiar patch of desert to hold back the outside world. I was looking for a place with that elusive composition of elements that would finally set my painting free. I was primed for a crazy phone call from Virginia Lebermann, my soon-to-be cofounder and collaborator, insisting our next stop would be Terlingua, Texas.

Population 249, Terlingua is the gateway to the Big Bend National Park and home of the West's best chili cook-off—a place that seemed sufficiently off the grid to grant me the solitude I was so dearly craving. And so, in 2002, I packed easel and oils and brushes into my father's well-used Chevy Tahoe and headed for the most distant point amid the wide stretches of Texas. My father dropped me off at a rental casita, which I would share with Virginia.

Our new home was set within rubble, the crumbling walls of ruined cabins once occupied by long-dead mercury miners. Interspersed, here and there, were signs of life: bright, ramshackle homesteads of the few year-round residents—park rangers, hopeful artists, and aging hippies selling fossils and bottled water to tourists on their way to Big Bend. The population fluctuated depending on the camping seasons and the dates of the chili cook-off. Scorpions, always finding their way into shoes and showers, were our only constant companions. Six months in, paintings of decay and vast landscapes were taking shape on my canvas, but the lunarscape of West Texas continued to mystify me. I painted that distinct horizon line over and over and over again, always moving toward a vanishing point that never seemed to arrive.

My move to Terlingua was not the first time I had explored the far western edges of Texas. For generations, my family had tried to make something out of the hardscrabble landscape of the high desert. From cattle ranches to mercury mines, my grandparents and great-grandparents had done their best to forge a living out of that vast nothingness of sand and sagebrush. I remember, as a child, trips to the JD Ranch in Kent and family reunions in Marathon, and like a faded dream, I recall gazing out the back seat window while we drove through Marfa, which seemed always to be on our way to somewhere else.

Over the years, the West Texas horizon line had been slowly embedding itself in my consciousness, setting me up for that moment when Virginia and I would make the two-hour drive from Terlingua to attend a reading at the Lannan Foundation at the Crowley Theater in Marfa. Unexpectedly, the writer presented her work more like a performance piece. She recited snapshots of her life and family by reading postcard essays. She was far from home . . . learning something about herself from the isolation and distance that the high desert gives every visitor. The experience was profound for both Virginia and me. Together we suddenly saw how it could all be possible—a space in Marfa for artists, musicians, and filmmakers, a space for seeing more clearly because of the separation from the familiar. The vision was beautifully naive and crystal clear. This quiet, sleepy town could become a locus of possibilities, a place to manifest what anywhere else might be impossibilities. This was not a new idea. For generations, the horizon of West Texas had coaxed and inspired and seduced those who gazed into it, encouraging each to practice the art of the improbable. Its expanse had called to risk-takers and adventurers and to artists like Donald Judd, and now it was calling to *us*. ▷

"Together we suddenly saw how it could all be possible—a space in Marfa for artists, musicians, and filmmakers, a space for seeing more clearly because of the separation from the familiar."

So it was the reading that triggered the idea, but it was the building that made us believe in it. Virginia, with her sixth sense for magical spaces, knew there was something extremely special about the tumbledown onetime bus stop, car repair shop, grocery store, gallery, and (most importantly) dance hall. It was a place for bringing people and ideas together. And, with the arrival of Vance Knowles, who appeared from seemingly out of nowhere ready to join in and lend a hand, Ballroom was born.

After a year of plotting and renovating, Ballroom Marfa was ready for its inaugural exhibition, which showcased the work of Colombian performance artist María José Arjona. For three days, María stood on a handmade stepladder and inscribed hundreds of stars on the walls of our new space. Her hands were stained black and her feet were bloody from the repetition of her movements. It was a performance. It was an installation. It was a message about the violence happening in Colombia. It was a new vantage point that was presented and shared, both with the small community of Marfa, Texas, and the world beyond.

Since that first remarkable event, every artist, performance, exhibition, film screening, and installation presented by Ballroom Marfa has manifested this same convergence; we have continually explored the creative horizon line, the merging of idea and experience.

Twenty years on, Ballroom has become a kind of shelter for artists. The clear West Texas light, the community, and the history of the place displace the feelings of competition, the self-doubt, and the never-ending noise that shadow artists in New York, London, and Berlin. Ballroom, and Marfa as a whole, offers artists and visitors alike a chance to pause, see the artwork, and see each other. The results have been profound. Countless exhibitions, films screenings, and music performances later, the world has beaten a path to our door, in search of that shelter, that peace, and that pure access to the creativity of some of the greatest artists of our time.

Somehow Virginia, Vance, and I, with the help of many others, managed to create a space for fearless artistic authenticity and relevancy, for bringing together ideas and community to experience new perspectives. In the process, we found those unforeseen vanishing points, those unheard-of sounds, those contradictions of being human—all in hopes of better understanding our own evolutions. □

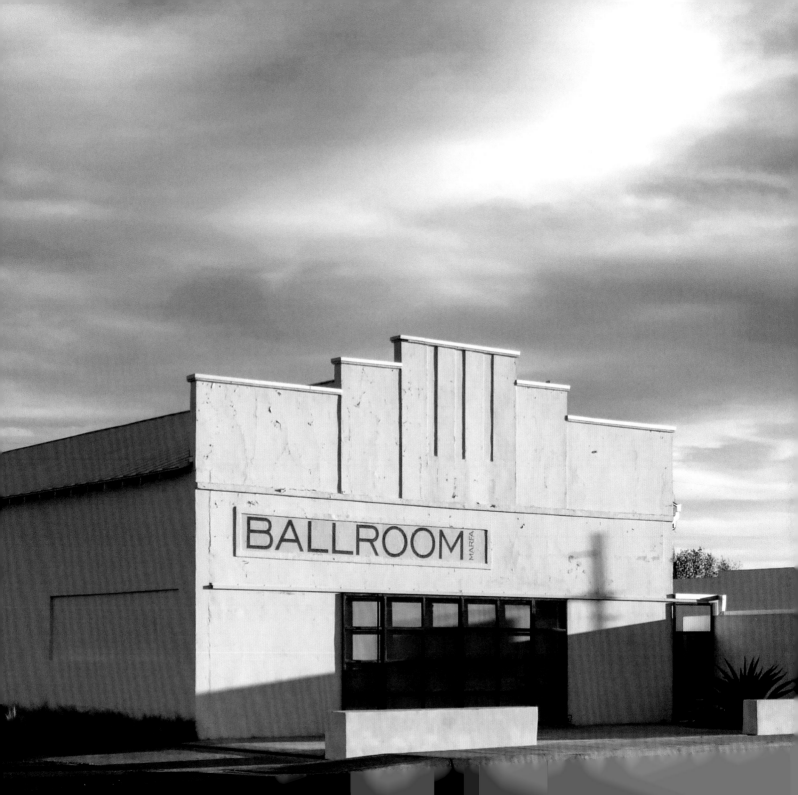

SOMETHING FROM NOTHING IN THE MIDDLE OF NOWHERE

VIRGINIA LEBERMANN

Around Marfa, you can drive for hours and never see another vehicle. The expanse of unobstructed light holds a twinge of romance from a distant land, or a time long ago, the feeling that you're living a story that was written in the past, when there were fewer stories to be told.

I was running hard when I first came back home to live in Texas full-time in 2000. I did not yet realize that, like my family before me, I would become immersed in the land, the history, the wildness, and the unique potential that Texas offers for existing on the edge—where one culture ends and another begins. Despite all my time away, I found the romance, the nostalgia, and all the potential of the future existed, for me, in the open spaces, the broad landscapes, and the expansive skies of Marfa and the West. When I returned at the age of thirty, I saw it as a place where I could begin to build a legacy of my own—not entirely separate from family history but not right on top of it either.

Now, when I break it down twenty years later, I see the line of my life filled with people gathered in community, in celebration of cerebral creativity. Ballroom Marfa began with a unifying collaboration between three of us—me, Fairfax, Vance—and was brought to life by a list of sharp people who have made it happen with us over the years.

Fairfax was the perfect wingwoman; her laugh made everything seem possible. We had both descended from long lines of eccentrics. Vance emerged out of nowhere and somehow, suddenly, there we were, gathering energy, creating energy. That was the point of the constant rolling happening, the experimentation. We were running in tight circles to create a force field against mediocrity. It was unmitigated youthful savagery—pour all the ingredients in a pot and whistle while you wait— in avoidance of anything resembling the obvious.

I could try and tell the story or sketch the highlights, but I would not succeed. The contents of this book will provide enough of an echo for you to feel it if you are inspired to dig in through the cracks.

For me, the arrival started in the driver's seat of an old green sedan. My bag phone was plugged into the lighter. I had to drive up to a high point along 118 South to get the service needed to call home. ("I'm still alive.") At the time, Fairfax and I were living down south, in Terlingua. The Chihuahuan Desert felt like liberation and an anchor. An anchor to a grittier substance. We would circumnavigate the globe by bringing the world to the desert. Fairfax, Vance, and I moved to Marfa to make that happen.

In the beginning, we were drawn to the rhythm of the pilgrimage, the long-drawn-out space of time required to encounter world-class creativity in the silence of a remote and precious landscape. It was tremendously exciting and strangely exhilarating. To experience art in Marfa has always been a unique counterbalance to the overstimulation of urban environments. You feel the work in a different and perhaps deeper context. Once you finally arrive in Marfa after the long journey, the vast landscape, the quality of the air and light, and the sunsets change the quality of your perception.

With the initial formation and creation of Ballroom Marfa, Fairfax, Vance, and I jumped in hard and fast. I did not know how much will and persistence it would take. I did not know how much it would sting. I certainly never guessed at the depth of connection and richness it would bring to my life. I'm constantly amazed by the ripples of impact Ballroom still creates. We are all three still tethered there. The invisible tentacles that connect us to the strength and grit of our past. How our pasts connect us to our current wander, our celestial lunacy. ▷

15

"The Chihuahuan Desert felt like liberation and an anchor. An anchor to a grittier substance. We would circumnavigate the globe by bringing the world to the desert. Fairfax, Vance, and I moved to Marfa to make that happen."

Art Asylum, Art Box, Culture Collective, Concentric Circles. We collected many bizarre names before realizing the building had begun as the Queen's Ballroom in 1927 and should remain the Ballroom for all time. Fairfax was twenty-six. Vance and I were thirty-two. We were young and wild as hell. But our intention was pure. We dreamed of a place that brought people together to make new work, to connect to one another in that moment and beyond, and for there to always be music playing. We wanted to be a conduit to uplift ourselves and anyone who wanted to come along for the ride.

And we succeeded, every once in a while.

To be in rural Texas on the high desert plains yet connected to the faraway world through visual art, film, and music . . . I could not have imagined anything more profound or exciting at that time. With my knowledge and experience in 2002, I could not have envisioned how to live a more textured and impactful life. We created a venue for the constant celebration of being alive, surrounded by collaborators and kindred spirits.

And so, on we roll, into the next twenty years, still kicking the dirt and making it up as we go along. □

A painted truck parked in front of Ballroom.

18

CHAPTER ONE

CONCEPT INTO MANIFESTATION

2003–2007

Installation view, *Every Revolution Is a Roll of the Dice*, 2007, with Gardar Eide Einarsson, *Captain America (Inverted)*, 2007. Overleaf: Ballroom Marfa founders Virginia Lebermann and Fairfax Dorn.

The enormous double-sliding doors, standing nine feet tall and sixteen feet wide, made of glass and metal welded in Ojinaga, Mexico, were finally open for the first time in 2003. These doors admitted visitors free of charge, a policy that still stands today. Most important, they also welcomed artists, musicians, performers, curators, and writers to make work and be a part of Ballroom Marfa.

Those early burning questions—*What is Ballroom Marfa? What is it going to be? How will this space be used? Who is this space for?*—were being asked and answered simultaneously. The guiding principles were being formed through action. If there were curators with brilliant ideas for shows, they were invited to enact those ideas through an exhibition at Ballroom. This began with Alexander Gray, who curated the first group show. If there were artists who wanted to create a work that responded to a societal issue, they were commissioned to make the work—for example, Agnes Denes and her sculpture in response to the water crisis. Collaborations and partnerships started to form, such as the one between Art Production Fund and Elmgreen and Dragset. Ideas were constantly being hatched and pursued.

Inviting artists, or any visitors, to Marfa was no easy task—let alone fabricating, installing, and exhibiting art, or setting up a concert. Three hours from a major city, access to materials and equipment is limited. There were only three places to eat in town and the historic Hotel Paisano had just reopened. The key was creative problem-solving; Virginia, Fairfax, and Vance could always come up with ideas and arrive at solutions, often during the course of a meal. Cooking, hosting, and bringing people together around a table were necessary to get anything done. Nothing in Marfa is quite at your fingertips—materials, food, fresh produce are not readily available—but because of this, Ballroom was born from a place of immense beauty and extreme ruggedness. □

23

VAULT

MARÍA JOSÉ ARJONA

Vault, a performance and installation by María José Arjona, was Ballroom Marfa's inaugural program. For three days, Arjona transformed the Ballroom by circling a ring of heaped charcoal shaped like an ouroboros, then using the charcoal to draw starlike symbols on the walls of the gallery. "*Vault* is a space transformed by the motion of a body," said Arjona. "It is a process of meditation where drawing is the basic tool to address evolution, simplicity, and life. . . . [It] contemplates the cycles of matter and its deconstruction in order to create again."

A REFLECTION BY MARÍA JOSÉ ARJONA

I met Fairfax in New York and she talked to me about the project of the Ballroom. I was then also migrating from Colombia to the United States, so it was a transitioning time. I had never been to Texas. I was starting to have a voice as a performer, and I was also understanding how the aesthetics and my needs and concerns, coming from Colombia, were going to merge there [at Ballroom]. I had a lot of questions regarding how this piece could work there, with me being so foreign to the area. When I got there, I was very moved by the landscape. I started to look around and it was just perfect. It became like more of a political space of understanding that we are all in the same ground. Also, understanding that I was an immigrant. I felt that kind of weight of being from Colombia and being [near] the border.

We had a very big circle of charcoal in the center of the main space, and I started to perform. And I remember the movements of my hand in this very beautiful white space. And I remember the sound like of the charcoal going through the wall and then working with this ladder also to get to the upper part of the wall. And then the people entering. I felt that there was this very beautiful force in the space and within this performance that was very subtle at the beginning because the space is so big. But then suddenly, over days the charcoal started to kind of invade all the walls, make them acquire a volume and kind of resonate.

Duration work is always very complex. Sometimes it allows people to engage, but sometimes it poses some sort of a problem. You know, that if, as a performer, you're not performing fast, then people start to think, *Okay, where is this going? How is this going to finish? Is it going finish? What is going to happen?* So, I think a lot of conversations started to

emerge around the work. It opened up for me a lot of possibilities to understand, within my aesthetics and within my needs as an artist and as a performer, how to navigate a completely new topography. Not only in terms of the work, but also in terms of networking, of understanding what other artists were doing. My stay in Marfa was not only about performing but also about understanding where I was.

It's quite amazing to see what they have done and from the point where they started. . . . I also think that it's been very beautiful to me to see how the space is open to artists that are not normally accepted. You know, it's not very easy to get exhibitions in the US when you come from Latin America. In my time, it was almost impossible to think that you were going to get to a place to have an exhibition in the US. So, this openness to other artists, to see other perspectives, to understand other ways of living and perceiving the world, I think it's quite unique because diversity has only become very relevant lately because of the historical process we are going through. But at that time, twenty years ago, nobody was talking about diversity. I think that, in a lot of ways, Ballroom always had a very open program.

I talked to Fairfax about ideas, and they were open to all of that. It is very important to talk about those things now, because now they are important. At the time, to open a space with a long duration [piece] by a Colombian performance artist who nobody knew—it was quite a risk. You know, [they were] taking risks where it's difficult to do that. It's very easy to take risks when you are in certain places or galleries or institutions. But to take that risk, opening your space with somebody that is just arriving, I thought that was quite a powerful political gesture. □

Interview, María José Arjona and Alexann Susholtz, February 7, 2023.

Installation view, *Vault,* María José Arjona, 2003.

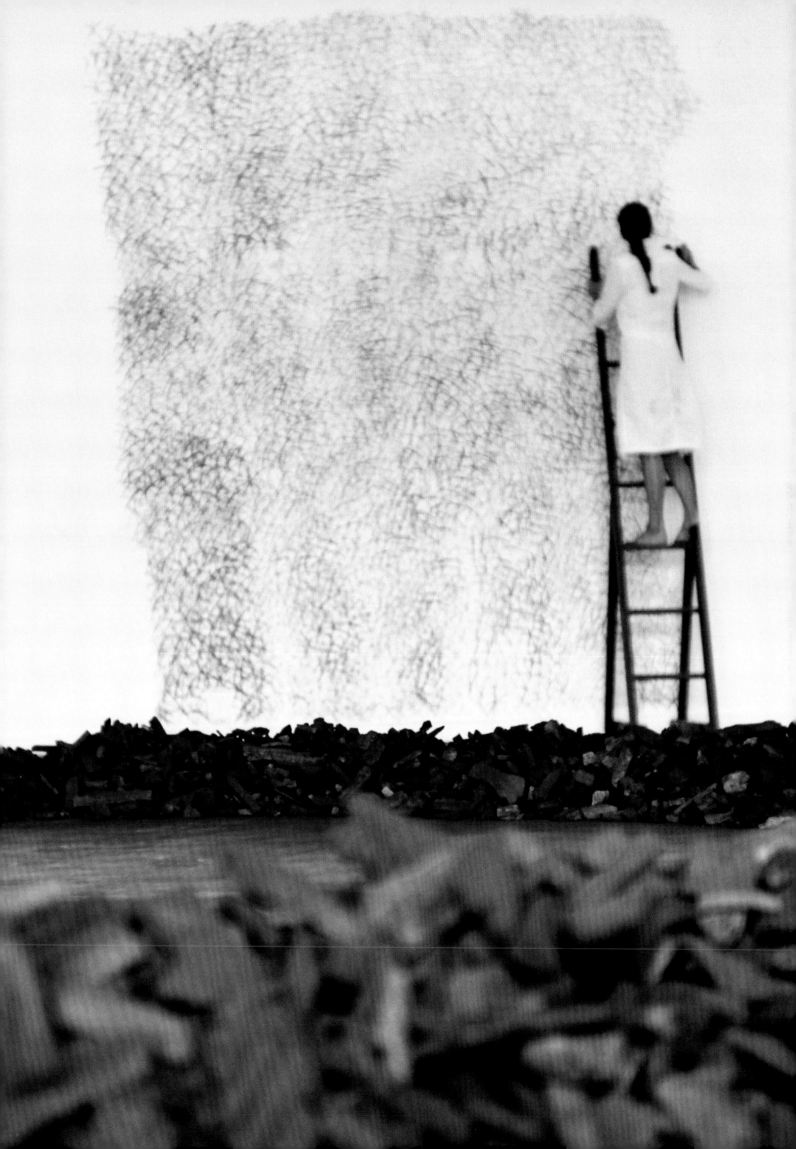

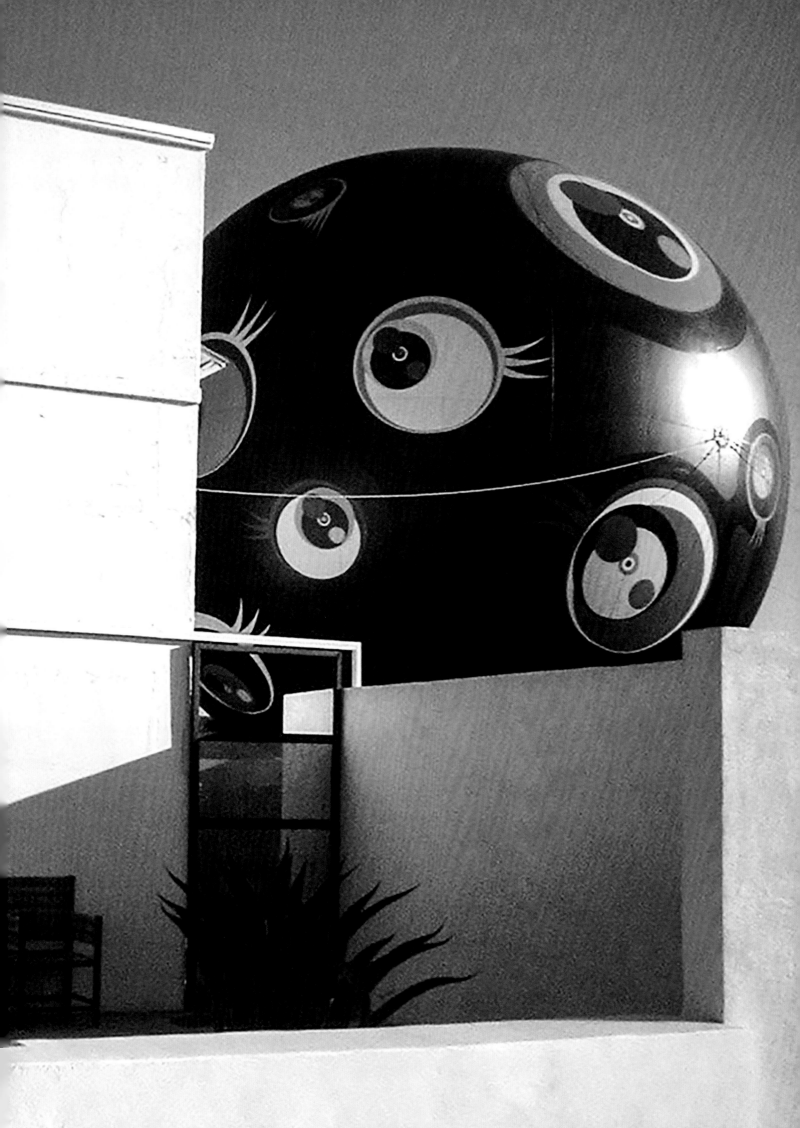

OPTIMO

POLLY APFELBAUM, MARTIN CREED, KAREN FINLEY, FORCEFIELD, EMILY JACIR, BEATRIZ MILHAZES, TAKASHI MURAKAMI, ADAM PENDLETON, LEO VILLAREAL

Takashi Murakami, *Jellyfish Eyes, Black*, 2003.

In April 2004, independent curator and art consultant Alexander Gray joined forces with the Ballroom team to organize the group exhibition *OPTIMO: Manifestations of Optimism in Contemporary Art*. Mirroring the vision of Ballroom itself—a nonprofit cultural space founded on the belief that art can positively impact the human spirit—*OPTIMO* brought together nine artists whose work celebrates the complexities and wonders of contemporary life, incorporating visual pleasure, humor, interactivity, color, technology, industrial design, politics, landscape, spirituality, and popular culture. The exhibition included site-specific installations, performance-based work, painting, video, photography, and sculpture that bravely envisioned a future with ever-expanding possibilities.

 OPTIMO was composed of works by leading contemporary artists from around the globe, including Martin Creed's *Work NO.200: Half the air in a given space*, a room-sized interactive installation of balloons; Karen Finley's *Psychic Portraits*, a collection of drawings produced by Finley during psychic readings with Ballroom audience members; Takashi Murakami's gigantic eyeball balloon, which was suspended in Ballroom's courtyard; and Leo Villareal's site-specific light sculpture referencing the endless sunrises and sunsets of the West Texas sky. Others in the exhibition included Polly Apfelbaum, the artist collective Forcefield, Emily Jacir, Beatriz Milhazes, and Adam Pendleton. Berlin-based duo Stereo Total performed at the opening. ▷

"There was the international audience, and Marfa was ripe and ready for generational change. So we put together *OPTIMO*. We wanted to do a show about optimism."

A REFLECTION BY ALEXANDER GRAY

I had spent a lot of time in Marfa when I was at Artpace San Antonio—this is Marfa before a cappuccino machine. We'd show up from San Antonio, we'd cook dinner. I was lucky to be part of this initial kind of brainstorm about Ballroom, along with Susan Courtemanche—*What is the organization? What is it going to be?* So what started as a consulting dream session became a conversation that generationally clicked in. [Fairfax and Virginia's] original vision was to do something with Texas artists and Texas musicians, but even then, Marfa was way too big an international stage. So there was a stepping back and rethinking about what and where the opportunity was in the Marfa landscape. Marfa was already international. This is in the '90s, and people were just coming for Judd. Chinati was happening. It was really a perfect convergence, a perfect storm. Things were starting to happen. The bookstore was there. There was the cappuccino machine, and then there was a second, and then there was a third. There was the international audience, and Marfa was ripe and ready for generational change. So we put together *OPTIMO*. We wanted to do a show about optimism. The first working title was *Here Comes the Sun*. And that shifted to *OPTIMO*. This kind of optimism was definitely something we were trying to lean into, an exuberance.

At the time, the culture wars and the AIDS crisis weren't that far in the rearview mirror. But there was a spirit of globalism, the art fairs of the internet, just a generational shift that felt very optimistic. The optimism that Fairfax was bringing to Ballroom, that was also part of the goal, the assignment. The whole show had a lot of bright colors, a sense of play. The Murakami balloon was the most audacious, ridiculous idea. The Martin Creed installation was totally buoyant and absolute fun. Beatriz's and Polly's and Leo's work was also dealing with these manifestations of positivity, these possibilities of technology. The whole space was filled with art and music. Fairfax was making art then too. Her studio practice was very active, and we really looked at the show through the lens of an artist rather than an organization. And Vance was focused on bringing music into the conversation.

At that time many institutions weren't fruitful for artists. It was a time when a shift was happening toward more artist-focused spaces. And Marfa was and is still the perfect place to create that. It is a place where art can catalyze in a different way. Sometimes those types of connections people have with art are lost when you're in the echo chamber of a big city. In Marfa, you are allowing all kinds of people access to art.

I remember being there with one of the ranchers from outside of town. We are cooking in the kitchen and I'm queening it up. We are having the time of our lives. And this Texas rancher says to me, "Alex, I just want you to know I've been having a great time with y'all, and I have no problem with you being a Jew or you being a homosexual. My one thing I do take issue with is you being a vegetarian." Thank God that was before I became a vegan!

That's one thing I really appreciate about the Texans: they really come to your level. They bond around stories and people; they love to talk to you about things that are real and human. The human spirit is the thing that connects people. The consistency of hospitality and generosity of spirit of Texans and Marfa is part of that. It is such an amazing, magical, and totally weird place. □

Interview, Alexander Gray and Daisy Nam, July 31, 2023.
Gray is owner and principal of Alexander Gray Associates.

Installation views, clockwise from top left: Wallpaper by Takashi Murakami and Forcefield, ZMTRX, 2002–3; Adam Pendleton, wall drawing; Takashi Murakami, *Reversed Double Helix*, 2003; Martin Creed, *Work No.200: Half the air in a given space*, 1998; Leo Villareal, *Horizon 24*, 2004, and Polly Apfelbaum, *Today I Love Everybody*, 2003; Leo Villareal, *Horizon 24*, 2004.

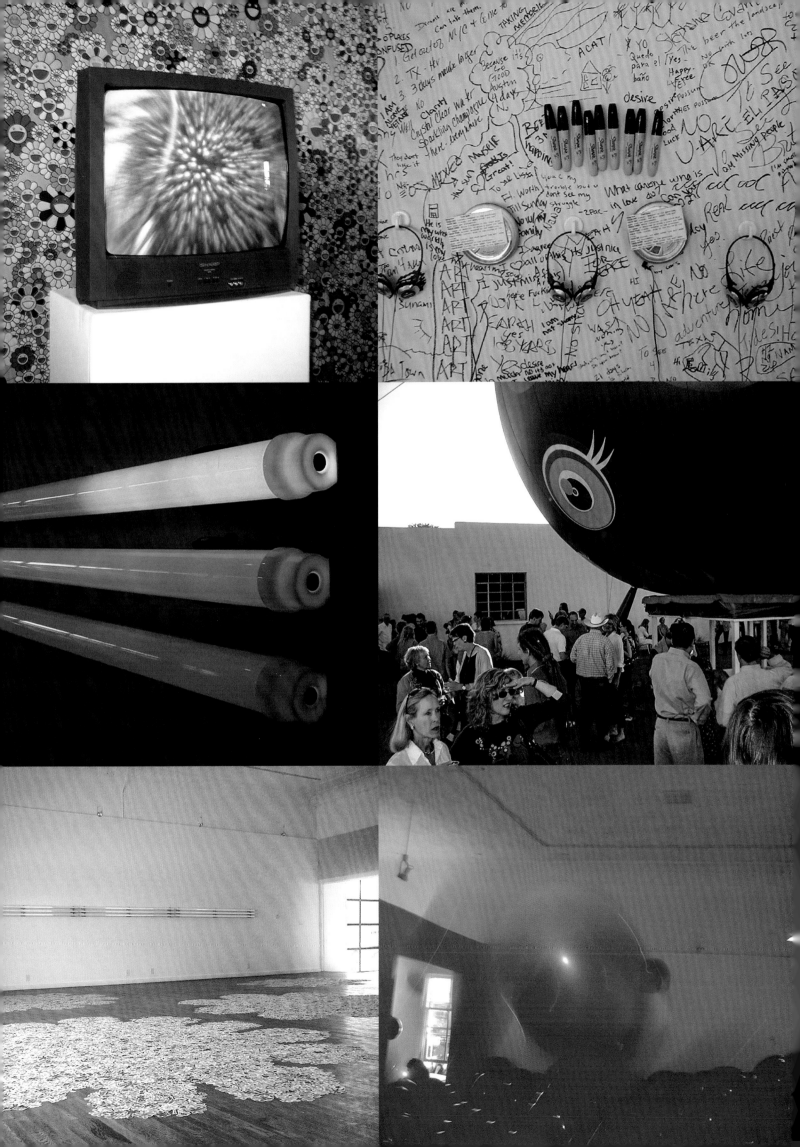

YOU ARE HERE

LARRY BAMBURG, SUNTEK CHUNG, DEBORAH GRANT, ANDREW GUENTHER, HILARY HARNISCHFEGER, ADAM HELMS, MATTHEW DAY JACKSON, KARYN OLIVIER, BLAKE SANDBERG, SIGRID SANDSTRÖM, ALLISON SMITH, IAN SULLIVAN,

The exhibition *You Are Here*, curated by Fairfax Dorn, was devoted to emerging artists whose work is informed by their experience of urban and suburban life in contemporary America. Through their visions, and writer Mary Robbins's accompanying essay, the exhibition addressed collective and individual responses to a moment in time and cast artists as social and cultural cartographers.

Installation view with, from left, SunTek Chung, *Suburban Fury*, 2005; Matthew Day Jackson, *Hung, Drawn and Quartered*, 2005; Andrew Guenther, *Untitled*, 2005; Hilary Harnischfeger, *Blue*, 2005; William Villalongo, *The Abduction of the Black Cowboy*, 2005; Hilary Harnischfeger, *Red*, 2005.

THE DREAM OF THE HIGHWAY
MARY ROBBINS

America has a low-grade fever, a flu-like condition that cannot be treated by the countless medications that line the aisles of the monster drugstores in our monster malls. This persistent illness may be related to the unshakable suspicion of having been somehow duped, having been sold a marketing man's idea of this new America, having been deluged by slogans and promises that all lack any fundamental truth.

The flashy catchphrase "homeland security" has a jazzy Hollywood feel; it sounds tough and reassuring, but it is just a line from a movie, just a bit of film noir dialogue: there is no security, not from foreign threats and not from domestic threats. The "homeland" is so deeply divided that we are all a threat to one another. The words do not mean anything but still the political ad men keep pushing their mottoes, their pithy phrases, their homeland security and, just like the medications, these words bring no relief. Even for those who never bought into this hard sell, there is still the queasy sense of having been conned, of having been taken for a ride. Clearly, nobody wants to be taken for a ride but, on the other hand, taking a ride, going for a ride is almost the premise of this nation. Railways and mountain passes and highways were all built so that we might take a ride.

Motion is the incredible luxury of this oversized country. Keep moving: if you don't like where you are, you can move. If you don't like who you are, you can move. Motion used to be the guardian angel of the highway. There was freedom and change and exhilaration, but the age of terror brought a wariness of the unknown and the highway is always unknown. So motion was supplanted by paralysis: stay where you are and, if you feel restless, get in your car but keep it local, stay close to home, and go shopping: buy cereal and bread and alarm systems and lock yourself in tight. Our superstores are open all the time and they offer a staggering array of goods and services but still there remains a void that cannot be filled. Buy more and be more, that is the twitching jingle that trickles out of every television and magazine. Keep buying the flu medications in the hope that one will eventually relieve those strange and disquieting symptoms. The superstores and the medications are everywhere in this enormous country, and they give the illusion of unity, consumer camaraderie. Kmart, Walgreens, Rite Aid, McDonald's—these are the common threads, and they link the states, one by one, coast to coast, an alliance of products rather than people. These superstores can be found trailing the outskirts of our cities, they can be found thriving in suburban ghettos, in the malls that churn across this country, all exactly the same in some weird way. Beyond the malls are the mini-marts and the greasy food and gas stops that litter the off-ramps and service roads. These endlessly repeated stores and drive-through windows are touted on signs that lurch over the highways, almost grabbing drivers off the road. Drivers stop for this or for that, but the highway carries on, rushing across the country, flying westward with an urgency that must owe something to the famous plea "Go West, young man." Maybe this is in part what ails us. The current directive, "Go East, young man," runs counter in all ways to the old-fashioned highway dream, a dream about fast cars and money and pretty girls and extreme youth. It is a naive and pointless dream in this era but is, nevertheless, almost charming compared to the contemporary dream of the administration, which is a dream about power and conformity and death and hypocrisy. Although the archaic dream of the highway, the dream of the West, is not an antidote to the nightmare of the East, it is still an important ▷

"The current directive, 'Go East, young man,' runs counter in all ways to the old-fashioned highway dream, a dream about fast cars and money and pretty girls and extreme youth. It is a naive and pointless dream in this era."

part of the American mythology and having been dismantled does not mean that it is completely gone. The ghosts of the highway are still radiating out in spiderweb zigzags and straightaways. The roads are still waiting to be repaved for new destinations. These new destinations come from the images that are evolving right now.

Look at the photographs and the paintings, the sculptures, and installations. Look for clues about the future. Look at the new signs or—as with Karyn Olivier's photographs, Roger White's painting, and Ian Sullivan's quilted pieces—look at the old signs in a new way. Olivier, White, and Sullivan take up these old images and force reconsideration, force an uncomfortable attention to the things we have come to accept. All the artists in *You Are Here* are paying attention to details, they are looking at things that are typically overlooked, and they are considering where we are and where we can go. Deborah Grant's collages soak up the flood of old signs and crush them up against each other until there is a screaming incoherence, which may be the sound of the future. SunTek Chung's suburban horror glimmers with a gleeful nod to Hunter S. Thompson's lunacy; Thompson in suburbia could lead to a curious new place. Matthew Day Jackson's shattered emblems of democracy and freedom could lead to a new emblem, a new democracy, where Allison Smith's elegantly fanned arms might fight a new civil war. Adam Helms's intricately detailed guerrilla warriors could fight this war and what a war it might be. Sigrid Sandström's bleak installation suggests that there may be a need for a stripped-down survivalist lifestyle in the future. Hilary Harnischfeger's sculptures might be the future beyond that future; a million years from now, perhaps, this world will be a long-forgotten place, frozen and uninhabitable. All the roads and signs lead to different

variables and outcomes, often contradictory: Blake Sandberg's eco-dome is chillingly apocalyptic but Larry Bamburg's world flutters and dances with a whimsy that is electric and immediate. We cannot know where the new highway leads. It is only half paved, and this is truly in keeping with the dream of the highway, to charge at the unpaved horizon and chase the unseen edges of the Earth. Look at Andrew Guenther's fantastical swirling painted song; it might be a new anthem for a new road. William Villalongo's stained-glass cowboy may be a new hero for those who are brave enough to walk away from Raphael Zollinger's eerie and unnerving offer of a place that always waits to welcome those who do not wish to move, to travel, to think.

Look at the photographs and the paintings, the sculptures, and the installations; these are the signs that lead to a new highway that is already pointing toward a reenvisioned West. □

Exhibition essay.

Installation views, clockwise from top left: Raphael Zollinger, *Welcome*, 2005; Alison Smith, *The Gun Wall*, 2005; Andrew Guenther, *What I Like About Floating*, 2005; Larry Bamburg, *The Sweet White Light of a Cream Colored Variable*, 2005; William Villalongo, *The Abduction of the Black Cowboy*, 2005; Deborah Grant, *Boys of Lawton, OK*, 2005.

34

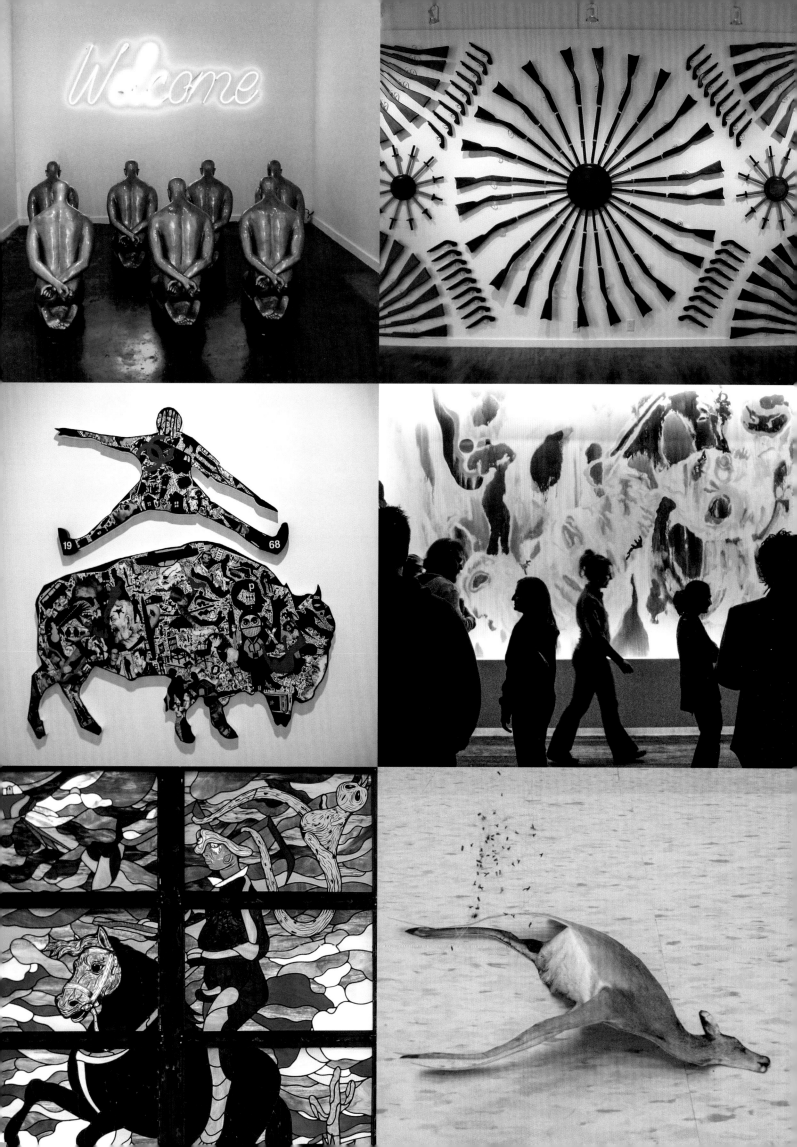

SEE DONALD JUDD'S BED!

EAT FOOD ALL THE SAME COLOR!

SCARE THE LOCALS!

TAKE THE WHOLE FAMILY TO MARFA★ TEXAS

"THE JONESTOWN OF MINIMALISM"

YOU CAN'T FLY THERE!

IT'S A L-O-O-O-O-N-G DRIVE!

Pretend to See "The MARFA LIGHTS"

CARL ANDRE LOOK-A-LIKE CONTEST!

RIGOROUS BONFIRES!

WIN A DATE WITH JOHN CHAMBERLAIN

AN EVENING WITH JOHN WATERS

In October 2004, as one of its first art activations, Ballroom Marfa welcomed legendary filmmaker, photographer, writer, and provocateur John Waters for *An Evening with John Waters.* Waters was dubbed "the Pope of Trash" by William S. Burroughs. His films, photos, and writing have transitioned from underground to mainstream without losing their singular aesthetic. Among his best-known films are *Mondo Trasho*, *Multiple Maniacs*, *Pink Flamingos*, *Polyester*, *Hairspray*, *Cry-Baby*, *Serial Mom*, *Pecker*, and *Cecil B. Demented.*

A REFLECTION BY JOHN WATERS

Marfa was a lovely experience. I had a great time. I was invited to perform at Ballroom Marfa early on. I most likely upset and offended some people.

At the time, it was a true pilgrimage to go to Marfa. Marfa at that moment was the city that Judd built—a sort of cult city, only no one kills themselves. People also knew about Marfa because of the famous 1956 Hollywood movie *Giant*, starring Rock Hudson, Elizabeth Taylor, and James Dean. And then later they came for Donald Judd—to see the art, an art town at the edge of nowhere. So going there then it was like going to a cult city. What can I say? I became a Judd hag. ☐

Interview, John Waters, Daisy Nam, and Alexann Susholtz, May 5, 2023.

Detail, cover of *Artforum*, Summer 2004, with artwork by John Waters.

PRADA MARFA

ELMGREEN & DRAGSET

In October 2005, Ballroom Marfa unveiled *Prada Marfa*, a site-specific, permanent public art project by the artist duo Elmgreen & Dragset, commissioned by Art Production Fund and Ballroom Marfa, and located on a barren stretch of highway one mile west of Valentine, Texas. Modeled after a Prada boutique, the sculpture houses luxury goods from the famed fashion brand's fall 2005 collection of bags and shoes, but thwarts commerce, as access is impossible; the door is always locked.

PRADA MARFA: AN ART PRODUCTION FUND DIARY
YVONNE FORCE VILLAREAL AND DOREEN REMEN

MARCH 2004

When Michael Elmgreen and Ingar Dragset came to Art Production Fund's office in New York City, they introduced to us a simple and captivating proposal: to place a life-size model of a Prada boutique, permanently, in the middle of the Nevada desert. In line with their other installations, in which they recreate and displace common signifiers causing surreal experiences for viewers, this was intended to be a hyperrealistic sculpture of a luxury store. The Prada shop would have a sealed door, never to be opened to commerce, and it would display a selection of coveted objects of our time for those who cared to stop and gaze: six bags and twenty shoes from the Prada Fall 2005 collection. The building would be constructed as a minimal white adobe box adorned with an awning, beige carpet, and the Prada logo, moored on a barren landscape with no potential customer in sight. As the Art Production Fund usually produces artworks that have a temporary duration, we most of all loved the project's aspect of permanence and the natural process of gradual decay. At the time, we were in the midst of launching Rudolf Stingel's Plan B at Grand Central Terminal and had yet to take on two major productions simultaneously. But the curious nature of the proposal made it impossible for us not to join in the endeavor.

For several reasons we all decided to move the site from Nevada to Marfa, a small town in the big desert of southwestern Texas. Marfa was already an art world destination through Donald Judd's renowned Chinati Foundation and was identified as a center for minimalist and land art.

APRIL 2004

Marfa, Texas, is also home to Ballroom Marfa, a contemporary art space cofounded by Fairfax Dorn and Virginia Lebermann. Art Production Fund introduced the idea of *Prada Marfa* to Fairfax and Virginia, who quickly embraced it and became invaluable production partners for the project. Together, we began to strategize how to acquire the land, secure an architect, find a contractor, and transport all the materials and trappings needed to build a luxury store on the ranching farms of Texas.

MAY 2004–AUGUST 2005

Elmgreen and Dragset made their first site visit. Ballroom had identified several locations that fit the description of what the artists wanted: flat, near a highway, and at least twenty miles outside of Marfa. The spot the artists settled on was in fact thirty-five miles away and just on the outskirts of the small (ghost-)town of Valentine.

As producers, one of our fundamental roles is to secure sponsorship. We all believed that the obvious potential sponsor, Prada, was a conflict of interest. However, we welcomed guidance from the Fondazione Prada on the structure, paint color, and carpet, which would allow us to match the sculpture exactly to existing stores. Miuccia Prada gave us the right to use the Prada logo on anything directly related to the project and they sent us the file and a letter of permission. Prada generously donated twenty pairs of high-heeled shoes and the six handbags.

For over a year we built our production team. Casey Fremont, Art Production Fund's production coordinator, and Vicente Celis of Ballroom Marfa oversaw the details. Boyd Elder, artist and local resident, became our indispensable on-site manager. Architects Ron Rael and Virginia San Fratello were visiting Marfa when Fairfax and Virginia invited ▷

Elmgreen & Dragset, *Prada Marfa*, 2005.

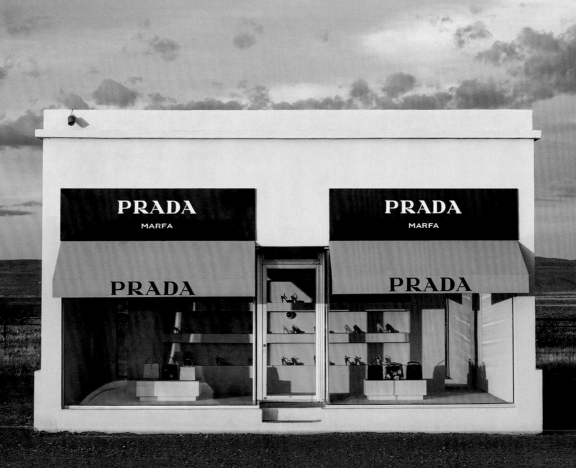

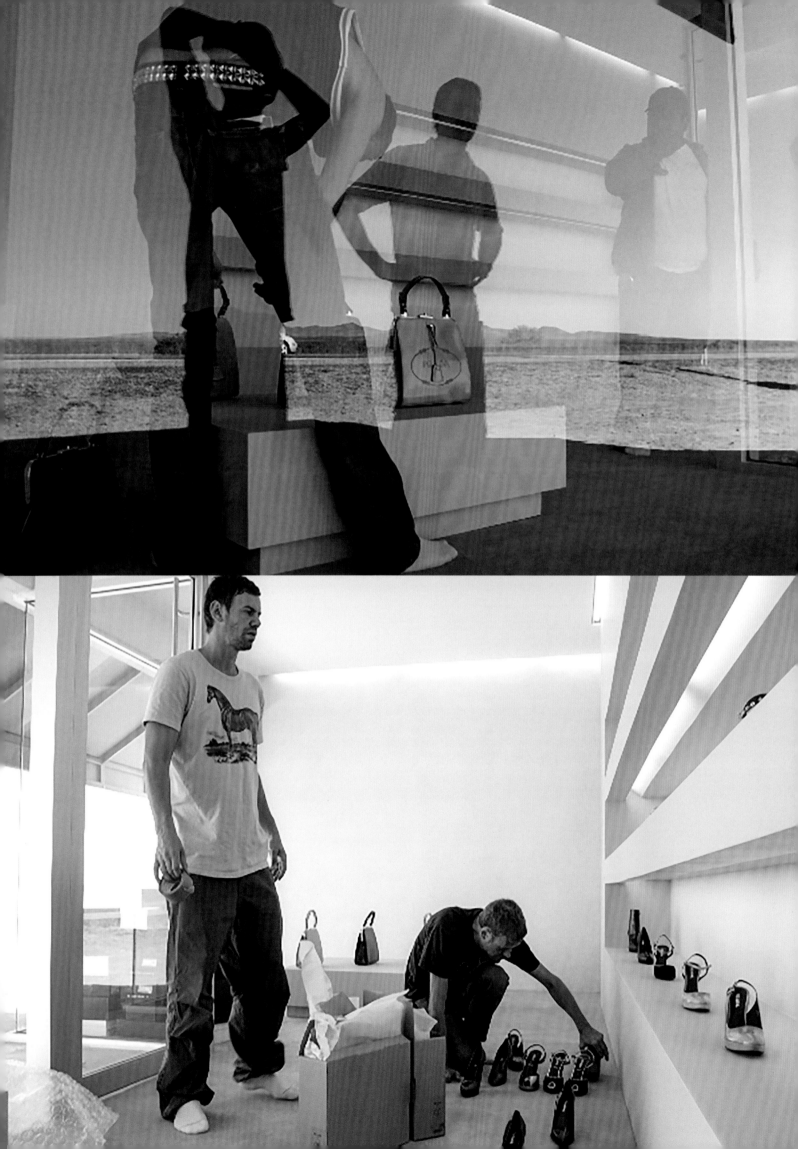

"From afar we could see a green glow off to the side of the highway. As we approached, the building took shape, the awning was apparent, and we saw what looked like the iconic Andreas Gursky photograph of a Prada shoe display transplanted into the middle of a tough, flat, and beautiful terrain."

them to take on the project. A local family, represented by matriarch "Smokey" Hall, generously agreed to lend the land that the artists had chosen and gave us the right to buy the lot in the future. Calvert Electric erected the necessary pole and strung the electrical wires, and the contracting job went to Charles Maxwell. A blog was set up for production updates and photos, and we watched as *Prada Marfa* finally took form.

SEPTEMBER 2005

The Art Production Fund team flew into El Paso from New York, rented a car, and started the three-hour drive to Marfa, Texas. As the city began fading away, buildings were replaced by open space and big sky. Two and a half hours later the sun had set, and we were nearly at our destination. We started looking out for *Prada Marfa*; up to this point we had only seen images on our blog. From afar we could see a green glow off to the side of the highway. As we approached, the building took shape, the awning was apparent, and we saw what looked like the iconic Andreas Gursky photograph of a Prada shoe display transplanted into the middle of a tough, flat, and beautiful terrain. *Prada Marfa* was everything it promised to be.

OCTOBER 1, 2005

The formal opening was in fact a rather informal roadside gathering next to the sculpture with local residents, visiting and local artists, international gallerists, curators, critics, and reporters in attendance. A guitar played, truckers honked as they drove by, and the convenience store in Valentine offered a discount in honor of their new neighbor. It seemed that *Prada Marfa* would seamlessly, if incredibly, blend into its new environment.

OCTOBER 3, 2005

Only two days later the sculpture was vandalized. Someone spray-painted one side, pulled off the door with a truck and chain, and stole the handbags and right-foot shoes. We were taken completely off guard and had to decide whether to restore the work immediately or let its decline into a ruinous state begin. Because it was premature for such damage and few people had even seen the work, we determined that it should be repaired. In the middle of the desert, this was no easy task. People repainted and cleaned the broken glass and mud, off-duty sheriffs guarded the site until a security system and new door were in place, Prada sent six identical bags and the left-foot shoes were taken out of their boxes. Intense press coverage ensued, including the second *New York Times* article, only this time on the cover of the National Report.

OCTOBER 2005

Thousands of bugs, rodents, and dust particles later, the aging of *Prada Marfa* is underway. The accessories have dulled, perhaps from the dust or as they are no longer this season's luxury goods. Yet the concept of how we desire cultural commodities, how we can buy our taste and our art, is somehow more poignant. *Prada Marfa* appears on postcards, has become a meeting place for teenagers, and has grown into a destination, if only a place to spend a few moments. The lights still click on at seven every night to illuminate the mirage that can be seen for miles. We hope the artwork matures slowly, that people will visit as it evolves and continue to send us their photos and comments on this mysterious sculpture in the middle of nowhere. ▷

Excerpt, Elmgreen & Dragset, Prada Marfa *(Köln: Walther König; New York, NY, 2007).*

"We thought, What is the high fashion industry? What does it look like if you take it out of its normal environment? ... We are not surprised by [luxury stores] when they're on Fifth Avenue or in the middle of Paris, but how would they look if you would take them on a survival trip out in the middle of the desert ...?"

A CONVERSATION WITH ELMGREEN & DRAGSET

Michael Elmgreen: First, everything happened more or less as a coincidence. [Ingar and I] met in a nightclub in Copenhagen, and after a year we started also doing some work together, but both of us never went to any art academy, [or received] any professional art education. So we started questioning all the structures in the contemporary art world. We wondered why all these spaces look so much alike. I mean, even Burger King or McDonald's look a bit different if you go to Russia or Texas or Berlin.

Ingar Dragset: I think maybe growing up as kids in the suburbs, Scandinavia in the seventies and eighties, you know, being gay, wasn't what it is today. It wasn't as accepted even in the fairly liberal Scandian context. So I think that gave us the kind of early critical eye into the structures immediately surrounding us. And that's something that probably inspired us early on to want to express a reality as we saw it. And I knew I kind of wanted to do something artistic, but as you said, being an artist, that wasn't really something that seemed really rich. You thought about Picasso, or—I didn't really know about contemporary arts or much growing up. So, for me, it was going to the theater. I studied acting and that's how I moved from Norway to Copenhagen at some point and where I met Michael. Michael had been writing poetry for some years then and we combined then, after having been boyfriends for a year, our two practices in a way, and started doing art performances and as a different kind of performance than theater, it's more like duration, often. It's more physically challenging. It's more like a ritual, maybe. And through this activity, I think we discovered all the conventions that really are within the art world as well. And that was maybe kind of

a disappointment for us. I think we thought maybe the art world was more liberal and open, and it is to some extent, but there are also, as we know, many, many rules within the architecture and the social structures that surround it.

Elmgreen: Now I think there's a lot of rethinking of all these structures in the light of the climate at the moment, following the coronavirus crisis. I think we are all like thinking about what we are, what are we part of, this constant rush to achieve something like the extreme hurdle of traveling, the pressure, the social functions, all the fluff, as well. That's often also very hierarchic, or very exclusive. I think a lot of people right now are thinking that maybe we should be a bit more open and welcoming and collaborative in our approach. This is partly what inspired *Prada Marfa*. We thought, What is the high fashion industry? What does it look like if you take it out of its normal environment, its normal urban context? I mean, a product store, its own store. We are not surprised by them when they're on Fifth Avenue or in the middle of Paris, but how would they look if you would take them on a survival trip out in the middle of the desert, where they would have to survive on their own?

Dragset: And we got quite obsessed with this idea about having a small store with nothing around it. Also as a comment on the landscape around because the landscape you often don't notice if you just drive through, if you drive for two hours on Highway 90 and you just see the same landscape all over again, you don't notice it and, in the end, when you put something there that is completely displaced, like a small, forever-closed Prada store, then you suddenly think about where you are. And you also think about how strange this store looks in this context. Marfa was the perfect location because of course ▷

Prada Marfa security camera stills capturing artist, local, and on-site manager Boyd Elder, 2005.

42

lamarfa
9/10/05 12:12:10
x480 15 S X4

pradamarfa
2009/10/05 12:12:10
720x480 10 S X4

lamarfa
9/10/06 18:09:32
x480 15 S X8

CH2

pradamarfa
2009/10/06 18:09:29
720x480 10 S X8

CH2

lamarfa
9/10/05 10:42:04
x480 15 S X4

pradamarfa
2009/10/05 10:42:03
720x480 10 S X4

CH2

lamarfa
9/09/28 13:48:27
480 15 S Y1

pradamarfa
2009/09/28 13:48:27
720x480 10 S Y1

"The artist and local legend Boyd Elder came to the opening and then just kept coming to the site. He lived on a ranch in Valentine, which is a ghost town, basically still.... He came by, brought some beers, and then invited us over for chili, really, spicy chili. And we became friends."

Donald Judd, and the interior design or the minimalism that you experience throughout the nineties and the beginning of the millennium couldn't have existed without Donald Judd. The boxy shelving of the Prada store reminds us so much of Donald Judd's furniture pieces—well, painted mint green, but more or less the same—this whole kind of commercial take on minimalism. That was interesting to investigate so close to the Judd Foundation. It was the beginning of the minimalism and maybe also the end of the minimalism that would meet only some miles in between. It was a project that, in a way, combines minimalism, pop art, and land art.

Elmgreen: The opening of the piece was pretty unforgettable. There were only about fifty people. Country music. Homemade tequila. Mexican beer. There were a lot of the local ranchers. It was a very local thing. Some people said, "We don't really know what it is. Is it really a sculpture? I don't know, but it looks beautiful." Because they enjoyed seeing these stilettos and the gorgeously fabricated handbags. And of course, let's face it, when you put anything in that spectacular nature, it tends to look good.

Dragset: We could explain about our art and then we could learn something from them. So [we were] really coming with very different backgrounds. I didn't know how to shoot rattlesnakes and some of these guys, they didn't know much about contemporary art installation, but we could learn something from each and we were curious about one another.

Elmgreen: The local artist and legend Boyd Elder came to the opening and then just kept coming to the site. He lived on a ranch in Valentine, which is a ghost town, basically still, and the closest town to [*Prada Marfa*]. He came by, brought some beers, and

then invited us over for chili, really spicy chili. And we became friends. And in a way he was from the beginning a self-appointed caretaker of *Prada Marfa*. But it was really through friendship and through him being this incredibly fascinating person himself. He was caretaker and spokesperson. And over the years, the piece took on its own life. When you do an outdoor sculpture, you have to accept that it takes on its own life. It's almost like being a parent and the kids move from home. You can't control them any longer. And that's also the beauty of it. Our initial intentions got disturbed by incidents of vandalism and people trying to break in and steal stuff. But . . . the local community [also wanted] to maintain it. I mean, you start the whole process, but then you need to accept that the process evolves in a way that is beyond your own decision-making. And that was super exciting, as an artist, when that happened. ▷

Excerpt, interview, Michael Elmgreen, Ingar Dragset, and Diana Nguyen, 2020.

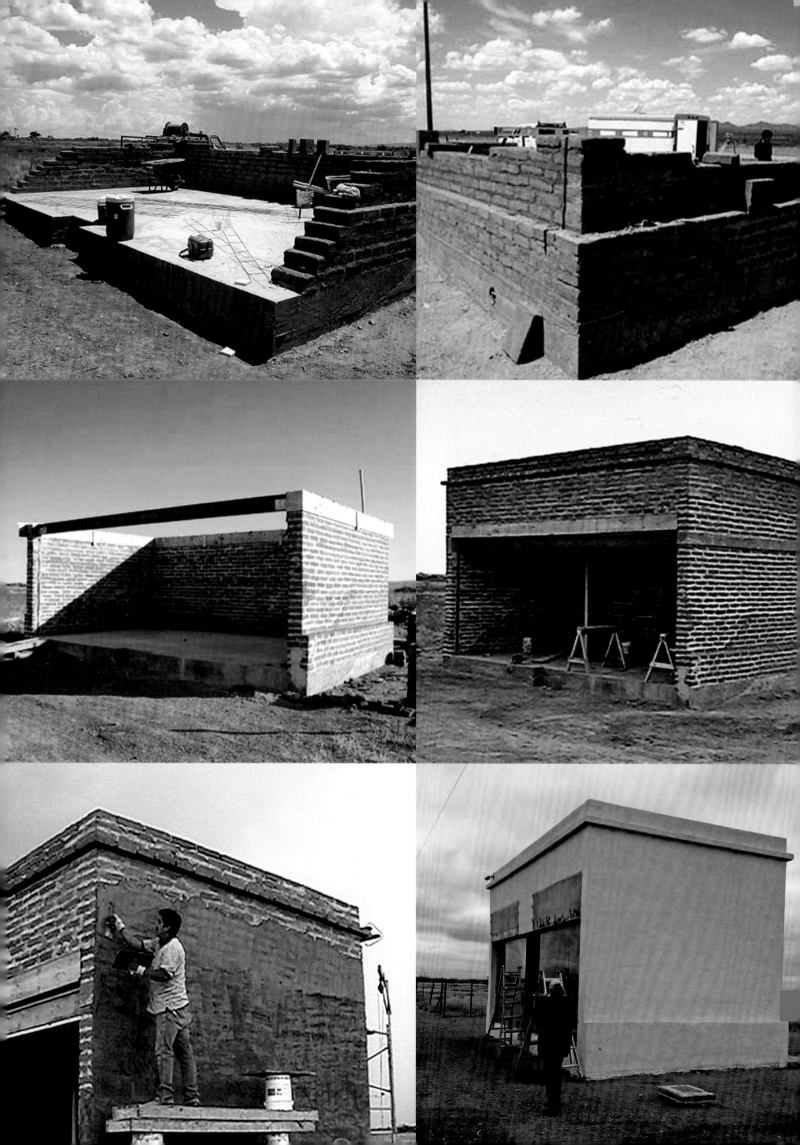

HOUSE OF PRADA/HOUSE OF MUD
RONALD RAEL

On July 13, 2005, twenty-two miles north of the US–Mexico border, patrol agents from the Marfa sector (known as "Big Bend" Sector) of the United States Border Patrol surrounded five people traveling through the Chihuahuan Desert in West Texas. Suspecting illegal activity, the agents had been informed that illegal immigrants were detected by the tethered aerostat radar system hovering overhead that provides counter-narcotics and border crossing surveillance and can distinguish targets as small as a meter across at ground level. It is not uncommon that "coyotes," smugglers involved in the profession of human trafficking, drive the desolate roads searching for "wets," the derogatory term for illegal immigrants, in the vast desert expanse surrounding Marfa. When the five suspects were questioned on the nature of their business, the answer was not so clearly comprehended by the Border Patrol. The suspects were a gallery curator, a photographer, an artist, and two architects who were discussing the selection of the future building site of *Prada Marfa*, a minimalist sculpture that replicates the luxury boutique in which the Fall 2005 line of Prada shoes and handbags were to be displayed.

The juxtapositions between the United States and Mexico, or between wealth and poverty, that are clearly evident in the Big Bend region of Texas define a landscape charged with the contrasting conditions in which *Prada Marfa* is built. The immense ranches that make up the area, each several thousand acres or larger, often appear to be abandoned but are owned by many of the wealthiest people in the United States. Most of the ranch owners have ties to oil, and more recently, dot-com wealth, including a ranch owned by Amazon CEO and founder Jeff Bezos, where he has announced plans to construct a spaceport just down the road from *Prada Marfa*. Just as each of these polarities is somehow equally at home and "foreign" to this environment, so too is *Prada Marfa*, with its delicate interiors and massive walls, schizophrenically positioned in the geopolitical and cultural framework in which it is built. In fact, the process of building the project is as simultaneously contextually grounded and extrinsic as the work itself.

The primary building material used to construct *Prada Marfa* is dirt. While it may seem odd to construct a building with soil—particularly one with the associated title *Prada*—building with earth is actually quite common. It is estimated that currently half of the world's population, more than three billion people on six continents, lives, works, or worships in buildings constructed of raw earth. This makes fragmental soil—not to be confused with other materials that come from the ground, such as

stone, cement, or metals derived from ore—the most ubiquitous building material on the planet. Earth buildings can also be found in almost every climatic zone on the planet, from the deserts of Africa, Australia, and the Americas to England, Denmark, China, and the Himalayas.

Whereas earth is a material that Westerners commonly perceive to be reserved for the small, humble structures of developing countries, there are earth buildings of almost every architectural type in use by all economic and social classes. Examples of churches, hospitals, museums, embassies, and even an airport demonstrate the wealth of earth building types found throughout the world. Typically, earth is considered to be a building material only used in rural environments, but earth architecture can be found just as easily in contemporary urban environments. The world's first skyscrapers, two-story buildings first constructed over five hundred years ago, continue to be constructed entirely from mud in the dense cities of Yemen. Perceived as a material of low quality, earth buildings also represent the oldest extant buildings on the planet. Using approximately seven million mud bricks, the Ziggurat of Ur dates to 4000 BCE. The Taos Pueblo, constructed in New Mexico between 1000 and 1450 AD, is the oldest continuously occupied dwelling in North America and was also constructed from raw earth.

While earthen architecture is often considered the building material of the very poor, many wealthy residents inhabit the vast mud brick suburbs of Santa Fe, New Mexico. Ronald Reagan's former Rancho del Cielo (also known as "the Western White House) in California, Saddam Hussein's childhood home in Iraq, and Chairman Mao's childhood home in China were all constructed of mud brick, which speaks of the great breadth of ideological extremes represented by this omnipresent material. Now we can add *Prada Marfa* to this "A-List" of earthen architecture—the first Prada-related building constructed of mud.

A large percentage of buildings in the region surrounding *Prada Marfa* are also traditionally constructed of mud brick. Often made directly from soil excavated from the build site, mud brick, called adobe in Texas, is a brick made from soil mixed with water and straw and left to dry and harden in the sun. Historically, this was the traditional construction method used by the Mexican and Mexican American populations. In the case of *Prada Marfa*, the 2,500 mud bricks used to construct the building were made by machine and express-shipped to the site from a mud brickyard in Alcalde, New Mexico, some five hundred miles away. Not unlike the luxury goods that fill the faux boutique, the mud bricks arriving from this adobe yard are primarily manufactured to supply a growing population of southwestern affluence enamored with the romantic notion of living in a house constructed of earth. Increasingly, the ▷

47

demands made by wealthy interstate immigrants longing for mud brick residences have had a dramatic effect on the cultural and built landscape.

At one time, buildings made of earth were looked down upon, and ultimately made illegal to construct for several decades. Today, however, mud brick's increasing popularity has created a demand for the material that has transformed it into a status symbol in the southwestern United States. The humble earthen houses of Marfa's residential district now fetch several hundred thousand dollars from New Yorkers, Houstonians, and Los Angelenos. Thus, what was once a vernacular tradition has transformed into a capitalist-driven process that often leaves the traditional descendants of earth dwellers unable to afford mud, forcing them to switch to an ironically more affordable consumption of prefabricated mobile homes and concrete-block houses. Much like the knockoffs of Prada bags that are a consequence of the high price tag of authentic Prada merchandise, adobe knockoffs, "faux-dobes," are the preferred style of manufactured Southwestern homes.

Unlike traditional mud brick buildings whose bricks are laid in an earthen mortar, the mud bricks used to build *Prada Marfa* were set in a cement mortar. The juxtaposition between the industrial material of cement and the traditional mud brick could be read as a nod to Donald Judd, but the combination also represents the bipolar nature of the context in which it is built. In Marfa, the use of industrially produced cement, introduced by the U.S. military, and traditional mud, used to construct buildings in the region since pre-Columbian times, is also the material combination used to construct the walls of the military buildings purchased by Judd in the 1970s that now house his vast and priceless collection at the Judd Foundation in Marfa. The significance of this hybrid building technology reveals the history of militarization and occupation of the sector that encompasses Marfa and the US–Mexico border. Native Americans called Jumanos (or, humans) by the subsequent Spanish military occupiers, were the original inhabitants of this, the oldest inhabited region in the United States. Jumanos lived in buildings made of earth and wove baskets and shoes made of yucca fiber. After the Spanish occupied the region, it was the Mexican government and later the U.S. military, each leaving bulk traces in the landscape that are evident today. By crossing a border between art as commodity and commodity as art, *Prada Marfa* offers a conceptual interpretation of the latest wave of occupation in the region Judd and the gentry of gallery owners, artists, and art lovers who are his followers. It also raises questions regarding the consequences of this history.

While *Prada Marfa* was not constructed with illegal labor, mud brick construction is labor intensive, and labor provided by illegal aliens is cheap.

The demand for inexpensive labor in America coupled with a search by immigrants for higher-paying jobs, work hand in hand to prompt people to cross the desert by foot. Although it is difficult to know exactly how many immigrants cross the border in the Marfa sector each year, in 2005 there were 10,536 illegal border-crossing apprehensions and around twelve migrant border-crossing deaths. Most of these deaths are attributed to heatstroke or hypothermia. From a distance, illegal aliens walking through the desert at night might perceive the illuminated building to be a possible source of water or shelter. However, upon closer inspection, *Prada Marfa* reveals an irony that connects the history of the region while also offering a prognostication. It is not uncommon for one's shoes to wear out during the arduous journey across the desert. In a desperate attempt to protect tired feet from the rough terrain, immigrants are known to try to fashion shoes from the only material available: the yucca plants that dot the landscape. The contrastingly opulent presentation of meticulously organized shoes and bags housed within the familiarity of mud brick walls also foretells the future: a growing socioeconomic polarity at the local and, indeed, global level. □

Excerpt, Elmgreen & Dragset, Prada Marfa *(Köln: Walther König; New York, NY, 2007). Ronald Rael is an artist, designer, architect, and activist.*

A bullet hole through the window of *Prada Marfa.*

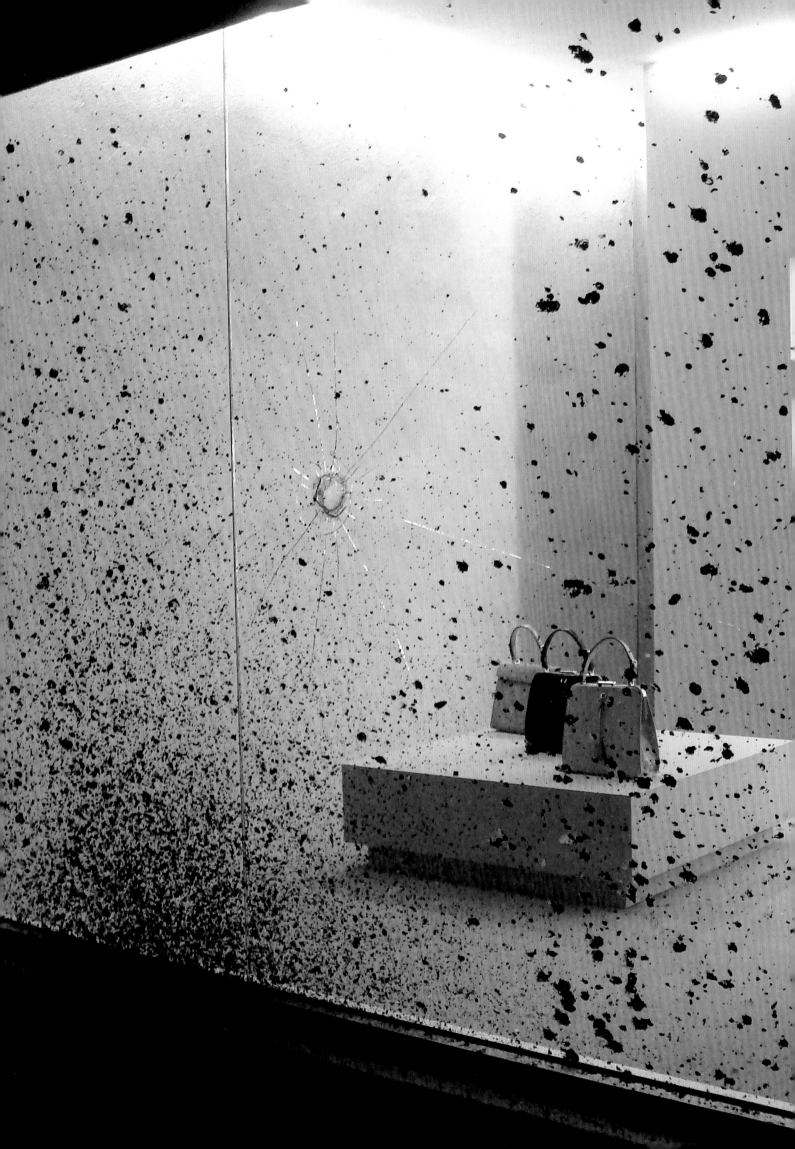

TREADING WATER

MARÍA JOSÉ ARJONA, JAMES BENNING, AGNES DENES, MATTHEW GOULISH, SIGALIT LANDAU, MICHAEL PHELAN

In 2005, Ballroom Marfa mounted *Treading Water*, a multidisciplinary group exhibition curated by Fairfax Dorn and devoted to bringing attention to the global freshwater crisis. Through installation, performance, sculpture, drawing, and video, *Treading Water* examined the critical role of water in the twenty-first century. Agnes Denes's important large-scale work *Pyramids of Conscience* was created for the exhibition. Comprising four pyramid forms, three filled with different substances—fresh water, oil, and polluted water from the Rio Grande— and a fourth pyramid featuring mirrored surfaces that reflected viewers to themselves, it prompted us to consider our relationship to water and the extreme challenges facing its conservation. ▷

TREADING WATER, UNDER(STANDING) WATER
WILLIAM L. FOX

Water has been a central element in art for as far back as we can see. The petroglyphs and pictographs of pretechnological people frequently symbolized water and were oriented toward its sources. The rugs of ancient Persia and the paintings of classical Egypt were often composed around the picture of a garden pool, and a water element in the middle ground has been a key element of landscape painting in everything from Mughal miniatures and Chinese scrolls to European history paintings from the Renaissance onward. Likewise, water has been physically present in architecture and sculpture since the paradise gardens of Mesopotamia and the invention of fountains. When modern art fragmented into the multiple new genres of contemporary art in the 1960s—just as projections for a worldwide scarcity of fresh water were beginning to appear as a tenet of the environmental movement—the use of water both as a subject for and a material of art only increased.

We start with water at the center of the picture because there is no other place to start. Life can exist as bacteria in space where it is simultaneously frozen down to absolute zero and blasted by radiation, and in geothermal vents where exposed flesh would boil away and there is no sunshine whatsoever. It can sit dormant in sand, ice, and rock miles beneath the surface of the planet and subsist by eating minerals. But the one thing that life as we know it cannot do without is water, the molecule that enables energy to move around in a living system.

Fortunately for us, water is ubiquitous throughout the universe. Hydrogen was the most abundant element formed in the big bang and oxygen is formed as a byproduct of stellar fusion. When stars go supernova in their death throes, they spew out both elements, which combine into water that then freezes around specks of dust. The dust combines into huge clouds that feed comets and planetary systems, hence water on Earth. Water ice is one of the most common minerals in the entire cosmos, and in its melted form covers almost 75 percent of our planet's surface. Unfortunately, 97.5 percent of Earth's water is salty, and 70 percent of the remaining 2.5 percent is locked up in polar ice. This leaves only 0.007 percent of the world's water available for our use, most of it in groundwater, and we're already consuming the readily accessible sources faster than they can be replenished. During the past century, the world's population has tripled, but water usage has jumped 600 percent. One recent United Nations study projects that seven billion people in sixty countries will face water scarcity by 2050, a date by which perhaps as much as half the world's population may live in arid regions. The upshot is that we are

using and polluting fresh water faster than it can be replaced, and conflicts over it will only increase during this century.

The hydrological cycle on Earth has been pushing water around the planet and in the atmosphere for three billion years, but the amount of water diverted and impounded behind eighty-eight of the world's largest dams built during the last fifty years is so great that it has altered the rotational periodicity of the planet itself and titled its axis. This and other consequences of the Industrial Age, such as global warming, mean that we have surpassed nature as the most pervasive agent of change on the planet's surface. The last ten thousand years have been referred to by geologists as the Holocene, or Recent Era—some of them now propose that we acknowledge that we live in the Anthropocene, the Human Era.

Contemporary environmentalism became widespread in America during the 1960s, due in no small measure to books written by marine biologist Rachel Carson about life in the oceans, and then her seminal *Silent Spring* published in 1962. Environmental studies must, by definition, rely on cross-disciplinary efforts among biologists, botanists, chemists, and others in order to proceed. Artists in that decade, seeking to escape the strictures of modernist painting and sculpture, which found its apotheosis in minimalism, likewise began to adopt a multidisciplinary approach in order to accommodate an increasingly complicated worldview. Painters became sculptors became installation artists became performers became video artists—whatever it took to follow their ideas. Agnes Denes was one of the first artists working with environmental concepts to jump the boundaries; Sigalit Landau, María José Arjona, and Michael Phelan are three of the more recent ones. Water is a central concern for all of them.

The four sculptures by Denes included in *Treading Water*—collectively entitled *Pyramids of Conscience*—set before us issues and forms with which Denes has worked for four decades. Since the mid-1960s, environmentalism has been central to her art, as evidenced in "eco-logic" works (a term she coined) such as *Rice/Tree/Burial* (1968); *Wheatfield—A Confrontation* (1982), for which Denes planted and harvested a two-acre wheat field on a landfill in Lower Manhattan just blocks from Wall Street and the World Trade Center; and *Tree Mountain—A Living Time Capsule* (1992–96), for which eleven thousand people planted an equal number of endangered pine trees in a delicate and convoluted spiral pattern. Over this period, pyramids became, for Denes, metaphors through which she expressed her global anxieties over environmental and social trends; translations of the human thought process into a symbolic system based on mathematician-philosophers Alfred North Whitehead and Bertrand Russell's project to ▷

Performance of John Cage's "Inlets," conducted by Matthew Goulish, 2005.

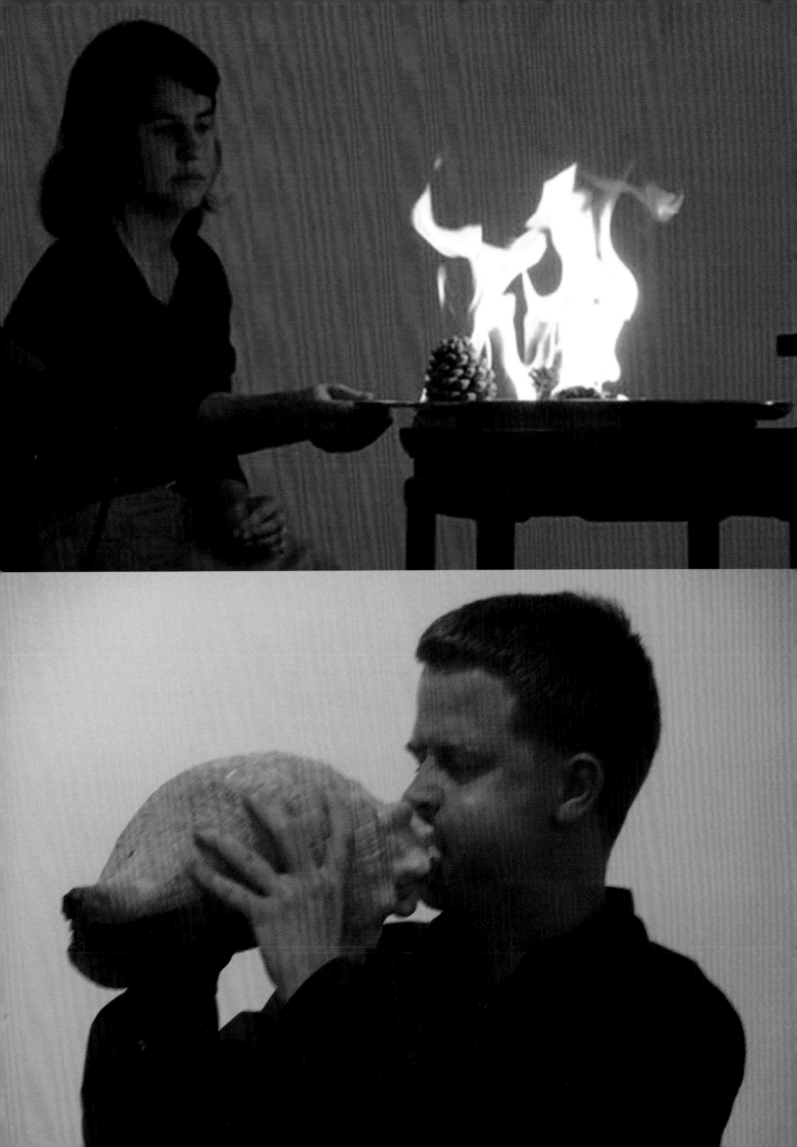

"The one thing that life as we know it cannot do without is water, the molecule that enables energy to move around in a living system."

analyze language with mathematics by breaking it both down into irreducible "atoms" of expression and symbols that allude to attempts by past cultures, such as Mesopotamia and ancient Egypt, to erect geometrical forms as monuments to Utopia on Earth, or to the perfect hereafter. *Pyramids of Conscience* offers a constellation specific to both the beginning of the twenty-first century and to Texas, where they were premiered in Marfa as the centerpiece of *Treading Water*.

Here are the four elements representing the quadripartite division of the original paradise gardens, which had their roots in the arid desert cultures of the Middle East. The four streams carried out from the central fountain traditionally represented honey, milk, wine, and water—they symbolized both sustenance and bounty. In Denes's version, the four pyramids hold pure water, crude oil, industrially polluted water, and a mirrored surface. She has replaced milk and honey with oil and its by-products, a symbolic feat performed in a state where oil has driven politics and policy on the local level for more than a century, and more recently on an international scale.

Oil and water do not mix, though they are often found together in wells, given the geology of oil-bearing strata. In world politics they are inextricably related. The world's currencies are denominated in oil precisely because that fossil fuel provides the portable energy that drives development. The growth drives us to oversubscribe our water supplies even as we increasingly pollute them. That this dynamic often converges in arid regions, such as Texas and Saudi Arabia, places where there is little we recognize in terms of traditional landscape value, encourages us to expand civilization into grotesque proportions of scale and form. Think Las Vegas. The city is located in the most arid desert in North America, has been

the fastest-growing metropolitan area in America for more than a decade, and uses more water per capita than any other city in the country. It receives more than thirty million visitors a year, all of whom must cross the desert via car or airplane, which is to say by consuming large amounts of oil.

Denes is not a naive Utopian thinker. She understands the balance between what geometry can offer humanity and how it can run amok. The pyramid can express aspiration or oppression, or both at the same time. If the mirrors make us face reality, they also reflect the environment itself. Denes continues to insist in her work that there is a third way, one in which it remains possible to create an environment that is neither a rigidly defined paradise, nor a hopelessly polluted pit, but a place in which rational thought can mediate a path that knits together the rent between culture and nature proposed by René Descartes in 1619, a consequence of how he described scientific method.

The Israeli conceptual artist Sigalit Landau presents us with a different geometrical proposition, one that also uses water and the spiral as two of its terms, but includes more directly the human figure in the equation. The water situation in Israel is as intense as any in the world: the twenty-five million people estimated to be living in the Israel, Palestine, and Jordan region by 2050 will by then be using up more than all of the available fresh water in the Jordan River system. At that point, most of the water for industry and agriculture will be desalinated seawater or reclaimed wastewater, resources already being utilized more extensively by the Israelis than perhaps any other desert dwellers in the world.

The end point of the Jordan River is the Dead Sea, which is actually two basins. The shallow, southern one is today a dry sink, while the deeper, northern one holds remnants of the landlocked sea. The

surface level of the hypersaline lake is more than 1,300 feet below sea level and falling more than ten feet per year due to natural evaporation coupled with the water withdrawals upstream. The inflow to the Dead Sea is now only a tenth of the original volume, and the sea has lost a third of its surface area. If you are an artist in Israel concerned with water usage, the Dead Sea offers an almost irresistible trope. Not only is it the lowest point on Earth's surface, and contains the saltiest water—with almost ten times the salt content of seawater, its brine can literally hold no more salt—but it is also an environmental disaster in the making.

Landau has made several works in or around the body of water under the collective title *The Endless Solution*. The most visually compelling is *DeadSee*, a stately meditation on life and death, the intimate and the monumental, all played out in the waters that cover the site where Lot's wife may have been turned into a pillar of salt.

The video begins with a shot above shallow water, a shoal faintly visible below the surface, a gentle wave pattern moving across the image. The camera lowers into a close-up of watermelons floating on the water. As the camera follows them, we realize that they are stitched together in a spiral, which we are following inward. We are surprised when the camera reaches the feet of a naked woman embedded in the 250-meter-long spiral of five hundred melons. Her outstretched hand rests in one of several melons that have been hacked open, their red insides a vivid analog for the body of the woman, and by extension all humans.

Over the roughly eleven-and-a-half minutes of the video we travel inward to the center of the six-meter raft and then, as the camera pulls up and away, watch as the outer end of the spiral is unwound by an invisible force out of frame. The spiral shrinks and Landau's body is borne away. The interior end of the line flicks slowly open, sends off a last ripple, and is gone.

The video is quiet, succinct, and contemplative, but the more we learn about its components, the sharper its metaphor comes into focus. The fruit is almaliach, a strain of watermelon that was developed by the Israelis to grow in saltwater. The saltier its environment, the more sugar it produces to compensate. The fruit is a triumph of genetic engineering, but a response to an environment that grows ever more saline as the population increases and the necessity for irrigation increases. This is a problem that has plagued and eventually undone every hydraulic society from the ancient Mesopotamians and Egyptians up through Mesoamericans, the indigenous cultures of the American West, and contemporary Texas.

Between them, Denes and Landau map out two categories of response to the world. The former is based in mathematics and stationary forms, the latter on intuition and ephemeral performances. That simplification, however, threatens to perpetuate the dualistic parsing of reality rejected as inadequate by everyone who decries the supposed split between science and art—a group that includes artists and scientists, as well as philosophers. So, when one posits the performance by María José Arjona, *Body over Water*, as related to Landau's time-bound sequence of actions, and the installation by Michael Phelan to Denes's pyramids—one should, forgive the expression, take the parallel with a grain of salt.

Phelan's installation of sixteen prefabricated plastic pools in the Ballroom courtyard is yet another variation on the readymade environments that he has been assembling for several years using materials such as wooden decking, planters, and garden pots.

The ponds of *We do not remember days, We remember moments (part 2)* are set out in pairs arrayed around quadrilaterally symmetrical axes. The four-sided pattern is a fragment that can be tiled into ever-larger repetitions, a tessellation used throughout the Islamic world first in its gardens and rugs, then in architectural mosaics, and even urban planning. Such patterns were derived from the early Mesopotamian settlements around oases, which by 3000 BCE were already codified in the paradise gardens. This rectilinear exclosure around water, framed with a repeating pattern of vegetation, is still the dominant landscape architectural response to aridity in the American Southwest. Think of the ten thousand backyard swimming pools in that California oasis, Palm Springs, most of which are surrounded by lawn and flowering plants. Then multiply that by Phoenix and Las Vegas, the two fastest-growing metropolitan areas in the country.

Phelan, albeit less deliberately than Denes, is quoting the mathematics that underwrite the ability of humans to manipulate the surface of the planet into the Anthropocene. While our talent for landscaping has its moments of monumentality and aesthetic grandeur—from the Hanging Gardens of Babylon to New York's Central Park—in suburban America, it mostly works itself out in the banality of endlessly repeating patches of lawn bordered by flower beds. By stripping away the vegetative frame and aggregating the ponds, Phelan alludes to the sophisticated yet ancient mathematical pattern underlying the history of gardens. That pattern is one that can be repeated for aesthetic effect, or metastasize through mass production into landscapes of degradation.

Colombian-born artist María José Arjona's works take advantage of the fact that water is a medium manifested as ocean, river, rain, and bodily fluids. She performed *Body over Water* by transferring water from place to place, from container to container, a miniature hydrological cycle of her own devising. First she heaps 365 shirts into a large pile on one side of ▷

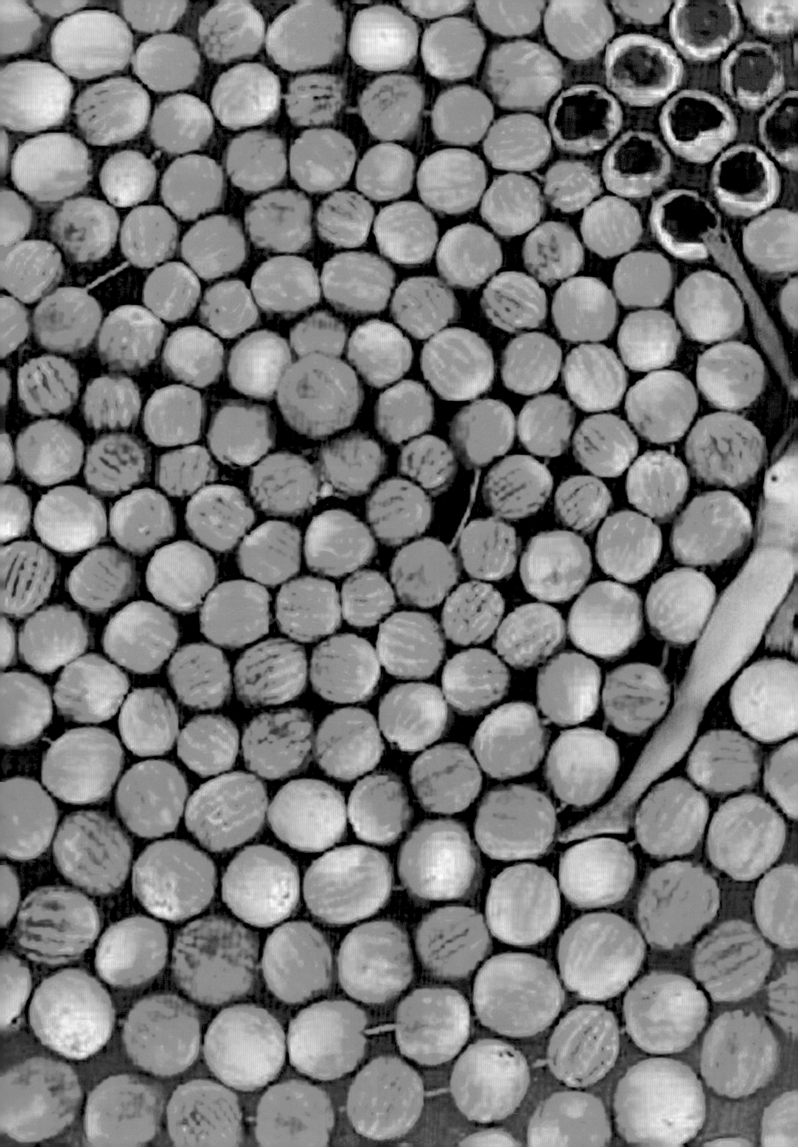

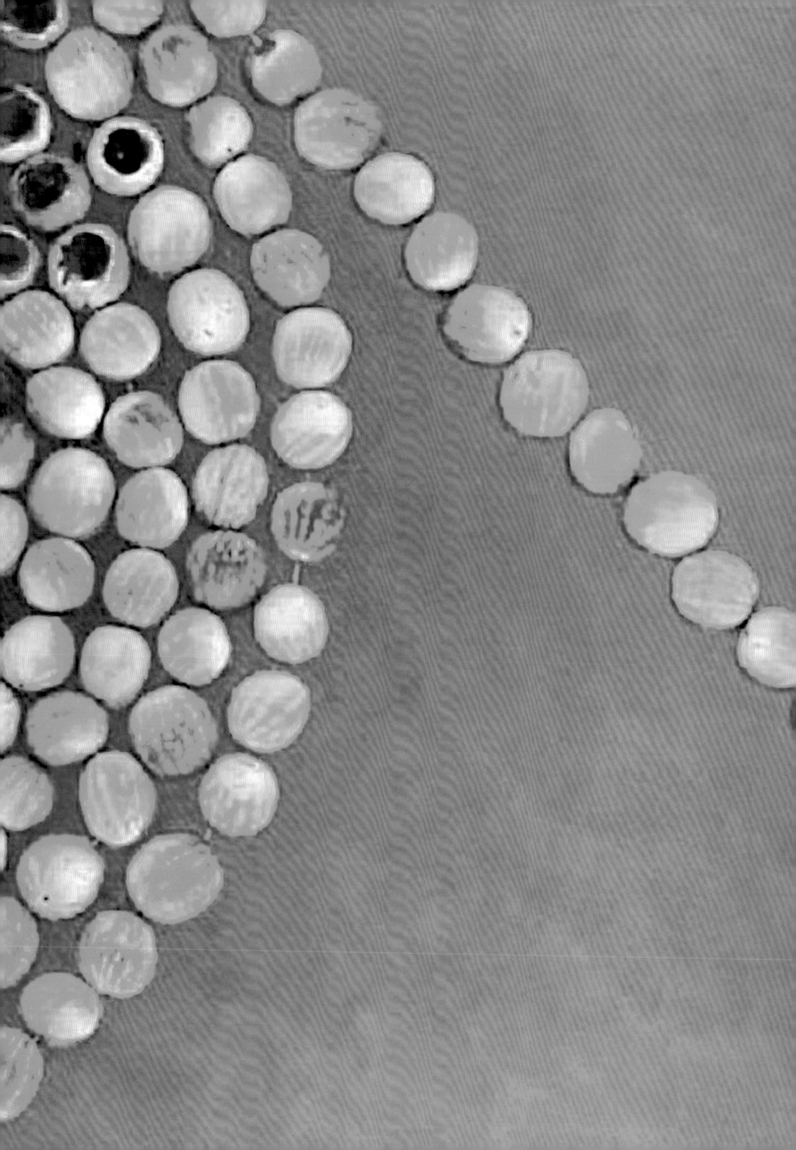

the gallery floor, and puts water into a bucket from a faucet. She selects a shirt, notes with a pencil its size in a pad, then folds the shirt and washes it in the bucket. She lifts the wet shirt in one hand and in the other balances a small transparent container in which a fish swims. She carries both across the gallery floor to where she hangs the shirt on a line over the tub. The piece, a feat of endurance that takes several days to complete, is conducted in a silence broken only by the sound of the wet shirts dripping into the tub, an artificial rain that becomes a percussive rhythm for the washing and walking.

Arjona considers the bucket to be a simile for the brain holding its memory, and the T-shirts a representation of the torso and a symbol of what we carry as we travel. By personally transferring water, she acts out an analog for both the circulation of it in the larger hydrological cycle and in the human body. As a performative agent in a gallery and juxtaposed with other works about water, she creates a durational experience for the audience that forms a memory of water even while creating a metaphor about the formation of memory itself—not to mention references to the mythical abilities of water to both hold memories and to wash them away. Her washing of the clothes, a purifying ritual, reminds us that water isn't something we simply drink, but a substance that has the ability to cleanse both body and, through ceremony, the spirit.

Water is a unique chemical compound in that it exists in all three states—gas, liquid, and solid—at natural temperatures on Earth. Perhaps that is why it is presented as the fundamental substance from which the universe is born in almost all our creation myths. Even though it is a universal solvent that can take apart almost anything, and has been studied as much or more than any other substance on the planet, chemists still do not fully understand all its properties. And, even though water is present in all its forms in every genre of art in the history of the world, it may never be exhausted as a metaphor, a material, or a medium for expression. This is as it should be, given that we cannot exist without it.

Taken as a whole, *Treading Water* makes evident that there is a subset of contemporary art related to and contiguous with, but distinct from, earthworks. The latter, in fact, often struggle with water precisely because they use earth to construct a cultural geometry in contrast to nature. To list two well-known examples, Michael Heizer's *Double Negative* began eroding in 1970, the year he excavated its twin trenches in the Mojave Desert. Robert Smithson's *Spiral Jetty*, constructed the same year in the Great Basin Desert to the north, has spent most of its life underwater. To label the art in *Treading Water* as "waterworks," however, would risk conflating such sculptures, installations, and performances with plumbing and fountains—with the transportation and

celebration of water as a substance subject to human will. That would deny the art its ability to inquire more deeply into the matter. But neither are the contents of the exhibition paeans to ecology. As worthy as such might be, eco-art is a category of response potentially as limited in intent as public waterworks.

The works in *Treading Water* acknowledge the nature of water, but also its culture, that complex and often contradictory history of how society has taken it as a symbol for purity, rebirth, and transformation. The "eco-logic" sculptures of Denes, Landau's waterborne spiral, the ritualistic transference of water by Arjona, and Phelan's fractal geometry criticize how we have handled and mishandled water, but they also seek to broaden our reverence for it. An artist could not pick a better medium through which to attempt, as Russell put it, an understanding and reformation of the world. ▷

Excerpt, exhibition essay. Fox is an art and cultural critic, a geographer, and a historian.

Ball, Philip. *Life's Matrix: A Biography of Water.*
 NY: Farrar, Straus and Giroux, 1999.
Denes, Agnes. *Isometric Systems in Isotropic Space: Map
 Projections.* Rochester, NY: Visual Studies Workshop, 1979.
Griffin, Tim. Untitled and unpublished catalog essay
 on the work of Michael Phelan, 2003.
Hartz, Jill, editor. *Agnes Denes.* Ithaca, New York: Herbert
 F. Johnson Museum of Art, 1992. Introduction by
 Thomas W. Leavitt; essays by Robert Hobbs, Donald
 Kuspit, Peter Selz, and Lowry Stokes Sims.
McEvilley, Thomas. "Philosophy in the Land," *Art in
 America*, Nov. 2004, pp. 158–63, 193.
Mills, Dan, ed. *Agnes Denes: Projects for Public Spaces.*
 Lewisburg, PA: Samek Art Gallery, Bucknell University,
 2003. Essay by Eleanor Heartney, writings by Agnes Denes.
Spaid, Sue. *Ecovention: Current Art to Transform Ecologies.*
 Cincinnati, OH: Contemporary Art Center, 2002.

Installation views, *Body over Water*, María José Arjona, 2005. Previous: Sigalit Landau, *DeadSee*, 2005.

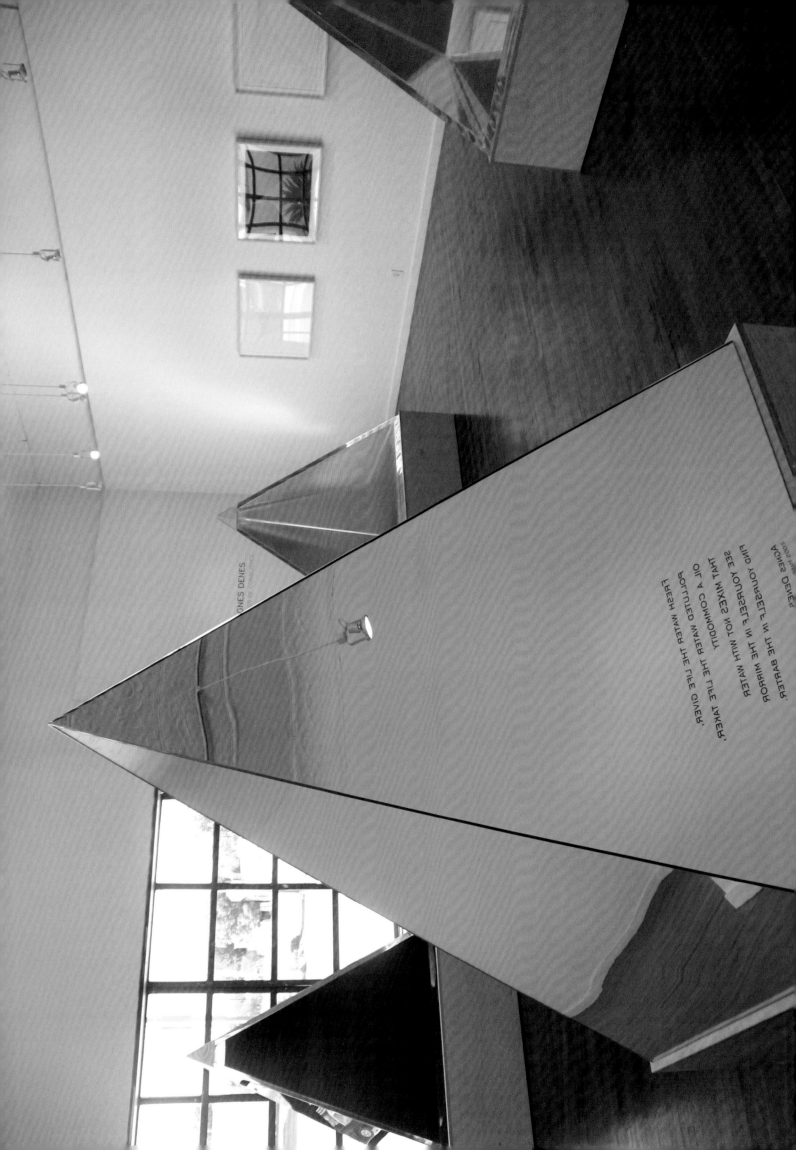

AGNES DENES

FRESH WATER THE MIRROR

ADVICE TO A LIFE GIVER:

FIND YOURSELF IN THE MIRROR

SEE YOURSELF IN THE WATER

THAT MIXES NOT WITH OIL

OIL, A COMMODITY

POLLUTED WATER THE LIFE TAKER,

FRESH WATER THE LIFE GIVER.

NOTES ON *PYRAMIDS OF CONSCIENCE*
AGNES DENES

I believe that the new role of the artist is to create an art that is more than decoration, commodity, or political tool—an art that questions the status quo and the direction life has taken, the endless contradictions we accept and approve. It elicits and initiates thinking processes . . . My concern is with the creation of a language of perception that allows the flow of information among alien systems and disciplines, eliminating the boundaries of art in order to make new association and valid analogies possible.

The *Pyramid Series* (1970–) adopts an abstract mathematical theory of probability to create a variety of structures, the perfect pyramids, that embody human knowledge and the paradoxes of existence. These forms serve as complex metaphors for our time, vehicles through which analytical propositions can be visualized. They are unique in that philosophy and mathematics are made visual through them. They represent our era, social evolution, and transformations and create structures for future travel in space and survival on Earth.

The pyramid forms are created from mathematics and the visualization of Pascal's triangle. This method preceded today as computer graphics basing design and philosophy on the nonerratic language of mathematics to build form and create a new language with which to communicate. There are over one hundred [installations] in the *Pyramid Series* reflecting aspects of human existence and the consequences of our actions. They embody human knowledge and the paradoxes of existence. They serve as complex metaphors for our time, vehicles through which analytical propositions can be visualized.

The pyramids begin to stretch and sway as they break loose from the tyranny of being built, knitted into form . . . they are pure technology, visual mathematics with yet another kind of "perfection," that of the flexibility of natural systems. They have a look of freshness and vulnerability . . . They are the future and the future is always vulnerable.

PYRAMIDS OF CONSCIENCE

fresh water the life giver,
polluted water the life taker,
oil a commodity
that mixes not with water
see yourself in the mirror
find yourself in the barter.

Agnes Denes
Marfa, Texas 2005

EVERY REVOLUTION IS A ROLL OF THE DICE

BARRY X BALL, HUMA BHABHA, CAROL BOVE,
TRISHA DONNELLY, GARDAR EIDE EINARSSON,
JASON FOX, WAYNE GONZALES, ROBERT GROSVENOR,
GUYTON\WALKER, ADAM HELMS, COREY MCCORKLE,
JOHN MILLER, WANGECHI MUTU, HAIM STEINBACH,
MIKA TAJIMA/NEW HUMANS, JOAN WALLACE

Ballroom Marfa's 2007 exhibition *Every Revolution Is a Roll of the Dice*, organized by Bob Nickas, included sculptural objects that, by way of their presentation, could be seen as actors on a stage. The floor of the main gallery was covered with a thin layer of black volcanic sand and the floor of the second gallery with white sand. The freestanding objects were placed in these deserts/desert islands; to viewers walking the perimeter, the objects were stranded, castaways. The staging evoked the poignancy and absurdity of a Samuel Beckett play.

The gallery became a landscape in which various objects, particularly figurative objects, were isolated in small groupings to create a heightened sense of interaction between them. A marble head by Barry X Ball and an unfired clay head by Huma Bhabha, for example, seemed to be looking, together, at Joan Wallace's *The Pool Ladder Painting No 2*—a work composed of a tabletop equipped with a trapdoor through which an aluminum swimming pool ladder has been placed. Each piece activated the other, the trapdoor in the tabletop perhaps recalling the trapdoors of stages and gallows, the works by Ball and Bhabha, with their cracks and fissures, and exposed chicken wire, respectively, representing scarred or wounded heads.

The title of the exhibition was borrowed from the title of a short 1978 film by Jean-Marie Straub and Danièle Huillet, the dialogue for which was the Stéphane Mallarmé poem "A Roll of the Dice Will Never Abolish Chance," published in 1897, the year before his death. The film, shot in Père Lachaise Cemetery in Paris, near the graves of the Communards of 1871, is structured around the textual and graphic elements of the poem. The works in the exhibition, many of which were made expressly for this program, were meant to be read as symbolic objects, conveying through association and interaction a sense of a troubled but not hopeless world. This is, after all, a world in which artists continue to give form to the bigger questions—to life and death—and to create objects that are as beautiful as they are poignant. ▷

Top: Installation view, *Every Revolution Is a Roll of the Dice*, 2007. Bottom: Installation view with, from left, Robert Grosvenor, *Untitled*, 1975; Guyton\Walker, *Coconut Chandelier*, 2007; Jason Fox, *Monument for Destruction*, 2004.

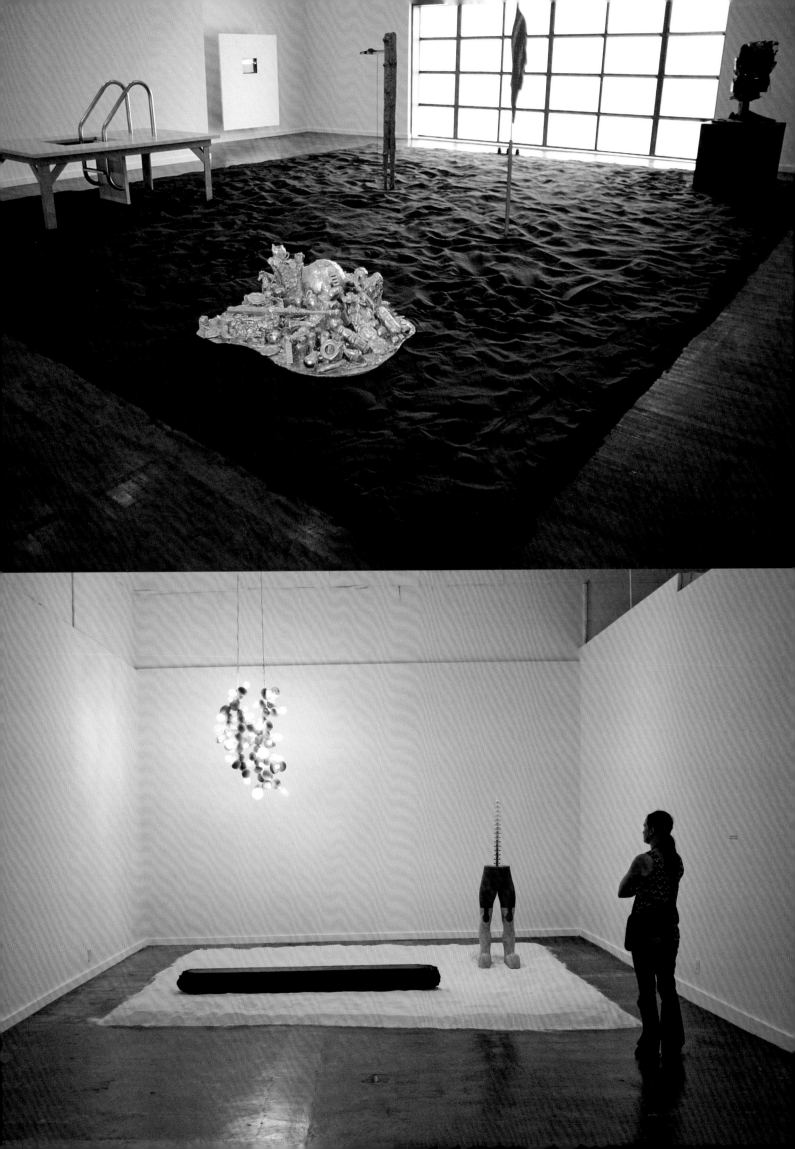

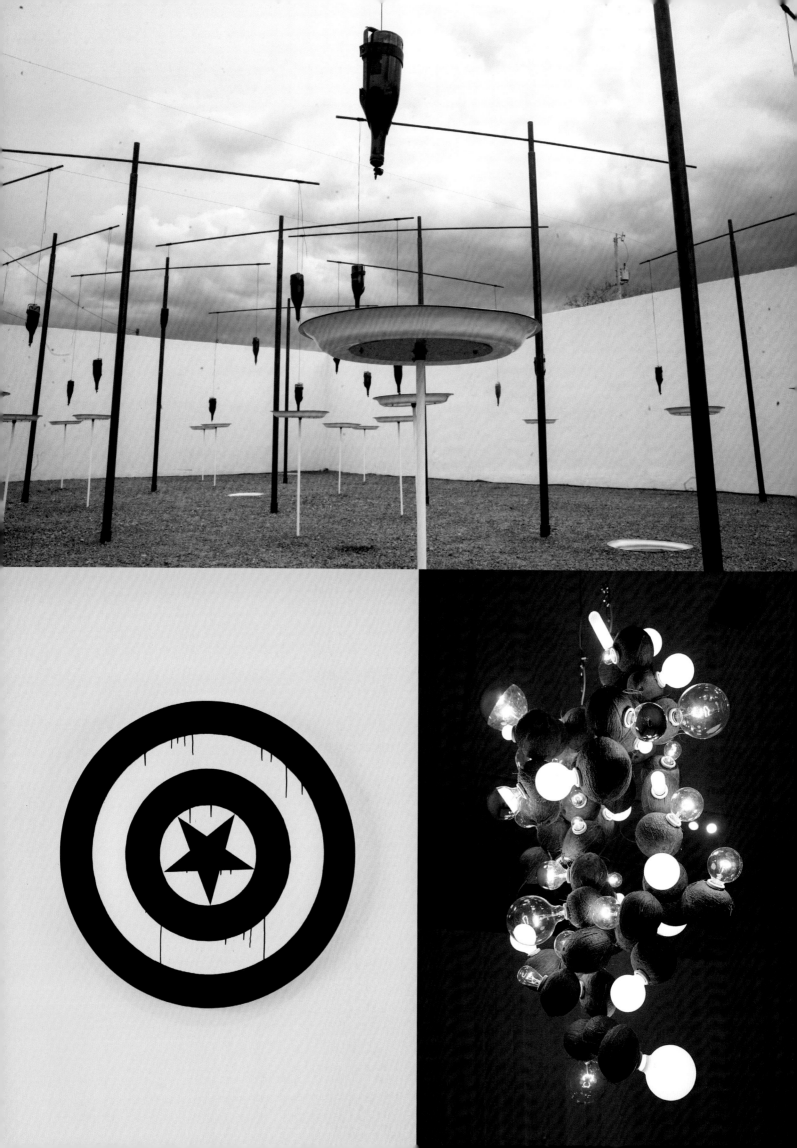

"I was aware of Judd's involvement in [Marfa], although I had never visited. The distance was both geographical and admittedly judgmental. For someone of my generation, coming to art in the late 1960s, this artist was a major figure, someone for whom I had to keep a space between the man and his art."

Clockwise from top: Wangechi Mutu, *The Master's imaginary duel is over*, 2006/2007; Guyton\Walker, *Coconut Chandelier*, 2007; Gardar Eide Einarsson, *Captain America (Inverted)*, 2007.

A REFLECTION BY BOB NICKAS

I met Fairfax Dorn and Virginia Lebermann in New York through my old friend Adam Helms. He had told me about Ballroom, very enthusiastically. I'm guessing this would have been sometime in 2005 or 2006. Before that, like most in the art world, I was aware of [Donald] Judd's involvement in [Marfa], although I had never visited. The distance was both geographical and admittedly judgmental. For someone of my generation, coming to art in the late 1960s, this artist was a major figure, someone for whom I had to keep a space between the man and his art. This has been the case for many other artists, mostly strong-willed men. The world must bend toward them. At the time, more than ten years after his death, he still exerted a formidable presence. And so, I was interested right away that two women had founded a space there, and it was about an opening up to artists, especially younger [artists], in close proximity to a place where one had been enshrined.

When I met Fairfax and Virginia, I had just finished working for four-plus years at MoMA PS1. I was looking for new projects, particularly outside New York. In that period and soon following, I organized shows in Los Angeles, Boston, Vancouver, Zurich, and Berlin. I was eager to work outside my comfort zone, and for audiences in other parts of the country and in other countries. I liked Marfa immediately. The people I was introduced to, the whole vibe. There was [an hours-]long drive from the airport, so you really ease into the landscape. Even if I'm a city person, I have always related to the artists who worked in the American West: Walter De Maria, Michael Heizer, Nancy Holt, Robert Smithson. Once in town, the slower pace, the friendliness . . . really put me at ease. One morning I was taken to a breakfast place, which was like being invited over to someone's house.

My second trip to Marfa was for the show. I had flown from New York with Wangechi Mutu and her assistant. I think it had rained, and at one point either Wangechi or her assistant called out, "Look! A double rainbow!" Beautiful. I had never seen one before.

A main feature of the show were two expanses of sand: one that was white, the other black volcanic sand. I had never asked a gallery to do anything like this before. At Ballroom, no one questioned the request or tried to dissuade me. A big part of art is problem-solving, and they got it done. I was impressed.

What was resonant? The works in the show. Wangechi's sculptural installation outside in the courtyard, and the performance on the night of the opening by New Humans, on a "stage" of white sand. In a book published of all my shows, I recalled, the scene: "The music they played can only be described as symphonic, rising, and cascading under the big West Texas sky. Near the end, as if on cue, an eagle soared overhead, gliding through a darkening field of blue, and was gone."

Back then, a number of the artists—Wangechi, Trisha Donnelly, Huma Bhabha, Carol Bove—were not as prominent as they are today. . . . It was not a show I could have done in New York. And it galvanized me to see if it was possible.

Ballroom Marfa is another example of how a handful of people far outside major art centers can create an energy that draws an audience to them. □

Written reflection, Bob Nickas to Daisy Nam, May 13, 2023. Nickas is a critic and curator based in New York.

DEEP COMEDY

FISCHLI/WEISS, ISA GENZKEN, JEF GEYS, RODNEY GRAHAM,
CHRISTIAN JANKOWSKI, JAPANTHER, JULIA SCHER,
ROMAN SIGNER, MICHAEL SMITH, WILLIAM WEGMAN,
JOHN WESLEY, JOSHUA WHITE, ELIN WIKSTRÖM

Deep Comedy, curated by Dan Graham with Sylvia Chivaratanond, featured work by a range of artists whose conceptual practices are underpinned by humor, including Fischli/Weiss, Isa Genzken, Jef Geys, Rodney Graham, Christian Jankowski, Japanther, Julia Scher, Roman Signer, Michael Smith, William Wegman, John Wesley, Joshua White, and Elin Wikström. The works in *Deep Comedy* transformed elements of the commonplace into playgrounds for amusement through a wide range of media including sculpture, video, installation, photography, and performance. The exhibition embraced the often oxymoronic nature of the comic—where banality, irreverence, and trauma occasion the deepest bestial laughs. In the works presented, easy allies are made of critical thought and humor, intellectualism and play. The featured artists employed absurdism and sarcasm to critique current sociopolitical and artistic institutions, undermining the earnestness and solemnity of authoritarian projects and insidious systems of social organization. Core themes of Dan Graham's own art practice were also recognizable in the exhibition: architecture as a means to control physical and psychological space has been an interest of Graham's since the 1960s, as have television and video as transmitters (and receivers) of information. □

Julia Scher, *Girl Dogs, Haus of Scher*, 2007. Overleaf, top to bottom: Installation view, Rodney Graham, *A Little Thought*, 2000; Installation view with, from left, John Wesley, *Blue Blanket*, 2000; Christian Jankowski, *Direktor Pudel*, 1998/2003; Christian Jankowski, *My Life As a Dove*, 1996. Page 69: Japanther performing with RobbinsChilds, Liberty Hall, Marfa, March 23, 2007.

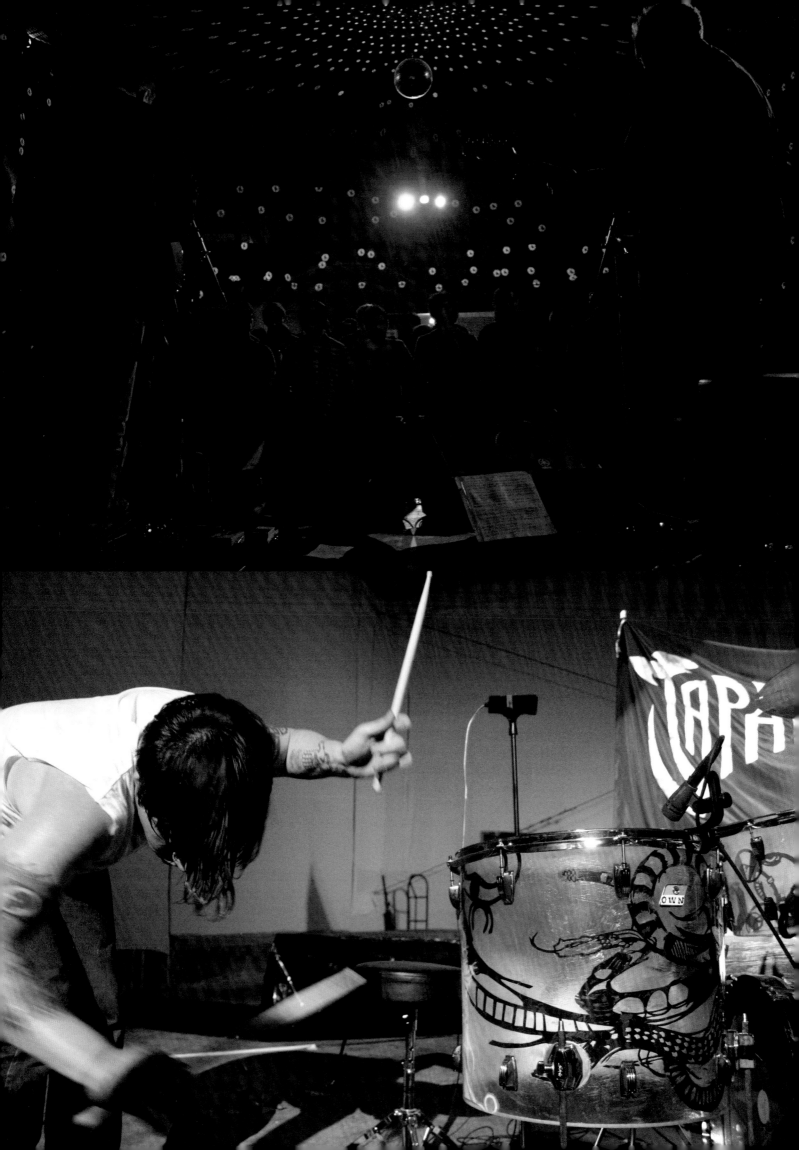

GLORIA

MARIA HASSABI

In 2007, Ballroom Marfa premiered *GLORIA*, a new work by artist-choreographer Maria Hassabi. Hassabi's practice reflects on concepts of the live body, the still image, and the sculptural object. Her photographic and video works use her performances as points of departure, with technology employed to override the limitations of temporality and reality. For Ballroom's *GLORIA*, Hassabi worked in collaboration with performers Hristoula Harakas and David Adamo, visual artist Scott Lyall, sound designer Jody Elff, and lighting designer Joe Levasseur.

Hassabi explained, "*GLORIA* is composed through the layering of two individual solos, moving between one iconic posture and another [drawn from popular-culture milieus such as fashion shows, nightclubs, and exercise classes]. The dancers invoke a set of fleeting images within their abstract, mobile diagram. Each solo was developed separately and then conjoined. As a result, they inhabit a space of quiet stillness and isolation in which the body is viewed as sculpture. Space becomes denser with emptiness as it unfolds. The two dancers are only connected in ways they themselves cannot imagine. The common setting is illuminated by stark continuous lighting, while each of the costumes suggests a graphic sense of the body. An original sound score drawn from everyday street noise includes melodic fragments of song as a respite from the work's density, but just in passing." ☐

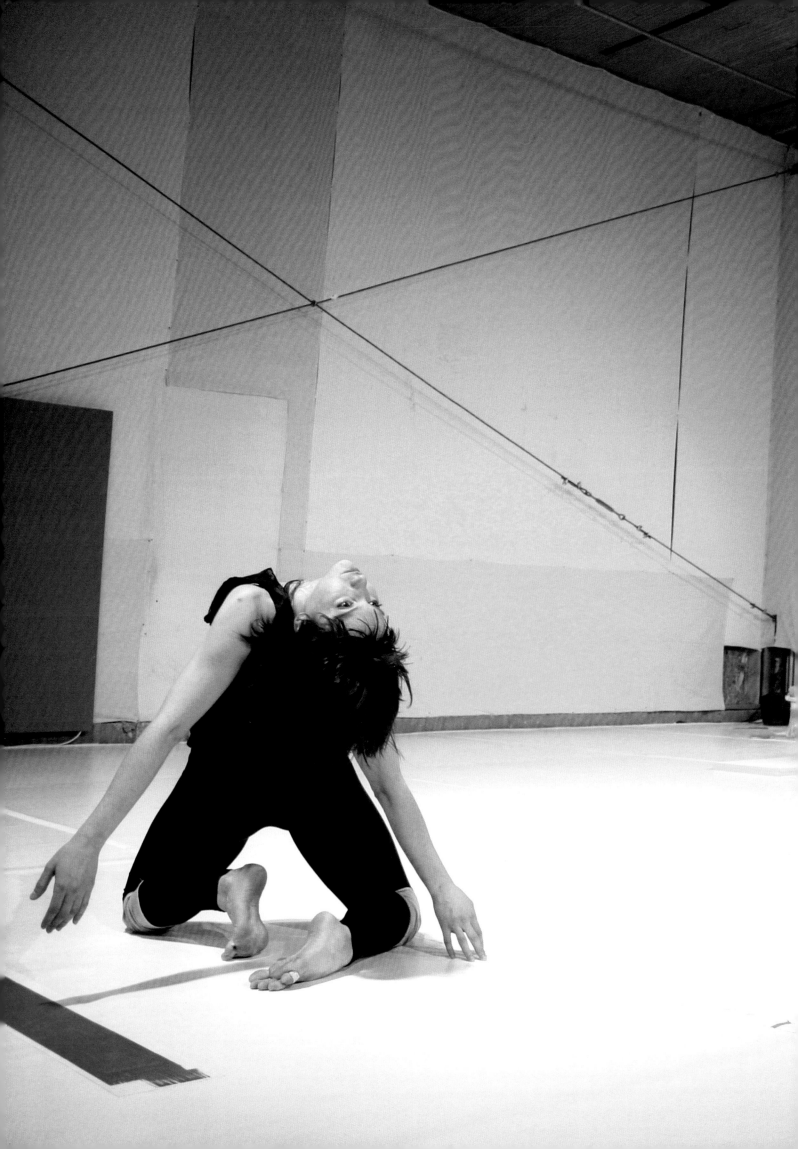

BALLROOM BEAT.

Vol. 1

Featuring:

Vance Knowles
Terry Allen
Sonic Youth
Nikolai Haas
Lyle Lovett
Fire Into Music
Steve Swell
Mariachi Las Alteñas
Mary Lattimore &
Jeff Zeigler
Yacht

"ROLLING BY"
ROBERT EARL KEEN

"It's a busted old town on
the plains of West Texas

The drugstore's closed down,
and the river's run dry

The semis roll through like
stainless steel stallions

Goin' hard, goin' fast, goin'
wild

Rollin' hard, rollin' fast,
rollin' by."

I THOUGHT WE WERE OPENING A NIGHTCLUB

VANCE KNOWLES

I grew up around a jukebox in South Texas, where life imitated the songs on the box. We come from a long line of showmen, Old West sideshow types, and that's what the original incarnation of Ballroom Marfa was to me. Dinner and a show.

I joined Fairfax and Virginia to bring music into Marfa, and then music brought in the community, and the community got used to us and the idea of it all. Fairfax and Virginia directed me to bring in people not accustomed to the higher arts or art on walls: Punks. Ranchers. Cowboys. Queers. Escapees. Local legends. City. Town. Country. It was a kind of magic act, and it was fun to pose as the ringmaster. "Ladies and gentlemen! Step right up! Come one, come all! Here is the snake charmer, here's the band, here's the show and next door we're going to show fine art and then we're going to walk on fire!"

It was epic. It was real. Perfect alchemy. An amazing accident.

Twenty years ago, time moved differently in Marfa, and pretty much most places outside the city. Everything stood still longer. In Marfa, then, time was wider and more expansive. And there was somehow more time to think. More time to play, more time to plan, and to execute. This was before social media, before everyone was a critic. A nicer time, maybe. Freer.

I was from Texas, but I had been living in Los Angeles for a few years when Molly mentioned that Virginia and Fairfax had fled New York after 9/11 and had settled in some cave outside Terlingua. Not long after, I DJ'd a party for them in Austin and followed them back to West Texas and the rest is history. Virginia and Fairfax had found the old ballroom building first, then the plan followed the find. Marfa then was an in-between place, an ether area between nostalgia and space travel. A sweet spot for sure.

Moving there in 2003 there were maybe nine or ten like-minded souls in equal search of small-town homespun as well as rock 'n' roll "freedoms" with nothing left to lose. Life was lunch at Mike's Kitchen or Carmen's, nights spent at Maiya's and Rays. I remember early on talking to Boyd Elder, later to become the patron saint of *Prada Marfa*, and he told me that he held the land speed record from Alpine to Valentine. But the thing is, between those

two places was Marfa and Marfa had a stop
sign. Only one stop sign, but a stop sign,
nonetheless. So maybe Boyd flew, or teleported?
Maybe he was swooped up in the UFOs and gently
deposited back down? That was Marfa then.
Strange and empty and beautiful and a place
where you could do anything and anything could
happen. There was so much more buzz than bite.
Everything was standing outside itself, more
real and translucent and vivid than anything
would ever be in the city. It was the perfect
time and the perfect place to roll fast and
high and hard because everything else in the
town was standing still.

"Step right up!"

And the bands, they came. And the people came.
And it was miraculous — to see a musician you
knew and loved in a place you never expected.
The bands fell in love with Marfa. Jeff Tweedy
of Wilco arrived early on in Ballroom's days.
Tweedy jumped off the bus from Los Angeles,
took a deep breath in front of the Hotel
Paisano, said he could hear his heartbeat.
Marfa was like nowhere else exactly because
it was "nowhere." Everything that happened
there was heightened because of that. There
was a fluidity between artist and audience.

The bands, the audiences, the town — everyone
elevated from being together.

When you finally arrive in Marfa, you are
half out of your senses. To go to see a
concert here, it's the perfect mind-and-body
experience. To be in that state and to hear
music this wild and wondrous by artists you've
never seen in a place like Marfa . . .

In 2006 we hit our stride: sixteen shows in
less than a year. Tweedy, Terry Allen, Grizzly
Bear, Zykos, Ryan Bingham, Animal Collective,
Sonic Youth, Ghostland Observatory, Conor
Oberst, Joanna Newsom, José González, Jenny
Lewis, and on and on and on. It was madness.
Around that zeitgeist time, in 2007 or 2008, I
was out on the highest point of the Hip-O Ranch
with Jona and Claire of Yacht and the Marfa
lights appeared — these bright orbs rising
up from the south over the horizon and then,
suddenly, rolling hard, rolling fast, rolling
by across the sky . . . and over our heads!

Everyone wanted a front row seat.

So, step right up. Here we roll, hard and fast.

POW!!!!!

The Seventeenth of December, 2005

BALLROOM MARFA PRESENTS **TERRY ALLEN** Doors 8pm, Show 9pm. Tix 20.

GOODE CROWLEY THEATER

A PLACE WITH SPACE

A REFLECTION BY TERRY ALLEN

In 2005 Ballroom Marfa invited world-renowned artist, musician, legendary songwriter, and Texas visionary Terry Allen to perform as part of their nascent music series, kicking off a long and ongoing collaboration that continues to this day. Allen returned to play again for Ballroom in 2007 with veteran Texas country musicians from Lubbock, Panhandle Mystery Band.

All of my experiences with Ballroom have to do with playing, with performing, but my memories are of the people that we met along the way. In Marfa, to me, it feels like everybody's kind of connected in some kind of weird way. I first connected with Ballroom in 2005, through Vance Knowles. We'd had a big anniversary party there for the band and we stayed at the Thunderbird. There were a lot of musicians that came to town, a lot of artists. My wedding anniversary is the eighth of July. So, the Fourth of July, we all got together there for that. And there was a huge fireworks war, a lot of Roman candles fired at trucks going by and stuff like that. And cops chasing kids and couldn't catch 'em. It was very festive.

Vance asked me to perform later that year. The thing that was memorable to me about that first show with Ballroom was that the poster was the most bizarre poster I've ever had. Vance just randomly picked some person out of some anonymous book and put that on the poster as me! I thought it was perfect. I have no idea who that person is. And you know that that's appropriate because I don't know who *this* person is [gestures to himself]. But I always

connected with Marfa as a town, in part because I pretty much grew up in that kind of a landscape — a place with space. That's the thing that I always loved about Marfa, that immense space around you.

When we had one of our parties, there were some people from back East who had never really been in that part of the country. One woman was terrified of the space; she wasn't used to that kind of a volume and vastness that was just around her from every angle. I never thought about that because to me it's always been like a comfort, like a breath of fresh air.

I've stayed in Marfa over the years for months at a time and written songs and worked with the band here. We were very civilized about it. We wouldn't start till about one o'clock. Then we'd play all afternoon, have dinner, then go back and play until twelve, one, two at night. And that's been a great experience, I think, for everybody involved in it. Being here is very creative, very productive. We've played shows with Ballroom with different configurations of people — and it's always been good. □

WOLFMAN OF DEL RIO

MARFA
7-7-07

AMARILLO HIGHWAY

TRUCKLOAD OF ART

ART MOB

QUEENIE'S
SONG

SALVATION

BEAUTIFUL WAITRESS

THE DOLL

HELENA MONTANA

TEXICAN BADMAN

CORTEZ SAIL

WHAT OF ALICIA

OUGHTA BE A LAW

WILDERNESS OF THIS WORLD

GIRL WHO DANCED OKLA

BUCK NAKED

PEGGY LEG

AFTER THE FALL

FLATLAND BOOGIE

Terry Allen, December 17, 2005.

SONIC YOUTH

A Reflection by Kim Gordon

IN 2007, IN COLLABORATION WITH THE JUDD FOUNDATION AND CHINATI FOUNDATION'S OPEN HOUSE WEEKEND, BALLROOM MARFA PROUDLY COHOSTED THE VANGUARD ALTERNATIVE ROCK GROUP SONIC YOUTH. THE CONCERT WAS HELD AT THUNDERBIRD HOTEL'S NEW PERFORMANCE SPACE, A RENOVATED AIRPORT HANGAR.

I have fond memories of Marfa being a magical place. I had never been to the high desert before, and because I was doing a sound check and missed the group tour, I got a solo tour of all the artworks. I remember being in the buildings that house Judd's aluminum boxes — I think there were glass walls — and it started pouring rain outside. It was torrential and just incredible,

the sound of the rain and being with those boxes. Later that night when we played, I want to say there was a full moon, but I may be making it up. There was very dramatic thunder and lightning, and I remember how pitch-dark it was in the desert. When Sonic Youth gets invited to play unconventional places, I'm always a little worried, like, "Are you sure you really want dissonant, loud music?" Afterward, I think there were a lot of unhappy people just because so many people came and showed up and maybe didn't know what to expect.

INTERVIEW WITH KIM GORDON,
CHINATI FOUNDATION NEWSLETTER,
VOL. 26 (2021), 16. □

"I grew up in Austin and I'd gone out to Marfa a couple times as a kid. And when I was asked to play my first show at Ballroom in 2005, I was still a kid — I was eighteen. Later, my brother and I opened our cabinet studio, which quickly changed into an art practice — that was sort of by accident. I like it

when art can impact people that are not looking to be impacted by art, you know? That's part of what's amazing about Ballroom. It's like an outpost or like a place that's not necessarily made for the coasts. That was the magic of Ballroom for me: it was sort of this mystery. It was almost like a whisper in the wind that, once you listened to it and showed up, you're like, 'Oh, it's real. This is a real place.'" □

You Just Have to GO THERE to Understand

Lyle Lovett

IN 2009, BALLROOM MARFA PRESENTED SINGER, SONGWRITER, AND PRODUCER LYLE LOVETT ALONGSIDE HIS ACOUSTIC GROUP FOR A LIVE CONCERT AT THE CROWLEY THEATER. TEXAS NATIVE LOVETT IS AN ICON OF COUNTRY-WESTERN MUSIC. LOVETT HAS WON FOUR GRAMMY AWARDS, INCLUDING BEST MALE COUNTRY VOCAL PERFORMANCE AND BEST COUNTRY ALBUM.

Well, it was Ballroom that got me out to Marfa for the first time. And of course, I was aware of Marfa and Donald Judd's influence. We played nearly twenty years ago, and it was quite different than it is now.

Marfa is just that kind of place: when you're there, you just feel better. And when you leave, you wish you had just a little more time. To be there at the beginning of Ballroom, it's given me a better perspective on Marfa than I would've had if I were just going out there now for the first time. On that trip I was able to tour the Judd facility and all the galleries there, and it was just an eye-opening experience. I'd been to that part of West Texas, of course — I mean, many times going through. The natural beauty of that part of West Texas is indescribable, really. You have to go there to realize what it is.

Marfa is just a very special place. The elevation, the air, everything about it physically is what makes it aesthetically appealing to the artists who want to make it home. The first thing I would tell somebody is, you just have to go there to understand. Geographically, it's unusual for the state of Texas. It has an appeal in a physical sense, which then translates to that aesthetic sense. And the fact that a world-renowned and accomplished artist like Donald Judd would pick Marfa to be the home for his work really says something. And of course, his being there, I'm sure, was a big reason why other artists were interested in investigating it. But what seems to be consistent is that when people do investigate Marfa, when people do go there to see it for themselves, they're drawn to it. You see the ongoing interest. Every time you go back you see more people there than you did before. And what you see is a thriving community and surrounded by that peacefulness that comes from being out in West Texas.

Marfa itself may not be quite as peaceful as it used to be, but it doesn't take a very great distance out of town to feel like you're just right there among the landscape. Because of its elevation — it's at five thousand feet — the vegetation is different than you see at lower elevation. Things look different, things feel different — the air feels different. And you know immediately that you're in a special place. You're in a different place than being in the rest of Texas. □

Hamid Drake and
William Parker.

FIRE

INTO

MUSIC

Jemeel Moondoc, Steve Swell, William Parker, and Hamid Drake

A Revelation:

A Reflection by Steve Swell

In October 2004, Ballroom Marfa presented Fire Into Music — featuring Jemeel Moondoc, Steve Swell, William Parker, and Hamid Drake — in the outdoor courtyard. While reminiscent of artists such as John Coltrane, Cecil Taylor, Ornette Coleman, and the Art Ensemble of Chicago, the quartet's sound is shaped by their ever-changing contemporary creative visions. Spanning the sonic spectrum from delicate to devastating, their shows appeal at once to primitive and futuristic sensibilities. In conjunction with the performance and homage to the musicians, artists Noel Waggener and Satch Grimley created a mural in the galleries titled *A Silk Screened Mural in Four Movements: African Genesis, Free Spiritual Musics, Black Power and Afro Psychedelia.*

Since the time of our engagement, and arriving in Marfa itself, it was a revelation to me that this town and the art scene here, all of which seemed to be in the middle of nowhere, actually existed. I kept wondering to myself, How did this happen? Why haven't I ever heard of this place? Also, it was amazing that during this tour that Fire Into Music with Jemeel Moondoc, William Parker, and Hamid Drake, was embarking on, we had no plans to perform at the Ballroom. But I guess after Vance Knowles found out we were scheduled to play in Houston, he contacted me and invited Fire Into Music to come and play. As we had an open day and the fee for the band was very good, I decided we should definitely do it.

The place and getting there all seemed very exotic and adventurous at the time, since I wasn't even sure where we were going and had never even heard of the place. This little town in the desert in Texas in 2004 — I'm sure it's grown since then — seemed like an oasis, thriving and supporting the arts in the face of all the politics and the minimal support the arts receive throughout the rest of the country. A revelation.

I remember the performance was well attended. I remember Quincy Troupe being there and meeting him. I also remember having a great steak dinner at a restaurant in town, which was very good, and it surprised me that such a good restaurant should be out here in the middle of nowhere.

When I returned to New York after our tour, about a couple of months later, I received a huge box from the Ballroom and inside it was about fifty LPs that were pressed of our concert there. I was quite surprised and wasn't sure what to do since we had not approved of any kind of release, but after some of the business was taken care of, I am very grateful and happy that it was recorded and released. It was also included recently in a release on the RogueArt (France) label for even wider distribution as part of a three-CD set to honor Jemeel Moondoc, who passed away in 2021.

While listening to the LP I was surprised at one point, during a William Parker bass solo, a freight train's horn can be distinctly heard, which rather than ruin some perfectly good

music, made me smile and, I thought, enhanced the experience. I have since heard from other folks who heard the recording that they thought that that moment was amazing — in addition of course to the great music we made that day.

We were playing outside at the Ballroom, in an open area that was part of the facility, so the desert was definitely going to play a part in how we sounded. I don't remember it being particularly humid that day, so the air was probably pretty dry, as the desert usually is, which helps, especially when playing a horn that uses your own air to produce a sound. I don't do well playing in very humid spaces, so this was not an issue for us here. Sometimes when it is too humid, your sound can face a "wall" of humidity and it can block the sound and make it physically harder to play. But as I remember, and from listening to the recording, it seemed to me that the sound wasn't getting lost and away from the band. We could hear each other very well, which isn't always the case when playing outside. The desert provided a very easy, pliant space that allowed our sound and all its nuances to flow effortlessly from the bandstand and be appreciated by everyone there. □

INTERVIEW, STEVE SWELL AND SARAH MELENDEZ.

Mariachi
Las Alteñas,
September
30, 2011.

MARIACHI
LAS ALTEÑAS

In 2011, Mariachi Las Alteñas performed as part of the opening weekend of Ballroom's exhibition *AutoBody*, which explored the mythology of the American automobile in industry and art. Considered Texas's finest all-female mariachi, Mariachi Las Alteñas has been captivating audiences since 2002. Hailing from San Antonio, these ten women are dedicated to promoting the majesty of mariachi music. Breaking the mold of what has historically been an all-male tradition, this ensemble's mantra is "Tradition. Passion. Excellence." Known for their exceptional stage presence and harmonies, Mariachi Las Alteñas has performed all over the country — most notably at the Go Tejano Mariachi Invitational, where they won first place for Best Mariachi in both 2004 and 2005. They returned to compete in 2010 and reclaimed the title once more. Las Alteñas's success goes beyond their music; they inspire audiences with joy and emotion. ▷

Marfa Public Radio: I'm Rachel Linley at Marfa Public Radio. We have one of the members of Mariachi Las Alteñas, Sandra Gonzalez, on with us today, and she'll be our guest on the program.

Sandra Gonzalez: Thank you for having me.

MPR: So, Mariachi Las Alteñas has been around since 2002. You're ten women who work together in this mariachi group. There actually aren't that many all-female mariachi groups. So I was wondering how you came to mariachi and how you started this group.

Gonzalez: Well, many of us have played mostly with men — with me, with my father. Some of the girls started with a school program and started in middle school, junior high. Valerie Vargas just decided that it would be best for all of us girls to get together and show our talent all together. All the members all just decided, "Yes, I'd like to be in an all-female group." And it took a real good hold — it really did — in San Antonio.

MPR: You are from San Antonio [as is] Valerie, who is the musical director of the group.

Gonzalez: She is the founder of the group and the director of the group.

MPR: You have performed many places. You've played all over America and you're one of the primary vocalists, I've noticed from these online videos.

Gonzalez: I do sing quite a bit, but there [are] several of us that sing in the group. We not only play our instruments, but yes, we do sing.

MPR: So let me know a little more about the ten women that make up the Mariachi [Las Alteñas], and of course its singers, but also the traditional instrumentation, violin, guitar, and trumpet as well.

Gonzalez: We do have a band director in the group, and then we have students. Several of the girls in the mariachi group are attending a university in San Marcos, which is on the outskirts of San Antonio, that has a music program with a focus on mariachi. Then we have an orchestra director that's also in the group. And Valerie Vargas herself, she just received her bachelor's degree, but in business. And I'm a registered nurse, so we all have something that we do along with playing music. It's our second job, but our first love.

MPR: If you're just joining us, I'm speaking with Sandra Gonzalez of Mariachi Las Alteñas. They'll be performing on Friday as part of the opening for Ballroom Marfa's *AutoBody* show.

As we were saying earlier, y'all have traveled all around the US, and you were chosen to represent San Antonio on *Good Morning America*. Can you tell me more about that?

Gonzalez: They featured San Antonio, and they invited the mayor of our city, Julián Castro, and then invited us. We did an intro to the city and we performed in our red outfits that we usually wear, and it was at Christmas. It was just such an honor to go out there, it was humbling. It was beautiful.

MPR: Y'all have excellent live performances. There are many videos of the group performing online if one was interested in checking them out. There's so much emotion and energy in the music and in the performance. And you've also competed in the Mariachi USA Festival in Hollywood for several years. What is it like to compete in a festival like that against many other mariachi groups, especially as an all-female group?

Gonzalez: We are alongside very, very talented people from around the United States. There are mariachi groups that are all-male. And there is another mariachi group from California that's all-female, and wow, they're just fabulous. When we go out there and perform alongside them, it's kind of a festival. We are very honored to do that.

MPR: I'm originally from the Midwest, and I noticed that you'd played a lot in Ohio, Wisconsin, Chicago. What is it like bringing mariachi music to those parts of the country?

Gonzalez: Oh, that's really nice. People say, "I've never heard of [a] Mariachi group before," for instance. They are really, they're surprised with it. They really enjoy it. So many people come up to us and say, "I didn't understand a single thing you said, but we loved it." We're all about smiling and performing and bringing in the crowd to enjoy it. So they do. They really do enjoy it. ◻

Mariachi Las Alteñas

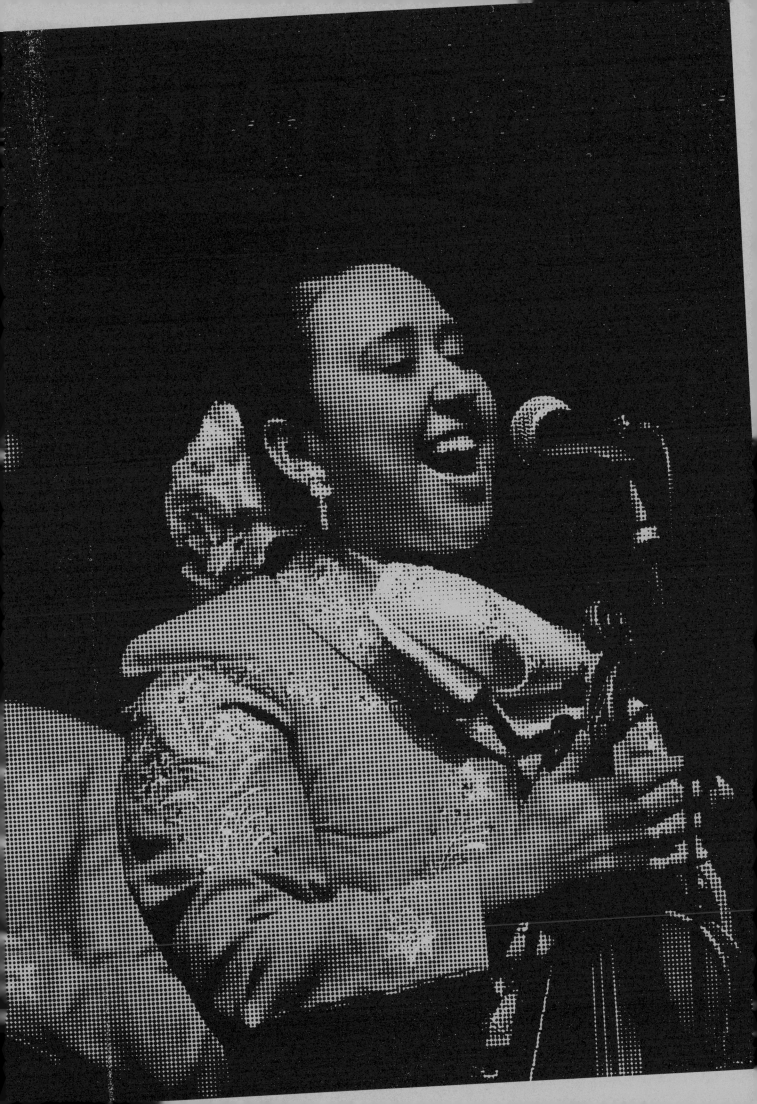

LE RÉVÉLATEUR

Under a Pastel
Sky: A Reflection
by Mary Lattimore

In December 2013, Ballroom Marfa presented the 1968 film *Le Révélateur*, with a live score by harpist Mary Lattimore and synth player Jeff Zeigler. Lattimore is a classically trained harpist whose collaborations have seen her working with such esteemed luminaries as Kurt Vile, Meg Baird, Thurston Moore, Ed Askew, Fursaxa, Jarvis Cocker, and the Valerie Project. Zeigler is part of a space-rock outfit Arc in Round and produced music for Kurt Vile, Purling Hiss, and the War on Drugs. Lattimore returned to Marfa in 2018 to perform at Ballroom with Julianna Barwick. The 2013 performance was my first visit to Marfa. First impressions: I was invited with Jeff Zeigler, on synths, initially to play a live score of a silent film of our choosing for Ballroom Marfa. We chose *Le Révélateur* by Philippe Garrel. It was really interesting to get an email out of the blue from Nicki Ittner inviting us to come to a little town in Texas called Marfa. I didn't really know what to expect, but a friend of mine lived there — and I'd soon meet many more, as the community is so strong and welcoming. My first impression of Ballroom was that Nicki was so warm, that the freedom to choose a film to score was really interesting, and that we were really well taken care of while we were there. There was a house with a James Turrell–esque window that we stayed in, and Jeff and I were able to stay for a while, I remember. We got really good groceries from the Get Go and Jeff met a cool lady at the Lost Horse. Marfa just seemed to be like a lovely, inclusive, vibey little town that loved art and where people had a good balance of solitude and camaraderie. I really fell in love with it and have been back a bunch. For that first performance with Ballroom Marfa, I consulted a very film-knowledgeable friend. He suggested a few silent films and I checked them out and *Le Révélateur* seemed to have some really memorable images. It's a very strange film, very stunning, filmed in 1968. Our piece to accompany *Le Révélateur* was a thought-out improvisation, with harp through a Line 6 looper and melodica, guitar, and synth.

It was a little over an hour long and a combination of melodic, hypnotic strings and maybe some harsh-ish noise. Jeff Zeigler and I want to be conscious of space, too, and to incorporate minimal moments, because the images are so affecting on their own. I have done a few film projects. I was a member of this eleven-person ensemble [the Valerie Project] that composed an alternate score for the Czech New Wave film *Valerie and Her Week of Wonders* in 2007. We traveled around with the original print of the film and performed in theaters, recorded it, and Drag City put out the record. I learned a lot from the way we composed the music together. I also did a soundtrack for a film that's set in Iceland. And I played on the score for the documentary *Marina Abramovic: The Artist Is Present*. The interaction between music and story/visuals, how they can complement each other to create a singular, memorable experience, is something I really love. Whenever I improvise or whenever Jeff and I improvise together, we're always trying to paint a picture or to inspire a mood, and often there's a narrative structure where things get stirred up in the middle and resolve themselves by the end. Our show was the night before New Year's Eve, and on New Year's, after coming back from a celebration, I grabbed the comforter from the bed and went out to lie in the backyard and look at the sky, listening to a little Neil Young. It was such a beautiful little shimmering jewel of a first experience in Marfa, and I'll never forget it! Then years later Julianna Barwick and I were on tour, and we stopped in Marfa to play in the courtyard of Ballroom. The colors of the sky are just so vivid there, and I'm not sure about the sound being different but definitely the smell of the air and the colors of the sky transmute the songs into a different flavor; the atmosphere really affects your music brain in the best way. I've written some songs that have made it on to different records while in Marfa. It's funny to have it encapsulated so you can relisten to the feeling of being kind of lonely in the best way there, under a pastel sky. ◻

Mary Lattimore,
December
30, 2013.

YACHT

Yacht, January 31, 2009. Overleaf: Jemeel Moondoc.

End of the Universe and Center of the World

A REFLECTION BY CLAIRE EVANS

Yacht performed at Ballroom Marfa in 2009. Yacht is one of the many creative alter egos of Jona Bechtolt, a musician and multimedia artist who embraces an eclectic but playful blend of electronics, acoustic percussion, and noises of all sorts. Writer, media artist, and musician Claire Evans joined Yacht in 2008 after sharing a "mystical experience" with Bechtolt, and together they embarked on an international tour that made its way Marfa to kick off Ballroom's 2009 music season.

We moved to Marfa in 2008. At the time, we were mostly interested in the Marfa mystery lights. We were fascinated by the idea of living alongside a mysterious presence, and loved the fact that the locals had made their peace with the fact that they'd never really know what the lights were. Even then, we felt like there weren't many mysteries like that left in the world. We thought we'd make a little space for ourselves in a quiet desert town and make an album about that idea: living with mystery. We thought, foolishly, that we'd be isolated.

It ended up being the most social period of our lives. It was a small community, but everyone knew everyone. At the time, there was only one coffee shop in town, and it went out of business. Folks started hosting coffee at their houses every morning; we posted the rotating schedule on the door of the old coffee shop. We opened our doors, and everyone came by for a cup. I have never experienced anything like it, and I wonder if I ever will again. It was true community.

We made lifelong Marfa friends, and we met artists, musicians, and writers who were passing through town for events and residencies of their own, many of whom were connected to Ballroom. We became fast friends with Vance Knowles, who was running music programming at Ballroom at the time — a larger-than-life figure in town who was famous for his alter ego, Jackie Pepper.

After we finished our album (*See Mystery Lights*) and started touring, Vance invited us back to West Texas for two shows, in Marfa and in Terlingua. It meant so much to us to be able to perform the music that we had made in Marfa to the community that had inspired it. The shows were legendary — for us, anyway. In Terlingua, we ran naked through the desert and played under the full moon. There was hardly enough power for us to plug in our equipment. My most vivid memory is of the late Boyd Elder, a great artist and longtime West Texas fixture, howling at the moon with a broken tequila bottle in his hand. It felt lawless.

Ballroom is truly unique. Every time we come through Marfa, it's our first stop. It brings the world to Marfa, and it brings Marfa to the world. It doesn't shy away from difficult ideas, it doesn't pander. It's the real deal. It's a global institution in a small town. Thanks to Ballroom, Marfa can feel like the end of the universe and the center of the world at the same time. ▢

INTERVIEW, CLAIRE EVANS AND JESSICA HUNDLEY.

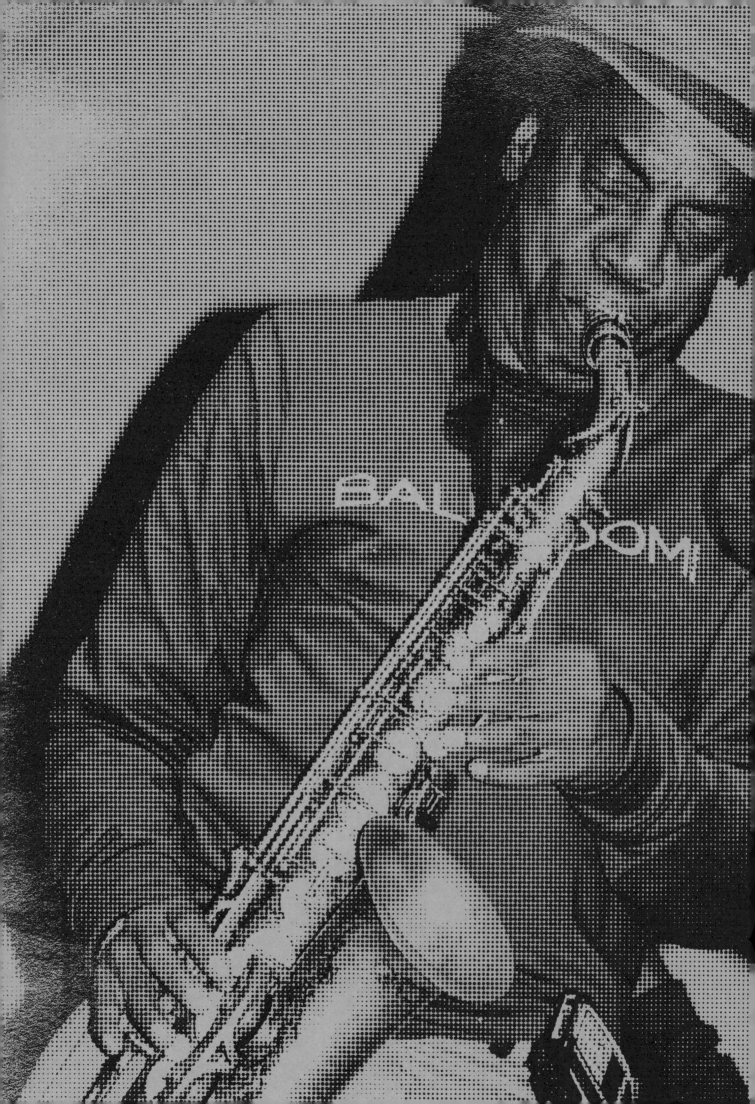

CHAPTER TWO

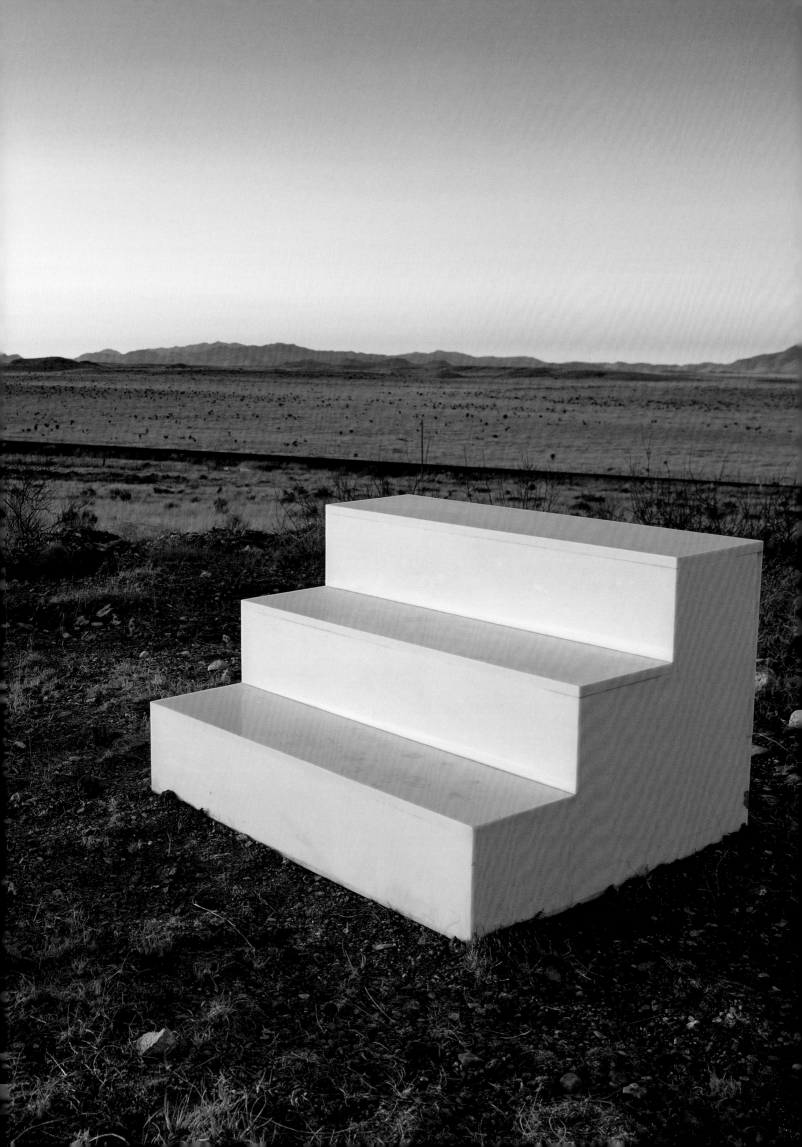

FOUNDATIONS LAID/
DIALOGUES INITIATED

2008–2012

With the foundation laid for artists to explore and present their ideas freely and completely, Ballroom entered its next phase. *Hello Meth Lab in the Sun*, a fully immersive large-scale installation, transformed the space, as if to underscore that Ballroom was not a white cube gallery. The artists that were creating at Ballroom, in Marfa, understood that artwork had the potential to ignite critical dialogues. That was clear through the series Marfa Dialogues, which would continue annually for the next six years. It addressed pressing and complex issues such as border culture and politics.

Ballroom's exhibitions and programs responded and related to larger global conversations, such as Art in the Auditorium, a film screening series that connected art venues around the world. Mel Chin's Fundred Dollar Bill Project, which was traveling across the country to raise awareness of the terrible impact of lead poisoning on children in many American communities, made Ballroom Marfa one of its stops. DJ Camp, Ballroom's capstone music education workshop, was created to teach young students in Marfa the art of DJing. During this period of Ballroom Marfa, these programs had "legs": shorthand among staff to signify that a programming concept was strong enough to stand on its own legs. And once they had legs, you could let them walk anywhere they wanted to. □

FUNDRED DOLLAR BILL PROJECT

MEL CHIN

In February 2010, Ballroom Marfa hosted a stop on Mel Chin's Fundred Dollar Bill Project tour. A conceptual artist, Chin is known for deploying a broad range of approaches in his art, including works that require multidisciplinary, collaborative teamwork and others that enlist science as an aesthetic component in developing complex ideas. The Fundred Dollar Bill Project is an ongoing collective art initiative involving hundreds of thousands of people across America. Participants' hand-drawn interpretations of one-hundred-dollar bills—expressions of value—are original works of art that together call attention to the danger of lead poisoning to children and remind us that every child's future has worth.

In partnership with Marfa Studio of the Arts's SITES program (Studio in the Elementary School), the event began at the Marfa National Bank with an official welcome to Chin and his Fundred Guards, followed by a parade with members of the community marching from the bank to Ballroom Marfa. The goal was to connect and collect voices from around the country to raise awareness around the issue and support a solution to lead poisoning–related health and quality-of-life challenges that are still particularly acute in post–Hurricane Katrina New Orleans. ▷

Mel Chin leading the parade to deliver the Fundred Dollar Bills to Marfa National Bank, February 27, 2010.

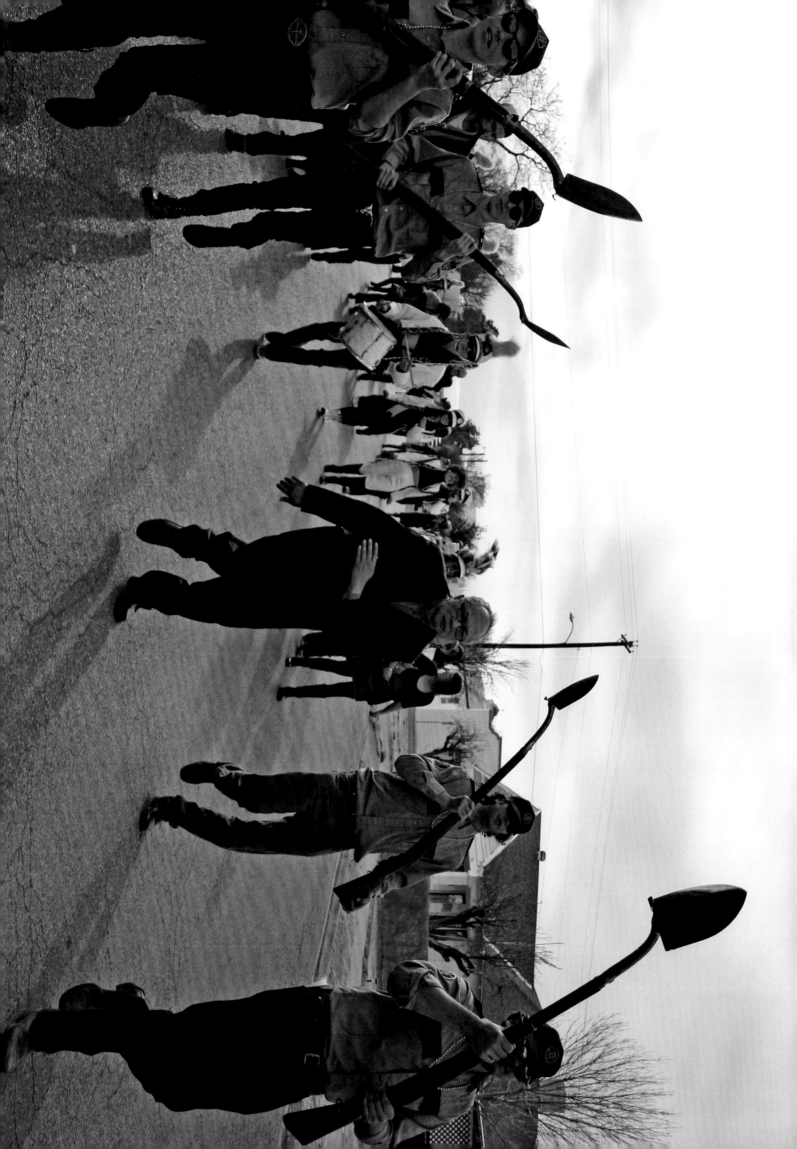

FUNDRED.ORG

DRAW A FUNDRED DOLLAR BILL

HERE'S A PICTURE OF A $100 DOLLAR BILL
CAN YOU MAKE **YOUR** VERSION OF THIS MONEY?

INSTEAD OF BENJAMIN FRANKLIN - **DRAW :**
YOURSELF - A FRIEND - A PET - A FLOWER - A HERO - A MONSTER
YOUR MOM - YOUR DAD - YOUR GRANDPA OR MA.

WRITE
IN THE NAME
OF CITY - STATE
COUNTRY
WHERE YOU WERE BORN

MAKE UP YOUR OWN SERIAL NUMBER

THERE
IS AN
EAGLE
IN THE CIRCLE
BUT DRAW YOUR OWN
BIRD
LIKE A
PELICAN!

TRY
TO PUT IN FIVE
100s
IN FOUR DIFFERENT WAYS!

SIGN YOUR NAME HERE

YOUR TEACHER CAN SIGN HERE

AND WRITE IT TOO!

NAME YOUR DRAWING

FILL IN THE BLANK BILL

Name 2006 Teacher

Mel Chin, Fundred Dollar Bill template, 2010.

"To see the legendary stuff from the Judd situation, of course, to complete my education, I felt was important, and then to understand the living spirit of Ballroom. I think about one as a historical kind of thing and one's a hysterical kind of thing. In the best way."

A REFLECTION BY MEL CHIN

Marfa was expanding always, right? I was always wanting to go. I think the first real time I went, before bringing the Fundred truck in, was a trip with three people that I've since lost. And it was so meaningful because these three people had an impact on the way I think, the way I work, the way I care about things. And so it was like a family: very strong family of ideas.

I also remember meeting Fairfax many years ago. Maybe it was in 2006, when I had a show at the Station Museum [in Houston]. So essentially, Marfa was always calling me. And so, getting there was a major moment, and then getting to know what Fairfax was doing, even more.

It was surprising because there's not just one thing about Marfa. Being from Texas, it is always a joy to see other parts of the state and to be part of Marfa, it just opened up this part of Texas that I had not frequented. And to see the legendary stuff from the Judd situation, of course, to complete my education, I felt was important, and then to understand the living spirit of Ballroom. I think about one as a historical kind of thing and one's a hysterical kind of thing. In the best way. Ballroom is about life, of and for everything it entails. I felt that the potential was even more important because you could have art that is so highfalutin, so to speak, and then to have it connected with the local community to make those bridges that some people don't care about. I've been in places that choose to keep art elite, and there are reasons for that, of course. But when you start integrating musically and then socially, that's the chance when you reach people like me. When I was a kid growing up in Texas, that's not something I remember happening.

To come to Marfa, which you would think is a more West Texas cow-town kind of situation, and to have Judd there and to have Ballroom—just the idea of Ballroom and what that means: it's celebratory. I was surprised that it was thriving, is what I would say. And I think that owes a lot to the people involved. It was celebratory in my mind, coming to be in that environment and to soak it up.

I remember once at the Thunderbird, I maybe helped to stop a bar fight involving Vance [Knowles]. It was no fault of his own; Vance was just being Vance at that moment. And I remember this person just ready to hit him. And I know Vance is not a fighter, so I remember interceding at that exact moment to stop it, maybe setting out to defuse it. And of course, I was under in the influence of some strange hallucinatory tequila that someone had brought in a little red wagon—or some desert tequila or mezcal or maybe a special cactus-infused situation—and wandering around. I remember wandering around in the desert and just soaking it in. You don't get that experience where I live, down the mountains of Appalachia, or the streets of New York. But that's what I think of Marfa: I think of these moments. I remember just walking alone in the night under the skies and then maybe ending up at someone's place. Or the dance parties that have prolonged effect, or even the subtleties of relationships that were part of it. In all, what I felt is it is something that I could connect with the spirit of Ballroom. And then you have the possibility of intellectual discourse with your peers. That's another thing that strengthens it. There's something easier for me while I'm in Texas, or something like that.

The project I did for Ballroom—part of it, the Marfa Hundreds—is now in the Brooklyn Museum's permanent collection. The project brought us face-to-face with people like Nancy Pelosi. It brought us face-to-face with members of Congress from the right and the left. Orrin Hatch. And just that ▷

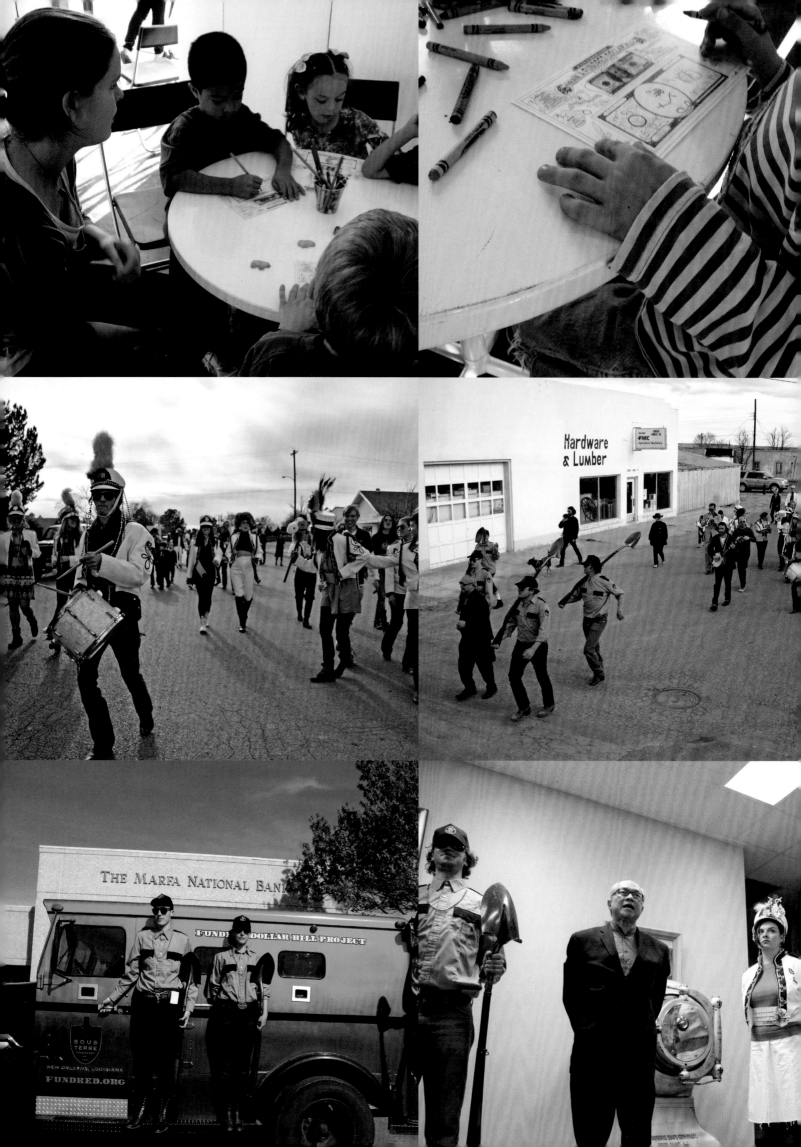

"Some things are about a celebration of the possibilities of expression. With the art world, there can be inordinate focus on the cult of the individual. But there are other aspects of conceptual art that say, 'Well, that's not the only thing.'"

From top to bottom: Designing Fundred Dollar Bills at Ballroom Marfa, February 27, 2010; parade to deliver the Fundred Dollar Bills to Marfa National Bank, February 27, 2010; delivering the Fundred Dollar Bills to Marfa National Bank, February 27, 2010.

representation of kids under threat, and getting to understand the work is because of the value; I'm talking about how you had to have people that understand what I was trying to do. And I felt like Fairfax certainly understood it, and it was reflected in the curation at Ballroom.

I remember the armored truck came in and it was detoured. It was a detour we weren't planning. It was twenty thousand miles through America, I think they finished in Roswell, New Mexico. I said, "No, they're going to go another route." I said, "No, we've got to stop in Marfa." From alien territory to another alien territory. . . . We stopped in Marfa to account maybe a hundred thousand bills that had been collected at that time, a couple of hundred thousand drawings, and adding Marfa's to it. I remember counting there at Fairfax's place. By that time, the Fundred Project was not my project; it belonged to anybody who drew [a Fundred], and I had become just the delivery person by that time. You can go from conceptual art to deliveryman. It was a meaningful moment.

Some things are about a celebration of the possibilities of expression. With the art world, there can be inordinate focus on the cult of the individual. But there are other aspects of conceptual art that say, "Well, that's not the only thing." I think finding a place like Ballroom that can accept the complexity of art discourse is what I felt most comfortable with. It was a place where I could feel comfortable. You see? I remember the wild things. What was that—*Hello Meth Lab in the Sun*, wasn't it? Immersive; a very powerful kind of a re-creation of a possible reality. And then to have this joyous celebration about a child having a voice when no one else is listening, and not to say, "Oh, this is art. That's a kid's drawing," but say, "Please come. Please be part of it." And we were looking for that. We're traveling in that veggie oil truck that was breaking down and busting up. And it

was important. It was important that we made it to Marfa. Like I said, it was slightly off the track.

It was emblematic, my friendship with the people that are part of Ballroom. I'm very fond of the people involved and the reasons why they're there. I think as long as Ballroom is showing that and pushing the envelope in terms of performances, it's not just a safe space. It's going to transcend the physical space when you do things like that. And we need more of that, not less. I think there's a creative acceptance with Ballroom, and I think it's encouraging that Ballroom is still around doing it after twenty years. □

Interview, Mel Chin and Daisy Nam, August 4, 2023.

HELLO METH LAB
IN THE SUN

JONAH FREEMAN, JUSTIN LOWE, AND ALEXANDRE SINGH

Ballroom Marfa's spring 2008 exhibition, *Hello Meth Lab in the Sun*, a collaboration between Jonah Freeman, Justin Lowe, and Alexandre Singh, was a rumination on the theme of alchemy. To uncover sites of transmutation in the modern world, the exhibition transformed Ballroom's galleries into a labyrinthine assemblage of rooms, hallways, closets, and observation platforms. Functioning like museum dioramas or period rooms, *Hello Meth Lab in the Sun* featured theatrical depictions of three specific social/historical contexts: the utopian hippie commune, the clandestine meth lab, and the varied sites of modern industrial production. Says Singh, "The consistent thread through these different narrative realities was this engagement with alchemy. In the utopian community's cooking, in the dystopian meth production, in the sculptural elements, there is this constant theme of material transformation." ▷

Installation view, *Hello Meth Lab in the Sun*, 2008.

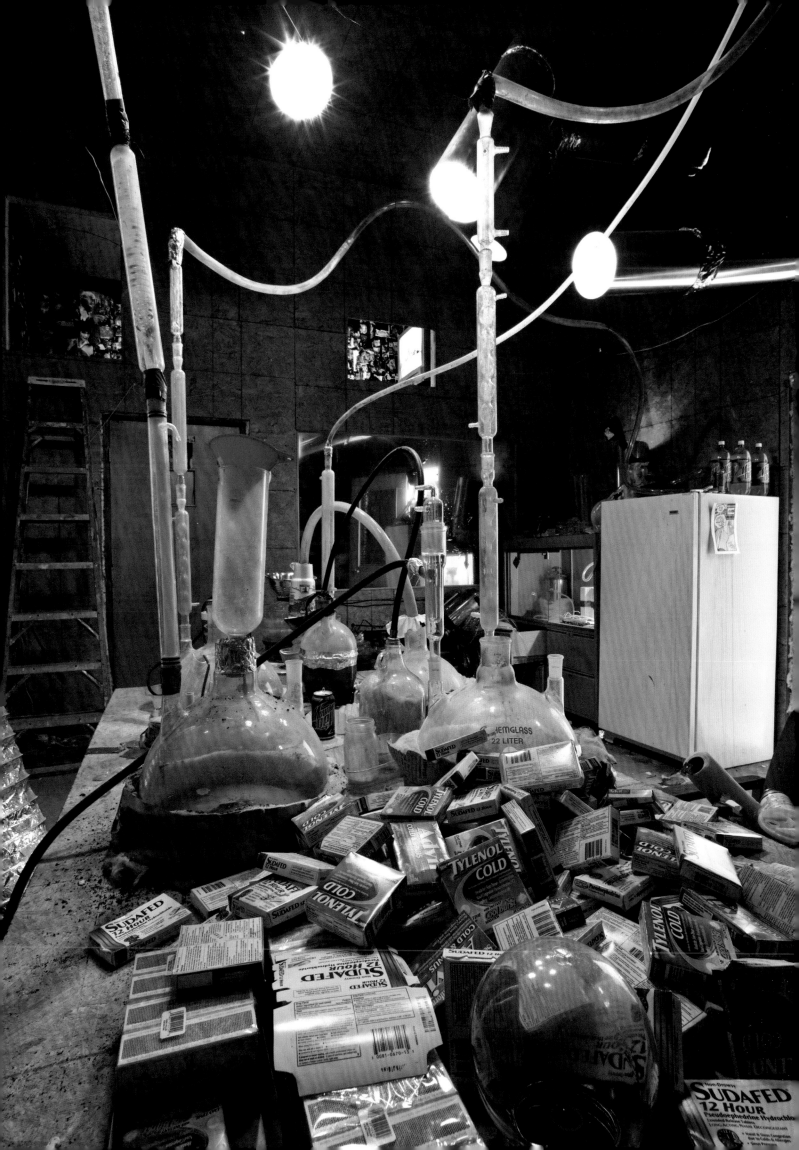

360 DEGREES IN THE SUN
ALISON DE LIMA GREENE

"We were somewhere around Barstow on the edge of the desert when the drugs began to take hold."
—Hunter S. Thompson, *Fear and Loathing in Las Vegas*

You pull off the highway. Getting out of the car, you might see a bicycle or two, a couple of parked cars hugging the shade. No one is on the street. To the right is an entrance papered over with fading advertising circulars from El Paso and a Visa/Mastercard decal. The narrow door lets you into a dim, claustrophobic hallway with a small receptionist's alcove. Faded astrological charts and snapshots are arrayed across the wall opposite, like a yearbook of long-absent residents. The hallway continues, taking you past travel posters, a dusty mirror, a closet, until you reach the first room, an abandoned domestic space littered with rags, books, albums, magazines, an upended mattress, and a dead television set. Eye-popping wallpaper, red carpeting (stained), and a candy-colored canvas showing the molecular structure of methamphetamine indicate past attempts to decorate the space, while a discreetly placed microphone points to a more recent intrusion. Around the corner you are confronted with further evidence of surveillance, as additional microphones, recording devices, and wires eat into the walls.

These are the first stages visitors encounter in *Hello Meth Lab in the Sun*, a complex, densely layered installation created by Jonah Freeman, Justin Lowe, and Alexandre Singh for Ballroom Marfa in the summer of 2008. Two years earlier the artists had proposed "a sequence of seemingly disparate environments, interpreted through the practice of alchemy. Each of the various rooms . . . will bleed and morph into each other. The totality of the installation will create a ricochet of ideas, a focus on the metamorphosis of materials: vegetables into broth, match heads into meth. An industrial, culinary, and narcotic revolution."[1] Detailing the scheme further, they referenced museum culture, specifically natural history dioramas and period rooms, as they laid out the framework for the three main settings: an underground meth lab, a corporate trophy room, and an organic hippie cult kitchen.[2] These core components anchored the project as it was realized within the walls of Ballroom Marfa, but other elements were added, at times in an improvisatory spirit, as *Hello Meth Lab in the Sun* evolved into a more discursive project, existing in an insistent present and filled with echoes of our immediate past.

"Everything seems to be ready. Are you Ready? Ready?"[3]

Like a filmic jump cut, the next room abruptly changes the tenor of your passage. The kitchen you're now standing in has been the site of a corrosive blast, and most likely you would like to leave this room as quickly as possible. Harsh shafts of daylight spotlight the blistered and blackened refrigerator, stove, and sink, appliances that seem capable of reigniting. There is a gothic humor here too. Reaching out of the oven door is a single chicken's foot, clawing its way back to air.

At this point the first component of *Hello Meth Lab* coalesces, and the ensuing rooms conflate the ordinary with the bizarre. Immediately following the kitchen is a brightly lit showroom displaying an array of exploded mannequin heads, evoking Ralph Steadman's adrenaline-fed illustrations for Hunter S. Thompson's novel *Fear and Loathing in Las Vegas*: "What sells, today, is whatever Fucks You Up—whatever short-circuits your brain and grounds it out for the longest possible time."[4] Off to one side is a bag of kitty litter (which is often used to smother the acrid smell of meth production), and litter also spills from the burst mannequin heads. Past a vitrine filled with cacti, the next passage leads to the heart of the meth lab: stacked magazines create a bunker-like cell, while boxes upon boxes of over-the-counter medications—Sudafed, Advil, and Tylenol—share a table with a sprawling homemade still.[5] You can climb up to a sleeping loft/love nest, where the walls are papered with pages ripped from *Fangoria* magazines and watch a yoga exercise video enacted by a figure in a gorilla mask.

As the artist Alex Hubbard has demonstrated, a virtual taxonomy of meth labs and the lives they encase can be culled from the internet. Parsing one such image, Hubbard suggests: "What is also important about this lab is the photo of a lake above the worktable. It recalls long sleepless nights, stressful mornings of cooking meth, listening closely for the sound of brakes, or the police, or perhaps a disgruntled partner to break down the door and shoot the manufacturer or burn them with chemicals. In spite of all that, this photo can serve as a sanctuary, a place to imagine as one waits for the binders in your pseudoephedrine to break down."[6] Freeman, Lowe, and Singh elaborate on Hubbard's reading, offering clues to their absent protagonists through a scattering of magazines, action photographs of muscle cars, as well as in the retreat offered by the sleeping loft. "The habitual users became 'freaks' lost in an obsessive personal mania," they observe. "In some sense the mentality of a meth addict could be seen as a mirror to that of a modern corporation: each on a singular pursuit at the expense of everything else."[7]

"They came, but they resented it. They were full of excuses for coming, but there were coins in their eyes and sand in their mouths."[8] ▷

"The kitchen you're now standing in has been the site of a corrosive blast....Harsh shafts of daylight spotlight the blistered and blackened refrigerator, stove, and sink, appliances that seem capable of reigniting...Reaching out of the oven door is a single chicken's foot."

Installation view, *Hello Meth Lab in the Sun*, 2008.

A door ushers you into a white room. Your degree of comfort depends on your familiarity with Upper East Side art galleries and VIP lounges. The carpeting is bloodred and pristine. Wainscoting and paneling give measure and rhythm to the walls. You see a series of tastefully framed black-and-white photographs. Isn't that Gena Rowlands? Nico? And over there, that man—wasn't he in that movie with Mia Farrow? Vitrines encase monolithic architectural fragments, one of which is charred and warped as if salvaged from a burning building. Haven't you just seen this? A second series of photographs, now in color, further reprises your previous passage. Here the paraphernalia of a meth lab is captured through the flattering lens of a magazine stylist; in some instances, pure anarchy seems to have invaded the lab as absurdly constructed experiments erupt in cascades of foam and boiling liquids. In others, each plastic bucket, canister, and tube assumes the status of a sacred instrument.

Originally conceived as a trophy room, this segment of *Hello Meth Lab* departs significantly from the artists' 2006 project description. In place of the array of products associated with corporate drug culture that Freeman, Lowe, and Singh planned to present, the artists introduce instead an insistently temporal shift. Where the first rooms of *Hello Meth Lab* loosely evoke the American underground of the past three decades, the dramatically staged black-and-white photographs specifically resurrect New York's café society, somewhere in time between Capote's 1966 Black and White Ball and Norman Mailer's 1973 fiftieth birthday bash. Frozen in the flash of a paparazzo's bulb, partygoers either loll before the camera or mask their faces with cacti and crystals, as if engaged in some arcane ritual. The enshrined mural fragments elsewhere in the gallery suggest a further extension of this ritual, adding yet another layer of temporal complexity to the environment.

"Can I stay here for a while?"[9]

Stepping through a fissure in the wall you leave New York City for Drop City (circa 1969). Shelves of mason jars catalog both food and artifacts: lentils, tinfoil, magazines, light bulbs, crystals. A sturdy ladder leads you to a large kitchen under a geodesic dome. You are first greeted by the sight of a coyote and a fox together. Collages, assemblages, crystals, and dream catchers are scattered throughout, and you encounter yet again a series of astrological charts, restating the possible future of what has passed. You missed supper, however; only dusty traces of food, a few cigarette butts, and an assortment of gourds remain. In the center of the table, a reel-to-reel player unspools a continuous loop of tape, and another winds a labyrinthine path around both levels, while two microphones await your response.

The artists' specific evocation of Drop City, a Colorado commune that was founded in 1965 and largely abandoned by 1970, once again locates *Hello Meth Lab* in time and place. Created in an attempt to realize Buckminster Fuller's social ideals and the collective spontaneity of Allan Kaprow's Happenings, Drop City later became a symbol of failed promise in the writings of Ray Mungo and T. C. Boyle. For Freeman, Lowe, and Singh, the environment is both inviting and suspect: "The ideas of freedom, openness, land were very attractive . . . But utopianism of any kind is still an ideology that is in negation of something else."[10]

"The buttons said on and off, forward, and backward. I caught on to that fairly fast. I don't think I'm so stupid as to erase what's on a tape."[11] ▷

86

Exiting the Drop City rooms through a refrigerator door, you find yourself in an undecorated space, empty but for two speakers wired to play back the sounds of your progress through *Hello Meth Lab in the Sun*.[12] You were last the object of surveillance inside this maze of corridors and tableaux. You were the protagonist. And it is this situational encounter between viewer and environment, history, and memory, that brings your visit to a close.

> *"Pomegranates from St. Dominic's tree, Indian idols, a copper knife, with which Jews circumcise their children, together with the stone that belongs to it; one deer antler, which sweated blood in a synagogue during Lent."*[13]

Hello Meth Lab in the Sun is not unique in its immersive detail, nor in its engagement with the viewer. Prior examples can be cited: Claes Oldenburg's garrulous storefront installations or Ed and Nancy Kienholz's arresting tableaux, for instance. More recently Ilya and Emilia Kabakov, Mike Nelson, and Christoph Büchel have created similarly elaborate site-specific environments that reenact these projects of abandoned spaces, and the cinematic theatricality of *Hello Meth Lab in the Sun*.

What distinguishes *Hello Meth Lab*, however, is its central metaphor of alchemical transformation. Looking back to this premodern era of scientific and spiritual inquiry, Freeman, Lowe, and Singh uncover the generative wonder inherent in creative action, and their installation finds its most powerful precedent in the *Wunderkammern* of the Renaissance and Baroque periods. Created by princes, scholars, and merchants, these assemblages brought together *naturalia* and *artificialia*—natural wonders and marvelous artifacts—gathered from around the world. The eclectic and even mystical intent of these displays did not survive the Enlightenment, and the museum practices that evolved from *Wunderkammern* reflected instead the encyclopedist's penchant for classification, a transition that has been described as a passage from wonder to knowledge.[14]

Freeman, Lowe, and Singh reverse this course. Each detail of *Hello Meth Lab in the Sun* is grounded in research and made concrete through physical labor. Early inventory notes for *Hello Meth Lab* spell out the artists' intent to riffle through both materials and concepts: "Potato, Raven's Fake Blood, Dusty Hot Plate, Scatter Philosophy, Fluorescent Mirrors, Cactus, Horror in Wallpaper, Glass Covered Sports, Reel to Reel with Waist High Plants."[15] The temporal fugue that both disrupts and unites each segment of the environment successfully mines both the mainstream and counterculture of the late 1960s and early 1970s, perhaps not coincidentally the era when Freeman and Lowe were born. Yet, like a dream play in which objects and events recur and mutate, *Hello Meth Lab* is also

insubstantial and fantastic, vivid in recollection and vital in presence. The artists have insisted that their project is not a political one; it is not about meth labs, drugs, exploitation, or the failed visions of 1960s idealism, nor is it about surveillance, although all these themes run through the installation. These are but props and signifiers for a greater revolution proposed by Freeman, Lowe, and Singh, one that reconnects the mind-blowing nature of wonder to everyday experience. ▷

Excerpt, exhibition catalog. De Lima Greene is curator of Contemporary Art & Special Projects at the Museum of Fine Arts, Houston.

1. Jonah Freeman, Justin Lowe, and Alexandre Singh, unpublished project proposal for *Hello Meth Lab in the Sun*, 2006. Courtesy of Ballroom Marfa.

2. Neil Young's 1969 "Cowgirl in the Sand" lyrics not only provided inspiration for the title *Hello Meth Lab in the Sun*, but each verse also found its echo in the tripartite installation.

3. Hunter S. Thompson, *Fear and Loathing in Las Vegas: A Savage Journey to the Heart of the American Dream* (New York: Vintage Press, 1971), 198.

4. Ibid, 202.

5. Given the FDA restrictions by then placed on selling these products, the medication boxes were meticulously fabricated by the artists and their assistants.

6. Alex Hubbard's "A Taxonomy of Meth Labs," was first delivered as a lecture at Whitney at Altria in March 2006. A version of this lecture was published in *Plazma 29* (2007): 30-31. I am indebted to Charles Frolick for bringing this to my attention.

7. Freeman, Lowe, and Singh, proposal for *Hello Meth Lab in the Sun*.

8. John Leonard, "Happy Birthday, Norman Mailer!" *New York Times*, February 18, 1973. Http://www.nytimes.com/packages/html/books/mailer-birthday.pdf.

9. Neil Young, "Cowgirl in the Sand," 1969.

10. Freeman, Lowe, and Singh, proposal for *Hello Meth Lab in the Sun*.

11. Rose Mary Woods, on the gap in the Nixon White House tapes, November 8, 1973. *Time*, December 10, 1973.

12. Within a few weeks of the opening of *Hello Meth Lab in the Sun*, the playback function ceased to work. Nonetheless, the insistent presence of tapes and monitors throughout *Hello Meth Lab* successfully conveyed the artists' intent to give the impression that "one is always watching and being watched." Indeed, by happenstance, the silence of the recording devices evokes one of the most notorious moments in recent surveillance history, the 18½-minute gap in the Nixon White House tapes. Revealed to the public in the summer of 1973, this ominous lacuna fulfilled Mailer's prophecy that the time had come to monitor "how far paranoia is justified." Leonard, "Happy Birthday, Norman Mailer!"

13. A description of the *Wunderkammer* created by Archduke Ferdinand of Tyrol, from Philipp Hainhofer's 1628 travel diaries. Quoted and translated by Mark A. Meadow, "Quiccheberg and the Copious Object: Wenzel Jamnitzer's Silver Writing Box," *The Lure of the Object* (Williamstown, MA: Clark Studies in the Visual Arts, 2005), 40.

14. Celeste Olalquiaga, "Object Lesson / Transitional Object," *Cabinet Magazine* 20 (Winter 2006–2007): 8.

15. Freeman, Lowe, and Singh, proposal for *Hello Meth Lab in the Sun*.

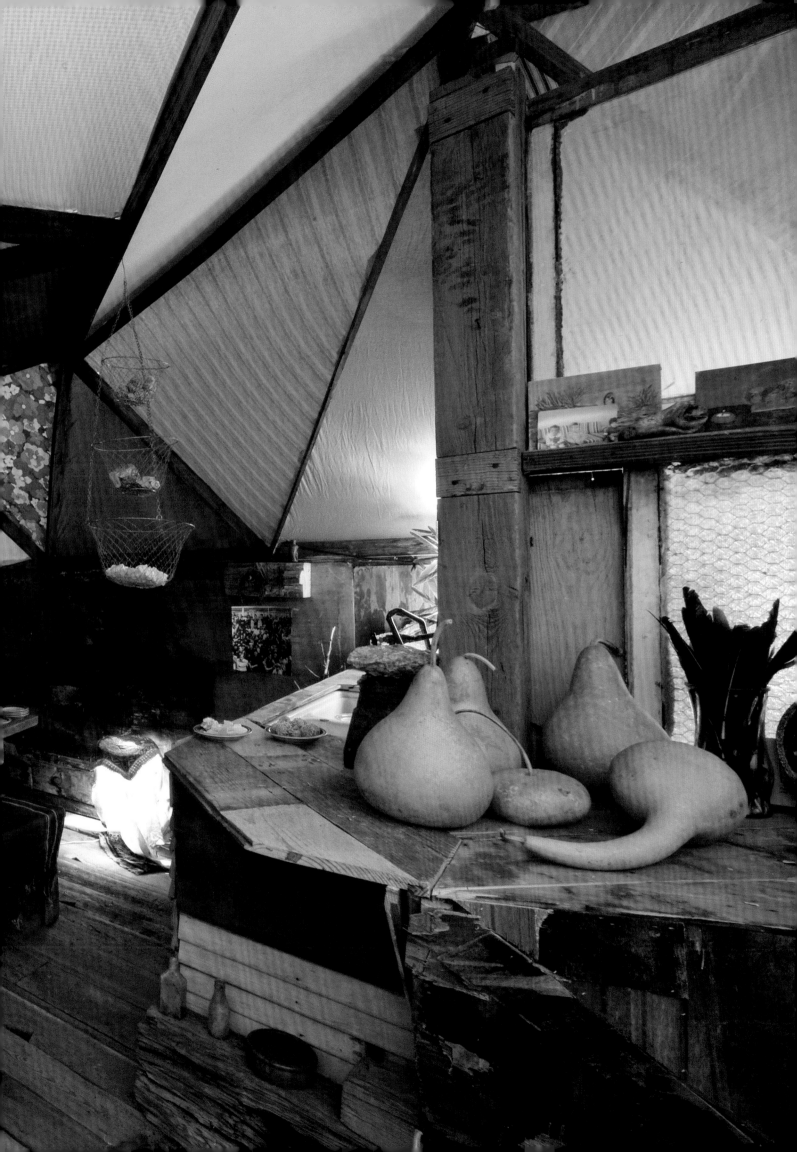

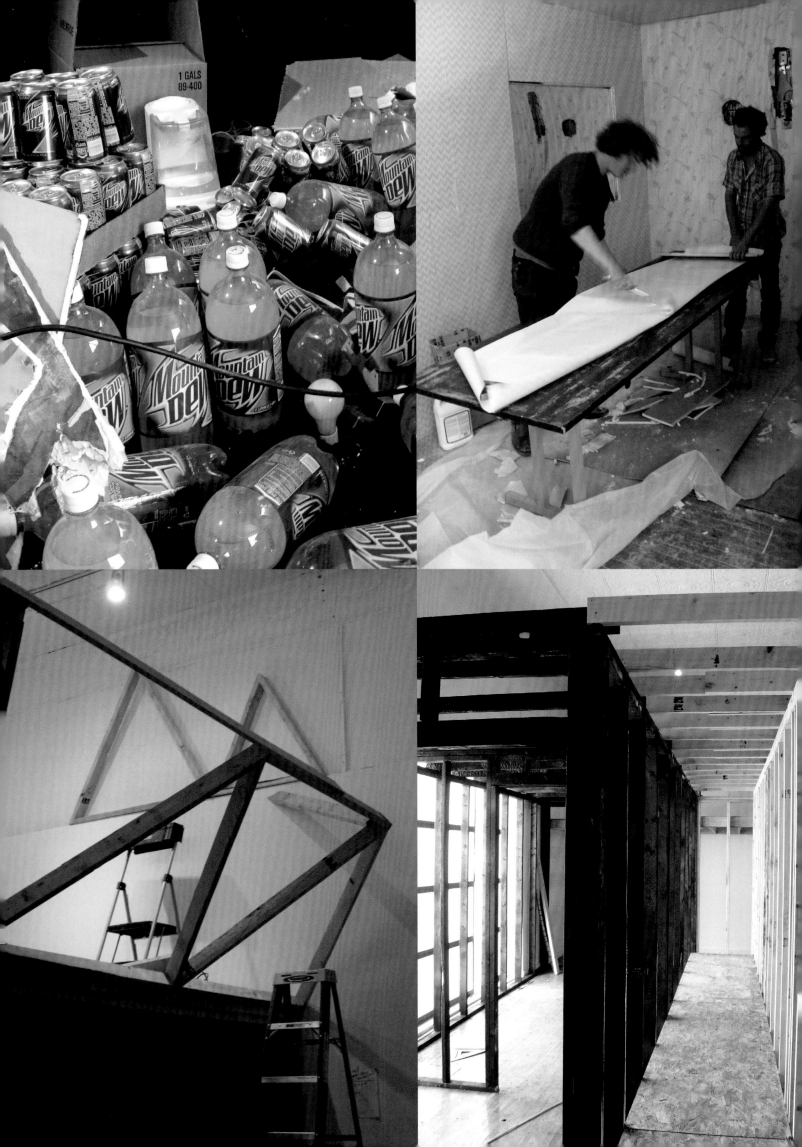

A CONVERSATION WITH JONAH FREEMAN, JUSTIN LOWE, AND ALEXANDRE SINGH

Jonah Freeman: The idea of a meth lab in the sun or meth lab as a sculpture started to spring forth because looking at all these images of meth labs, we started to think there was something kind of—although it's something gross and eerie and terrible about it—there's also something beautiful about the way these spaces look. There's something very powerful, at least. And then we started to think about the hippie communes, and about if we were to juxtapose those two, what would be the themes that would emerge, and alchemy became one of them. And then we thought the third sort of element would be this reference to industry, industrial alchemy, and the way that product proliferation is really of a certain form of hyperchemistry or something like that. So, it's these three themes that emerged.

Alexandre Singh: The consistent thread through these different narrative realities was this engagement with alchemy. In the utopian communities' cooking, in the dystopian meth production, in the sculptural elements there is this constant theme of material transformation. For example, in the creation of the distillation still. Researching all the glassware that we used for the laboratory, I learned more than I'll ever need about the different ways to purify a substance. It is quite beautiful how, for example, a cold finger condenser loops back on itself. It seems that there are a million different ways for the snake to eat its own tail.

Freeman: And we made lists of the things we thought would be in the installation. We would sit around and sort of brainstorm the various things that would be involved in these rooms that you would move through.

Justin Lowe: We thought that maybe just behind this sort of abandoned hippie commune kitchen might be the meth lab, as if to reveal that there's something darker just beyond this seemingly harmless and kind of ideal sort of kitchen.

Freeman: We liked this idea of the clandestine meth lab. They're often hiding things and having all these chemistry experiments in holes buried underground, like in closets. People have buried eighteen-wheelers in the ground so they can have meth labs underground, with kitchens, bathrooms . . .

Singh: Remember also that the toilet pissoir's primary function is to receive the golden stream of a human being. Later Duchamp has it transform itself into aesthetic gold. You may laugh, but there was a long-held belief in medieval times that urine did in fact contain gold and there were serious attempts undertaken to extract it. They were literally trying to "take the piss."

Freeman: And one of the themes for the hippie commune was natural magic being natural alchemy, something that's very idealistic in a more holistic approach to using materials. That was based on Drop City, which was an early hippie commune, I think one of the first hippie communes, and it was around the Four Corners, and they were very inspired by Buckminster Fuller; that's why it's a dome structure. It was a real idealistic way of dropping out of industrial society and building your own community from scratch. But it failed very quickly. I think within a couple of years the original members were gone and then soon I think it was completely abandoned. And so, the idea was an abandoned hippie commune and there would be the detritus of some sort of very decadent party, and this was the image we used to convey that which we staged in our kitchen.

Lowe: There was also this idea of the imaginary cast of characters that would have inhabited this space.

Freeman: We were also exploring this idea of industrial civilization being some form of alchemy. And I guess we were trying to think about, in loose ways, the ideologies and how they link up, all these three ideologies or in the case of the meth lab, maybe lack of [ideology]. But the meth lab being some sort of nexus of the two industrial and the natural magic section in that clandestine meth labs just use household materials, these products that require intense science and development and big manufacturing plants to make, are then sort of used, co-opted, and reformed into this powerful and toxic substance, but a DIY kind of thing. And then the link between the counterculture drug movement and biker gangs and stuff from the 1960s that had a sort of utopian idealistic approach, but in some ways that had spun off into something that doesn't have that [idealism] anymore, and it's just about pure nihilistic escapism. For the proposal for Ballroom, we did a big photo shoot in New York, part of which was to create these very theatricalized versions of the meth lab images that we had been working off. We built a set in our studio and lit it and obviously got the smoke machine out. ▷

Excerpt, interview, Jonah Freeman, Justin Lowe, and Alexandre Singh, Marfa Public Radio, 2008.

"Industrial production requires control and a degree of secrecy. The recipe for the production of Coca-Cola is much harder to find on the internet than the recipe for homemade crystal meth."

RESTAGING INTENSITY
LIAM GILLICK

"In fact their amazement and excitement were enormous. They expected a tomb, but they saw the most incredible and endless galleries of art. All was installed in spaces more beautiful than those of Versailles, in magical palaces where all extremes of climate were unknown. Countless lamps, some incredibly bright, others soft, glowed constantly through the blue depths. It was like daylight that would never become night. Of course the sight was nothing like we know now; we need to work hard to imagine the psychological condition of our poor ancestors. They had become so used to discomfort and inconvenience on the surface of the earth that it is hard to imagine their enthusiasm at the moment that they were saved from death and relieved of all their worries at the same time."
–Gabriel Tarde, Underground Man

French philosopher Gabriel Tarde's only work of science fiction, *Underground Man*, was published in 1904. Yet it is a very contemporary tale: globalization is followed by ecological catastrophe, leading the last few inhabitants of a frozen Earth to reject the surface and construct a new architecture with no exterior—underground. The subterranean for Tarde is a place where art and philosophy reign. The underground as a total alternative, a permanently private zone of activity unrestrained by the relentless presence of surface nature. As such his book can be seen in the context of a culture that was at that time accentuating art as an autonomous activity for its own sake. His characters initially imitate nature, but as time passes they begin to produce a new art that is "better than nature."

A link exists between drugs, class, and industrial production in their amplification of denial of "nature." Within spaces constructed to produce synthetic drugs, there is a necessity to exclude the view. It is important to neither see or been seen from the outside. A new world is created, both in the site of production and in the head. Class systems control nature, apply their own naturalizing processes to any understanding of the way things are and, most importantly, the way things should always be. Industrial production requires control and a degree of secrecy. The recipe for the production of Coca-Cola is much harder to find on the internet than the recipe for homemade crystal meth. Each of these categories carries its own aesthetic and its own veils against the cyclical relentlessness of nature. The cycles of nature are replaced by cycles of intoxication, production, reinforcement, striving, and perverse growth. It is these semiautonomous concepts the artists in *Hello Meth Lab in the Sun* deploy, embedding an artistic sensibility in an overwhelming series of structures that accentuate and exceed the natural.

The notion of a hidden space that reveals both inner and outer potential is at the heart of narcotic fulfillment. A meth lab is an excess of appropriation: materials, time, knowledge, and the redesignation of elements. The drug of the title always implies a degree of crazed focus and a delusion that it might actually be possible to make your own complex drugs. Speed gives you the energy to focus on complex tasks, up to a point. Meth as a substance is a self-generating concept. Taking it makes you want to stay up and do something. What better than deploying that excess focus for the production of more speed? In other words, the consumption of what is produced provides exactly the kind of jagged stimulus necessary to enter into the process of producing more. The producer and the consumer, often the

94

same person, are locked in a cycle of excessive focus and production. A closed world emerges, of secrecy, delusion, and transformation—a perfect analogue of the artist's studio.

And a meth lab really is a lab; it is not a metaphor. The further appropriation of the laboratory as a nominative base for an exhibition challenges the notion of exhibition-as-laboratory that has been perpetuated as an experimental paradigm over the last fifteen years or so. A meth lab is a post-discursive space. It is a site of excess, silence, and danger. Using a meth lab as a model for an exhibition is more complicated than organizing a series of lectures or being contingent and imprecise about the potential of the art object. It carries less clarity in a standard critical sense. It explains less while showing more. The meth lab is always barely under control. It is a site where the aesthetic is provided by necessity. It is this aspect of the meth lab that has been unraveled here, a new methodology toward the production of a shattered art.

Despite the title, this is not merely a simulation of a meth lab. Of course, there is a trashed kitchen, a signifier of the best party and the site of domestic production and rebuilding—a site to rebuild a motorbike engine, start a company, or write this text. The kitchen is always the logical site for the homegrown laboratory. But this kitchen is also a site for the generation of ideas and a critical challenge to formalist and super-subjective art. This kitchen functions as a moral locus within the analysis of desire, coding, and projection. It is also the first place to look when a house is raided.

This exhibition is a carefully executed thing, but that does not imply that it is the result of the careful study and reproduction of a series of real sites or actual situations. In this case, the artists are not showing us what such spaces of production, flake-out, and delusion look like; they have taken on the frame of mind that creates the incidental aesthetic of intoxication, with the possibility that there was some parallel form of intoxication taking place at the same time.

The role of the viewer in this case is strained. We are not being shown a *tableau vivant*, nor a true diorama in the museological sense. In fact, the exhibition has more in common with the perceptual shift familiar from science fiction. A dose of Tarkovsky, or even Kubrick, is cut with the techniques of repetition and clarity following chaos already familiar from the battle between angst and irony at the heart of much contemporary art.

This exhibition offers a number of spaces, each of which reveals more of the artists' complex reading of process and desire, while at the same time stripping away the viewer's set of reliable reference points. We should come to accept this work not as a challenge to any values in particular, but as a series of corrupted and reimagined spaces, each of which exceeds—in terms of symbolic signification—and simultaneously avoids operating as a mirror of that which we already know.

Hello Meth Lab in the Sun does not revel in the display or re-creation of excess for its own sake. Instead, the exhibition searches for new markers and sites of production and attempts to offer them as zones for the rethinking of art, in particular and in general. All elements could be stripped out and presented separately, but there is an important point here about collective practice. We do not imagine ourselves in a series of spaces beyond art, but rather in a series of new places that have been redefined by artists. Maybe this process has taken place without checking, and that's the key. A documentary described down the phone and produced with no degree of verification or care. If this is the case, then the same is true for the art component of its aesthetic DNA. A lack of documentary rigor is matched by a collapse of artistic logic; these twin attacks are the essence of the project. The viewer or potential user of the work is locked in a perpetual interplay between the semiotic textures of the work "as art" and the misleading evidence of devastated sites of class, excess, decay, and delusion. □

Excerpt, exhibition catalog. Gillick is an artist, theorist, curator, and educator working across diverse media including installation, video, and sound.

THE MARFA SESSIONS

STEVEN BADGETT, EMILY JACIR, NINA KATCHADOURIAN, CHRISTINA KUBISCH, LOUISE LAWLER, IÑIGO MANGLANO-OVALLE, KAFFE MATTHEWS, ANGEL NEVAREZ, DARIO ROBLETO, STEVE RODEN, STEVE ROWELL AND SIMPARCH, DEBORAH STRATMAN, JULIANNE SWARTZ, VALERIE TEVERE, STEPHEN VITIELLO

The Marfa Sessions was Ballroom Marfa's first major exhibition devoted to artists working with sound. In 2008, independent curators Regine Basha, Rebecca Gates, and Lucy Raven united artists with specific interests in sound work and its potential as a transgressive medium across place and geography. Individual sound projects were installed at Ballroom and embedded within public spaces and private corners of Marfa, creating a sonic portrait throughout the town. Through these site-specific works activated at different locations and in collaboration with the community, *The Marfa Sessions* amplified the varied sets of physical and metaphoric characteristics that define Marfa—its geopolitical position, local identity, and mythology, as well as its significant relationship to minimalism and land art. *The Marfa Sessions* called the ear to Marfa and its environs, noting the aural and conceptual depth and breadth of its vast setting. ▷

Performance, Steve Roden and Stephen Vitiello, 2007.

96

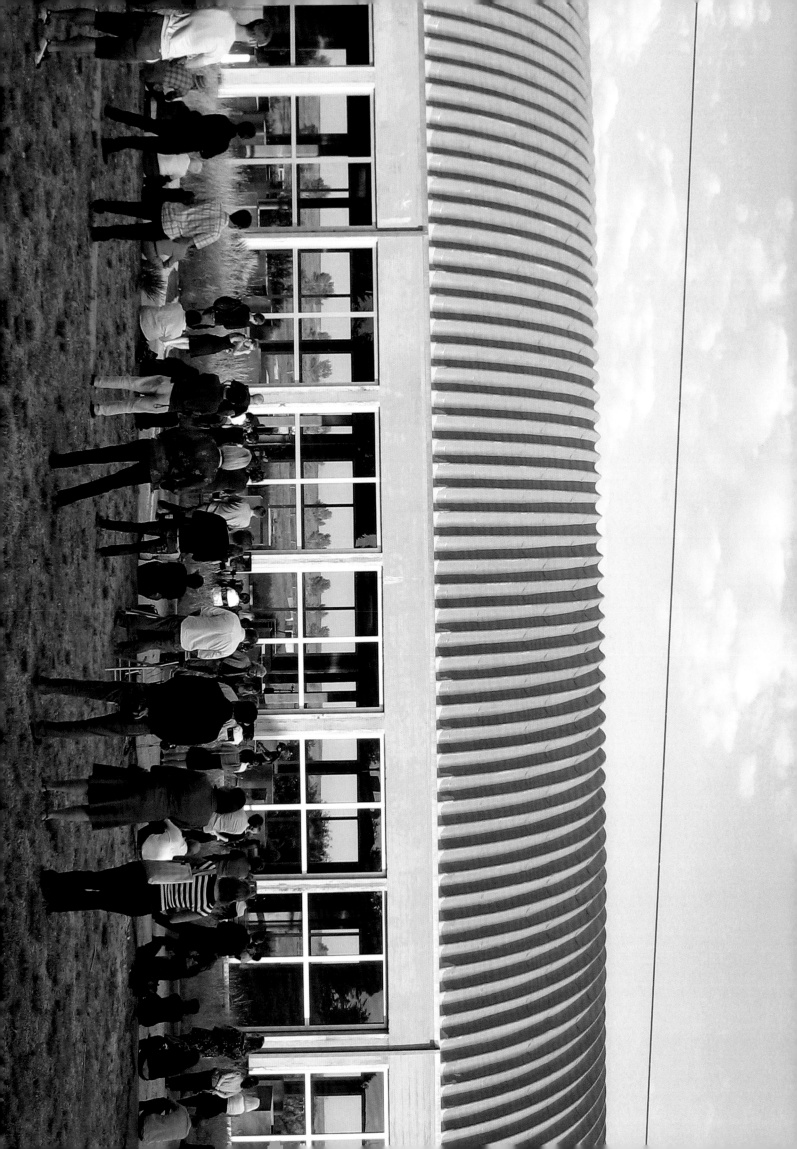

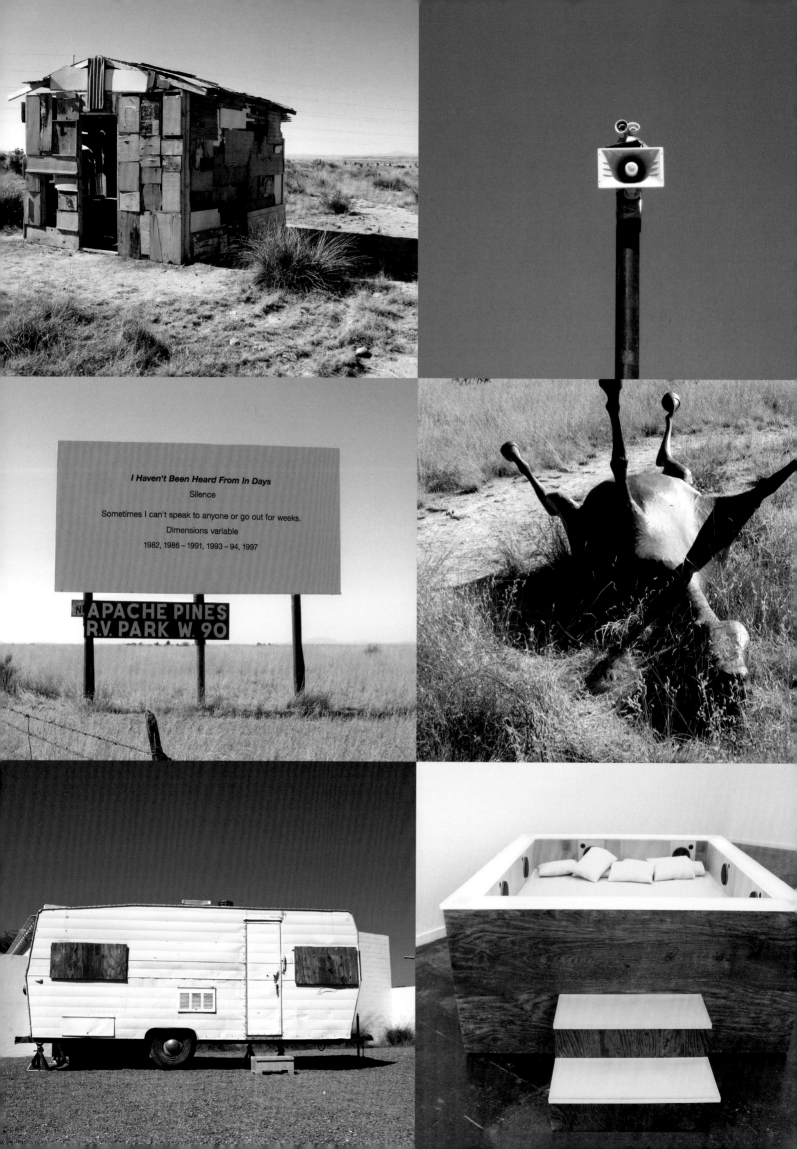

I Haven't Been Heard From In Days
Silence

Sometimes I can't speak to anyone or go out for weeks.
Dimensions variable
1982, 1986 – 1991, 1993 – 94, 1997

APACHE PINES
R.V. PARK W. 90

A REFLECTION BY REGINE BASHA

This is the thing that I tell to people when we talk about Marfa, or they say to me, "Oh, you've been to Marfa. What was it like?" The first thing that comes to mind is, "It's like a social experiment. It's like a utopian community or something." The thing that rose to the surface is that you never have to say goodbye to anyone because you will, let's say, go to the grocery store in the morning, and the nice person at the checkout counter—I don't know if this is true or not, I'm just going to make this up—the person at the checkout counter is also working at the library in the afternoon. So then you go to the library and you're like, "Oh, hey! Here you are again." And then you go to have drinks at a bar later and that same person is the bartender. When we were doing *The Marfa Sessions*, the person who was kind of director of parks and recreation was also this major curator of a film festival in Rotterdam. And this just kept happening. It was a very familiar, very family-like environment. It felt very welcoming and, I don't know, utopic. And then, I guess, on off days, it also feels like you're trapped in a bubble.

Over the course of about three years, I was going back and forth to Marfa for different lengths of time because Ballroom was just starting out, but they were really open to having us visit and investigate. *The Marfa Sessions* were just as much about the town and its own folklore as they were about what the artists were bringing in. We had to really learn about all the stories and all the local characters and the kinds of places that had been there for a long time. All the different stories hidden in the pockets and that you needed to spend time just hanging out [to learn]. And Ballroom was really open to a flexible hosting situation. There was no hard-line timeline. It was, "Come and see. We'll see how it goes."

From afar, when you don't live in Marfa, you're always hearing about Marfa. It's a place that generates mythology and stories and rumors. It seems much bigger in one's head because of the rumors you hear about it. When you arrive there as a first-time visitor, you're always like, "Oh, this is it. It's a junction. It's two streets, then that's it." But in the art world, it has this mythological status. People in Hamburg and Frankfurt know about it. People all over the world will come on their private jets to Marfa. At the same time, the film industry has another story about Marfa. We were interested in that kind of double-sided identity—or triple-sided identity in which, on one hand, you hear about it in the art world, in this fabulous way. And then, in another scenario, you hear about it as a kind of location [for film]. It's exotic and in the middle of the desert. But then there's the very real and very sobering fact that it's a border town. There are migrants crossing and sometimes dying to get to [this] side. That part of Marfa, we were really interested

in shedding light on. Just showing that there is a geopolitical spot on the map that has so many identities. That's why, for us, having sound artists deal with it felt more appropriate than picturing all these things, imaging all these things. So you could learn about it through narrative and narrative forms, rather than trying to address them through images. It just felt more appropriate. It's like the canvas was already there; Marfa is already the art piece.

That "come and see" attitude is what led to the formation of relationships that allowed this project to happen in an organic way. . . .

It was me and two cocurators, Lucy Raven and Rebecca Gates. Lucy and Rebecca had worked together. They had an audio zine at one point called *The Relay Project*. Lucy, being a media artist, works mostly in film and film installation, but early on, she was really into sound. Rebecca is more of a musician: an experimental musician, indie singer, and songwriter.

We set up a listening room. We wanted people to congregate there, and then it was a place where you could understand who the artists were. You could listen to some of the other works that they had composed, if they were composers as well. You could also just learn about the area, the land, and the fauna and flora. It was all part of the experience of the sonic portrait of Marfa, just listening to it, orienting yourself through listening. Kaffe Matthews built a sonic bed for Ballroom Marfa. That was a great, tactile, palpable piece to engage with on-site.

[*The Marfa Sessions* project] was one of my favorite projects ever, in part because you got really close to your collaborators, your cocurators, and the artists—the way everything unfolded, the way that everybody in the town got really into it, and became part of it as well. . . . That's why it was one of my favorite projects: because everybody rose to the occasion to do something that stretched them, but not in a highly pressured way.

It was really scrappy, the way it had to be put together. We didn't have a huge budget, so we had to be very inventive. I think the artists involved also just appreciated that their work was going to have a new life or be featured in public space where they might not have had that chance before. Everyone just got to rise to a new level because of it. I think the same goes for the town itself, the audience, because that was the first time there was a show that was [staged] throughout the whole town, in every little corner. You could go walk into the library, there was a piece there. Walk into the Rotary Club. That was cool; people remember that. Sound is a material, as memory material too. It just stays with you. □

Interview, Regine Basha and Daisy Nam, December 19, 2022.

Clockwise from top left: Steve Roden and Stephen Vitiello, . . . *from perfect cubes to broken trains*, 2008; Iñigo Manglano-Ovalle, *Sonambulo (Marfa)*, 1999; Steven Badgett and Deborah Stratman, *Caballos de Vigilancia*, 2008; Kaffe Matthews, *Sonic Bed, Marfa*, 2008; Steve Rowell & SIMPARCH, *TX AUX IN*, 2008; Dario Robleto, *Be Mad, Be Rash, Smoke and Explode, Resist or Move On*, 1997.

TWO FACE

AARON CURRY AND THOMAS HOUSEAGO

In 2009, Ballroom Marfa presented *Two Face*, an exhibition by artists Aaron Curry and Thomas Houseago. The culmination of a monthlong joint residency, the show supported the intense and generative dialogue the artists had established over the years. *Two Face*, which included new and recent sculptures by Curry and Houseago, invoked a Janus-faced approach to form and process, simultaneously looking to the past and the future.

ALL HAIL JANUS!
AARON CURRY AND THOMAS HOUSEAGO
MICHAEL DARLING

It's fitting that Aaron Curry and Thomas Houseago titled their show at Ballroom Marfa *Two Face*. As defined in common parlance, to be two-faced is to present a friendly, caring bearing toward a fellow human being when in their presence, but to harbor and even share malicious misgivings about them when apart. Such tension exists throughout the exhibition, where works by the artists respond to each other with shared formal bon mots, often followed by aggressive jabs of one-upmanship. This goading, teasing process is underwritten by a deep mutual respect and shared set of artistic ideals and heroes, fostered by a near-constant proximity and availability to one another in a shared studio complex east of Los Angeles. The results have been unusually beneficial to both artists (as well as to followers of their work), pushing their practices to a dazzling level of complexity and criticality.

Complexity and criticality are essential qualities to possess while navigating the shark-infested waters of the contemporary art world. In this roiling sea, not only do the beady eyes of art history stare down every mark or cut, but an ever-jaded and impatient public can consume and dispel new offerings ruthlessly. Both Houseago and Curry have engineered into their work a jittery nervous system that doesn't allow it to sit still for long. It ricochets from one visual source or reference to the next, picking up intellectual momentum with each move. These references can be ancient or modern, high or low, insider-y or plain as day. The artists are ardent students of history as well as the current scene, tracking their own moves against this complicated matrix so as to stay one step ahead of the competition and mark a territory that they can call their own. Their productivity and zeal have ensured that those territories remain exciting places to visit, some of the most reliable hunting grounds around.

Their Ballroom Marfa show is no exception. Packed to the gills with the results of a multiweek residency in Marfa, it featured more than thirty new sculptures, plus a series of linoleum prints. I have never experienced an exhibition this crammed but that still offered so much mental room to maneuver. There was an obvious and persistent dialogue between the cannily sited pieces, and yet if one wanted to zero in on a single work, or several works by just one of the artists, it was surprisingly possible. The north gallery is one such space, where Curry's *I Am Animal* (all works 2009) stood sentinel at the doorway. Perhaps taking a cue from Houseago's confrontational deployment of figures in his exhibitions (one such bully, *Giant (fallen)*, is actually the first thing one sees upon entering Ballroom), *I Am Animal* stares at the visitor through a silk-screened eye on cardboard, daring you to come into the testosterone-perfumed space. This eye is one of many disembodied parts that slot together like a three-dimensional puzzle, recalling a Noguchi sculpture in arrangement, but borrowing from Miró, Giacometti, Picasso, and even Rauschenberg in its multivalent forms. Rauschenberg is not an artist I have associated with Curry in the past, which is pure oversight, because the younger Texan has relied on the aesthetic of the *combine* when pairing gaudy advertisements with bold abstract gestures and delicately rendered passages. Here, Rauschenberg provides an even more important precedent as Curry's sculpture borrows a goatlike form with a sagging back that is straight out of *Monogram* (1955–59), the elder longhorn's consummate synthesis of painting and sculpture. ▷

Installation view, *Two Face*, 2009.

100

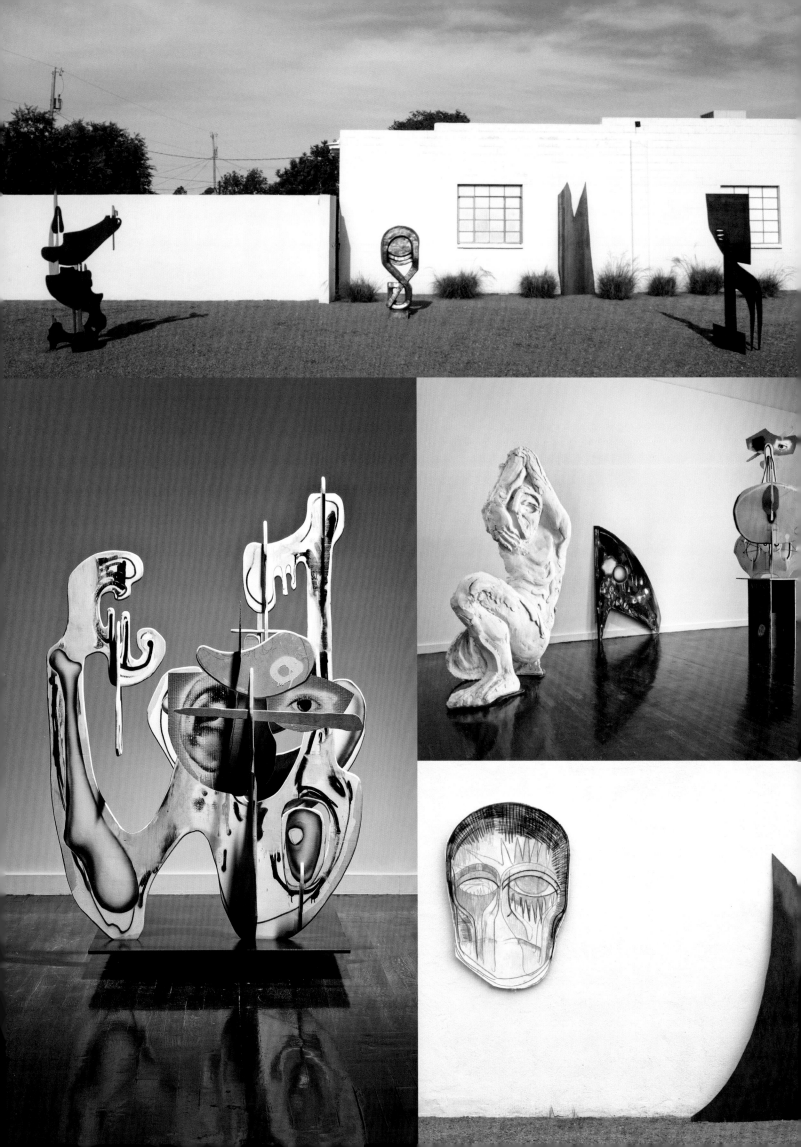

In this exhibition, Curry more confidently activates painterly concerns within a three-dimensional framework than ever before, showing a true (and rare) gift for both genres. Plywood cutouts are both mnemonic stand-ins for limbs, bone structure, and facial forms, and grounds for airbrushed or spray-painted images of those same subjects, offering a new twist on the age-old sculptural problem of inside and outside. Pentimenti, as well as sanded erasure, reveal an active process of addition and subtraction that link up with recent painterly approaches of Albert Oehlen or Christopher Wool, lending the work a sense of commitment and struggle that is lacking in the slick output of some of Curry's ascendant peers.

Nearby, *Pink No (Crouching Figure)*, extends the livestock references in another direction. An elongated skull-like shape in pink-sprayed aluminum at the base recalls Picasso's loaded use of the form, but as we are in the Wild West, it also calls to mind cowboys and Georgia O'Keeffe. We are not allowed to dwell in the past or in a romantic reverie for long, however, as the figure in this work also seems to snub us by thrusting a long, pointed nose between two upright fingers, a sexualized gesture smacking of disrespect. The grinding abrasion that Curry uses to remove paint from this aluminum sculpture, here and elsewhere, reveals an honest and meaningful effort to balance his compositions visually, yet is also a canny wink at a similar effect in David Smith's work, which has become a bastardized, cheap trick in public sculpture. Curry knowingly plays this for kitsch and homage, a tightrope he has become increasingly good at walking.

One also senses a particular site-specificity about Curry's work in this exhibition. In the land of Judd and Chamberlain [whose work the Chinati Foundation has installed in its own building at the center of Marfa], his use of anodized aluminum, plywood, automotive paint, and graffiti, previously seen by me (and others) as a symbol of Los Angeles car culture and skateboard/street aesthetics, now reads as time-honored tradition. Likewise, he flaunts his sculptural bona fides by strategically placing slabs of flat, shaped metal against the wall throughout the show, titling all of these works *Bad Dimension* as if only something in the round is worthy of serious consideration.

The artist has used this device before, and it is a successful way to activate the wall plane in a show comprising freestanding works, but never before have these "leaners" been so resolved and deserving of a second look as they are here. One three-part variant features a bright royal blue shoot in the middle, flanked by a darker indigo "leaf" at the bottom right and a yellow fake-metal-painted wedge on the other side. The yellow element features the raw, violent abrasions of Mr. Smith, made all the more potent because of the luscious, expensive surface they disrupt.

One of Curry's signature silkscreens of an image of a star pattern in rope—reminiscent of something one would find in a Picasso guitar construction or on the jacket of a Satanic death-metal follower—also jostles this panel, joined by crude black spray paint and hints of fluorescent yellow and pink. Curry is clearly at home in Marfa, where his work offers a smart, punk-inflected repartee to the rarefied discourse that has made this town a mecca for cerebral art.

If Judd and Chamberlain were never obvious interlocutors in Curry's sculptural get-togethers until Marfa brought them into the discussion, they certainly didn't occur to me when thinking about Thomas Houseago's place in the lineage of three-dimensional form-giving. Yet like those 1960s-era pioneers, Houseago has classical sculptural concerns guiding his work, such as a necessity for circumambulation, an accounting for inside and outside, and a desire to make the tectonics of building tantamount to understanding the object.

In fact, Houseago has found a process that allows him to reveal more of the steps that go into the final form than any other sculptor I can think of, past or present, giving viewers a sense of being right there throughout the whole creation of a work. This is particularly true of his plaster pieces, which start flat on the ground with fast, expedient drawings on huge sheets of slippery Formica. The artist follows these sketches by smearing wet plaster on top of the drawing, using the outlines as templates for the desired shape, and then adding heaped handfuls of plaster-soaked hemp to give rigidity and body. Industrial rebar of the type used to reinforce concrete walls is added to these viscous lumps of spaghettilike wet hemp, with more of the fibrous mix layered on to bond it to the plaster. The rebar is shaped for later use as handles or hinges that can be attached to other similarly constructed elements. When the plaster dries, these large planar forms simply slide off the Formica, bringing with them all of the evidence of their slapdash methodology from start to finish.

In such works, Houseago relies on the contrast between the smooth, flat surface on one side and the often quite dimensional bulk opposite it to make bodies that are simultaneously 2D drawings and fully 3D homunculi. The aforementioned *Giant (fallen)*, for instance, is a matrix of sketchy, delineated limbs on the exterior that come together on the interior in a knot of plaster lumps and interlocked rebar. Like a modern-day Michelangelo, the artist favors potential-laden stances such as a crouch that swells the muscles and suggests movement, something on the cusp of being unleashed. *Giant's* face co-opts science fiction and African sculpture in one fell swoop, an idea that is only at odds with the classicized white figure on which it sits, as if one has never heard of Picasso. ▷

"Not only do the beady eyes of art history stare down every mark or cut, but an ever-jaded and impatient public can consume and dispel new offerings ruthlessly. Both Houseago and Curry have engineered into their work a jittery nervous system that doesn't allow it to sit still for long."

One of Houseago's other potent processes is muscular wood carving, through which, again, he can conjure a whole textbook full of art historical references with a few swipes of a chisel and yet still remain resolutely in the here and now. One piece in this medium is *Sketch for 3 Heads/Carving/Column*, a raw totem with almond eyes straight out of *Les Demoiselles d'Avignon* but that in each stage along its length equally evokes masks, skulls, and ghosts, and artists from Baselitz to Brâncuşi, Kirchner to Modigliani, Easter Island to Inuit. *Coin-head* shows further multilingual prowess, starting with a blackened bronze helmet shape that contemporary viewers will recognize as Darth Vader–derived from the side, but the stealthy commander of the Death Star assumes a more vulnerable mien from the front: that of a hollowed-out death mask with one eye already gone and staggered, overlapping coin shapes for the other, as if depicting decay in stop motion.

This stuttering motif activates another nearby work, *Machine I*, a seemingly all-frontal stela made up of limb-like contours that repeat until they conjure a bent-over bather or a nude about to descend a staircase. A triangular elision midway down disrupts the smooth planarity like a Fontana cut, exposing the crude, plaster-splattered bracing behind, and once again proving that no viewpoint, material, or element is taken for granted or is unaccounted for in a Houseago creation. The tension between front and back could inspire a Freudian dissertation, and neither side would be half as interesting without the other.

Thus the *Two Face* theme again, wherein in each work, each artist, and the duality of the organization of the exhibition itself, we find psychological and material conflict that lends the entire affair a weighty, fateful seriousness. Here are two artists who are pulling both content and form from deep resources that are well-stocked and flowing freely, merging them in extremely complex and exciting ways that bespeak confidence and camaraderie. It would be hard to imagine any artists keeping up this frenetic pace and almost giddy belief in their creative powers for a truly extended period of time, but as long as Curry and Houseago have each other to help maintain an environment of critical self-regard, remaining two-faced as a creative strategy, it could be a long and productive partnership. □

Excerpt, exhibition catalog. Darling is the James W. Alsdorf Chief Curator of the Museum of Contemporary Art Chicago.

Installation view with, from left, Thomas Houseago, *Sketch for 3 heads/carving/column*, 2009; Aaron Curry, *Bad Dimension*, 2009.

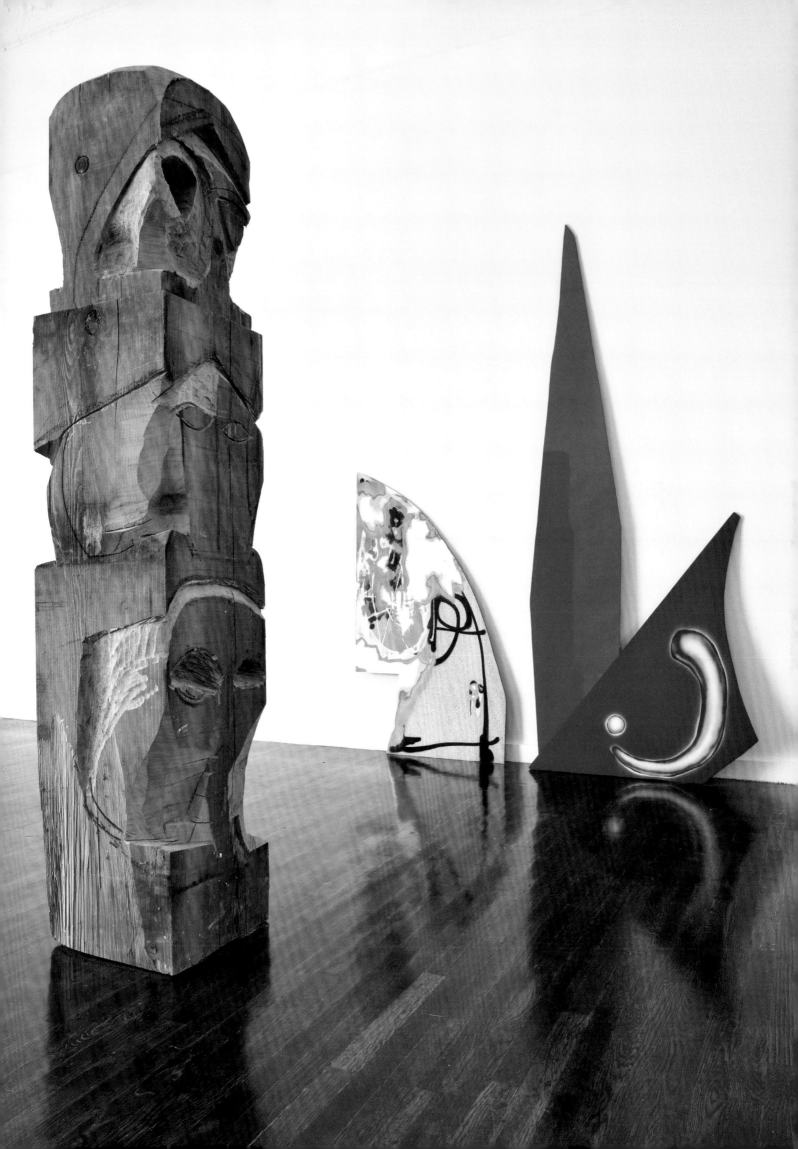

DJ CAMP

In 2010 Ballroom Marfa inaugurated DJ Camp, spearheaded by JD DiFabbio. An ongoing education program open to students in fifth through eighth grades, the camp is an opportunity for young people in and around Marfa to acquire lifelong party-rocking skills on the ones and twos, as well as lessons on the dance floor, in music history, in mixing and scratching, in flyer design, and the ever-expansive definition of a DJ. The summer camp is free, with breakfast and lunch provided to the kids.

A REFLECTION BY JD DIFABBIO

We were ready at Ballroom Marfa to explore the idea of having a summer camp. [DJ Camp] was very much born out of the desire to reflect the spirit of Ballroom, out of the desire to create a music program that would reflect what was really setting us apart from the other organizations. Also, a desire to have something that was cool, and have something that would truly be a hands-on experience, since we weren't going to be engaging the kids in art-making. We wanted it to be something that was still tactile. [At camp, the kids] create new sounds, they create new songs, they're singing, they're taking existing sonic elements and making them into something more. I was excited for music to have that painterly aspect, for people to think about [making] music in the same way that they would think about creating a work of art.

I think music is one of the first things you connect to as a kid, and how you dress yourself is one of the foundational elements of starting to assemble your identity. It was very important to us not only to give kids this hands-on experience but also to imbue the camp with the idea of the DJ persona. We introduced the idea that you get to pick [your DJ] name, because it is a magical thing. [While] you're growing up, you're given your name; the aesthetic that you live within is your caregivers' aesthetic. Maybe in your bedroom you can start to carve out your identity. But, when the kids can pick their names on day one, we see something happen. . . . That sense of autonomy that the kids get is unlike anything that they've ever experienced. DJ Camp's origin [is in] community spirit, and the idea that it could be passed on. It's about being allowed to have your voice. It's stayed within this spirit, truly, of encouraging autonomy within a network where everyone else is finding their autonomy, somehow lifting everyone up instead of it feeling competitive.

The kids first got the opportunity to select music that they felt represented them. And then the kids were given permission to control that music. Did they want to put sound effects on it? Did they want to scratch it? Did they want to play it soft? Did they want to play it loud? Did they want to put that weird echo [over it]? That's another layer, because you're not just picking the music, you're controlling it. You could see the kids' imagination and the way that they were thinking about music change, and the way that they listened to music change. Most of the time you're a passive listener: however the musicians have created that song, I'm engaging with it as it was created. The kids were able to take a leap and become active listeners, because then they're listening to this thing that they like, and thinking, "How can I change it and make it mine?" And that is what makes DJ Camp so beautiful. ☐

Interview, JD DiFabbio and Daisy Nam, December 21, 2022

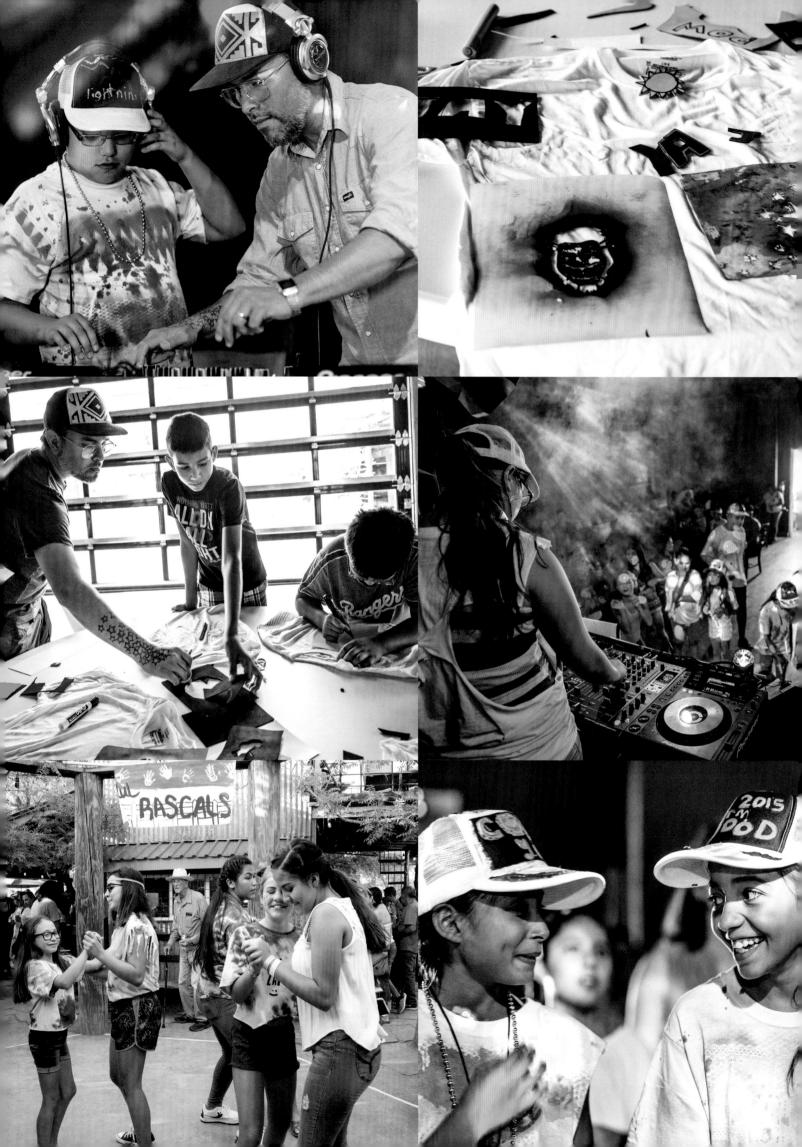

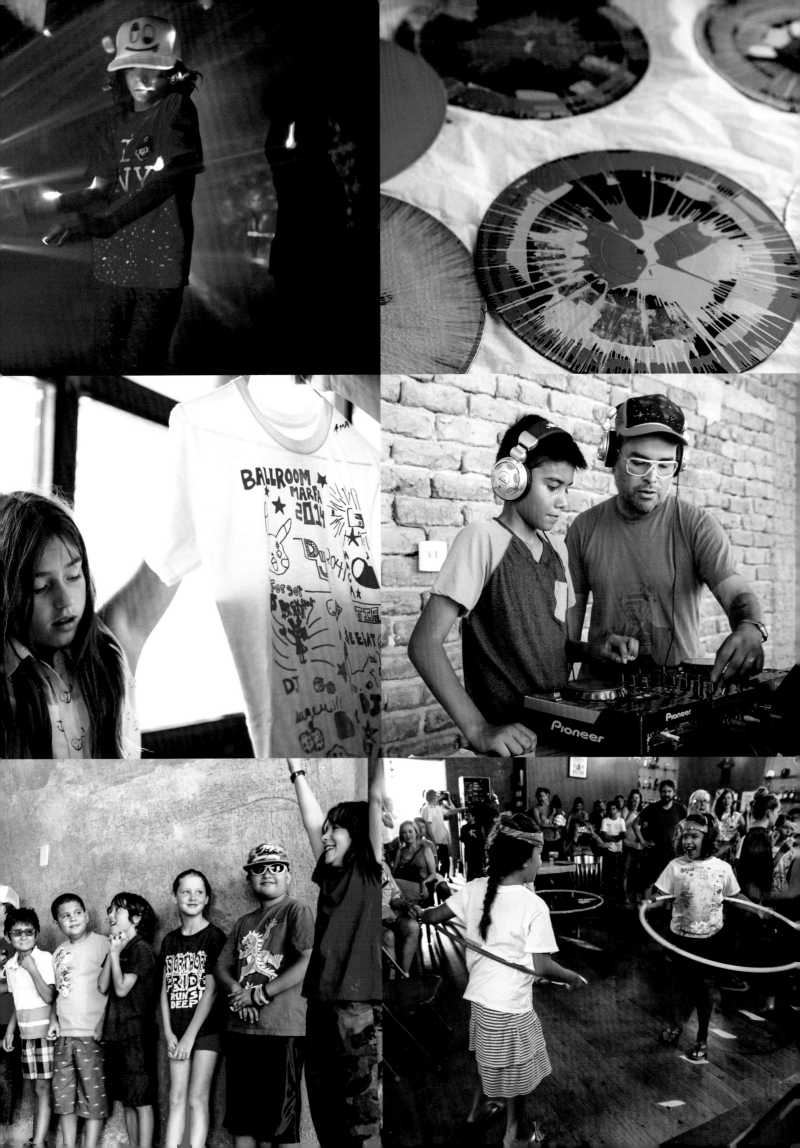

IMMATERIAL

BARBARA KASTEN, ROSY KEYSER, RACHEL KHEDOORI,
LALEH KHORRAMIAN, ESTHER KLÄS, LIZ LARNER,
ERLEA MANEROS ZABALA, LINDA MATALON,
JULIE MEHRETU, HEATHER ROWE, ERIN SHIRREFF,
CHARLINE VON HEYL

In October 2010, Ballroom Marfa presented *Immaterial*. Curated by
Fairfax Dorn, the exhibition examined the metaphysical aspects of artistic
production through artworks that investigate how an artist's choice of
material, palette, and form can create different physical and psychological
spaces. It considered art's potential to transcend conscious states through
visual languages and interrogated the complex relationships between color
and form; the artist's confrontation of the medium and its materiality; the
artist's interpretation of time, space, and perception; the intuitive process;
and the act of making material immaterial. ▷

Installation view, *Immaterial*, 2010.

110

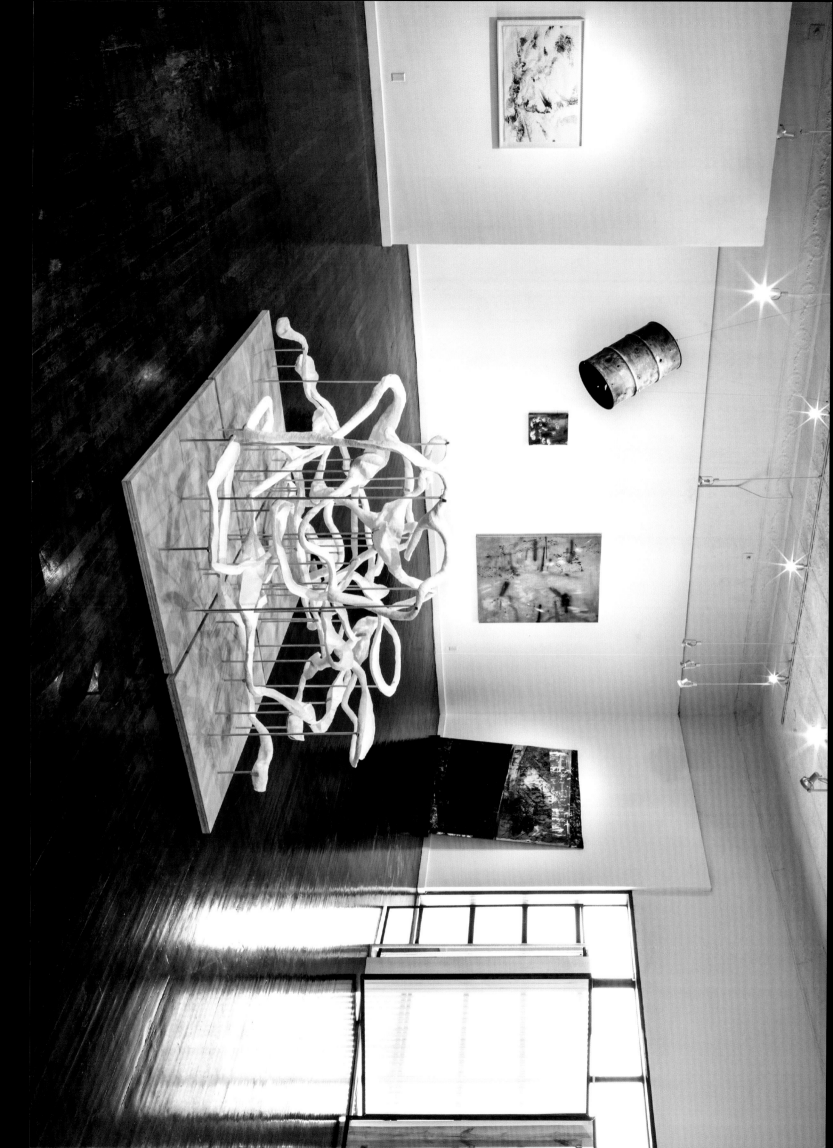

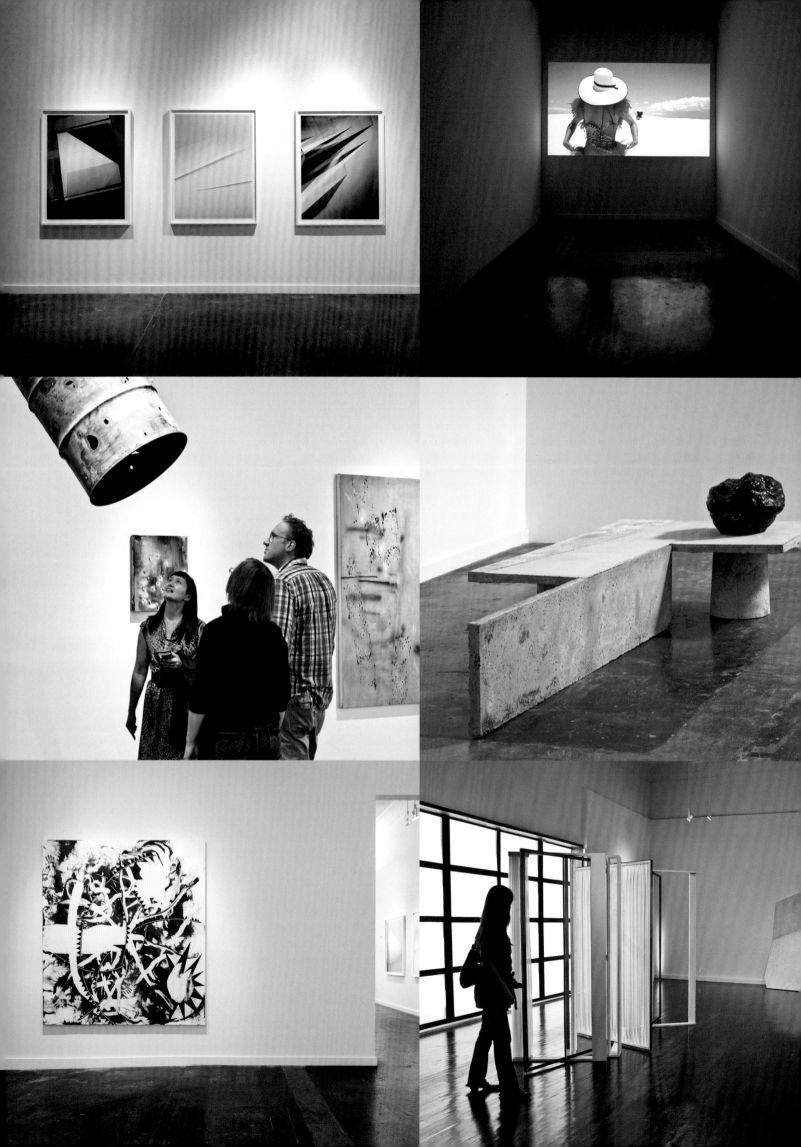

"The whole project was a real bonding experience. I think for a lot of us that bond lasted, that's what was so unique about it. It wasn't just six artists in Marfa together. It became 'These are really important relationships in my life.'"

Installation views with, clockwise from top left: Barbara Kasten, *Studio Construct 8*, 2007; *Studio Construct 17*, 2007; *Studio Construct 106*, 2010; Laleh Khorramian, *Liuto Golfo*, 2010; Esther Kläs, *Llena*, 2010; Heather Rowe, *All Day Light*, 2010, and Erin Shirreff, *Untitled (Shadow)*, 2010; Charline von Heyl, *Alastor*, 2008; Rosy Keyser, *Interior of Planetarium for the Absentminded*, 2010.

A CONVERSATION WITH ROSY KEYSER, LALEH KHORRAMIAN, LINDA MATALON, HEATHER ROWE, AND ERIN SHIRREFF

Erin Shirreff: I remember I met Fairfax through a gallerist who introduced her to my work. And then she came to the studio and we had a lovely afternoon. Later, it was exciting for me to meet everyone involved in the show in Marfa. After the exhibition, a lot of us stayed connected. I mean we all, Rosy and Heather and I, would visit each other's studios, and we stayed connected, and with Barbara [Kasten] also.

Heather Rowe: I got to also go to Marfa for about four weeks in the summer before making the piece. I stayed with Fairfax, and that was amazing. I was doing a residency there in the Masonic Lodge and it was very quiet, you know, like it was just me and it was just the street. It was really amazing to be there. In New York you can go get any material you want. So it was interesting to be thinking about materials and thinking about them in relation to where you work. I met Linda [Matalon] at the airport for the opening and we bonded immediately over our hatred of airplanes and flying.

Shirreff: Esther [Kläs] and I, after that, bonded over [being] the two artists that weren't on the residency. We just sort of came in cold and everyone else had been there for a while and hung out. They were all bonded with each other and Esther and I were like, "Who are you?" I think Barbara came late, probably just for the opening. I thought Barbara was awesome.

Linda Matalon: What was so amazing is that the show really spanned generations. For me, it was exciting to meet an older artist. I'm in my sixties now. And Barbara's in her eighties. I hadn't ever been close with an artist [from] an older generation and that was really inspiring for me. And we really kept up a friendship because that was super-important to me. That's one of the other kinds of nice things that's happened; a lot of us have kept supporting each other, like showing up at different locations for exhibitions. It's so rare where you're in a group show [that] all the artists can come in and you meet them—and it's like that [here]. It was rare, and everything kind of catalyzed for us.

Laleh Khorramian: We had some time together; it wasn't just one or two nights. I remember laughing a lot with Linda—like *a lot* a lot. For me it was a beautiful moment of freedom. The whole project was a real bonding experience. I think for a lot of us that bond lasted, that's what was so unique about it. It wasn't just six artists in Marfa together. It became "These are really important relationships in my life." We've all been in shows together since then. You wouldn't normally think to put us together in this way, but there is a kind of common spirit that Fairfax must have seen. That experience—not just the curatorial experience of that exhibition, but beyond—has had a lasting, profound effect on the individuals involved.

Shirreff: It's so hard to put into words, the kind of emotional connection for me that has happened with these women. I want to know what's going on with their work and their lives. It's not just a singular thing, it's "How do we help each other?" I've been in exhibitions because Rosy [Keyser] has suggested me to the gallery or the curator. I think we've all supported each other in ways that are . . . probably a bit unique, I think, for the experience of artists. We all want to see each other succeed, whatever we're doing. . . . I think we all want the other person to be the best that they can be, and how can we support that? It just brings so much joy. ▷

"I really do think about that night sky and the camaraderie and the fun and seriousness in equal measure. We each were super-serious in our practice. And there was space for us to also just be free and loving and kind with each other, and helpful. And that energy lasted—it's lasted for ten years."

Khorramian: I think a lot of the women have come to my clothing store. I started making clothing back in 2013, for about four years. That's all I did. And then I went back to making art. I still make clothing—more as costume stuff in the work, like part of exhibitions—but I don't really produce the way I [once] did. I wanted to say something about what Linda was just saying. I can't help thinking that the desert itself had an effect on that chemistry, because there's just something so pure about that territory. When you look out on a horizon, you somehow see a lot more sky—so that in itself just has such a power. If you put that combination—the cocktail of people that we were in such a setting, the time and place itself, and that land and that sky, and the light and the desert and everything, the high altitude and all that it is, and the sparseness—I think that also has an aspect to why art can be nurtured in that space.

Shirreff: It was in the late '90s when I first came to Marfa, and of course it was all about the Judd Foundation, and Ballroom is the first of now many arts institutions that started going in their own direction from that legacy. There was just general support that you felt within Marfa; there was a lot of goodwill toward artists. And I think what the others are saying—they were right about the desert, and my memory of it is the sky. The night sky was mind-expanding, mind-blowing for me. I still think about that night sky, and it still affects my work. It also was the incredible generosity of Fairfax and Virginia. I mean, their generosity was just so open and kind, and that was a really new experience for me in the art world. I really do think about that night sky and the camaraderie and the fun—the fun and seriousness in equal measure. We each were super-serious in our practice. And there was space for us

to also just be free and loving and kind with each other, and helpful. And that energy lasted—it's lasted for ten years.

Matalon: There is something about the space, the expansiveness of the space and being in that [space]. Just the sensations of being there in Marfa. Everyone was having such a good time. It was charged. It's from that presence of the space, it bonded all of us together. □

Interview, Rosy Keyser, Laleh Khorramian, Linda Matalon, Heather Rowe, Erin Shirreff, and Daisy Nam and Alexann Susholtz, September 1, 2022.

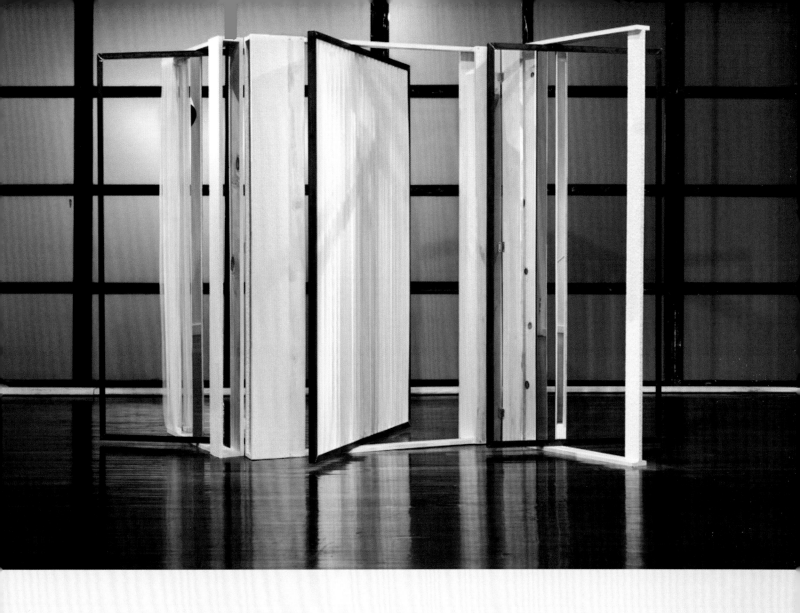

ART IN THE AUDITORIUM/ ARTISTS' FILM INTERNATIONAL

Kelly Nipper, *Weather Center*, 2009, video stills.

Art in the Auditorium is a collaborative film and video series that was established by the Whitechapel Gallery in 2008. The series brought together several partners, beginning with nine organizations around the globe. Later renamed Artists' Film International (AFI), the program has since expanded to include twenty-one partner organizations. Each venue that participates in AFI selects an exciting recent work of film, video, or animation from an artist living and working in their country or region. Each of the selections is shared with the network, and the program is adapted and distributed to the partner venues and screened over the course of the calendar year. Ballroom Marfa was the first North American representative, and for its inaugural contribution, Ballroom associate curator Alicia Ritson selected works by Ryan Trecartin. In Trecartin's videos, characters dress up, play up, and pose for the camera. Their relationships and attitudes are deeply affected by a hyperawareness of media; the slew of pop culture references and artistic forms that Trecartin's characters reference reflect his own post-media generation.

For its second installment, in 2010, Ballroom presented two films by Aïda Ruilova, *Two-Timers* (2008) and *Meet the Eye* (2009), and for its third, in 2011, Kelly Nipper's film *Weather Center* (2009). Partner organizations over the series included Bag Factory, Johannesburg; Cultural Centre of Belgrade, Belgrade; Bonniers Konsthall, Stockholm; Center for Contemporary Arts Afghanistan, Kabul; Cinémathèque de Tanger, Tangier; Contemporary Art Centre, Vilnius; Crawford Art Gallery, Cork; Fundación PROA, Buenos Aires; Galleria d'Arte Moderna e Contemporanea di Bergamo, Bergamo; Hammer Museum, Los Angeles; Istanbul Modern, Istanbul; MMAG Foundation, Amman; Museum of Contemporary Art and Design, Manila; Museum of Modern Art, Warsaw; Neuer Berliner Kunstverein Video-Forum, Berlin; New Media Center, Haifa; Para Site, Hong Kong; Project 88, Mumbai; Sàn Art, Ho Chi Minh City; Tromsø Kunstforening, Tromsø; Whitechapel Gallery, London. □

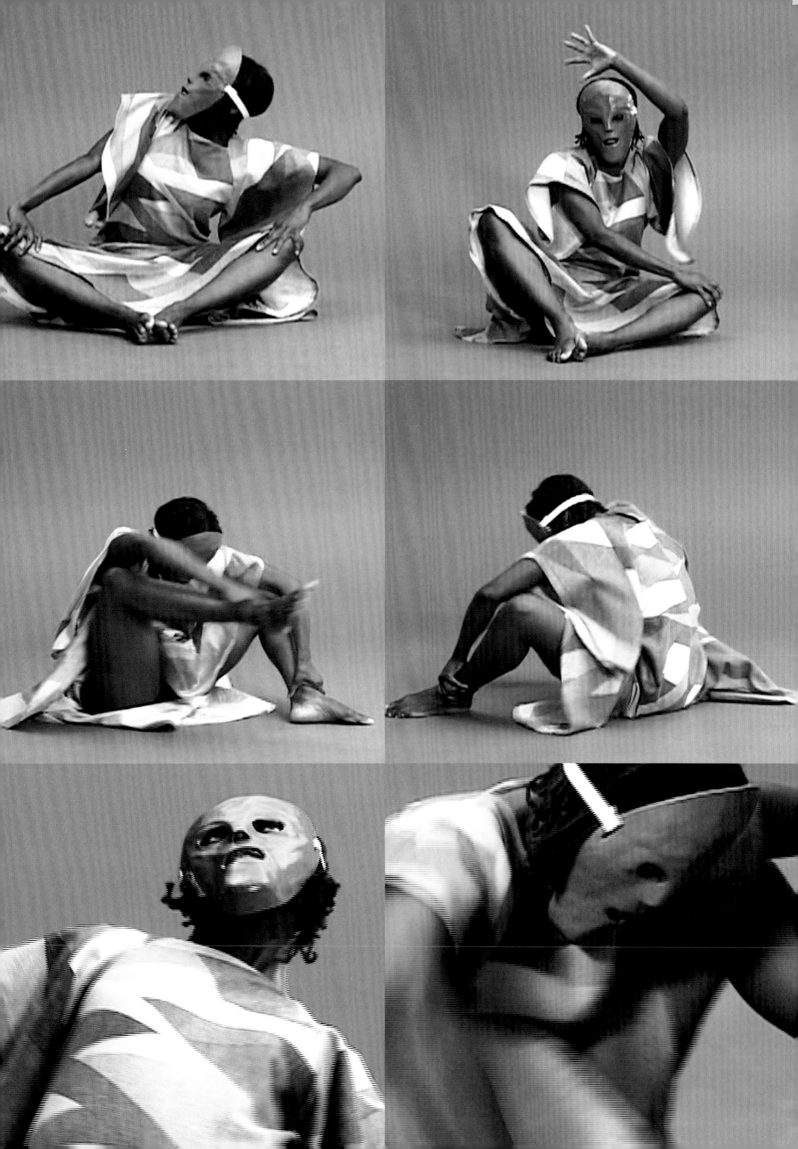

IN LIEU OF UNITY/EN LUGAR DE LA UNIDAD

EDUARDO ABAROA, MARGARITA CABRERA,
LIVIA CORONA BENJAMIN, MINERVA CUEVAS,
MARIO GARCÍA TORRES, MÁXIMO GONZÁLEZ,
PAULINA LASA, TERESA MARGOLLES,
PEDRO REYES, TERCERUNQUINTO

For the 2010 exhibition *In Lieu of Unity/En Lugar de la Unidad*, Ballroom Marfa associate curator Alicia Ritson brought together ten Mexican artists with socially engaged practices. The result was a collection of creative responses to social dynamics as they played out in specific locations in Mexico; within the context of Marfa, Texas; and throughout their shared geographic and conceptual borderlands. Through varied perspectives on what it means to be together, these artists relinquished utopian ideas of unity. Instead, they explored the underlying systems that influence everyday encounters, such as language, commerce, architecture, citizenship, and social mores.

With the aesthetic identity of Marfa so firmly rooted in the legacy of minimalism, *In Lieu of Unity/En Lugar de la Unidad* consciously shifted the focus toward another integral aspect of the town—its proximity to Mexico. Within this expanded framework, each artist's work exemplified a personal take on negotiating being together—encompassing relationships at all levels from the interpersonal to the international.

In Lieu of Unity/En Lugar de la Unidad included established and early-career artists working in video, sculpture, installation, performance/intervention, and photography. Of the ten participating artists, Eduardo Abaroa, Minerva Cuevas, Paulina Lasa, Teresa Margolles, and Tercerunquinto traveled to Marfa for research visits, to get a sense of the town's unique social context. Along with commissions by Margarita Cabrera and Pedro Reyes, and extant works by Mario García Torres, Máximo González, and Livia Corona Benjamin, projects by all of these artists collectively presented the means for thinking about communities outside idealistic notions of unified experience. ▷

Top: Installation view, *In Lieu of Unity/En Lugar de la Unidad*, 2010. Bottom: Tercerunquinto, *WHAT YOU SEE IS NOT WHAT IT IS*, 2010. Overleaf: Installation view, Minerva Cuevas, *Crossing of the Rio Bravo*, 2010.

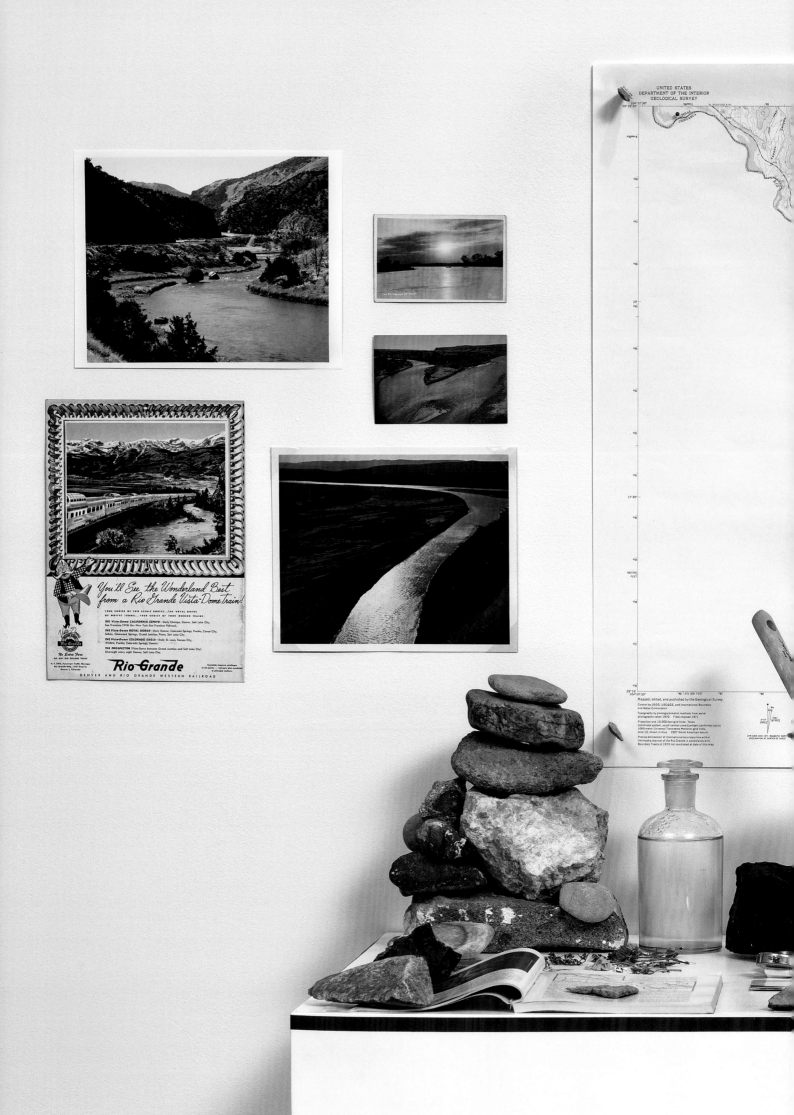

When curator Alicia Ritson first watched *Carta Abierta a Dr. Atl* (*An Open Letter to Dr. Atl*) at the 2007 Venice Biennale, she knew right away she wanted to show the video in Marfa. Now on display in the group exhibition *In Lieu of Unity*, Mario Garcia Torres' video layers six minutes of Super 8 footage of the Barranca de Oblatos canyon in Guadalajara, Mexico, with the text of his letter to Dr. Atl, a much admired Mexican artist renowned for capturing breathtaking vistas on canvas.

"You know, now more than ever, art is closely related to tourism," Torres writes in his letter.

Ritson curates exhibitions for Ballroom Marfa, a nonprofit space located in a small West Texas town that attracts 10,000 visitors a year to see large-scale installations by the canonical minimalist artist Donald Judd. For *In Lieu of Unity*, Ritson chose to move away from the minimalist aesthetic associated with Marfa and instead focus on the town's proximity to Mexico, about an hour's drive south. The exhibition features work by nine artists and one artist collective, all of whom are current or former residents of Mexico.

Despite the curator's conscious shift away from the look of minimalism, this exhibition clings tightly to other aspects of Judd's legacy. As illustrated by Torres's video of scenic canyon panoramas, many participating artists share Judd's attraction to landscape, a key factor in the artist's decision to establish a residence in Marfa in the 1970s. Teresa Margolles's video features views along the drive from Marfa to nearby Alpine, Minerva Cuevas's contribution includes large-scale photographs of the Rio Grande by Erika Blumenfeld and Margarita Cabrera creates her own landscape with sculptures designed to resemble desert plants.

With only two wall labels in the entire gallery space, *In Lieu of Unity* also holds the line on Judd's rejection of didacticism and interpretation. . . . Participating artists explore issues of identity in ways that call attention to our lack of common experience—a divide that, by design or not, is highlighted by the unavailability of wall text and background information on the work. The exhibition's title, inspired by the writings of French theorist Jean-Luc Nancy, means to affirm those differences and reject the utopian notions of unity typically associated with community.

Eduardo Abaroa's *Eighty Prepositions in English and their Spanish equivalents*, an installation in the Ballroom Marfa courtyard, focuses on language gaps. For this work, Abaroa attaches white plastic letters spelling prepositions in both English and Spanish—under/bajo, against/contra, for/por/para—to a chain-link fence. Inside the enclosure, Abaroa has placed junk store finds collected in Marfa and surrounding towns as well as Ojinaga and Juárez, Mexico. These items—old T-shirts and bras, paperback books, broken furniture, all left to deteriorate in the extreme West Texas sunlight and wind—serve as nonsensical illustrations of the words attached to the fence. By choosing prepositions, words that express relationships, and allowing his installation to decompose in the harsh climate, Abaroa sends a strong message about communication breakdowns and their effect on connections among people.

Minerva Cuevas also plays with language in her work. In *SU-US-US*, an action captured in a photograph by Erika Blumenfeld, Cuevas paints the letters *SU* in limestone on rocks lining the bank of the Rio Grande, the river forming the natural border between the United States and Mexico. Here, the *S* and *U* could stand for many different things: Estados Unidos Mexicanos, United States of America, su (which translates to "your" in English), or us. By writing two letters with such a mutable meaning on the border between the United States and Mexico, Cuevas calls attention to the fact that this boundary and the responsibilities for the complications surrounding it are shared by the residents and policymakers of both countries.

Although this exhibition opened before Arizona governor Jan Brewer signed SB 1070 into law, it's hard not to think of the controversial immigration ordinance when viewing Teresa Margolles's *Irrigación*. Projected on the gallery wall, Margolles's video shows footage of a truck driving Highway 90 through Marfa east toward Alpine, drenching the road with water. One of the two wall labels in the exhibition, a statement by the artist, provides background information in both Spanish and English on the act documented by the video. Margolles immersed dampened cloths that had been placed on sites of violent acts in Juárez into the 5,000 gallons of water filling the tank on the back of the truck. Margolles closes her explanation of the work with a straightforward and arresting fact: From January through March of 2010, more than 500 people were murdered in Juárez. This piece of information is underscored by a collection of Spanish-language newspapers displayed on a table underneath the artist's statement. Fluent reading knowledge of Spanish is not necessary to grasp the magnitude of the violent acts detailed in the newspapers—each cover features photos of uniformed members of law enforcement or bloody bodies.

Margolles's work has a sense of desperate futility: Why irrigate a surface where nothing can grow? ▷

Installation views with, clockwise from top left: Eduardo Abaroa, *Eighty Prepositions in English and their Spanish equivalents*, 2010; Teresa Margolles, *Irrigación*, 2010; Pedro Reyes, *Capula 18 (Dodecahedron)*, 2010; *Palas por pistolas*, 2008.

IN LIEU OF UNITY/EN LUGAR DE LA UNIDAD

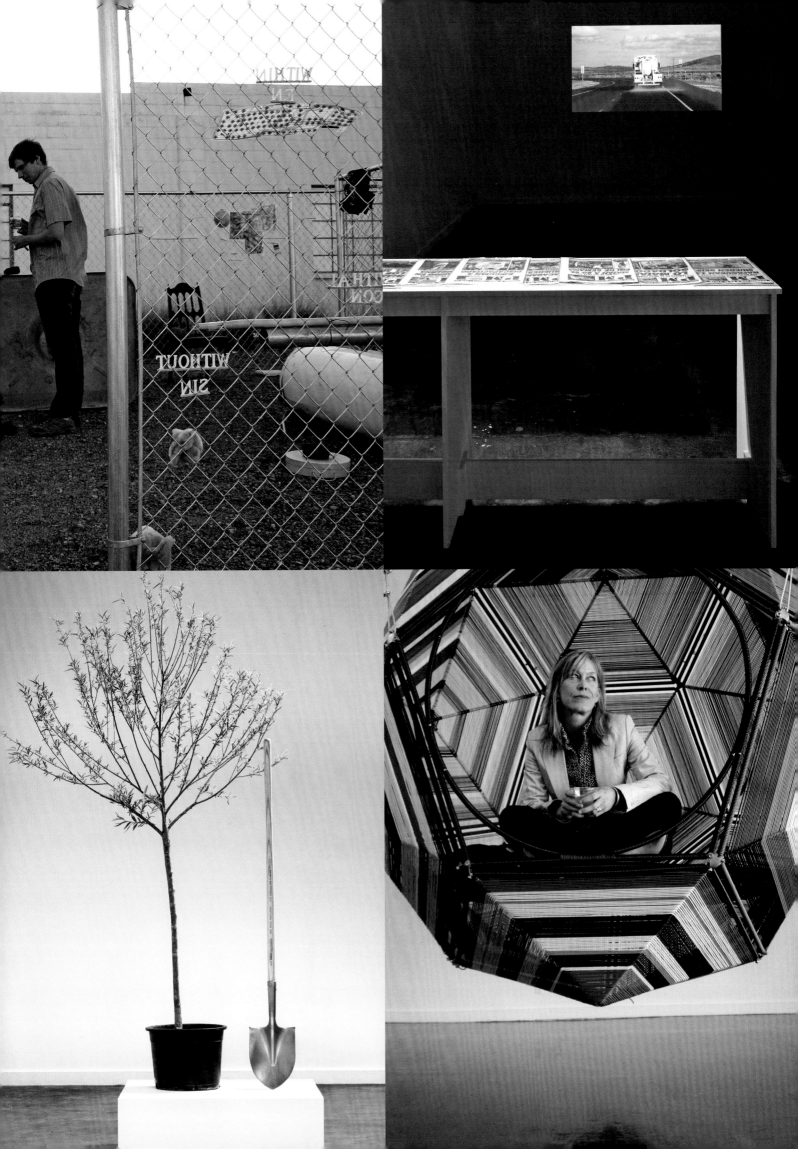

Yet at the same time, by depicting the remains of violent acts 250 miles away from where they took place, the work disseminates responsibility and awareness. What Margolles finally offers is a cleansing feeling—the sound of the rushing water fills the gallery as the truck moves along the highway.

Thanks in part to the brief artist statement (in addition to the graphic newspaper photographs), *Irrigación* is the most confrontational and hard-hitting work in the exhibition. Pedro Reyes's *Palas por pistolas*, which shares the south gallery with *Irrigación*, also consists of an action designed to increase awareness of violence, but without an explanation the work's effect isn't as strong. Reyes collected weapons by offering to trade for food stamps, then melted the weapons down to create shovels. Each of the 1,527 shovels will be used to plant a tree. On display in the gallery is a wilted, potted tree next to a shovel on a pedestal.

In Lieu of Unity's underlying theme of community is strengthened by the fact that, like *Palas por pistolas*, many works in the exhibition would not have been possible without the help of collaborators. In Paulina Lasa's untitled work, visitors wear rings collected in Marfa and neighboring Alpine and Fort Davis, attached to colorful strands of yarn tethered to the gallery wall. The yarn tangles and knots together as visitors move among one another. Máximo González's *Inflation* consists of 1,000 helium balloons featuring the design of 10 centavos coins. During the opening, balloons were distributed to gallery visitors; since then, the balloons have begun to deflate, reflecting the state of Mexican currency.

For Margarita Cabrera's *Space In Between*, a series of fiber sculptures resembling desert plants, Cabrera teamed up with nine recent immigrants from Central and South America working at Box 13 in Houston. The artist taught each woman a form of indigenous Mexican embroidery, which they used to illustrate their own immigration stories by stitching onto olive-green fabric once used for border patrol uniforms. Decorated with ominous imagery such as helicopters, tall fences and snakes, as well as happy scenes of smiling families rendered in thick stitches of brightly colored thread, the sculptures elicit both dread and contentment.

Cabrera's collaborators are listed by name in the exhibition checklist, but unfortunately Ballroom Marfa neglects to inform viewers that these women are telling their own immigration stories. Still, the lack of explanation allows *Space In Between* to subtly reinforce the point Ritson makes with *In Lieu of Unity*: community is not based purely on shared experience. □

Theresa Bembnister, "In Lieu of Unity at Ballroom Marfa," Glasstire, *June 5, 2010. Bembnister is a curator and art writer based in Cincinnati/Northern Kentucky.*

Máximo Gonzáles, *Inflation*, 2004/2010.

CHALK THE BLOCK: IRRIGACIÓN

TERESA MARGOLLES

Teresa Margolles, *Irrigación*, 2010.

In 2011, Ballroom Marfa collaborated with Chalk the Block, a downtown El Paso public arts festival, to install *Irrigación*, Ballroom's recently commissioned video work by Teresa Margolles. (*Irrigación* was first screened in Ballroom Marfa's south gallery during the 2010 exhibition *In Lieu of Unity/En Lugar de la Unidad*.) For the El Paso installation, Ballroom collaborated with Kate Bonansinga, the director of the Stanlee and Gerald Rubin Center for the Visual Arts at the University of Texas at El Paso (UTEP), and her students.

 Irrigación exposes the ongoing violence in Mexico, specifically along its northern border, through penetrating visual metaphor. *Irrigación* documented a water truck traveling along Highway 90 between Alpine and Marfa, Texas. Margolles filmed the truck from behind as it dispensed five thousand gallons of water mixed with blood, excrement, and other bodily matter that the artist had collected from multiple sites of violence in Ciudad Juárez. The truck's procession juxtaposed the waste of life with the waste of water in the desert. Installed adjacent to the video, the artist presented issues of Mexican periodicals that featured scenes of violence on their front pages, all of them published during the first quarter of 2010, when more than 500 people were murdered in Juárez. Each newspaper was preserved in a forensic bag, like those used to gather evidence at crime scenes. □

AUTOBODY

MEREDITH DANLUCK, LIZ COHEN, MATTHEW DAY JACKSON, AND JONATHAN SCHIPPER

In the fall of 2011, Ballroom Marfa presented *AutoBody*, curated by Neville Wakefield. *AutoBody* explored the mythology of the American automobile in industry and art.

Ballroom Marfa was at one time a body shop. Drawing on this history, *AutoBody* transformed the space into a car showroom—a place where fantasy, speculation, and promises of freedom, speed, and escape are embodied in objects of destruction and desire. Through the works of artists from Robert Frank to Richard Prince, the automobile has been a driving force of American concepts of independence—its mobility provided a promise of escape. However, as J.G. Ballard pronounced over forty years ago in *Drive* magazine, "The car as we know it is on the way out . . . for as a basically old-fashioned machine, it enshrines a basically old-fashioned idea: freedom." The American dream that the automobile once represented—and freedom, the idea it once enshrined— may, like the car itself, be becoming obsolete.

With a nod to those windshields that cinematized the landscape, *AutoBody* featured a commissioned four-channel video work, *North of South, West of East*, by artist Meredith Danluck, produced by Matthew Shattuck. Shot in both Detroit, Michigan, and in Marfa, *North of South, West of East* used the car as an entry point and connective tissue between the loaded archetypes of the cowboy, the rebel, the immigrant, and the actress. Each of the four characters' retention of the past, attention to present actions, and anticipation of the future played out on separate screens, simultaneously manifesting both mobility and stasis—the chronic existential crisis that is central to the American identity.

Local Marfa punk band Solid Waste and New York–based musician John Fraser Carpenter were featured on the film's soundtrack. Alongside the video installation were works by Liz Cohen, Matthew Day Jackson, and Jonathan Schipper. Ranging from the slow-motion eroticism of collision to high-speed ethanol ambitions, masculine relics of bodies past to feminized hybrids of bikini-clad futures, *AutoBody* figured the car as an extension of the body, laying bare the contemporary relationship between sculpture and performance. □

Top: Liz Cohen, *Rio Grande Repair*, 2012. Bottom: Installation view, Matthew Day Jackson, *Heart of Prometheus*, 2009. Overleaf: Jonathan Schipper, *The Slow Inevitable Death of American Muscle*, 2008.

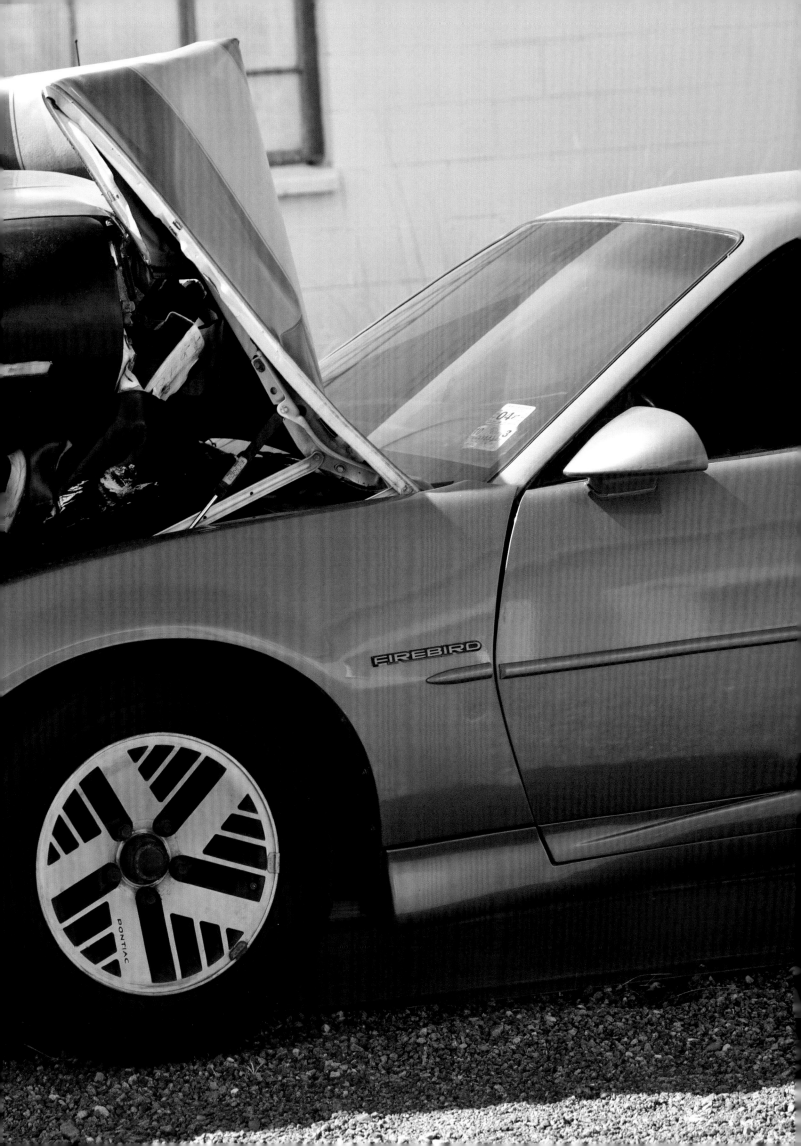

MARFA DIALOGUES

2010–2012

For Marfa Dialogues 2012, a nature walk on Mimms Ranch guided by Bonnie J. Warnock and Robert Potts.

The Marfa Dialogues program was launched in 2010 by Fairfax Dorn and Hamilton Fish of the Public Concern Foundation, a nonprofit advancing public education around social and political topics. The series connects writers, journalists, and artists with audiences to discuss art, politics, and culture in a public forum. Like everything in Marfa, the realization of the series was a group effort, with collaborators including the Marfa Book Company, the *Big Bend Sentinel*, Marfa Public Radio, the Dixon Water Foundation, the Crowley Theater, the Farm Stand Marfa, Cochineal, Maiya's, the Capri, Padre's, and Food Shark.

MARFA DIALOGUES 2010: POLITICS AND CULTURE OF THE BORDER

The inaugural Marfa Dialogues addressed some of the pressing and complex issues that confront all who live in the border region that joins and divides the United States and Mexico. Titled *Politics and Culture of the Border*, Ballroom Marfa and the *Washington Spectator*, in collaboration with the *Big Bend Sentinel*, Marfa Public Radio, and Marfa Book Company, presented three days of art, film, music, and literature that addressed the concerns and aesthetics of the border.

The weekend included a conversation between journalist, essayist, and author Charles Bowden and radio host Laura Flanders; a discussion including journalists Sandra Rodríguez Nieto, Robert Halpern, and Cecilia Ballí, and Kathleen Staudt, moderated by journalist Dahr Jamail; and a reading by poet Benjamin Alire Sáenz, introduced by Tim Johnson of Marfa Book Company. Woven throughout the weekend was visual art that captured the essence of the borderlands, including a screening of a documentary film about the Arizona-Mexico border, *389 Miles*, with the film's director-producer Luis Carlos Davis; a Ballroom Marfa exhibition, *In Lieu of Unity/En Lugar de la Unidad*, that brought together artists from Mexico; and, of course, a performance by the band La Santa Cecilia (named after the patron saint of musicians), which played a blend of cumbia, bossa nova, and bolero.

MARFA DIALOGUES 2012: POLITICS AND CULTURE OF CLIMATE AND SUSTAINABILITY

In 2012 Ballroom Marfa, the *Washington Spectator*, the *Big Bend Sentinel*, Marfa Public Radio, and Marfa Book Company, brought out the second biennial Marfa Dialogues, a three-day symposium with conversations around climate change and sustainability with artists, performers, writers, scientists, and entrepreneurs—among them Michael Pollan, author of *The Botany of Desire* and *The Omnivore's Dilemma*, and Rebecca Solnit, the distinguished critic and author of *A Field Guide to Getting Lost* and *A Paradise Built in Hell*.

Following the annual town-wide Marfa Lights Festival parade, Ballroom kick-started the symposium at the Crowley Theater with a thought-provoking conversation about art and activism with artists in its concurrent exhibition, *Carbon 13*, moderated by Rebecca Solnit. The next discussion examined the ecological challenges facing the Southwest with leading environmental expert Diana Liverman and Texas state climatologist John Nielsen-Gammon. On Sunday morning, guests were invited to engage with the West Texas landscape on a nature walk led by Bonnie J. Warnock, chair of the Department of Natural Resource Management at Sul Ross State University, and Robert Potts, president and CEO of Dixon Water Foundation. Sunday continued with two events at the Marfa Book Company—a reading by Rebecca Solnit and a presentation by Tom Rand, a Cleantech Group investor and expert on carbon mitigation. The weekend concluded with a performance by New York–based artist Cynthia Hopkins of *This Clement World*, a musical that sails through the burning ice and myths of the High Arctic. ☐

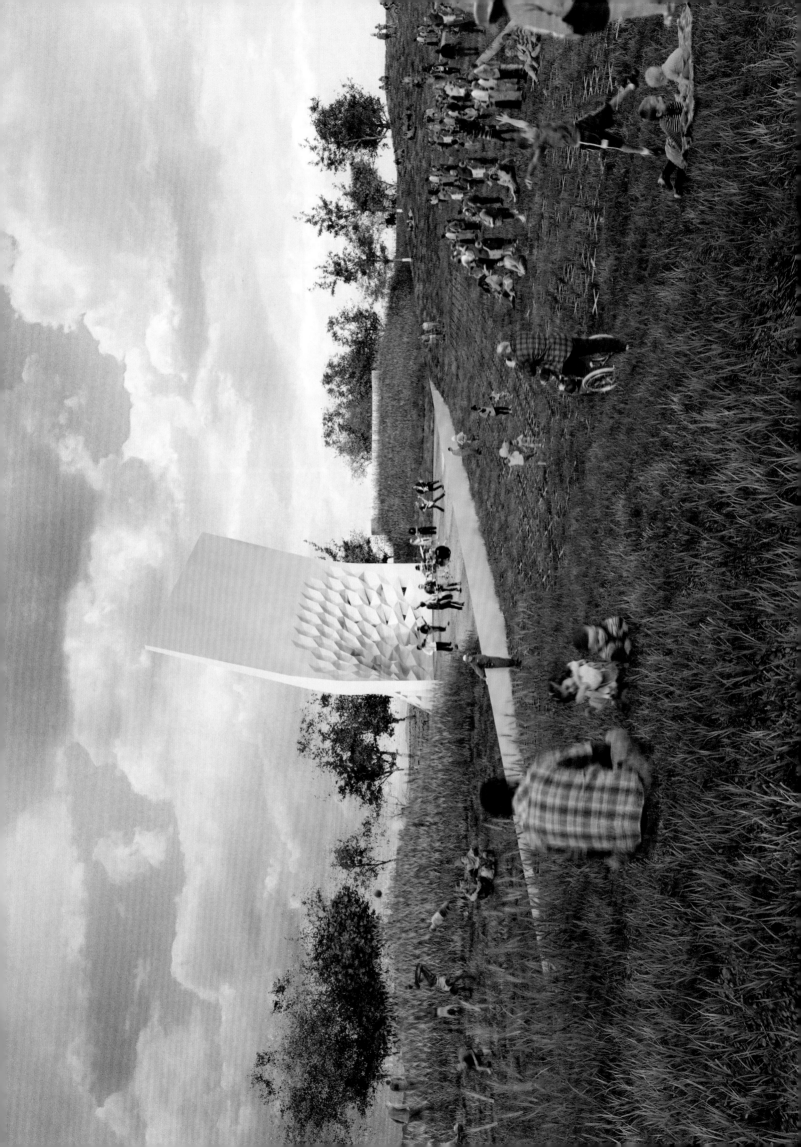

THE DRIVE-IN

Rendering of the Ballroom Marfa Drive-In by MOS Architects, 2012.

In 2006 Ballroom Marfa began developing an idea for a community space, the Drive-In, which would serve a range of purposes, from high school graduation ceremonies and community theater productions to Tejano concerts and, of course, film screenings. Plans also included the development of an eight-acre section of Vizcaino Park that was leased from Presidio County to Ballroom in 2012. After years of enthusiastic and imaginative collaboration between partners including the Presidio County commissioners and the architects at MOS, the project outgrew its original vision. As the tremendous scope of the Drive-In would have compromised the overall programming of Ballroom Marfa, the project was reluctantly terminated. ▷

"The project didn't happen—and that's okay....But I do still often pine for the designs that [the architects] came up with and think, 'God, it'd be so cool if we were able to build one of those.'"

A REFLECTION BY JOSH SIEGEL

I was driving across country with my then-girlfriend, now-wife, Meredith Martin, and we were passing through Marfa. A mutual friend, Katie Robbins, said, "Oh, you should call my sister Mary Robbins. She's involved with this amazing new space called Ballroom Marfa." This was about eighteen or nineteen years ago, so it was when it was still in its relative infancy. And so, we went through Marfa, and Fairfax was nice enough to host us at her house. . . .

We were hanging out with Fairfax and with Virginia and I said, "I've been on the road for two weeks. I'm desperate for a movie. Where can I see a movie around here?" And they said, "Well, the nearest place to see a movie is in Alpine, and that's about thirty-five minutes away." And I said, "Well, that's crazy. You should create a drive-in movie theater here." Because not only is the landscape incredibly beautiful, but it's also where they've made a lot of movies, from *Giant* to *There Will Be Blood* and *No Country for Old Men*. Six months later, they called me and said, "Let's do it. Let's create a drive-in." That's essentially how it all came to pass. . . . When they wanted to do this project, I had this feeling the two of them were nimble and adventuresome in experimenting.

At the time, celluloid film, 35-millimeter projectors were still an option. They wanted me to be involved in the programming of it and the conceiving of what it would be. We all agreed that the concept would be to have a stage with the screen so that you could have concerts at sunset as people were getting settled, but you could also essentially model it on MoMA programming, where I was and still am a curator. So you would have silent films with musical accompaniment, you'd commission amazing musicians to create scores. Ballroom had already worked with so many good musicians and it could

have been fun to have somebody like David Byrne or whoever do a score. And we could avail ourselves of the archives in MoMA, as well as film archives and studios and distributors around the world. The idea would be to show every kind of cinema. I was also intent on showing Spanish-language films because of the community in Marfa. I had a whole concept for all the kinds of films we could show. There was even a brochure they put together. I had two things I was really concerned about: making sure that it would feature films that would appeal and cater to the locals as much as it was to the people who fly into Marfa. And that it would be free—I thought it was important that it'd be free to the public. And there was no debate about this; everyone agreed. We also wanted it to not only be a drive-in, but also a place you could walk to. So it would be in the town, so that you could walk into the space, and there was an entire area allocated to people on blankets. The whole point was that it was meant to be a communal experience.

To make a long story short, we just couldn't figure out a way of making it happen. It was just very complicated and expensive. When we got the estimate on what it would cost, we thought at first that we would move in a different direction.

The project didn't happen—and that's okay. If you think about the number of architectural projects that never get realized, more often than not things don't happen when it comes to building structures and executing building projects. [The architects, Ole Scheeren and Michael Meredith,] went on to bigger things. I think the process was useful for them as architects and artists. But I do still often pine for the designs that they both came up with and think, "God, it'd be so cool if we were able to build one of those." □

Interview, Josh Siegel and Daisy Nam, July 29, 2022. Siegel is a film curator at the Museum of Modern Art, New York.

MARFA

MYTHS

2014-2019

MARFA MYTHS

Marfa Myths was an annual music festival and multidisciplinary cultural program founded in 2014 by Ballroom Marfa and Brooklyn-based music label Mexican Summer. During the first year of the festival, the five-band lineup played everything from ambient pop music to deeply lysergic folk and breezy shoegaze, all of it performed under the endless blue skies of the Trans-Pecos. As the festival grew over the following six years, Ballroom and Mexican Summer brought together a diverse collection of emerging and established artists and musicians to work creatively and collaboratively across music, film, and visual arts. The Marfa Myths Ballroom team was led by Nicki Ittner (2014–17) and Sarah Melendez (2016–19). □

A CONVERSATION WITH MUSIC CURATORS NICKI ITTNER & SARAH MELENDEZ

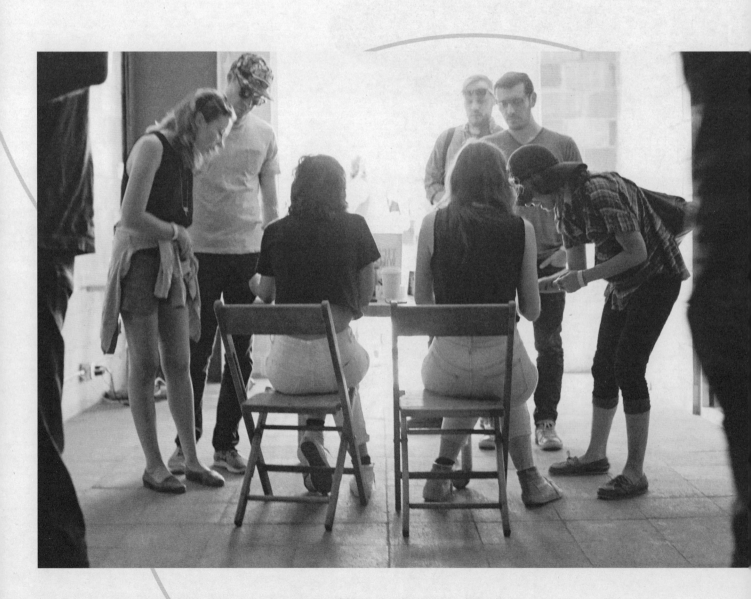

// Sarah Melendez and Nicki Ittner, Marfa Myths, 2017 // Photo by John Vogler //

Nicki Ittner: I was introduced to the NYC-based label Mexican Summer, and we decided to have five Mexican Summer bands come down and play in Marfa and it was totally insane. The whole event had this amazing spirit. But the weather was truly terrible. It had been beautiful the day before, and then the next day it was horribly cold. From that initial experience we fell in love with the idea of bringing together people and bands. It all felt interesting, in a different way. So that's how Marfa Myths started.

Sarah Melendez: I interviewed for my position at Ballroom right after the first Marfa Myths and worked on the second year of Marfa Myths. Because you were like, "We need help."

Ittner: Yeah, a lot of help! It grew so, so, so much in the second year. It went from zero to sixty, the second year. It had become so much bigger. It expanded so quickly, from five bands to a multiday, crazy insanity. There was a real feeling that first year that we wanted to expand and create something that we hadn't done before. No one was creating music like we were. It was such an incredible thing.

Melendez: What was really special, I think, about Ballroom and Marfa Myths was that it was inviting people and asking them to come, not just having them stop in Marfa on tour. Many of these bands were not super-popular. It's the kind of music that would make you think a little bit. I remember hearing from our audience members who would come to Myths, and they wouldn't know a lot of the lineup and then they'd leave with their new favorite bands — which was really cool. There was also the curation of the venues, just thinking about the music . . . and the best space for a listener to really hear it, you know? In the earlier years of the festival, they could be in really weird and awesome spaces. There's not as much noise and distraction [in Marfa]. I think there's a lot of space for things to really sink in.

Ittner: It was a unique experience of being in this remote place and going to see

music — it resonated with you. Especially if we were doing something at Chinati or Judd . . . and then you're deposited out into beautiful Marfa and you're wandering. I just think all those things combined to make it really memorable. That's also why residencies were important. Ballroom was the on the ground establishing relationships with these artists. And many returned the following years and stayed past the Marfa Myths to create new work. We just kept wanting to do interesting things and not necessarily repeat ourselves. So we had an artist residency and a musician residency. We were just wanting to see how we could grow it.

Melendez: The recording residencies were all at Marfa Recording Co., run by Gory Smelley. And those albums would come out on Mexican Summer's label, and they were always a collaboration between someone on their label and someone off their label. The first one was Dev Hynes and Connan Mockasin. And then the next one was Weyes Blood and Ariel Pink. We would have artist residencies also, and the work done there would become the zines and the identity for the festival. But ultimately there were limitations because Marfa is so far and so remote. But it became almost kind of a fun puzzle. I mean, we would book half the town's lodging with just talent, so then inviting an audience, that also needed a place to stay and food to eat. So, a lot of the care that went into the infrastructure was making sure that people had food and housing. And trying to communicate that to our partners; it's difficult to relay the limitations of a small town to partners in New York City, because the world is their oyster, in a sense. So it was definitely a puzzle for sure.

Ittner: I really felt like it was unique, and it was bringing a certain life to our program. Marfa Myths was a very special thing. People loved it. The town loved it. We had a huge audience. It was one of the most beloved Ballroom events. It just had a real character to it. I still feel very, very special about it. □

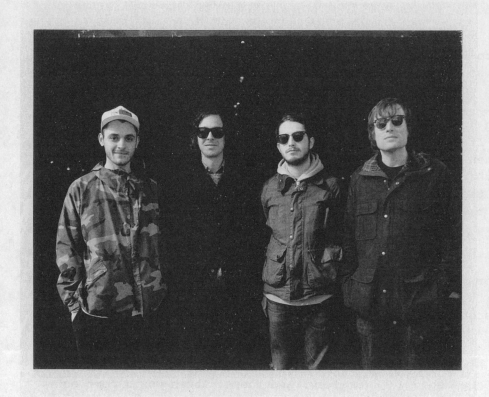

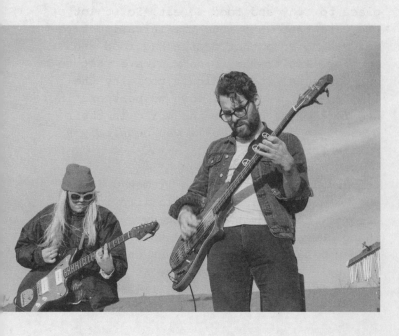

// Clockwise from top left
// Arp // Weyes Blood //
Connan Mockasin // Quilt //
No Joy //

2014

Connan Mockasin
No Joy
Weyes Blood
Quilt
Arp

// Top to bottom // Iceage
// Bitchin Bajas // Jefre
Cantu-Ledesma // Co La //
Thug Entrancer // Center,
top to bottom // Dev Hynes
& Connan Mockasin // GABI
// Opposite, top to bottom
// Grouper // Tamaryn //
Steve Gunn // Suicideyear //

2015

Dev Hynes
Iceage
Grouper
Tamaryn
Steve Gunn
Suicideyear
GABI
Co La
Thug Entrancer
Jefre Cantu-Ledesma
Bitchin Bajas
Gregg Kowalsky
Dev Hynes & Connan Mockasin
Weyes Blood

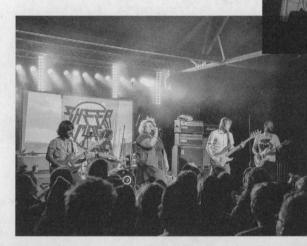

// Top to bottom // No Age // Parquet Courts // // Maria Chavez /// Mary Lattimore // Sheer Mag // Heron Oblivion // Center, top to bottom// Connan Mockasin's Wet Dream // Pill // Awesome Tapes from Africa, photo by Luis Nieto Dickens // Opposite top to bottom // Fred & Toody (of Dead Moon) // Dungen // William Basinski // Hailu Mergia //

2016

Parquet Courts
No Age
Connan Mockasin's Wet Dream
Dungen
Fred & Toody (of Dead Moon)
William Basinski
Hailu Mergia
Awesome Tapes from Africa
Raum with Paul Clipson
Heron Oblivion
Mary Lattimore
Maria Chavez
Sheer Mag
Pill
Ariel Pink & Weyes Blood
Real News
Emitt Rhodes
Quilt

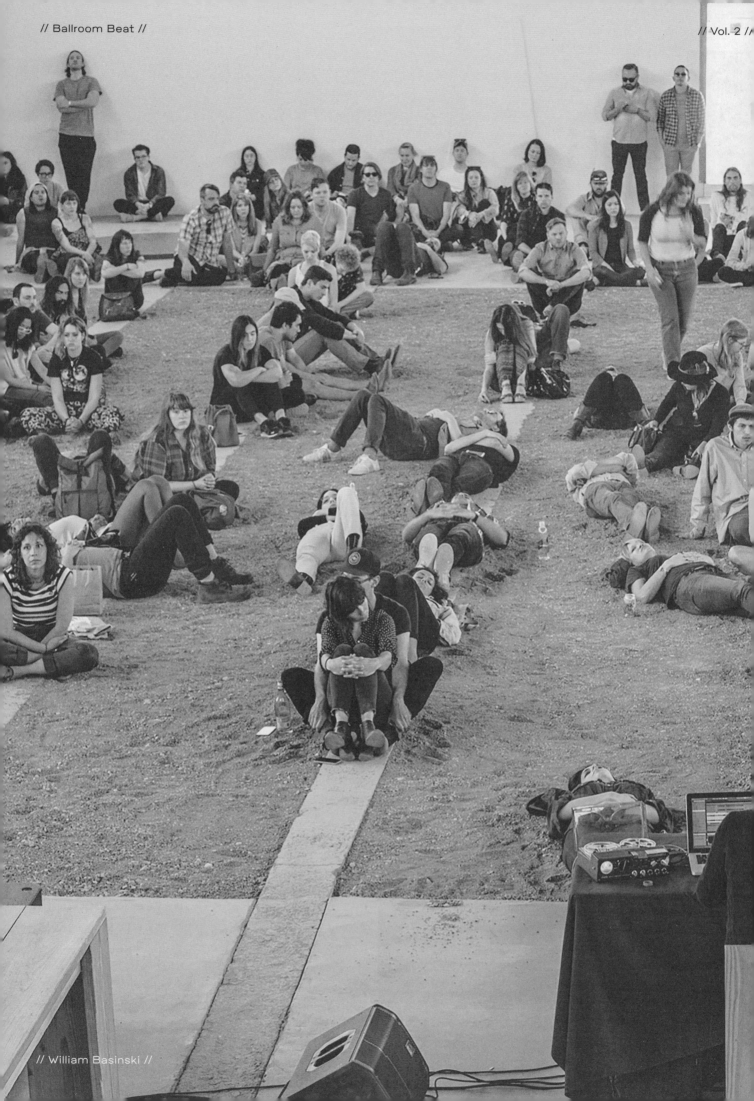

// William Basinski //

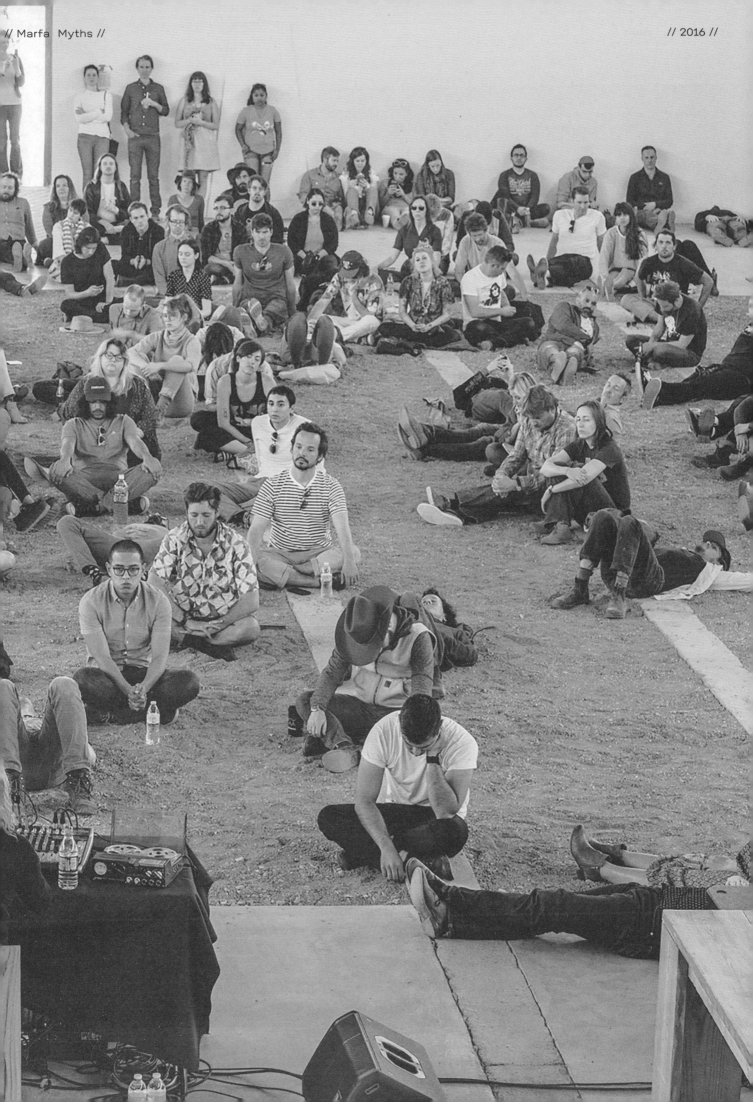

FREE

2016
2nd "Edtition"

MARFA
MYTHS

// *Marfa Myths* zine cover // Design by Real News //

THE MOST MAGICAL MOMENTS OF TEXAS'S REMOTEST MUSIC FESTIVAL

Jessica Hundley // *New York Times* // March 15, 2016

It's a blustery Saturday afternoon in Marfa, Texas, and hundreds are gathered inside a former Army hangar, much of the crowd lying prone on the red gravel floor or sitting cross-legged with their eyes closed. A few people stand, some staring dreamily up at a high row of windows that split the sky into perfect squares of indigo blue. The experimental music artist William Basinski is at the center of the hangar, his mirrored sunglasses focused on a table topped with computers, volume knobs, a thick knot of electrical cords. From the speakers flanking him comes a sweet, synthesized drone — complex tones that fill the massive space, lulling the audience into a kind of midday trance. Wind blasts at the cavernous arch of corrugated steel roofing, creating an aching, eerie, metallic rhythm, creaks and pops that seem somehow syncopated to Basinski's improvised soundscape.

This is the second day of Marfa Myths, an annual art and music fest cocurated by the Brooklyn music label Mexican Summer. Now in its third year, the festival is perhaps the most extreme example in a recent trend toward intimate, meticulously curated music events, many held in remote areas, most booked so bands align aesthetically with the surrounding environment.

Marfa (pop. 1,800), a three-hour drive from El Paso down an empty highway lined with cacti and wildflowers, may seem an unlikely host for a four-day indie music festival. But this tiny community on the high Western Plains knows a thing or two about art and experiment. In the early 1970s, the sculptor Donald Judd began to make the town his unlikely permanent home, buying up several properties, including the abandoned Army base and several thousand acres of ranchland, essentially transforming the area into live/work and gallery space, for both himself and his friends and contemporaries.

As a result, Marfa is a town shaped indelibly by the late Judd, by his belief in a seamless integration of art and life, creativity and industriousness, and a strident focus on engagement with — and the inspiration sparked by — one's surroundings. For Marfa Myths, Mexican Summer collaborated with several of the community's Judd-related arts institutions and galleries (including the Judd Foundation, Ballroom Marfa, and the Chinati Foundation), curating with exactly this intent. Each show takes place in careful sequence (no overlap, no overload) and is booked in an environment tailored to each act. □

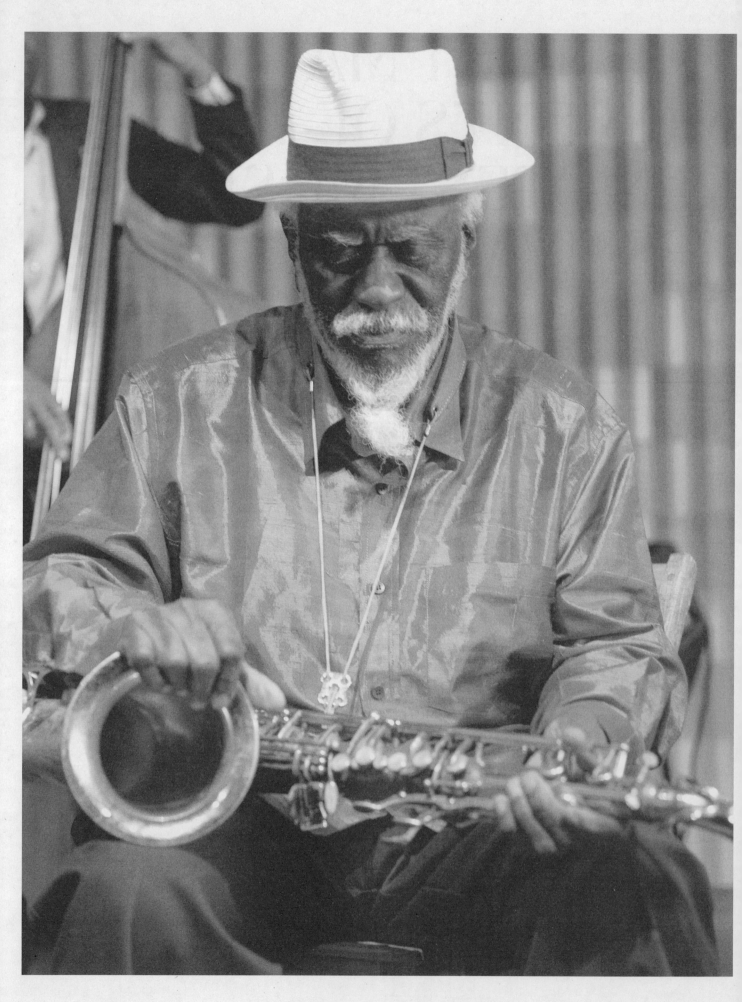

2017

Roky Erickson
Perfume Genius & Weyes Blood
Pharoah Sanders
Julia Holter
Idris Ackamoor & The Pyramids
Jenny Hval
Kaitlyn Aurelia Smith
Allah-Las
Cate Le Bon
Connan Mockasin Presents Bostyn 'n Dobsyn
Dungen
Zomes
Lonnie Holley
Rose Kallal
Woods
Tonstartssbandht
Botany & Shingetsu Billy White
Chulita Vinyl Club
Matt Craven

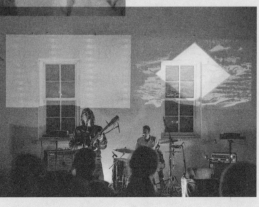

// Top to bottom // Perfume Genius // Roky Erickson // Matthew Craven, photo by John Vogler // Botany & Shingetsu Billy White // Tonstartssbandht // Center, top to borrom // Dungen // Zomes // Opposite, top to bottom // Idris Ackamoor & The Pyramids // Jenny Hval // Kaitlyn Aurelia Smith // Allah-Las // Cate Le Bon, photo by John Vogler // Connan Mockasin Presents Bostyn 'n Dobsyn //

If the Sun Had a Voice

Lonnie Holley

The legendary multimedia artist Lonnie Holley has been in Ballroom
Marfa's orbit as both a musician and a visual artist. The 2017
exhibition *Strange Attractor*, which explored networks, technology,
environmental events, and sound, featured a unique collaboration
between Holley and psych-rock duo Tonstartssbandht, with visuals
by Benton C Bainbridge.

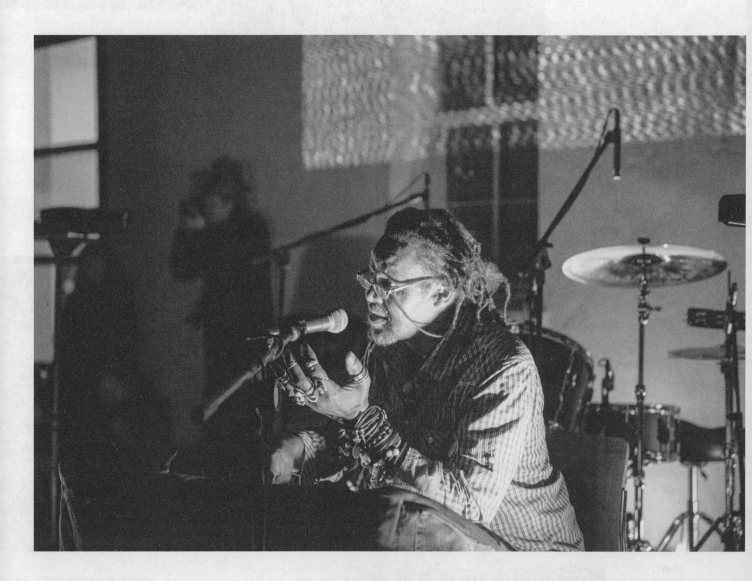

I don't find myself outside of cities very often, but I found myself very thankful this morning to be here in Marfa. I think it's really important to stay in that kind of state of mind. It's almost like we were coming somewhere, but in the midst of nowhere. It was so much of nothing around us, but all of it was something because my brain was going. I was looking at the mountain, I [thought], Oh goodness, I can use that big rock. I can take and get me some tools and I can sculpt that big rock. I can take and get me some big, big, big demolition tools and bust those big rocks down to make 'em a little bit of small rock. My brain was defining the rock, defining what I had to come through. I had to come through what somebody would've called a nothing land to get to somewhere in the midst of this.

When I got up this morning and I saw the clouds was, you know, kind of between us and the sun. If the sun had a voice, it would say, I'm just so proud to be out here in the midst of all these planets, just being the one that's burning. I'm being the one that's causing fruition. I'm being the one that's causing growth. I am the sun, therefore I shall sign and I will shine and I will continue to do so for as long as there is hopefully a universe. So, for me, to get from here to infinity is easy. But whereabout infinity. In infinity will I land?

I got up this morning, the first thing I saw was the border patrol cruising down by the window. I loved it because it was giving me something to make up, a reason to sing about on this. I'm so close to the border. My, you hear me? Yeah. I'm so close to the border. What is the border? It's just a little line that runs down between two spaces and on one side of

the space is this. And on the other side of the space is there. When I came to El Paso in the nineties, '94 or '95, I did a borderline project.

My thing was the grass, it's always to appear to be greener on the other side of the fence. El Paso appeared to be a blossoming and progressing and, and future trailing. And then on the Juárez side, you understand what I'm saying? Yeah. Where people's trying to get to do what they get on the other side; the United States of America, to some people, is a glory land. My thing [is], not so much of glory, a story land. Not so much of truth all the time. A fairy-book land.

And as Americans, if I'm talking to Americans, we have to see ourselves as a leading nation. We have to see ourselves as a nation that is inventing its own intention. I think Nina Simone said she was talking to God about God.

My intentions are good, but I'm no more than human. I may make a mistake. I may not be able to say the right word. I may not know how to read and write. I may not know how to sign the paperwork to register as a voter. I may not be able to do the right things, to get on some type of insurance where it could cure my cancer or cure my ills. I may not know how, again, to put on the right suit to fit into whose church. I may be considered to be an outsider, a castaway, or a leftover from days that have grown over. I'm more of an old man than I am a young man at this point. But I'm more of my great-grandfathers than I am of my father at this time. ☐

Interview, Lonnie Holley and The Lot Radio, Marfa Myths, 2017.

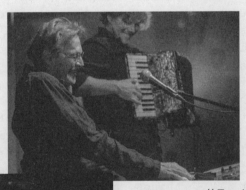

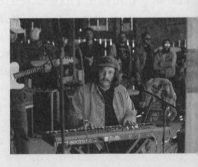

// Top to bottom // Suzanne
Ciani // Thor & Friends //
Kelsey Lu // Terry Allen
// Drugdealer, photo by
John Vogler // Allah-Las //
Center, top to bottom //
Wire, photo by John Vogler
// Bradford Cox & Cate
Le Bon // Ade Mockasin
& Connan Mockasin //
Innov Gnawa // Opposite,
top to bottom // Amen
Dunes // Helado Negro
with Ensemble // Jessica
Pratt // Gravity Hill Sound +
Image, photo by John Vogler
// Equiknoxx // Tom Zé //

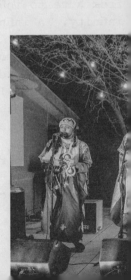

2018

Suzanne Ciani
Circuit des Yeux
Wire
Jessica Pratt
Amen Dunes
Helado Negro with Ensemble
Gravity Hill Sound + Image
Omar-S
Equiknoxx
Tom Zé
Innov Gnawa
Ryley Walker
Allah-Las
The Weather Station
Terry Allen
Laraaji with Arji OceAnanda
Thor & Friends
Visible Cloaks
Cate Le Bon & Bradford Cox
onnan Mockasin & Ade Mockasin
Jesse Moretti
Drugdealer
Kelsey Lu

A Breathing, Porous, Permeable Space: A Recollection

Suzanne Ciani

The extraordinary 2018 lineup for Marfa Myths included a performance by pioneering electronic synthesist Suzanne Ciani. Ciani has carved out a niche as one of the most creatively successful female composers in the world. A five-time Grammy-nominated composer, groundbreaking electronic musician, and neoclassical recording artist, she has released more than twenty solo albums, including *Seven Waves* and *The Velocity of Love*, along with a landmark quad LP, *LIVE Quadraphonic*, which restarted her Buchla modular performances. Her landmark performance at Ballroom Marfa brought her sonic explorations to an entirely new environment.

My initial introduction to Marfa was through that long, straight road, the umbilical cord that takes you there, and there were thousands of rabbits. It was like this fantasy dream where you're driving and there are rabbits every place, and they look like multiples of somebody's vision of an art piece or something. You started to think in terms of everything was intentional, but natural at the same time. It is quiet. It's a backdrop of perfection for listening, and seeing, and whatever senses you're dealing with; it's like being delivered to another planet, or an alien planet. I mean, there's just not a lot of input there. Just the bunny rabbits hopping around those roads.

Then arriving in Marfa, which is a big emptiness, right? It's like an empty canvas. It's like the perfect creative backdrop for your brain because there's not a lot of input there. You're drained of all your preconceptions. Everybody jokes about the wide-open spaces of Texas and all that. For me, there are very few places in Texas that I think I can relate to as an artist, really. I don't know about you, but Marfa . . . somebody dropped this conceptual space in the middle of no place. It seems so disconnected. That journey to get there, it allows you to kind of just drop all your preconceptions, and you arrive empty, actually — and then it's empty when you get

there. It's like, "Where is everybody?"
Then you go into the performance space and
suddenly it's filled with jillions of people.
It's an oasis. You don't find people walking
around in the town — it's not like a city —
but they come together for the experience.

It's a very generous space, and part of the
magic has to do with the way it holds the
audience. The audience felt so nested. It's
a big nest for having people just relax.
Everybody was on the floor lying down, ready
to be kind of transported into that. So that
was the magic. It was a daytime performance,
so it wasn't about lighting, or projection,
or other things that sometimes I do in a
concert. It was really about being in a
space, but it was an open space. Yes, you
could see the light coming through the
ceiling. I think there were birds inside
the space. I start out, of course, with
ocean sounds and bird sounds. So you feel
this integration of the virtual space and
the natural space, and that is something
very special. I don't think I've played in
a place that was that — What is the word?
What's the word when something is not closed
but breathes?

It's porous in a way. Permeable. It's not
like playing in a concert hall, where the
sound is bouncing off the walls and everybody
is kind of locked in. There's this feeling
of openness, open space, almost as if there
are no walls. You don't have the feeling of
confinement at all.

So for me, that's important because the music
that I play is dealing with the space. It
is quadraphonic, it's spacial, it's moving.
There aren't that many places that give you
that sense of playful, unconfined space.

I think of sound almost as a brushstroke, a
color. . . . I sometimes think of Jackson
Pollock or that breakthrough of just
being free to create a new vocabulary.
That's what analog electronic music is in
the music world. I mean, I was trained
as a classical composer and I wrote for
orchestra and piano and all kinds of
acoustic instruments. But when I'm in my
electronic world, I'm functioning more as a
sonic artist in the sense of the paradigm
of visual art creation. We saw that evolve
through the centuries from literal, to
perspective, to this, and being able to do
it right and being able to do it based on
reality. Then it just leapt out of reality.
That's the analog of analog music, that
it did leap out of reality in the same
way that painting did. It's live art and
it is living. I mean, all art when it's
made is living, and then maybe it gets
frozen. That's why I love the medium that
I work in, because it's not frozen and it
is transitory, and it dissipates out, and
you have to experience it in that moment.
For me, it's the moment too, because I'm
creating it in the moment.

I listened to that performance, and I was
explaining to the audience — because some
people don't understand that the sound
is being created in the moment — there's
no recording, there's no computer, there
are no samples. People get used to, with
technology somehow, that somebody hits a
play button and something happens. It's
not always understood that, in fact, there
is nothing there except what is created in
the moment. That it doesn't exist until it
exists. . . . I think that experience of
the present is so powerful. And that is
life; art is a form of life. It's the life
that we create. I know that sounds like
pontificating, but as a concept, it's always
been just so true for me.

I'm very at home in the context of the
visual arts and all that that means —
basically the unknown. I think everybody
is pushing the frontier of the unknown,
and that's exciting, being a pioneer going
someplace that is intuitive because there's
no road map. I'm really impressed that
Marfa, which began as a concept, continued
past Judd's death and has blossomed and
grown and nourished. It's really wonderful.
You have kept it alive. The young people
come in and they water the plant. Thank you
for your work, for carrying on the vision in
an organic way, growing the plant. There's
not a lot of interference up there. Just the
bunnies. Just those rabbits. □

Interview, Suzanne Ciani and Sarah Melendez,
August 17, 2023.

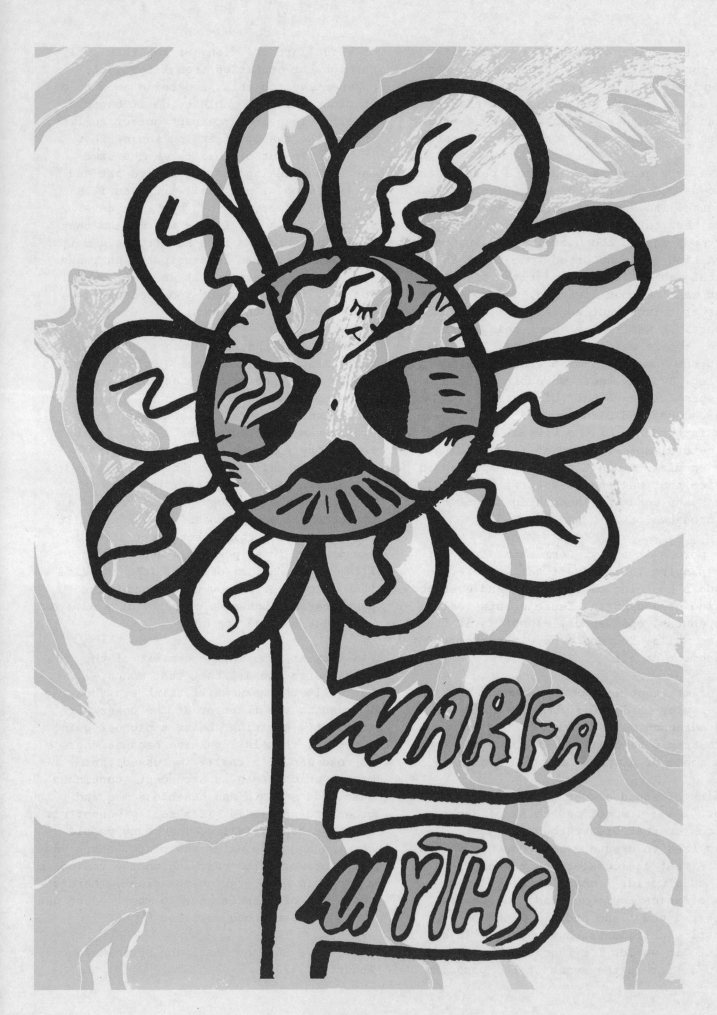

// *Marfa Myths* zine cover // Design by Natalie Anne Howard //

2019

Khruangbin
Annette Peacock
Vivien Goldman
Tim Hecker & Konoyo Ensemble
OG Ron C & the Chopstars
Träd, Gräs och Stenar
Kate Berlant & John Early
Cate Le Bon
The Space Lady
Josey Rebelle
Jerry Paper
Makaya McCraven
Jess Sah Bi & Peter One
Connan Mockasin
Deerhunter
Cass McCombs
Tim Presley
Jon Bap
Nadah El Shazly
Money Chicha
Photay
Superstar & Star
Jess Williamson
Emily A. Sprague
Natalie Anne Howard

// Top to bottom //
Khruangbin // Vivien
Goldman // Jon Bap //
Superstar & Star // Photay
// Deerhunter // Jess Sah
Bi & Peter One // Center,
top to bottom // Tim
Hecker and the Konoyo
Ensemble // Makaya
McCraven // Opposite, top
to bottom // OG Ron C and
the Chopstars // The Space
Lady // Jess Williamson //
Emily A. Sprague // Josey
Rebelle // Jerry Paper //

FROM THE EDITORS

Six years into Marfa Myths, slow and steady as we go. It's easy in this day and age to get wrapped up, or clean swept away, by the hustle and bustle brought on by a constant surge of information and stimulation. It's also tempting to partake in the rush; to keep up with the full-speed steam - and stream - ahead. To compete.

At this year's Marfa Myths we offer an alternative proposition: check out. Discovery and diversity remain fundamental to our festival experience. We hope the assemblage of music, visual arts, film, and comedy, and the people these different vessels attract inspire you to delve a little deeper into the unknown. (feel free to leave your device behind for full immersion)

Check out what music you can the next few days. This year, like many years before, you'll find an intersection of those musicians that blazed trails (and continue to), Annette Peacock, Träd, Gräs och Stenar, and Vivien Goldman, and boundary pushing contemporaries, Nadah El Shazly, Josey Rebelle, and Makaya McCraven. This is just some of the music represented across our weekend calendar.

Check out the amount of home state talent repped from Austin's Money Chicha, Burton's Khruangbin, Dallas' Jon Bap, and of course, Houston's OG Ron C and The Chopstars. Check out the awe-inspiring venues, The Arena at Chinati, The Capri, El Cosmico, and surrounding landscapes that stage all of these performances.

Check out our annual artists-in-residency programs. Natalie Anne Howard helms the look and feel of this year's festival, from the curious, conscious creatures lurking around our stages to the outer bounds of this publication in your hands. Marfa Myths' ambassador, Connan Mockasin, oversees a series of paintings to be donated and exhibited at the Marfa Public Library. And for the first time, we'll have a woodworker in residence: Cate Le Bon. Our annual recording residency brings together the songwriting talents of Los Angeles' Drugdealer and San Francisco's Tim Presley.

Most importantly, check out Marfa, Texas. We're only able to come together and enjoy this surreal West Texas vibe because this community allows us. And we're only willing to grow as Marfa grows, a signal of how important that symbiosis is and how this festival isn't possible anywhere but here. Please support our 2019 allegiance with Texas RioGrande Legal Aid and Marfa's local businesses, thank any number of the local crew members carrying the festival, and pick up some garbage if you see it.

For those just joining at Myths: welcome, good to have ya. For those returning, we know you won't be disappointed. Enjoy the music, art, and each other.

Keith Abrahamsson
Mexican Summer

Welcome to Marfa and to this year's Myths!

The spirit of our work at Ballroom Marfa is centered in our deep love for the Big Bend and our wish to share it with a wide range of artists and audiences. This spirit of connection and collaboration is why we are so excited to join our partners at Mexican Summer to invite you to the sixth annual Marfa Myths festival.

Myths started with five bands playing on a cold, windy day at El Cosmico. Over the years it has gradually grown in both scale and spirit into a truly eccentric, far-out, diverse and mind-bending celebration of imagination. We continuously experiment and work to collaborate with local partners, venues, and artists, to keep the Myths experience connected to this place that we call home. We couldn't pull it off without our local partners and the community of Marfa: *Thank you, Marfans – and all of our neighbors and friends across the Big Bend – for your generosity, hospitality and resourcefulness!*

We are grateful for this opportunity to take time and make space to come together, connect with one another and bask in the goodness and vibrations of Money Chicha, The Space Lady, Khruangbin, Nadah El Shazly, and so many other incredible musicians, artists, and performers who will be here doing their thing. I'm beyond pumped to hear Jess Sah Bi & Peter One perform in Ballroom's courtyard surrounded by the wildly imaginative sculptural works of Beatriz Cortez in celebration of our inventive spring exhibition, *Candelilla, Coatlicue, and the Breathing Machine.*

We are fortunate to have Natalie Ann Howard, this year's artist in residence, as our vibe guide for the weekend. She's here to remind us to indulge our childlike sense of wonder, to *play*, to be kind, and go forth with that Big Bend, big heart energy.

So, have fun, soak it all in, drink lots of water, do your best to recycle (cans + plastics #1 and 2), and maybe take a drive down Pinto Canyon to look up at the big sky and remember that we're all in this together.

Peace,

Sarah Melendez
Ballroom Marfa

CHAPTER THREE

CONTINUED GROWTH/ EVOLVING CONCEPTS

2013–2016

Arturo Herrera, *88 DIA*, 1998, installed for *Comic Future*, 2013.

As Ballroom Marfa continued to grow and transform, it gained more visitors and visibility. With the advent of social media technology, its vibrant activities and programs could be shared more readily, creating an entirely new audience and new waves of visitors. The organization's tenth anniversary was celebrated with the opening of *Comic Future,* curated by Fairfax Dorn, in the fall of 2013. The artists in the exhibition engaged with the world with an eye toward the future through language that was playful, satirical, and subversive.

Ballroom Marfa continued to play and experiment, too. In addition to its one-night concerts, Ballroom's music festival, Marfa Myths, was formed in partnership with the music label Mexican Summer in 2014. For the first iteration of Marfa Myths, five of the label's bands were invited to play for one day from noon to sundown. Over the following six years, the festival grew, in its final year hosting more than twenty bands and four residencies over the span of a weekend.

At Ballroom, music lives alongside visual arts, which lives alongside film, which lives alongside permanent installations and public programs. Graham Reynolds created a triptych of performances that connected music to the history of the land. Ballroom commissioned Teresa Hubbard and Alexander Birchler to make a film, *Giant*, that considers the kinds of traces movies leave behind. *Prada Marfa*, after almost a decade, received museum status, solidifying its iconic presence in West Texas. The structure of the organization expanded as well: Fairfax Dorn handed the reins of the executive directorship to Susan Sutton, while remaining as the artistic director. ☐

NEW GROWTH

RASHID JOHNSON

In March 2013, Ballroom Marfa presented *New Growth*, an exhibition of new work by Rashid Johnson, organized by Fairfax Dorn. For this exhibition, Johnson combined both personally and historically loaded material—such as shea butter and black soap—with LP covers and books in complex paintings, sculptures, and installations that confound the uniformity of collective identity and multicultural representation. It begins with the question, "What would happen if Sun Ra, George Washington Carver, and Robert Smithson started a community together in the desert?" Johnson addresses this hypothetical by drawing on personal and historical references. *New Growth*'s playful scrutiny intertwined cosmology, escapism, and irrigation in a recontextualization of the lines between past, present, and future in a desert setting.

The concept of physical manipulation of biomaterial into an abstract form ran through the work on display, with references to the transformation and rehabilitation of bodies, landscapes, and the identities embedded within them. This played out most dramatically in the outdoor installation in which the sunbaked gravel of the Ballroom courtyard was irrigated with shea butter, terraforming the high desert grasslands of Far West Texas. In keeping with Ballroom Marfa's mission, *New Growth* featured newly commissioned work including the video *Samuel in Space* and the *Shea Butter Irrigation System*, both of which were produced during the artist's stay in Marfa. Works in wax, burned wood, tile, mirror, and brass, as well as chairs and rugs rounded out the exhibition. A film program curated by Johnson in collaboration with MoMA film curator Josh Siegel also ran throughout the exhibition and screened, among other films, John Coney and Sun Ra's 1974 *Space Is the Place*. To inaugurate *New Growth*, Ballroom Marfa hosted a weekend of festivities, including an opening reception that featured a performance by multi-instrumentalist legend Kahil El'Zabar and saxophone master Hamiet Bluiett, whose musical styles range from avant-garde to bebop. Following its presentation at Ballroom, the exhibition traveled to MCA Denver. ▷

Clockwise from top left: Rashid Johnson, Untitled (*Love in Outer Space*), 2013; Rashid Johnson, Untitled (*Wood Chair*), 2013; Rashid Johnson, *Going to Meet the Man*, 2013. Overleaf: Installation view, *New Growth*, 2013. Detail, *Shea Butter Irrigation System*, 2013; Rashid Johnson,

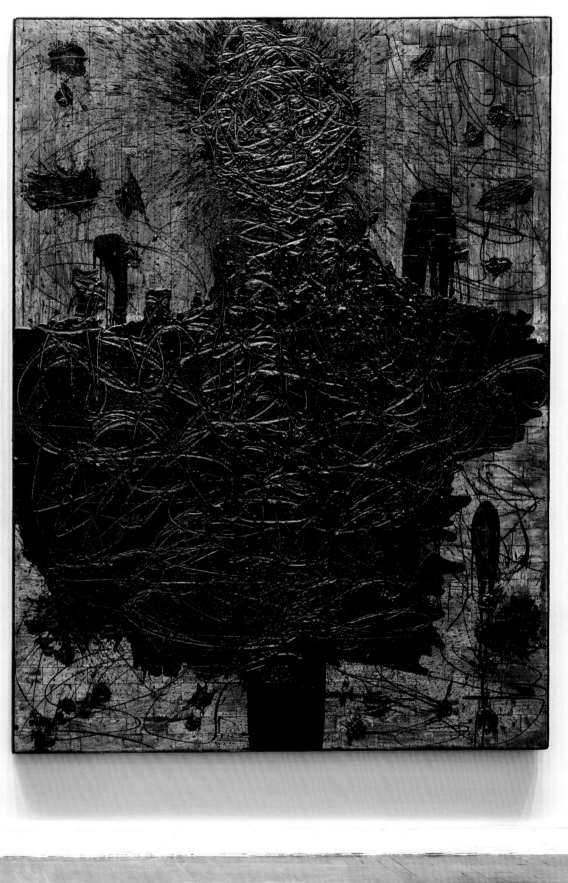

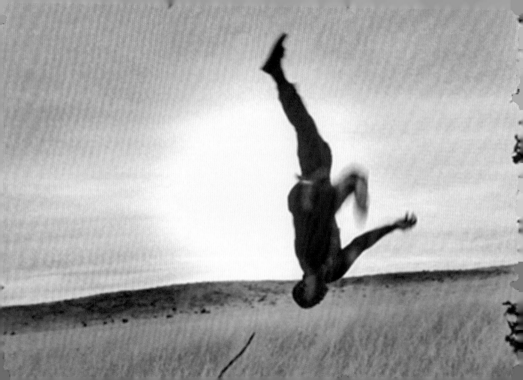

LIKE SHARDS FROM SOME VANISHED CIVILIZATION: AN INTRODUCTION TO *SPACE IS THE PLACE*
DANIEL CHAMBERLIN

In the 1970s, Sun Ra wasn't yet recognized as the eccentric genius that he is understood as today. He'd been leading bands for almost three decades, placing ecstatic chanting alongside percolating synthesizer pieces, using improvisational percussion and cosmic expansions of big band styles to create a voluminous if obscure repertoire that placed classic jazz and swing in an extraterrestrial timeline. This destabilized polyglot sound was too conspicuously wacky to fit in with the jazz establishment or its free jazz fringes, and though he'd already graced the cover of *Rolling Stone* in 1969, his music seemed equally as confusing for the Anglo-psychedelic music scene.

His canonization as one of the pioneers of Afrofuturism would have to wait until later in his career, though of course his work now looks right at home next to similar explorations from Miles Davis and Herbie Hancock, and would help set the stage for Funkadelic's Afro-cosmic psychedelia, MC5's liberation rock, Sonic Youth's deep noise grooves, and Boredoms' melted drum ensembles.

One place where Sun Ra did find a home was as an artist-in-residence at the University of California, Berkeley, where he delivered a series of lectures in 1971 under the heading "The Black Man in the Cosmos, Hyperstition and Fast-Forward Theory." The course's now legendary syllabus included the King James Bible, the Tibetan Book of the Dead, work from nineteenth-century occultist Madame Blavatsky, poetry from Henry Dumas, as well as texts about the pagan roots of the Catholic Church, Egyptology, and African American folklore.

Someone in the Berkeley AV department had the foresight to record one of these lectures—archived at ubu.com—wherein Sun Ra holds forth in such a way as to indicate that he's both serious about his cosmological thinking, while at the same time deliberately provoking laughter from the gathered students as he *tsk-tsk-tsks* his chalk across the blackboard.

At the same time that he was mapping these ideas out for a bewildered cohort of Berkeley students, Sun Ra was approached by Jim Newman, a producer with ties to Bay Area public television station KQED about making a PBS documentary. The idea for the project quickly evolved into a work described by John F. Szwed in his Sun Ra biography, *Space Is the Place: The Lives and Times of Sun Ra*, as "part documentary, part science fiction, part blaxploitation, part revisionist biblical epic." Newman produced, John Coney directed, and Joshua Smith came on as a writer.

The result was *Space Is the Place*, an eighty-five-minute feature that, like his music with the Arkestra, cherry-picks from a diverse set of visual and auditory traditions to produce a work that is distinctly Sun Ra. The premise of the film involves Sun Ra's return to Earth—Oakland in particular—in 1972 after a period of space exploration. He aims to recruit new pioneers to join him in an exodus to a planet that he's discovered, with the hope of, as Szwed writes, "the resuscitation of the black race." He encounters resistance from the FBI and NASA as well as a "supernatural pimp" known as the Overseer.

The film is a liberated combination of blaxploitation narrative tropes and Black Panther iconography with the sort of poetic low-budget abstraction seen in contemporary films like *El Topo* and references to Ingmar Bergman's *The Seventh Seal*.

As with Sun Ra's music, audiences had trouble figuring out how to process such visions. "After a couple of showings in San Francisco and New York," Szwed writes, "*Space Is the Place* disappeared, leaving behind only an album of that name on Blue Thumb Records, and thus became the consummate underground film. Pieces of it were sometimes projected behind the Arkestra without sound, like shards from some vanished civilization, but it was gone." The film found new life as the few existing copies were distributed via YouTube, and it was finally reissued on DVD in 2003.

As Szwed and others have observed, the film—like much of Sun Ra's body of work—was well ahead of its time, its influence echoing through sci-fi blockbusters like *Star Wars* and *Close Encounters of the Third Kind*. Likewise such a playful set of ideas regarding social control, black iconography, and transcendent science fiction ideology serve to identify *Space Is the Place* as a clear antecedent to the work of Rashid Johnson, and an excellent introduction to this film program component of *New Growth*, an exhibition that began with the question, "What would happen if Sun Ra, George Washington Carver, and Robert Smithson started a community together in the desert?" □

Excerpt, essay accompanying Space Is the Place, New Growth *film program, May 29, 2013. Daniel Chamberlin was Ballroom Marfa's communications coordinator.*

Rashid Johnson, *Shea Butter Irrigation System*, 2013. Previous: Rashid Johnson, *Samuel in Space*, 2013.

hot sticky cretacious
domes of peat

green sahara|

MARFA DIALOGUES

2013–2016

In 2013, Marfa Dialogues expanded beyond Far West Texas: Ballroom Marfa and the Public Concern Foundation joined with the Robert Rauschenberg Foundation in New York City. Marfa Dialogues extended its partnerships and collaborations with the Pulitzer Arts Foundation in St. Louis for MD/STL in 2014, and with the Menil Collection, Contemporary Arts Museum Houston, and the Museum of Fine Arts, Houston for MD/HOU in 2016.

MARFA DIALOGUES/NEW YORK 2013

For 2013, Ballroom brought the concept of the Marfa Dialogues series to New York City, aiming to take it "from a rural artists' haven to a large universe of diverse voices, audiences, and culture," Fairfax Dorn told the *Washington Spectator*. Over two months, MD/NY featured community forums, art exhibitions, music performances, and panels to engage in a deeper examination of climate change. An exhibition at the Robert Rauschenberg Foundation Project Space organized by Dorn, *Quiet Earth*, featured works by Rauschenberg, Donald Judd, Agnes Denes, Maya Lin, Amy Balkin, Trevor Paglen, Larry Bamburg, and Hans Haacke. Other highlights included *GhostFood*, a participatory performance by Miriam Simun and Miriam Songster, at Gallery Aferro; *Solar*, an exhibition organized by the High Line, featuring works by Rosa Barba, Neil Beloufa, Camille Henrot, and Basim Magdy; and two roundtable discussions organized by Triple Canopy.

MARFA DIALOGUES/ST. LOUIS 2014

Ballroom Marfa assembled a diverse range of collaborators spanning art, design, journalism, science, business, and activism to create thought-provoking projects across St. Louis. MD/STL challenged creative thinkers to propose imaginative solutions to the climate crisis in the Midwest and to increase awareness of the impact of our daily actions. In collaboration with the Pulitzer Arts Foundation's exhibition *Art of Its Own Making*, which featured artists who examine materials, environment, and how generative elements affect the works of art they create, the Pulitzer, Ballroom Marfa, and the Public Concern Foundation organized artist talks, town hall discussions, performances, and a community dinner.

A highlight was a trio of walks led by artist Mary Miss and local architects, urban designers, artists, and biologists from the Danforth Plant Science Center and the Missouri Botanical Garden on routes that brought participants to cultural, architectural, and ecological landmarks such as the site of the Pruitt-Igoe housing project. Along the way, participants learned about urban forests, hydrology, ecology, and sustainable design.

MARFA DIALOGUES/HOUSTON 2016

The final iteration of Marfa Dialogues took place in Houston in 2016. In conjunction with the FotoFest Biennial, *CHANGING CIRCUMSTANCES: Looking at the Future of the Planet,* MD/HOU considered scales of climate disruption from the hyperlocal to the hyperobject. The Menil Collection, Contemporary Arts Museum Houston, and the Museum of Fine Arts, Houston hosted events. MD/HOU opened with a keynote address by the Reverend Lennox Yearwood Jr., president and CEO of the Hip Hop Caucus, and one of the most prominent figures engaging communities of color in climate activism and green economy solutions. In his keynote, Rev. Yearwood said, "The climate change movement seemed to not have many people of color engaged in it. And even if they were engaged . . . it seemed to be that the way they were only engaged was very scientific and of the academic persuasion. . . . So when we got involved with it, we began to include culture and began to see how we can include art and poetry and music." Among the many highlights of MD/HOU were a performance by Lucky Dragons, an experimental music group from Los Angeles dedicated to educating audiences about ecology, and a panel that considered the long-term effects of the anthropocene and the possibility of interplanetary migration. □

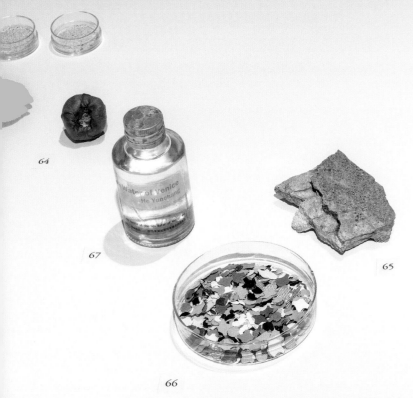

64

67

66

65

68

71

QUIET EARTH

AMY BALKIN, LARRY BAMBURG, AGNES DENES,
HANS HAACKE, DONALD JUDD, MAYA LIN,
TREVOR PAGLEN, ROBERT RAUSCHENBERG

Top: Installation view, *Quiet Earth*, 2013. Bottom: Amy Balkin, *A People's Archive of Sinking and Melting (State: From the Majuro Declaration to COP19 Warsaw)*, 2012–13. Overleaf: Installation view with, clockwise from top: Trevor Paglen, *The Last Pictures (An Entangled Bank)*, 2012; *Dead Military Navigation Satellite (COSMOS 985) Near the Disk of the Moon*, 2012; and *Contrails (R-4808N Restricted Airspace, Nevada)*, 2012; Maya Lin, *Silver Hudson*, 2011; Larry Bamburg, [...] 2005

As part of the 2013 Marfa Dialogues/New York program, Ballroom Marfa presented the exhibition *Quiet Earth* at the Robert Rauschenberg Foundation's Project Space. Curated by Fairfax Dorn, the exhibition addressed pressing environmental issues, particularly the climate crisis, and included environmentally engaged artwork from the 1970s to the present. Additionally, C. Spencer Yeh and Messages, the duo of Taketo Shimada and Tres Warren, performed in response to the exhibition.

Quiet Earth took its inspiration in part from the 1985 New Zealand postapocalyptic film of the same name. It serves as an abstract documentation of the ways that humans have responded to the ecological crises of climate change with scientifically informed aesthetic practices.

Among the art on view was Robert Rauschenberg's body of work *Gluts* (1986–95), assemblages composed of artifacts from the eighties-era oil boom in his home state of Texas and described as documentation of greed and excess, or "souvenirs without nostalgia." *Summer Knight Glut* (1987), made of detritus from gas stations, marked the effect of a surplus of a natural resource by recombining debris from its manifestation as consumer product. Hans Haacke's *Rhinewater Purification Plant* (1972) demonstrated the human impact on water systems, while Agnes Denes's 2005 large-scale *Pyramids of Conscience* monumentalized New Yorkers' relationship with Hudson River water, New York City tap water, and crude oil, all of which are entombed for contemplation within the artist's pyramids. Amy Balkin's *A People's Archive of Sinking and Melting (State: From the Majuro Declaration to COP19 Warsaw)* preserves human artifacts from lands that may be lost to rising sea levels—Anvers Island, Venice, New Orleans, Tuvalu, and others. *Quiet Earth* closes with the work of Trevor Paglen, an artist and geographer whose recent projects imagine the overflow of humanity beyond Earth, offering a sobering perspective on the place of our species on this planet and in the universe at large. □

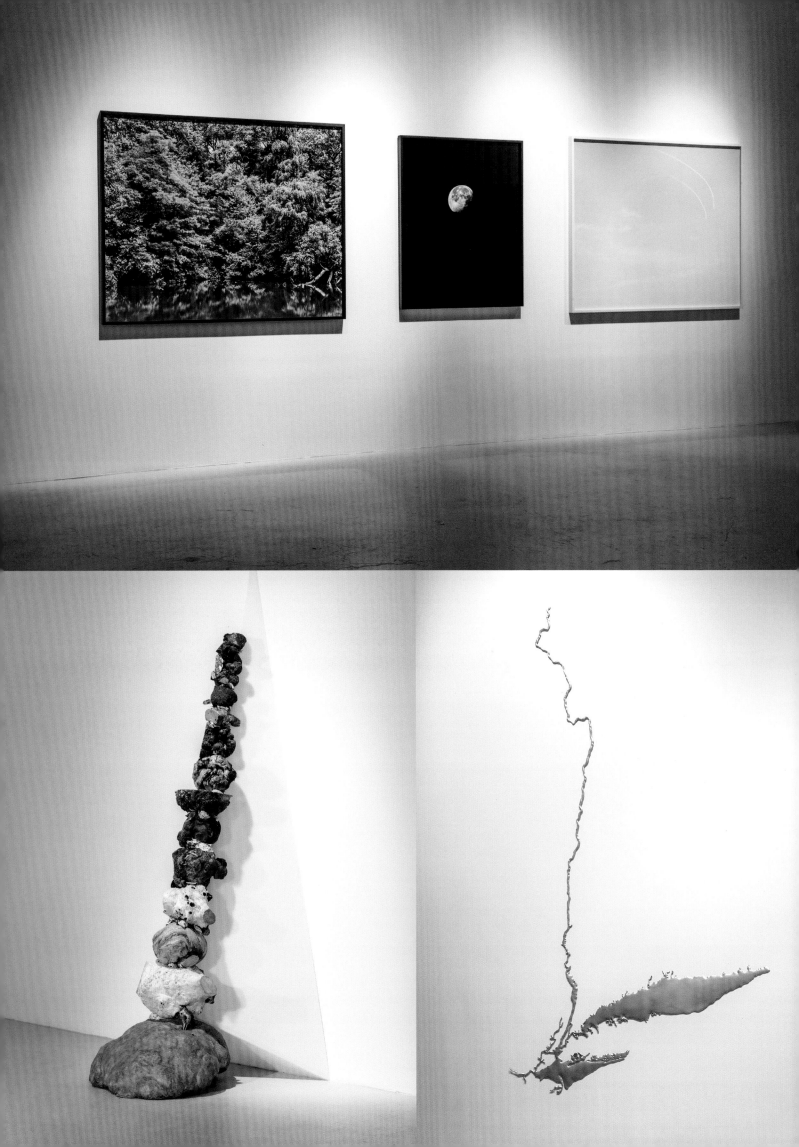

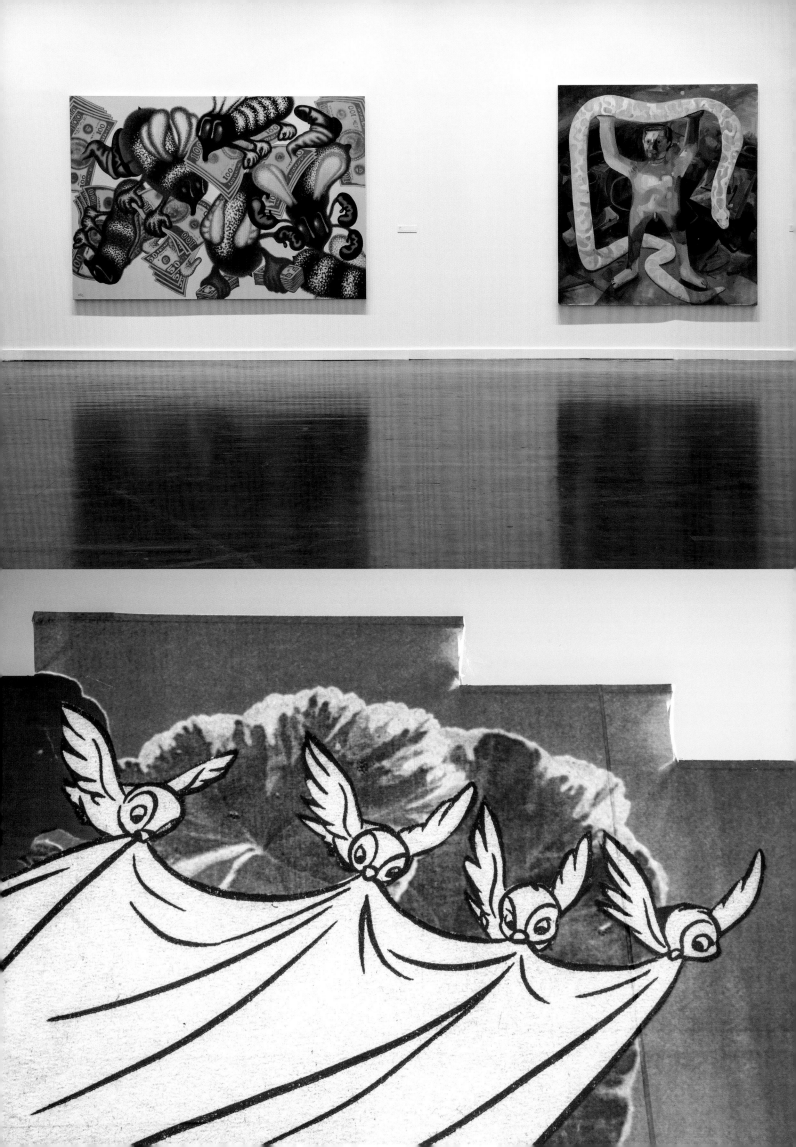

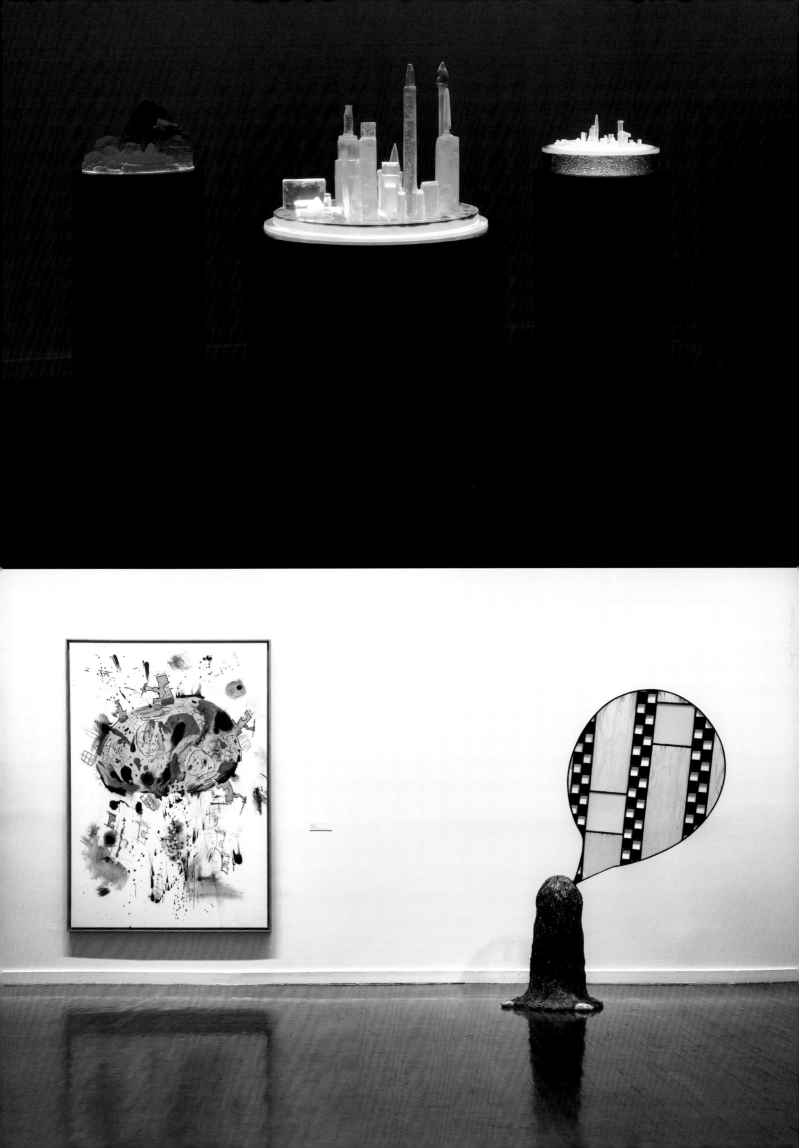

SOUND SPEED MARKER

HUBBARD/BIRCHLER

Top: Hubbard/Birchler, *Giant*, 2014. Bottom: Hubbard/Birchler, *Movie Mountain*, 2011. Overleaf: Hubbard/Birchler, *Sunrise Filmset Sunset*, 2012.

In 2014, Ballroom Marfa mounted *Sound Speed Marker* by Teresa Hubbard and Alexander Birchler (known as Hubbard/Birchler). The exhibition comprised three video installations and related photographs to explore film's relationship to place and the traces that moviemaking leaves behind. Hubbard and Birchler have collaborated in video, photography, and sculpture since 1990.

Sound Speed Marker, with its roots in the landscape that Ballroom calls home, brought Hubbard/Birchler's trilogy—including *Grand Paris Texas* (2009), *Movie Mountain (Méliès)* (2011), and *Giant* (2014)—to a close. The exhibition featured the premiere of *Giant*, a work commissioned by Ballroom Marfa. *Giant* interweaves signs of life and vistas of a decaying movie set built outside of Marfa: the Reata mansion from the 1956 Warner Bros. film *Giant*, starring Elizabeth Taylor, Rock Hudson, and James Dean. After filming was completed, the facade was left in the landscape. Hubbard/Birchler explore the skeletal remains of the set as seasons change, day turns to night, and the structure deteriorates. Scenes of a film crew recording the set's current conditions are juxtaposed with a Warner Bros. office in 1955, where a secretary types up the location contract for the motion picture that has yet to be made.

Grand Paris Texas considers the physical and social space of a dead movie theater, a forgotten song, and the inhabitants of a small town. The Grand Theater, an abandoned, pigeon-filled movie theater in downtown Paris, Texas, is the protagonist in a narrative that positions Paris as a meta-location constructed through celluloid and soundtrack. *Grand Paris Texas* connects three seminal movies of the Southwest: Wim Wenders's *Paris, Texas* (1984), Bruce Beresford's *Tender Mercies* (1983), and King Baggot's classic silent film *Tumbleweeds* (1925). In *Movie Mountain (Méliès)*, Hubbard/Birchler explore the site of a mountain in the Chihuahuan Desert near the town of Sierra Blanca, Texas. Narrative strands interweave remembering and forgetting. *Movie Mountain (Méliès)* features a script-writing cowboy and local residents whose relatives performed in an original silent picture that was filmed at the mountain. The project also posits a possible link between *Movie Mountain* and Gaston Méliès, the brother of famous filmmaker Georges Méliès. □

THE MARFA TRIPTYCH

GRAHAM REYNOLDS

In 2013 Ballroom Marfa commissioned *The Marfa Triptych*, three musical portraits of West Texas as envisioned by Austin-based composer Graham Reynolds. Over the next three years, Ballroom hosted performances of *The Country and Western Big Band Suite*, *The Desert*, and the epic conclusion, *Pancho Villa from a Safe Distance*. The genre-hopping, multimedia trilogy was inspired by Reynolds's interest in the intermingled populations of the Texas-Mexico border regions, from the ejidos, the ranches, and the Marfa art community. While creating the first installment, *The Country and Western Big Band Suite*, "I was highly influenced by watching the Marfa sunset on a bench on the western edge of town," said Reynolds. "When composing I would think of different experiences I had and then try to translate them into music." The second suite was performed within the desert landscape at dusk. And the third was an opera recounting the story of the legendary Mexican outlaw and revolutionary Pancho Villa. ▷

Thirteen years ago, I got invited to lunch. I arrived at the restaurant having no idea that I was about to enter into one of my favorite collaborations of my life. I did know of Ballroom Marfa; they had hosted the Rude Mechs, a theater company I'm a member of and that my partner codirects, and I had heard amazing things. And on the way back from a wedding in New Mexico, I had seen the truly incredible *Hello Meth Lab in the Sun*. When arriving for the first time, it quickly became apparent that there is no place like Marfa. Quiet but vibrant, tiny and isolated but culturally rich and diverse, it's a town that plays by its own rules. I've since had some transformative experiences there, sitting on a bench at the edge of town, watching the sunset over the desert. Paul Sanchez and Liz Cass hitting the final notes the night we opened *Pancho Villa from a Safe Distance.* The echoes in Closed Canyon. Walking through *Hello Meth Lab in the Sun*; that was my first impression of Ballroom Marfa.

All that said, I knew that Ballroom was supercool, but they were a visual arts organization, and I had no idea what they were thinking of with me. I sat down with Virginia and Fairfax, and they said, "We'd like to make an opera." That sounded fantastic to me, so of course I was an enthusiastic yes. But I had heard that Ballroom had a policy of working with artists only once. My solution: a triptych. That way we would get three collaborations in one and make the most of the time we would work together. The opera would be the finale. *The Marfa Triptych* was the result.

The first part [*The Country and Western Big Band Suite*] was a musical portrait of West Texas in the form of a suite for a big band that included players from three very different backgrounds: country, jazz, and classical. The second [*The Desert*] was a live score to the Chihuahuan desert sunset and moonrise, for solo piano and percussion. The audience was bussed to the middle of the desert, seated in a circle around me, and invited to shift as the sun and moon did while I played. The third was *Pancho Villa from a Safe Distance*, an opera for two singers and mixed ensemble, created in collaboration with Lagartijas Tiradas al Sol from Mexico City and my partner, Shawn Sides, from the Rude Mechs.

Ultimately, Ballroom offers a place to stretch artistically, experiment, and try to work to your full potential, all with generous and graceful hospitality, an audience ready for anything, and minimal distractions. With our current urban versus rural political and cultural divide, we need more towns like Marfa, where

For the first installment of *Marfa Triptych* I was highly influenced by watching the Marfa sunset from a bench on the west edge of town. The process is hard to explain. Some is overt and some is very subtle. When composing I would think of different experiences I had and then try to translate them into music. I'm trying to create the soundtrack of West Texas. The band I put together for the piece is a bit of an Austin all-star band. Redd Volkaert is one of the greatest living country guitarists. Ricky Davis is one of the leading experts on Sho-Bud pedal steel guitars; he repairs instruments from the defunct but highly regarded brand. John Mills is a professor of saxophone at the University of Texas at Austin and a fantastic live and studio player, having recorded with everyone from Aretha Franklin to Jonny Greenwood. Adam Sultan's guitar work was featured in the film *Before Midnight*. Alexis Buffum was the lead violinist for the film *Bernie*. Ruby Jane is fiddler, singer, and songwriter, and one of the greatest young talents to hit the Austin scene in a long time. Utah Hamrick and Jeremy Bruch are the incredible players that form the foundation of my band, and we play together all the time. It's a great band that I feel lucky to play with. Since we performed the first installment of the trilogy, I continued to do interviews, explore West Texas nature as well as its history, interview residents, and keep finding myself deeper in love with the region. We went to Big Bend Ranch State Park on the last trip and found some very out-of-the-way spots that I'd love to play music in someday. That is the most beautiful area of Texas, and the history is deep and complicated. The border is blurry and it's hard to explore Texas without also exploring Mexico and its history and culture.

Interview, Graham Reynolds and Jessica Hundley, December 10, 2022.

A TRIBUTE TO THE MARFA TRIPTYCH:
THE DESERT
R. MICHAEL BERRIER

West Texas towns peter out.
The blacktop turns to caliche.
In the end, one last house.
The garden fence.
And then the vast emptiness.
Of West Texas,
Of Mimms Ranch.
Of the desert.
And so we meet at that edge of reality.
Gather with strangers,
And ride in yellow school buses.
Along the ranch road until we stop,
And look up to the ridge.
Something happening there on the Marfa Plateau.
And we walk.
The light is fading, not fast.
We see,
The perfectly round architecture of concrete.
A smooth bench, an alien circle.
And inside, Graham stands among the instruments,
From which he will pull a cacophony,
Edging to serenity. ▷

Sent to Ballroom Marfa following the performance. Berrier is
an artist and writer.

Graham Reynolds, *The Marfa Triptych: The Desert* performance, 2014.

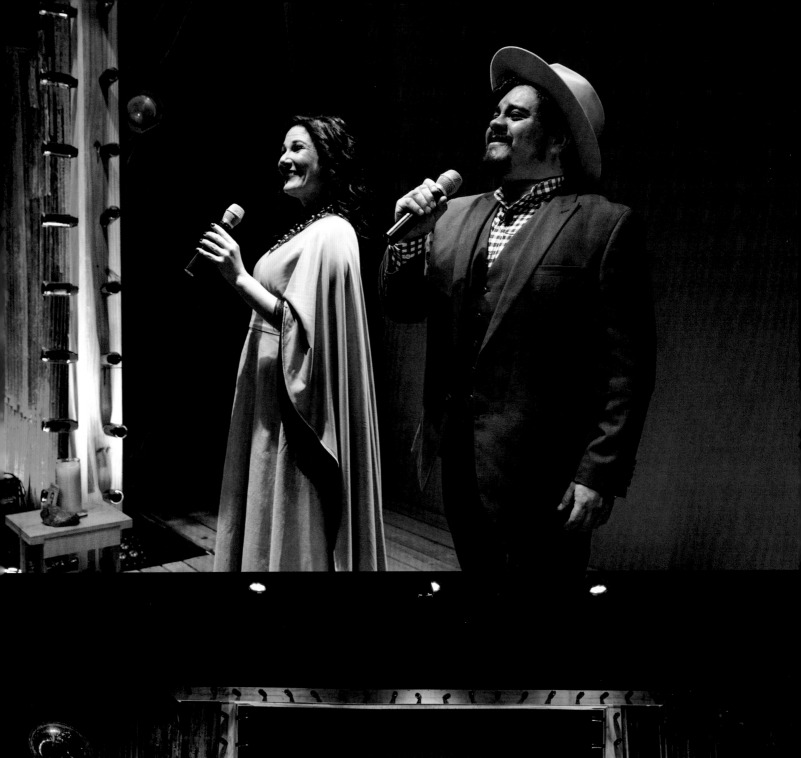
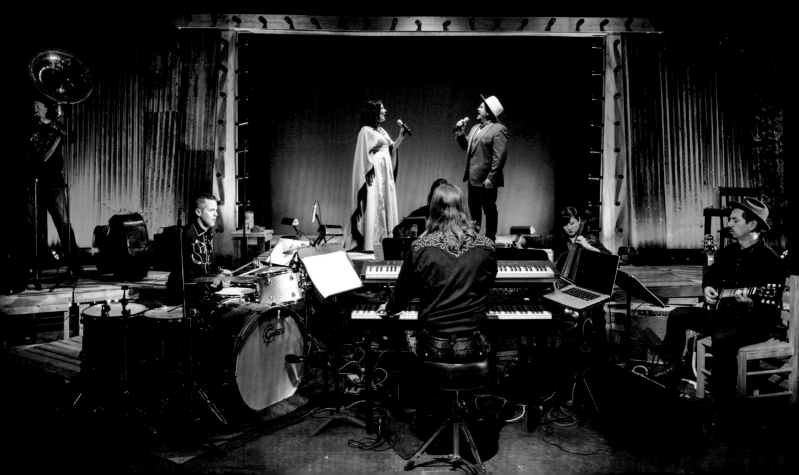

"Villa was nowhere and everywhere. He left the revolution on his own terms. He dreamed of living in peace, no longer having to flee."

Graham Reynolds, *The Marfa Triptych: Pancho Villa from a Safe Distance*, performed at the Crowley Theater, Marfa, 2016.

PANCHO VILLA FROM A SAFE DISTANCE

Pancho Villa from a Safe Distance is the epic closing chapter in *The Marfa Triptych*. The opera is an insightful examination of the Mexican and Mexican American impact on the culture and politics of West Texas, contributing to the current conversation about borders and the limitations of the concept of delineated states.

Exploring facts from Francisco "Pancho" Villa's biography while also examining the mythology surrounding him, the opera asks what Pancho Villa means to Mexican and American culture and where these meanings intersect and conflict. The opera brings together artistic collaborators from both sides of the river to engage in a borderless conversation about the shared history between Mexico and the United States.

Reynolds experimented with a hybrid of composition and production techniques while leading an eight-piece ensemble to bring Lagartijas Tiradas al Sol's fascinating libretto to intensely visceral and intimate life. These pieces were fragments of some versions of Villa's life. Reynolds and his collaborators consulted stories, testimonies, interviews, films, corridos, novels, news articles, and biographies. The opera is an attempt to better know Villa, who was perhaps the most entertaining, multifaceted, wrathful, and sentimental leader of the Mexican Revolution; but the opera is also an attempt to connect him with our present, with the freedom of a man from the North who knocked down every border. The opera's pieces are an evocation, a prayer, and a tribute.

Reynolds was taken by Pancho Villa's story. Francisco Villa was born in the Mexican state of Durango, where he was baptized Doroteo Arango. He knew firsthand what poverty meant in the countryside, where landowners had unlimited power over the life of a peasant who lived on and worked their farms and ranches, as he did. Villa escaped this life. He told many different tales of how he ran away. In one of the best-known, Villa wounded a landowner when he caught him trying to rape Villa's sister. Villa fled to the mountains and became a cattle thief and a highwayman. Eventually he ended up in Chihuahua, where some say he worked as a butcher.

A key figure in the Mexican Revolution, Villa's life as an outlaw was his training for the war that found him. Villa is said to have lived endless adventures. He made controversial decisions, was married many times, had many children by many women, fought many battles, and inspired countless people. He also assembled a great army: the Northern Division.

Crossing frequently from Juárez to El Paso to secure weapons, Villa relied on his charisma to negotiate with dealers across the border. He knew the borderlands and had a good relationship with its people, until one day he was betrayed when his contacts allied themselves with Álvaro Obregón, Villa's fiercest enemy. Filled with fury, Villa attacked the town of Columbus, New Mexico. While he was pursued and wounded, he was never captured. They say that while he was hidden, he listened to the songs of the African American soldiers who were sent to Mexico to apprehend him. It's said that their songs moved him to tears.

Villa was nowhere and everywhere. He left the revolution on his own terms. He dreamed of living in peace, no longer having to flee, of not having to look over his shoulder in fear. Eventually he retired to run a farm alongside Los Dorados, his most trusted men. Death found him in Parral, Mexico, where he was betrayed, ambushed, and murdered, long after the war had ended. □

DESERT SURF FILMS

DAVID ELFICK, SAM FALLS, ALBY FALZON,
IAN LEWIS, JOE ZORRILLA

In the summer of 2015, Ballroom Marfa presented Desert Surf Films, curated by Executive Director Susan Sutton. Screened outdoors in the courtyard were two iconic surf films by Alby Falzon and David Elfick: *Morning of the Earth* (1972) and *Crystal Voyager* (1973), which was written and narrated by surfer, photographer, and filmmaker George Greenough. At the time they were made, these films represented the beginning of a surfing revolution in terms of both culture and technology. Shown alongside these films were contemporary short films *Endless Bummer* (2009) by Sam Falls and Joe Zorrilla, and *The Adventures of NASASA* (2015) by Ian Lewis. Before and after the screenings, Daniel Chamberlin of Marfa Public Radio's Inter-Dimensional Music programmed dolphin-themed New Age, surf-folk, and Balearic psychedelic music. *Stay Golden*, a zine compendium for the program designed and edited by Hilary duPont, Liz Janoff, and Ian Lewis, featured a collection of artwork, prose, poetry, and other surf-informed ephemera, including contributions from Joshua Edwards, Sam Falls, Rae Anna Hample, Nicki Ittner, Tim Johnson, Eileen Myles, Caitlin Murray, Brandon Shimoda, and others. ▷

RIDE ON
SUSAN SUTTON

As a nod to Far West Texas's ancient history as an inland sea and in celebration of the wet summer months of our monsoon season, Ballroom Marfa presented Desert Surf Films. We selected two visionary films from the early '70s, Alby Falzon and David Elfick's *Morning of the Earth* and Elfick's *Crystal Voyager*. I was introduced to these films alongside others from the era—see: *Salt Water Wine* (Rich, 1973), *Super Session* (Jepsen, 1975), and *Tubular Swells* (Hoole & McCoy, 1975)—in a course taught by video artist Diana Thater at the San Francisco Art Institute. These surf films were sandwiched between works from Fassbinder and Godard, Thater conspicuously recognizing them as part of a continuum of challenging avant-garde film. Where the cutting-edge European filmmakers of the '70s were creating inspiring, if difficult, work, these surf films were taking a similarly innovative approach to editing, narrative, and filmmaking, but the end result is one of pure pleasure. These films capture a moment when both surf and film technology were changing. New camera techniques paired with faster, sharper surfing styles were able to successfully convey the new and experimental nature of surfing through film. George Greenough, the brilliant surfer, inventor, and engineer who is the subject of *Crystal Voyager*, says in the film, "You might be in there for a few seconds, but what goes on in your head lasts for hours." The way this temporal suspension is captured by the nonlinear editing styles, Greenough's breakthrough filming of the inside of a wave, and forays into the psychedelic on the shore, all communicate the ephemeral experience of riding the waves. *Crystal Voyager* has since become one of my favorite films, George Greenough a secret hero. And I don't surf. I've got a shark phobia (except for Food Shark). These films make it possible to experience the pleasures of surfing and affirm the innate value of fun, whatever form it takes for you. What stays in your head for hours is a sense of the true essence of pleasure, summed up perfectly by the title of Greenough's 1969 film *The Innermost Limits of Pure Fun*.

Susan Sutton was executive director of Ballroom Marfa.

MARFA
EILEEN MYLES

If I
stop to get
you I've
got nothing
wires around
god yet when
I'm passing you're the
the crown
of the
desert
making me thump ice
blue
cousins
these missing lakes
where
dinosaurs
grew & did-
dled. I'm driving one way
I'm driving
back I
sing
of your
giant rag
ed cap
taunting
the sky I
am so
young &
you're
old, so
ancient

Written for Stay Golden, *the Desert Surf Films zine, 2015. Eileen Myles is a celebrated poet, writer, and journalist.* □

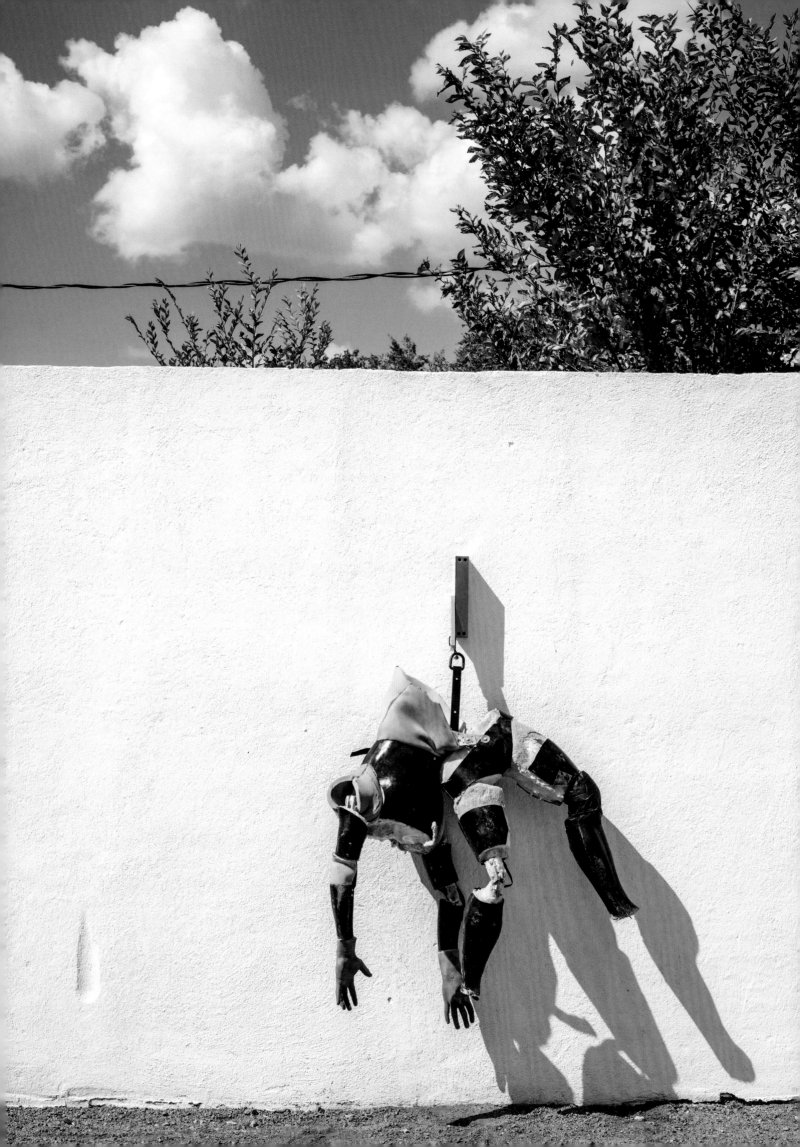

ÄPPÄRÄT

ED ATKINS, TRISHA DONNELLY, MELVIN EDWARDS,
CÉCILE B. EVANS, JESSIE FLOOD-PADDOCK,
ROGER HIORNS, SOPHIE JUNG, LEE LOZANO, MARLIE MUL,
DAMIÁN ORTEGA, CHARLES RAY, SHIMABUKU, PAUL THEK

Roger Hiorns, *A Retrospective View of the Pathway (Falling Sculpture)*, 2010–15.

Curator, writer, and editor Tom Morton guest organized *Äppärät* in 2015. The hand is a central motif, and the tools it touches, holds, and uses. From the Stone Age to the digital age, from the prehuman to the posthuman, *Äppärät* suggested not only a neglected history of touch and of tools, but also how this might help us to arrive at what philosopher Roland Barthes called "a certain philosophy of the object." During *Äppärät*'s run, a commissioned short story by Ned Beauman—author of the novels *Boxer, Beetle* (2010), *The Teleportation Accident* (2012), and *Glow* (2014)—was broadcast on Marfa Public Radio KRTS 93.5 FM through December 2015 and January 2016. Entitled "Workspace Ergonomics Assessment," the story explored tool use among animals, from ravens to crabs, over five installments. ▷

This is a show about the mammalian hand, and the tools it touches, holds, and uses. Taking its title from the name of a fictional, post-iPhone device at the center of Gary Shteyngart's 2010 near-future novel *Super Sad True Love Story*, *Äppärät* is concerned with labor, play, and the uncertain zone between the two; with the extension of the body, and the self, through technologies ancient and contemporary; with things (to borrow Martin Heidegger's formulation) "present-at" and "ready-to" hand; with compulsion and with death.

Äppärät opens with Jessie Flood-Paddock's *Just Loom* (2015), a wall painting–cum-sculpture based on an illustration of a worker operating a loom from Denis Diderot's *Encyclopédie* (1751–72), one of the first attempts to record and systematize all human knowledge in published form. Writing on this image in his 1964 essay "The Plates of the Encyclopedia," Roland Barthes observed that the operator of this proto-industrial machine is "not a worker but a little lord who plays on a kind of technological organ [who] produces an extremely fine web." *Just Loom* combines this Enlightenment-era depiction of labor (or is it leisure?) with a very twenty-first-century sculptural tableau, in which a bolt of mesh-like Kevlar fabric becomes the ground for several rubberized casts of the artist's hand and forearm. Looking at Flood-Paddock's work, we might think of a contemporary "prosumer" prodding at his or her smartphone, leaving a meniscus of greasy residue on its screen as they do work disguised as play.

From the Stone Age to the digital age, from the prehuman to the post-human, *Äppärät* suggests not only a neglected history of touch, and of tools, but also how this might help us arrive at what Barthes termed "a certain philosophy of the object." Originally conceived to hang from the ceiling of Sigmund Freud's study in Hampstead, North London, Damián Ortega's *The Root of the Root* (2011–13) is a sculpture formed from implements created by a community of chimpanzees in the Gashaka-Gumti National Park, Nigeria, gathered by the artist on a research trip in the company of a group of University College London primatologists. (While tool use is common in the animal kingdom, from insects to crustaceans and birds to monkeys, their symbolic use is restricted to the higher apes.) If we might read this work, as Ortega has said, as an index of how "the hand transforms nature," it is also a technological precursor to the objects displayed by Shimabuku in a pair of museum-like vitrines entitled *Oldest and Newest Tools of Human Beings* (2015). Here, Neolithic hand axes are set beside web-enabled Apple products of the same dimensions: tools created by members of the same species, albeit millennia apart.

The artist's deadpan presentation inevitably invites questions: Which technology might be more usefully substituted for the other? Which will persist longer? Which constitutes the greater evolutionary leap? In the Ballroom's North Gallery, Marlie Mul presents a pair of sculptures that take the form of oversized steel grilles of a type commonly used by street smokers to stub out their cigarettes. Burned, ash-smeared, nicotine-stained, and stuck with discarded butts, these compositions prompt thoughts about our addiction to handheld devices (whether they deliver nicotine or a constant stream of data), and their inevitable passage from pristine objects of desire to (self-)disgusting trash. Mul has also created an on-site intervention at the Ballroom, *Cigarette Ends Here* (2015), using spent cigarettes gathered from the Marfa bar the Lost Horse.

Hung at the artist's eye level, Melvin Edwards's *Lynch Fragments* sculptures reconfigure vicious-looking pieces of hardware into forms that recall both histories of (sometimes enforced) labor and exhibits in an ethnographic museum. His key piece, *Ogun Again* (1988), takes its title from the Yoruba spirit of metalwork (also celebrated in the Caribbean Santería and Vodun traditions), its components speaking, as the artist has said, of "how Ogun is related to all tools." If Edwards's sculptures suggest that human technologies might be imbued with a kind of quasi-animist life force, so too in its way does Lee Lozano's painting *No title (hammer diptych)* (1963–64). Here, an anthropomorphic hammer appears to engage in an impossible autoerotic act: its bulbous head penetrating the narrow cleft between its own claws. We get to thinking of cold, still metal transformed into hot and busy flesh—of tools behaving like bodies and bodies behaving like tools.

The hand, in *Äppärät*, is a central motif, giving many of the works their scale, and can be imagined as a kind of mouse cursor, manipulating information on the interface of the show. (The Latin word *cursor* translates as "runner" or "errand boy," a kind of spatial and temporal auxiliary.) At once the silvered remains of a martyred saint and an amputated cyborg's limb, Paul Thek's Untitled (from the series *Technological Reliquaries*, ca. 1966–67), points to enduring fantasies of the meeting of man and metal, and of how technology might protect, preserve, or even reanimate our fragile bodies. While Charles Ray's sculpture of an avian embryo, *Handheld Bird* (2006), does not feature the cupped palm suggested by its title, it nevertheless provokes us to meditate—through linguistic suggestion, and more importantly through its sequencing of form and space—on the indivisibility of the holder and the held. Equally enigmatic, Trisha Donnelly's photograph *The Hand that Holds the Desert Down* (2002)—a work making its second appearance at Ballroom, following its inclusion in the 2008 group show *Every Revolution* ▷

Installations view with, clockwise from top left: Cécile B. Evans, *Hyperlinks or It Didn't Happen*, 2014; Ed Atkins, *Even Pricks*, 2013; Melvin Edwards, *Ogun Again*, 1988; Marlie Mul, *Air Vent / Butt Stop (Passing)*, 2015 and *Air Vent / Butt Stop (Friend)*, 2015; Paul Thek, Untitled (from the series *Technological Reliquaries*), ca. 1966–67; Lee Lozano, *No title (hammer diptych)*, 1963–64.

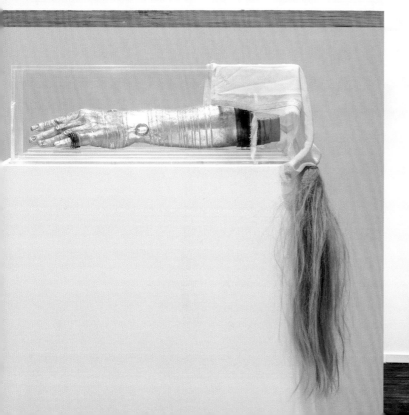

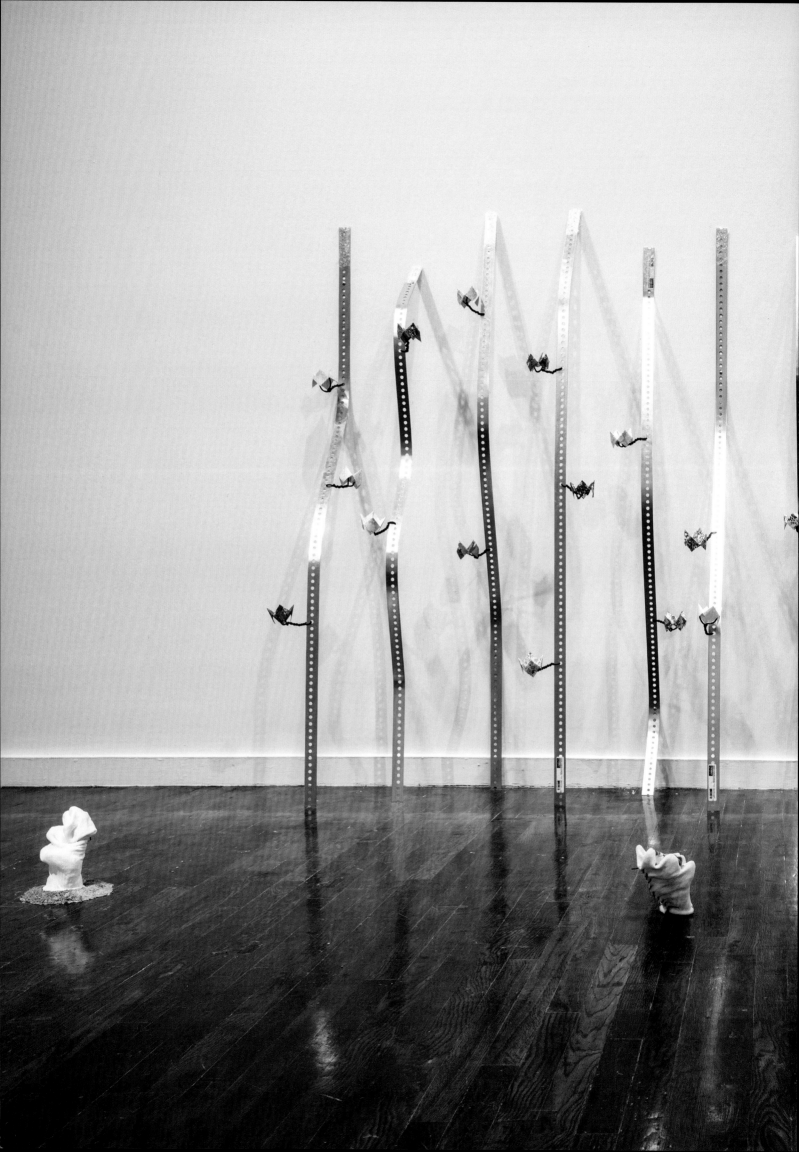

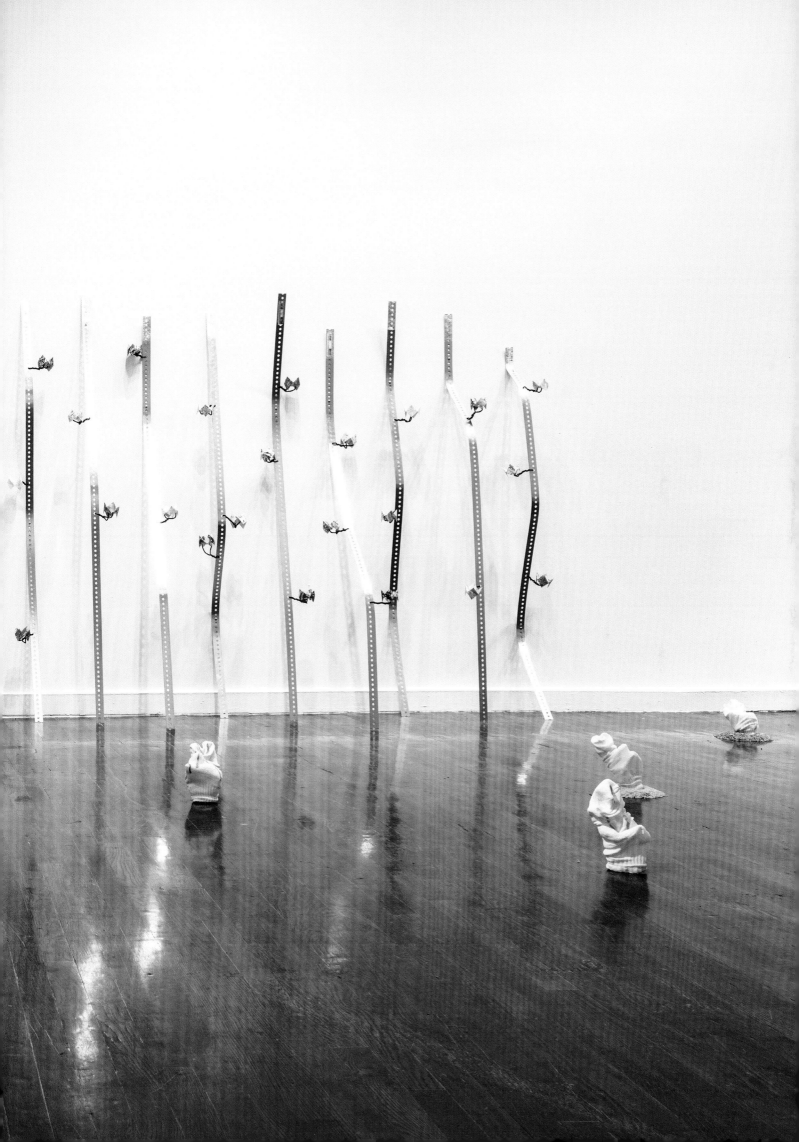

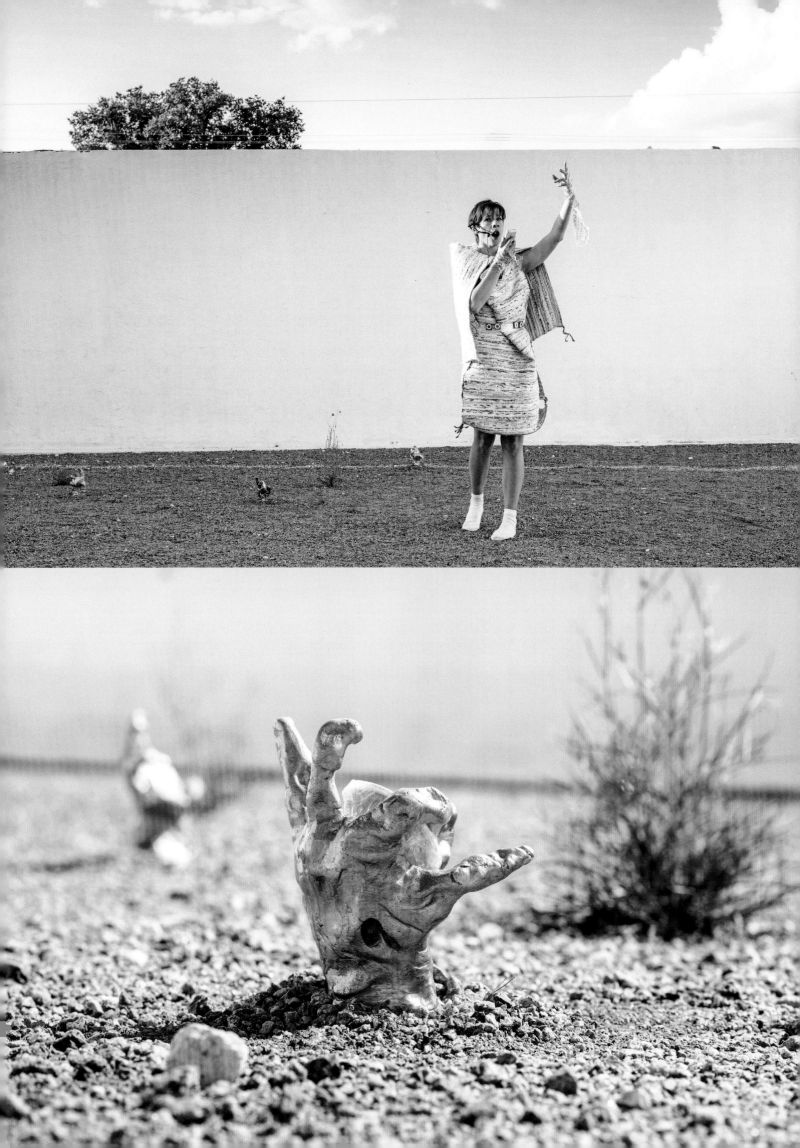

Is a Roll of the Dice—is a close-up of the lifeless stone back paw of the Great Sphinx of Giza. We might ask ourselves why the artist has insisted that this leonine appendage is a "hand," and what miracle or disaster would take place if it were, against all logic, to be raised. In Sophocles's *Oedipus Rex* (ca. 492 BCE) the Sphinx's primary tool—what makes her part human—is, of course, language. Is Donnelly's title a riddle, then, or something closer to a spell?

In Roger Hiorns's Untitled (2011), the artist invites visitors to Ballroom to chill their hands in a domestic freezer, the better to contemplate a series of paintings made with liquidized cows' brains. Performed on the exhibition's opening night by a naked person, this is a ritual of uncertain purpose. Viewing Hiorns's canvases, our numb digits slowly warming, we might interpret the washes of brain matter as an allusion to both the blinking out of consciousness at the moment of death and incidences of Creutzfeldt-Jakob disease in abattoir workers exposed to bovine cerebral tissue—an effacement of the self by the violence of capitalism. In Ballroom's courtyard, Hiorns presents a newly commissioned work, *A Retrospective View of the Pathway (Falling Sculpture)* (2010–15). Here, a headless figure—formed from a prosthetic used in a recent high-profile action film and stuffed with pages from Martin Heidegger's *Being and Time* (1927)—is suspended from an electromagnet. At certain intervals, the magnet cuts out and the figure plunges to the ground. One coordinate here might be Heidegger's contention that the human subject (or Dasein) is "thrown" arbitrarily into the world. Another might be Søren Kierkegaard's concept of the "leap of faith."

Sophie Jung's new body of sculpture and performance work made in response to *Äppärät* creates an associative chain between—among other seemingly disparate phenomena—handheld origami fortune-telling devices; handwoven (and hence "unique") IKEA rugs produced in the developing world; hand gestures that indicate money, salt, resistance, and digital navigation; sock puppetry, online and offline; "life hacks" involving fixing drowned iPhones with dry rice; "deskilling" in manual labor and in art; repetitive strain injuries; toxic "e-waste"; and Lady Macbeth's "Out damned spot!" speech. Jung's sculptures are accompanied by spoken narratives, to which visitors are invited to listen on a series of iPod shuffles mounted on twin newspaper ads for outmoded cell phones. At the opening of *Äppärät*, she will perform the work *Z* (2015).

In Ed Atkins's high-definition CGI film *Even Pricks* (2013), we see human and simian thumbs inflate and deflate, seemingly operating as an index of (digital) attention, the compulsive and destructive "economy of like." Snatches of music, speech, and invented promo slogans interrupt what the artist has called

his "super-viciously artificial" imagery, while the real makes a return of sorts both in the film's atmosphere of lingering, subcutaneous depression, and in its meticulously animated lens flares and moments of fuzzy "cinematography"—reminders of a tool, the camera, that has played almost no part in its creation.

Cécile B. Evans's film installation *Hyperlinks or It Didn't Happen* (2014) also explores questions of how new technologies impact representation, and on what constitutes a self. At its center is PHIL, a CGI rendering of the late actor Philip Seymour Hoffman, who haunts a world he thought he'd departed like a restless ghost. Featuring a cast of very twenty-first-century lost souls—from a Reddit user who claims his deceased girlfriend still posts on Facebook to an invisible woman permanently slicked with green screen paint—this is a work about the physicality of data and the digital afterlife. □

Excerpt, exhibition essay. Morton is a writer, curator and contributing editor of Frieze, *based in Rochester, UK.*

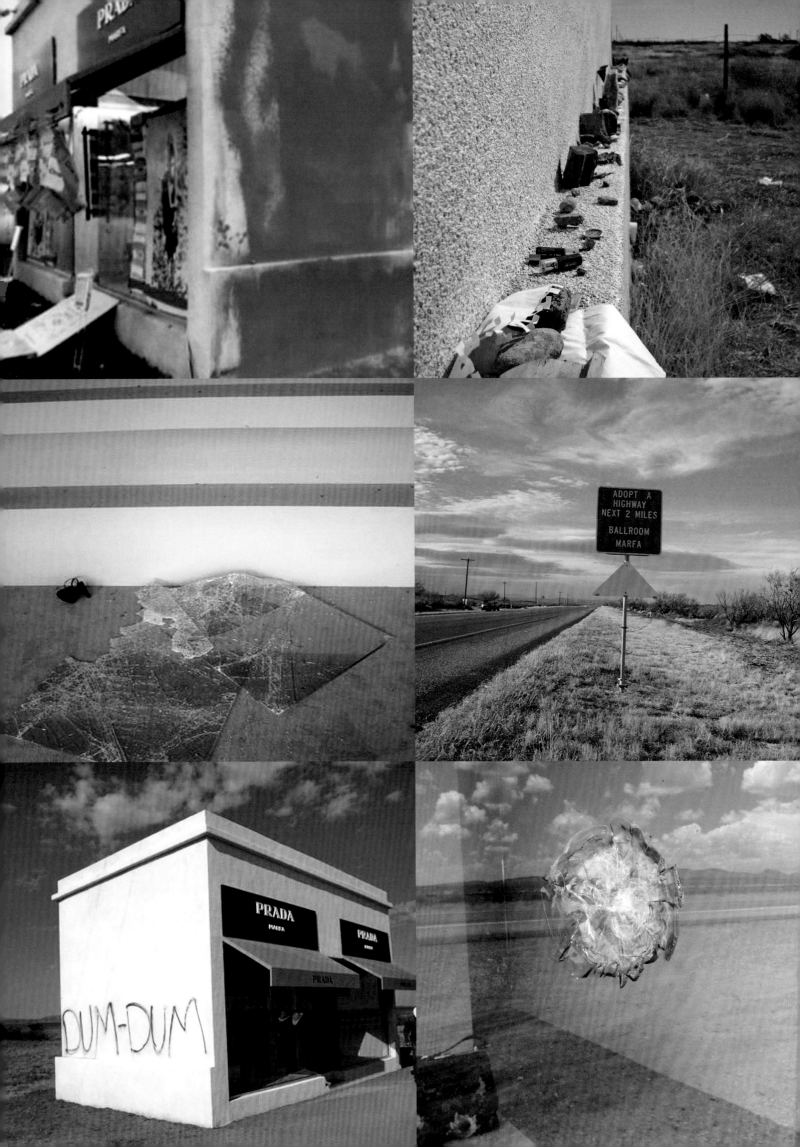

PRADA MARFA

2013–2016

In 2014, *Prada Marfa* was granted museum status, allowing the work to remain along US Highway 90 in accordance with the regulations of the Texas Department of Transportation (TxDOT). This official designation was precipitated by the installation of another outdoor artwork nearby in 2013.

Designed by Richard Phillips and commissioned by Playboy Enterprises, the sculpture featured the trademark bunny logo atop a forty-foot pole towering above a black-spray-painted 1972 Dodge Charger parked on a concrete platform. Playboy was given forty-five days by TxDOT to remove the piece, on the grounds that the transportation department had not issued a permit to display an advertisement. Playboy took the case to court, which drew *Prada Marfa* into the controversy with claims that it, too, was a roadside advertisement. Even State Representative Poncho Nevárez (D-Eagle Pass) joined the fray, writing in a letter to TxDOT in support of *Prada Marfa*'s existence, "I would disagree that an art installation that has been present for the last eight years is suddenly considered illegal when looked at relative to the Playboy Enterprises installation."

After many conversations and some negotiation, it was deemed that *Prada Marfa* was not an advertisement but rather a museum with a single artwork on leased land. John Barton, TxDOT's deputy executive director, wrote in a statement that the agency always appreciated *Prada Marfa*'s "cultural significance" and was "pleased that the agency was able to work together with Ballroom Marfa to preserve the iconic *Prada Marfa* for the enjoyment of current and future Texans."

Ballroom continues to organize multiple cleanups annually of the two-mile-long stretch of Highway 90 adjacent to *Prada Marfa* as part of the TxDOT's Adopt-a-Highway program. ▷

A REFLECTION BY YVONNE FORCE VILLAREAL

I would say there are many things about *Prada Marfa* that I did not expect. The first is that it has gained a museum status. I never expected *Prada* to gain the status of a museum. You know, we did this project, "Save Prada," when the piece was threatened by the Texas Department of Transportation. And then we basically had to make them understand that it was not commercial, there was no commercial link, and it was not an advertisement for Prada. That in itself it was a single art exhibition and therefore Texas Department of Transportation gave us museum status. So that was one of the most unexpected things. And it has since become a destination for cultural pilgrimage.

When *Prada Marfa* debuted, Instagram was still years away. And in 2010, when Instagram started, it began to appear on the grid and then it became international. Before that, it was more known in the art world, in the local community—a very important project. And then with social media, it became really a pop art icon. Beyoncé did her favorite famous jump there, right? It's been on *The Simpsons*. It goes on and on. Every year it's becoming more of an iconic international public artwork.

I had visited Marfa since the late 1990s and I started realizing in the early 2000s that it would be amazing to do public artwork in Marfa. I had recently cofounded Art Production Fund, and Art Production Fund's mission is to produce ambitious public artwork and expand the audience for contemporary art. And we wanted to—at that time, very early on—do projects both in New York, where we were located, but also in other places. So, when Elmgreen and Dragset came to us in 2003, they showed us an incredible rendering of this sculpture in the middle of the desert called *Prada, Nevada*, and we were blown away by the power of this image.

I had literally just come back from yet another trip to Marfa, and I'm like, What about *Prada Marfa*? And they thought that that was even more interesting than *Prada, Nevada* because of the relationship to minimalism and art. . . . So when we launched it with Ballroom—well, first of all, we knew we needed a partner, as we loved the idea of expanding the platform of public art through strategic partnerships.

So I asked Virginia and Fairfax if Ballroom Marfa would consider being commissioners and partners on this project. And they went to their board, and everybody agreed it was a great idea. Ballroom was newly established. We loved the idea of people driving by and being so awestruck by this surrealist image, almost like a mirage of this Prada store, this hyperrealistic sculpture of a Prada boutique in the middle of the desert. That was a real turn-on, the idea of that surprise. But we didn't think there would be the pilgrimage.

What has happened is that the pilgrimage is a reality now. It's like cultural tourism, I think at the highest level, is what *Prada Marfa* represents. It has survived many acts of vandalism— shooting, spray-painting, and destruction—taking, you know, all the objects out two days after it was opened. It has been through so much and has gained both local and international support, love, respect. And it is a total draw for people all over the world and on many people's bucket lists to go see *Prada Marfa*.

I think of the early 2000s as a new era. Art Production Fund and Ballroom Marfa, both were cofounded by two women. I saw artists struggling to make ends meet, to realize their visions. The late 1990s and early 2000s was an era of experimentation, when a lot of artists were forging their vision, but didn't have as much support. We realized that there needed to be more support . . . outside of the gallery [system], and more support for all types of art and artists.

I had just met Fairfax and Virginia when we had been in Marfa, and we were very excited about Ballroom Marfa. I looked at what they were doing in parallel with what we were doing with Art Production Fund. There were not so many organizations that were doing outside-of-the-box cultural programming. But in Ballroom's case we saw music, and really looking at artists from Mexico and the people who make up the population of Marfa. Looking at both really local and international artists. Ballroom paved the way for a lot of this thinking. There was a lot of energy because it was this new era. It was this idea of, Let's make this world a better place. Let's empower artists. Let's put creative visionaries ahead. And let's get funding for all these projects that really will be inspirational and empower communities.

With Art Production Fund—and I know in Ballroom Marfa too—we weren't looking at the old models. It was a new wave of thinking about how to make things happen. Ballroom and Virginia and Fairfax were putting a lot on the line to take this project on as partners with us, because you never know what to expect. We had to put our hearts into it, but we also had to be detached and let our beautiful child grow into this super-famous but sometimes fragile art that everyone now shares in.

I really see the piece as our child. . . . When you both produce and curate work, you are responsible for taking care of the artwork and also helping to educate and bring to the world the meaning of the work, and also be a protector and a custodian.

As *Prada* ages, it becomes more powerful in the important message that it brings forth—and in its mystery, because it is imbued with mystery. I want it to continue to grow, and through its experience in the public realm, become wiser and teach people more about the power of public art. It's been the greatest honor of my career to be part of this. It was dream-team work to realize something so important. □

Prada Marfa has become a site of pilgrimage well documented on social media.

Interview, Yvonne Force Villareal and Daisy Nam, June 3, 2023.

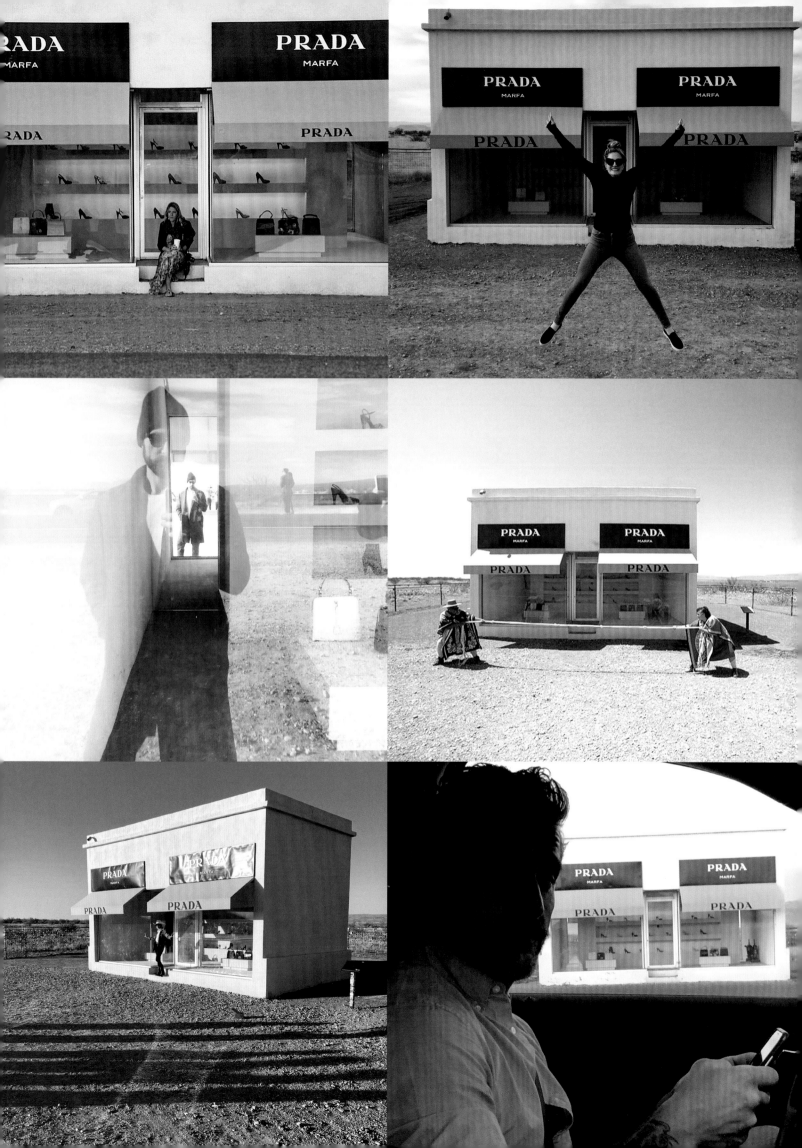

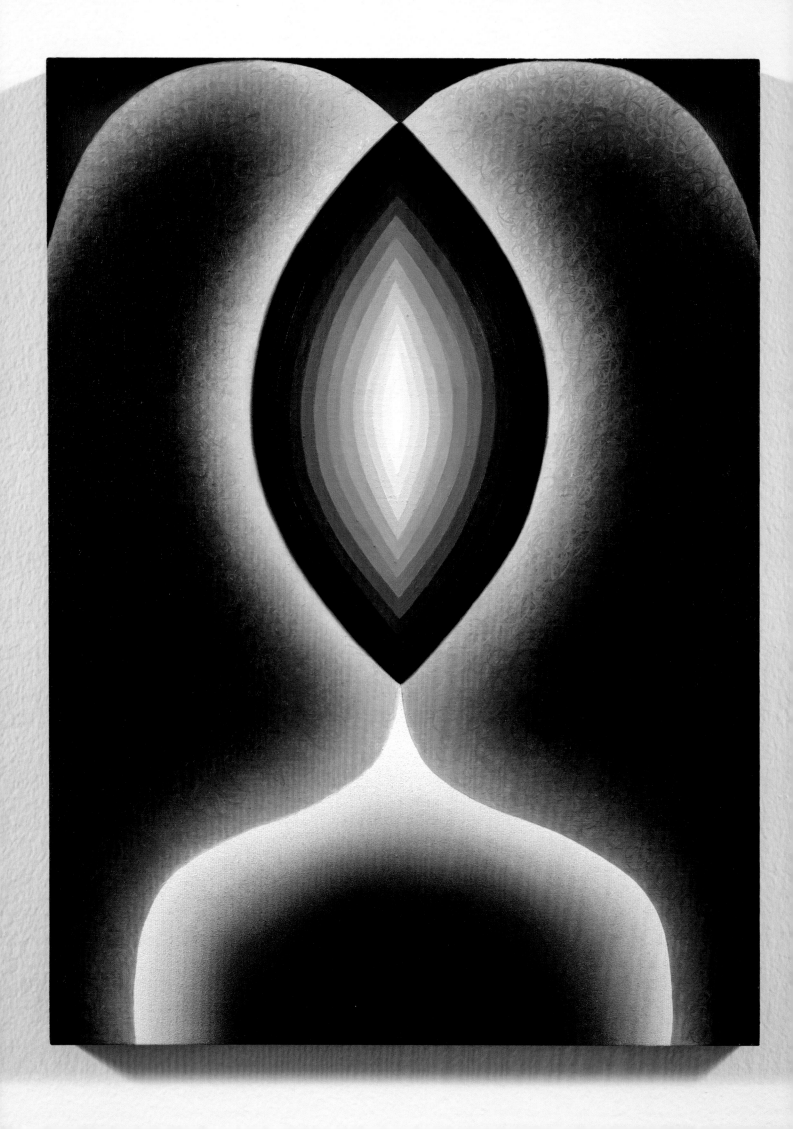

AFTER EFFECT

ARTURO BANDINI, DAN COLEN, OSKAR FISCHINGER, LOIE HOLLOWELL, THE TRANSCENDENTAL PAINTING GROUP, (WITH KELLY AKASHI, JOSH CALLAGHAN, MARTEN ELDER, JOHN FINNERAN, KATHRYN GARCIA, S GERNSBACHER, MARK HAGEN, RICK HAGER, DREW HEITZLER, YANYAN HUANG, WHITNEY HUBBS, SOFIA LONDONO, CALVIN MARCUS, SARAH MANUWAL, RONI SHNEIOR, BARAK ZEMER)

After Effect, a group exhibition curated by Fairfax Dorn and Laura Copelin featuring immersive artworks across media that ranged from the cosmic and psychedelic to the sensual and visionary, appeared at Ballroom Marfa in 2016. It presented historical paintings and film from the 1930s and '40s alongside works by contemporary artists that address notions of the sublime, mortality, landscape, the body, and various modes of abstraction.

Dan Colen produced a new triptych of skyscapes based on stills from the 1940 Walt Disney film *Fantasia*, continuing his exploration of spirituality and mortality via pop culture. Achieved through an arduous layering process, the cloud paintings evoke both the cartoon and the Romantic sublime. Loie Hollowell's abstract geographies of bodily forms—vaginas, nipples, phalluses, tongues—in vivid oil on linen canvases radiate with texture and symmetry. Hollowell draws inspiration from Catholic iconography and Gothic and Islamic architecture.

After Effect also featured historical works from members of the Transcendental Painting Group (1938–42), artists who figure prominently in Hollowell and Colen's lexicons. Oskar Fischinger's *Radio Dynamics* (1942), a silent animated film in which rhythmically edited abstract forms ebb and flow, is just one example of his influential role as the father of the visual music tradition.

In Ballroom's courtyard, Arturo Bandini hosted two shows-within-the-show: *Vapegoat Rising* and *Dengue Fever*. These micro-exhibitions play with *After Effect*'s transcendental themes. *Vapegoat Rising*, described by the artists as a "percolation of fog and rock," featured work by Josh Callaghan, Kathryn Garcia, Mark Hagen, Rick Hager, Yanyan Huang, Whitney Hubbs, Sofia Londono, and Barak Zemer. *Dengue Fever* functioned as "a sort of Henri Rousseau delirium, a jungle of feeling, and a landscape turned inwards," with work by Kelly Akashi, Marten Elder, John Finneran, S Gernsbacher, Drew Heitzler, Sarah Manuwal, Calvin Marcus, and Roni Shneior.

From the cosmic to the corporeal, the exhibition's works evoked a transformative aesthetic effect—showcasing a spectrum of sublimity across mediums and revealing the resonances that exists between the artist's process and the viewer's experience. ▷

187

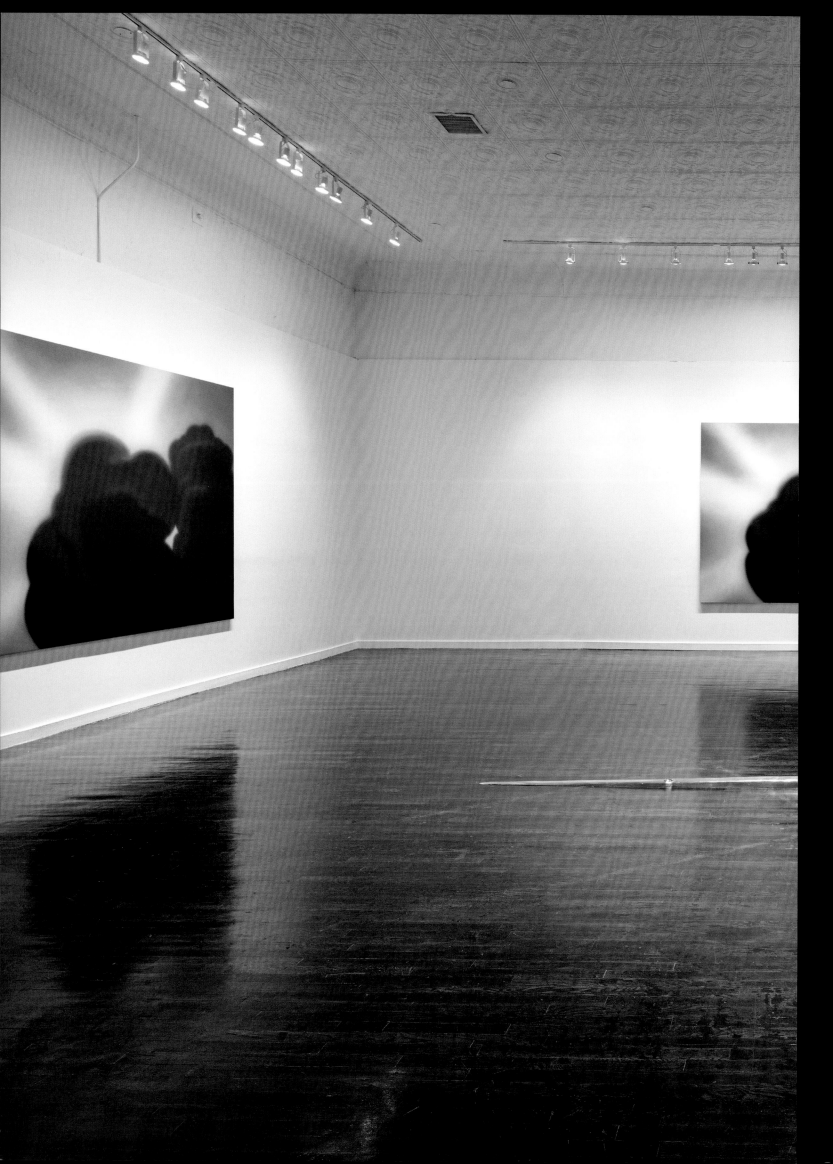

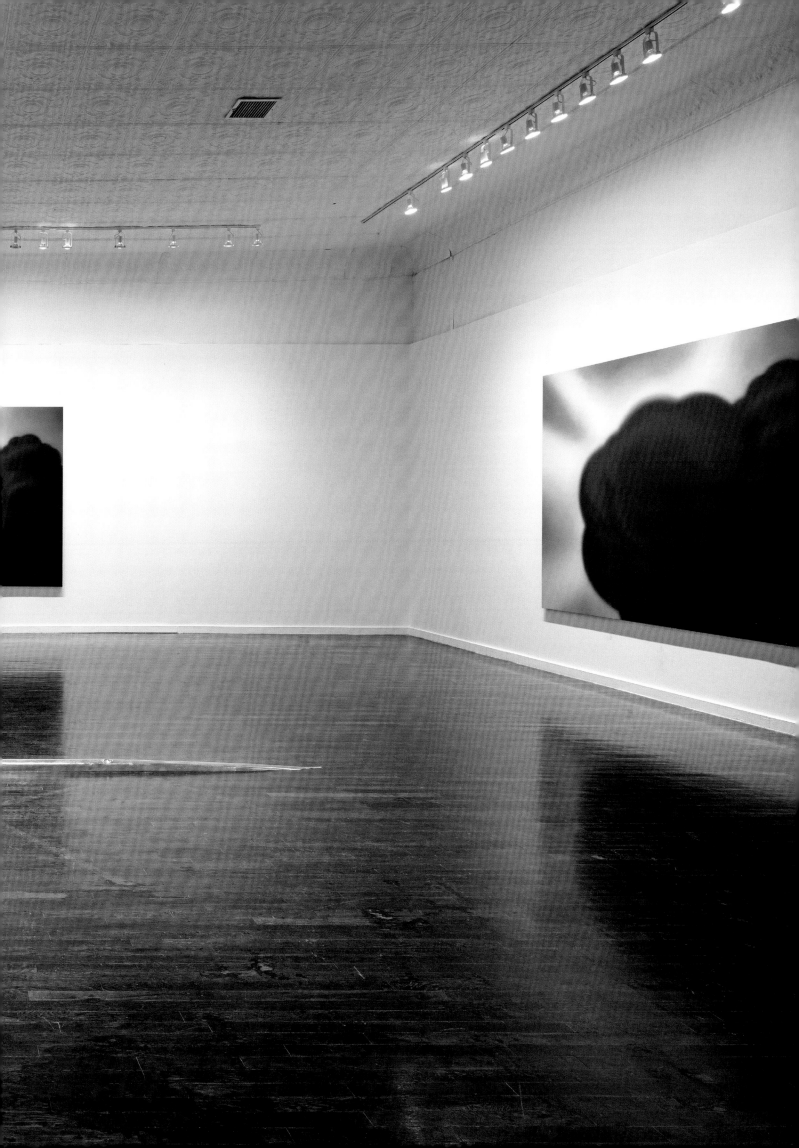

"The show has been one of the most fitting and exciting spaces for my work to be contextualized, seen, and understood."

A REFLECTION BY LOIE HOLLOWELL

After Effect was a show that paired me with some of my biggest influences in the Transcendental Painting Group, and the show has been one of the most fitting and exciting spaces for my work to be contextualized, seen, and understood.

One of my first impressions of Marfa was that it reminded me a lot of the landscape where I grew up: in Northern California farm country, with its vast and open views, big sky, and fresh air. It was in that setting [Marfa] that I remember one of my most vivid memories from my time there. My conversations at that afterparty with Fairfax Dorn and Marc Glimcher turned out to be life-altering. □

Correspondence, Loie Hollowell to Daisy Nam, August 4, 2022.

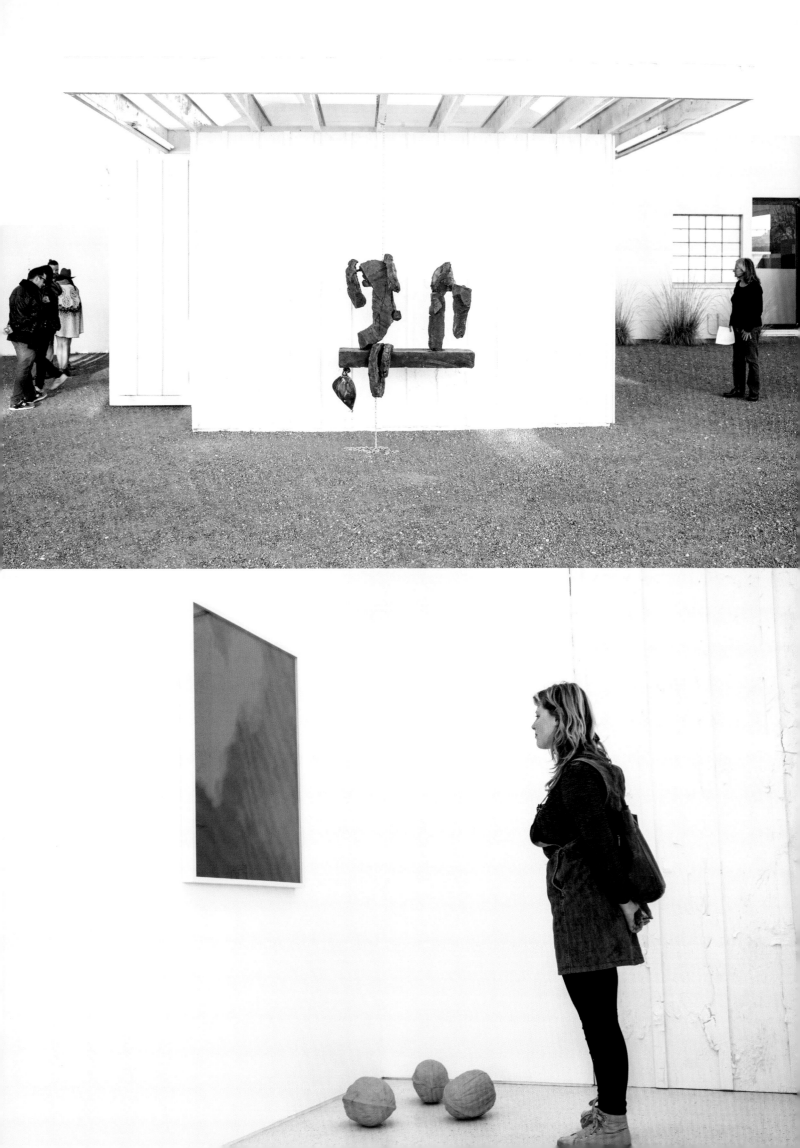

AGNES PELTON AND THE AMERICAN TRANSCENDENTAL

MARY WEATHERFORD

As part of the exhibition *After Effect*, artist Mary Weatherford delivered a lecture, "Agnes Pelton and the American Transcendental," introducing the work of Agnes Pelton, a member of the Transcendental Painting Group, which was active in New Mexico in the 1930s and '40s. As elucidated in its manifesto, the group's aim was to carry painting "beyond the appearance of the physical world, through new concepts of space, color, light, and design, to imaginative realms that are idealistic and spiritual."

In order to talk about the painter Agnes Pelton and the Transcendental Painting Group, we have to start with Ralph Waldo Emerson. He went to Harvard, became a Unitarian minister, and then coming out of that, he became a kind of metaphysical essayist and a public speaker. Essentially Emerson wrote that God is present in all things. Emerson pioneered the rejection of European learning and said that you could know God just as well or better walking in the woods of Concord or stocking the bookstacks at Harvard. His most famous [passage] is from *Nature*:

> *Crossing a bare common, in snow puddles, at twilight, under a clouded sky without having in my thoughts any occurrence of special good fortune, I've enjoyed a perfect exhilaration. . . . I feel that nothing can befall me in life,—no disgrace, no calamity, (leaving me my eyes,) which nature cannot repair. Standing on the bare ground,—my head bathed in the blithe air, and uplifted into infinite space,—all mean egotism vanishes. I become a transparent eyeball. I am nothing. I see all. The currents of the Universal Being circulate through me; I am part or particle of God.*

Emerson was one of the first to talk about Transcendentalism, and this movement had a profound effect on Pelton. She read Emerson, and kept copious notes on Transcendentalism, writing in her journal about the topic. It's important in understanding her paintings. . . . She had an interest in the occult and mysticism and sound, and a big theme of the work becomes silence.

Her mother was a musician, and opened the Pelton School of Music—and Agnes worked at this music school for a very long time, teaching. And that's when she starts putting color to sound, very early in her creative career. And then, in 1895, she goes to Pratt. . . . She graduates from Pratt and starts painting, again very influenced by Emerson. Nature becomes a theme in much of her work. In her journals she writes over and over describing the effects of moonlight and starlight and rainbows, and the feeling of the air and the sound of the birds. She studies at various art colonies in America and Europe, and then winds up with two paintings in the Armory Show in 1913. She became very involved in the suffrage movement, and joined the Association of Women Painters and Sculptors.

In 1917, she does another show at a gallery, where she has twelve paintings. She is still exploring nature, as well as looking at the relationship between color and music. She begins a lifelong interest in the occult. She studies theosophy and the work of Krishnamurti and Madame Blavatsky. She is inspired by various philosophies and Eastern religions. Pelton believed that there was a celestial body for every being on Earth. . . . She wrote that the paintings were like little windows opening into an inner realm.

Around this time, she met the astrologer and painter Dane Rudhyar and moved to the West to join what would become the Transcendental Painting Group. Dane introduced Pelton to astrology, and after that, she used astrology in her work. She began painting the Southwestern nature, skies, desert. Her work embraces a kind of Emersonian idea that all is one, everything gets leveled, that there's a feeling of oneness or vibration. She loved the desert—the sound of it, the colors. She would have loved Marfa. Pelton would have loved the quality of the air, the colors, the beauty. □

Excerpt, transcript of Weatherford's lecture, May 21, 2016

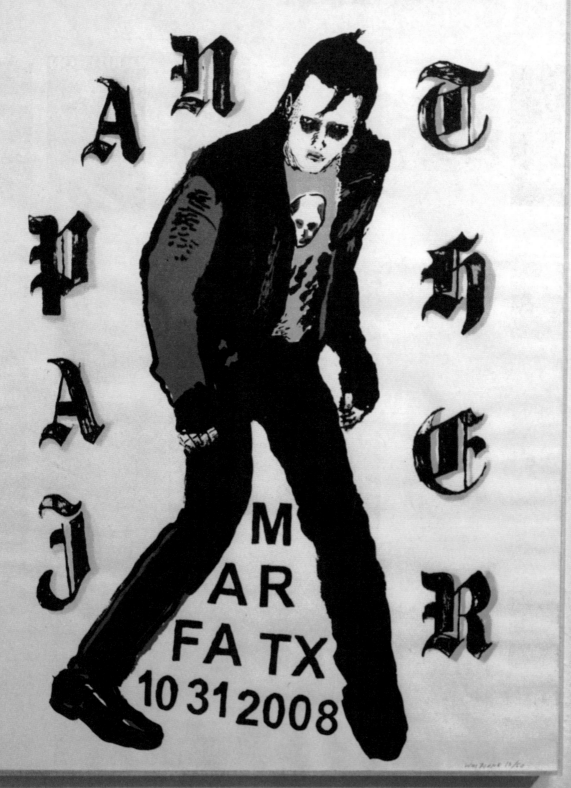

BALLROOM PRESENTS

ANTY PAJ THE CRAMER

M
AR
FA TX
10 31 2008

Front cover, poster designs, first row from top: Noel Waggener, Jaime Cervantes, Decoder Ring, Decoder Ring, Decoder Ring, Essen, Hatch Show Print. Second row: Decoder Ring, Dan MacAdam/Crosshair Design, Decoder Ring, Dirk

AN EVENING WITH

LYLE LOVETT

AND HIS ACOUSTIC GROUP

SATURDAY, MAY 30 | 9 PM | CROWLEY THEATER

BALLROOMMARFA.ORG

BALLROOM MARFA
108 E. SAN ANTONIO STREET
MARFA, TX 79843
432-729-3600
www.ballroommarfa.org

presents

A PERFORMANCE BY:

J D SAMSON & MEN

| 08/25/17 | 08:30 pm |
| ADMIT ONE | $0.00 |

FOLLOWING THE OPENING OF OUR VISUAL ARTS EXHIBITION: TIERRA. SANGRE. ORO.

MEN IS A BROOKLYN-BASED BAND AND ART/PERFORMANCE COLLECTIVE LED BY LE TIGRE'S JD SAMSON

Thank You!

CREDIT SALE COMPLETE

CUSTOMER COPY

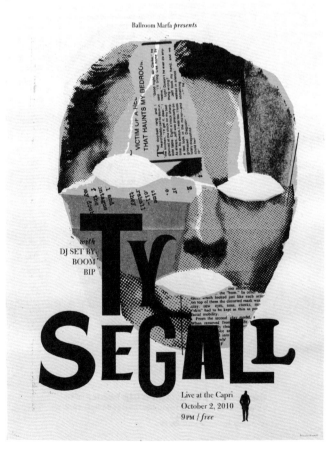

Ballroom Marfa *presents*

with
DJ SET BY
BOOM
BIP

TY SEGALL

Live at the Capri
October 2, 2010
9 PM / *free*

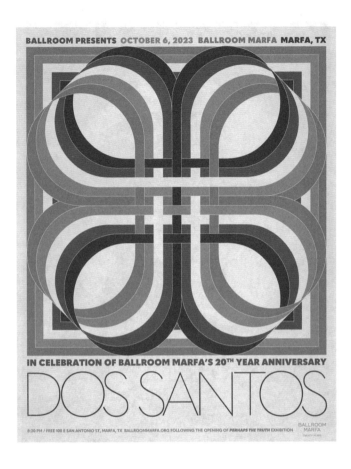

BALLROOM PRESENTS OCTOBER 6, 2023 BALLROOM MARFA MARFA, TX

IN CELEBRATION OF BALLROOM MARFA'S 20TH YEAR ANNIVERSARY

DOS SANTOS

8:30 PM / FREE 108 E SAN ANTONIO ST, MARFA, TX BALLROOMMARFA.ORG FOLLOWING THE OPENING OF *PERHAPS THE TRUTH* EXHIBITION BALLROOM MARFA

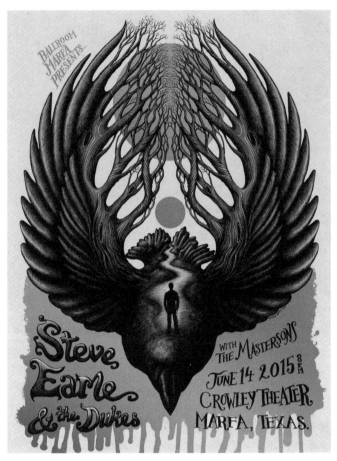

BALLROOM MARFA PRESENTS

STEVE EARLE & THE DUKES

WITH THE MASTERSONS
JUNE 14 2015 8PM
CROWLEY THEATER,
MARFA, TEXAS.

ballroom marfa presents

the marfa triptych:
3 portraits of west texas
the country & western big band suite
by composer graham reynolds feat. redd volkaert
world premiere 11.16.13
crowley theater marfa. tx

BALLROOM MARFA PRESENTS

DIRTY PROJECTORS

WYE OAK

31

2012

PM

$10

CROWLEY THEATER MARFA, TX

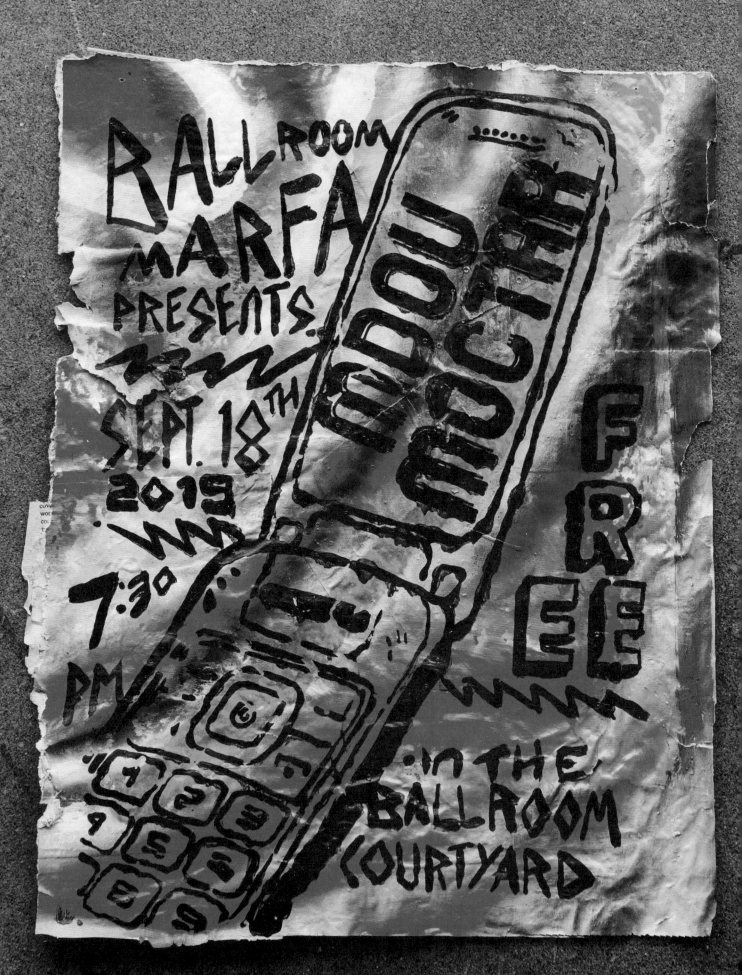

MUSIC. VISUAL ART & FILM FESTIVAL

MARFA MYTHS

04 . 12-15 . 2018 MARFA, TEXAS

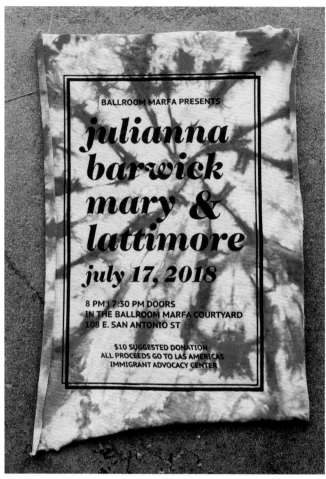

BALLROOM MARFA PRESENTS

julianna barwick mary & lattimore

july 17, 2018

8 PM | 7:30 PM DOORS
IN THE BALLROOM MARFA COURTYARD
108 E. SAN ANTONIO ST

$10 SUGGESTED DONATION
ALL PROCEEDS GO TO LAS AMERICAS
IMMIGRANT ADVOCACY CENTER

BALLROOM MARFA PRESENTS AUTRE NE VEUT OCT. 9, 2013 THE ANNEX 8PM, $5 WWW.BALLROO MMARFA.ORG

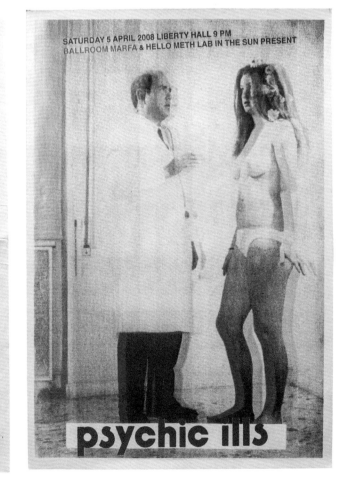

SATURDAY 5 APRIL 2008 LIBERTY HALL 9 PM
BALLROOM MARFA & HELLO METH LAB IN THE SUN PRESENT

psychic ills

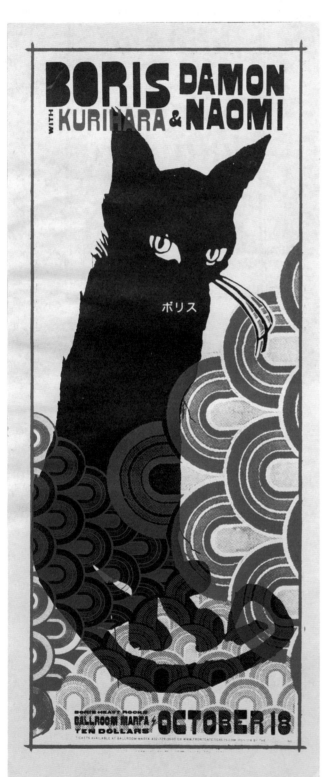

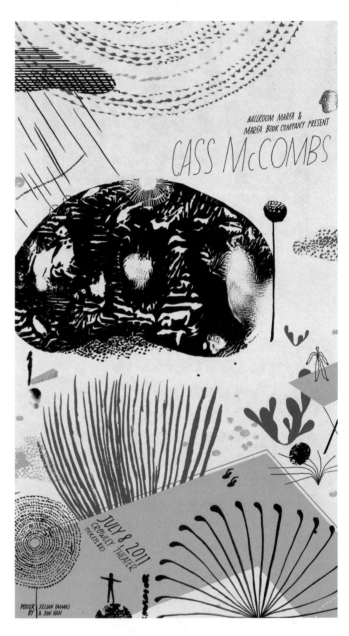

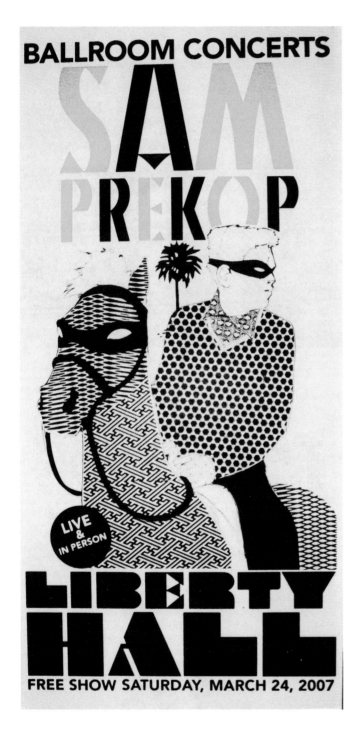

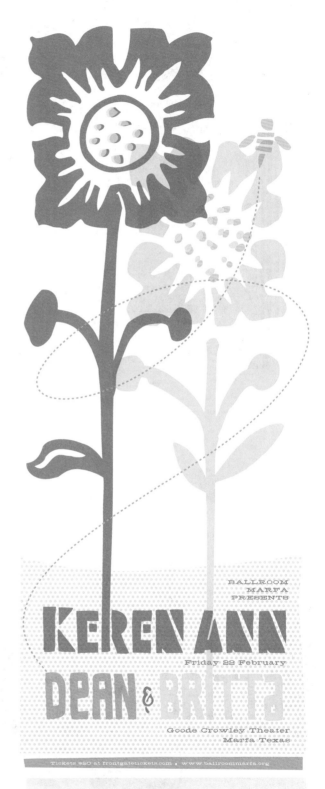

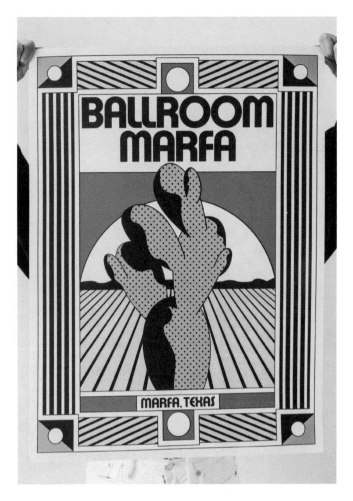

Sock Hop with the
Royal Butchers
at the Lost Horse Saloon
November 20, 2010
Doors at 9, show at 10
$5 ATD

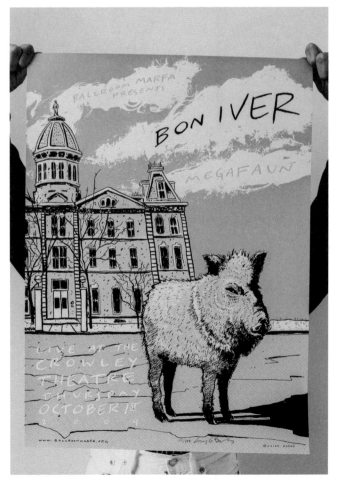

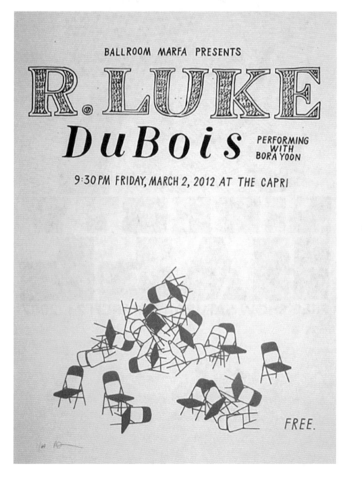

Ballroom Marfa Presents

the sebastian ensemble

5 January 2013 at Ballroom Marfa. Concert begins promptly at 4 pm. FREE

TINARIWEN

3 RD OF NOVEMBER 2011
THE CAPRI, MARFA, TX

* SOPHIE HUNGER OPENS *

SHOW * EIGHT $
DOORS --- SEVEN 10

BALLROOM MARFA
PRESENTS
AVEY TARE'S
SLASHER FLICKS
MAY 5th 8PM
FREE
BALLROOM COURT
MARFA, TX YARD
WWW.BALLROOMMARFA.ORG

* ANIMAL COLLECTIVE * SIR RICHARD BISHOP * MARFA, TX * MAY 25TH *

LIBERTY HALL
$15

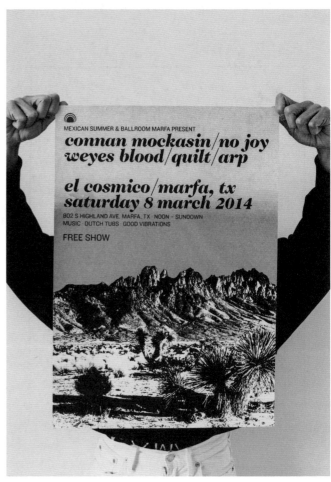

Ballroom Marfa

presents

Cassandro, the Exótico!

a film by
MARIE LOSIER

In the BALLROOM
MARFA courtyard
108 E SAN ANTONIO
ST, MARFA, TX

August 9, 2019
8:30PM

＊FREE＊

with a special
appearance from
CASSANDRO + DJ
set by TOKYO BOIS

＊ In case of rain, screening will move
to THE MARFA VISITOR CENTER

ballroommarfa.org

LEE FIELDS & THE EXPRESSIONS
10.12.12 BALLROOM MARFA AT THE CAPRI
WITH BLACK JOE LEWIS & THE HONEYBEARS

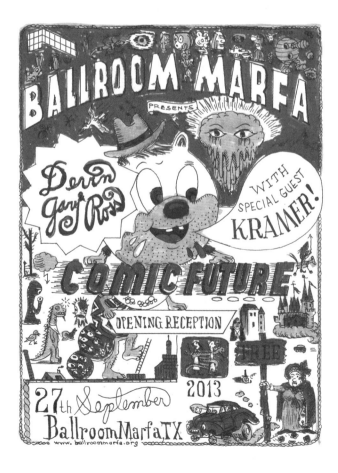

FOLLOWING THE OPENING OF
OUR VISUAL ARTS EXHIBITION
APPARAT

BALLROOM MARFA
PRESENTS
A DJ SET BY

MIKE SIMONETTI

FREE

FOUNDER
OF THE
RECORD LABELS
2MR, TROUBLE-
MAN UNLIMITED,
AND ITALIANS DO
IT BETTER

MARFA, TEXAS

IN THE
BALLROOM MARFA
COURTYARD

SEPTEMBER 25, 2015
8:00 PM
108 E. SAN ANTONIO ST.

BALLROOMMARFA.ORG

CHAPTER FOUR

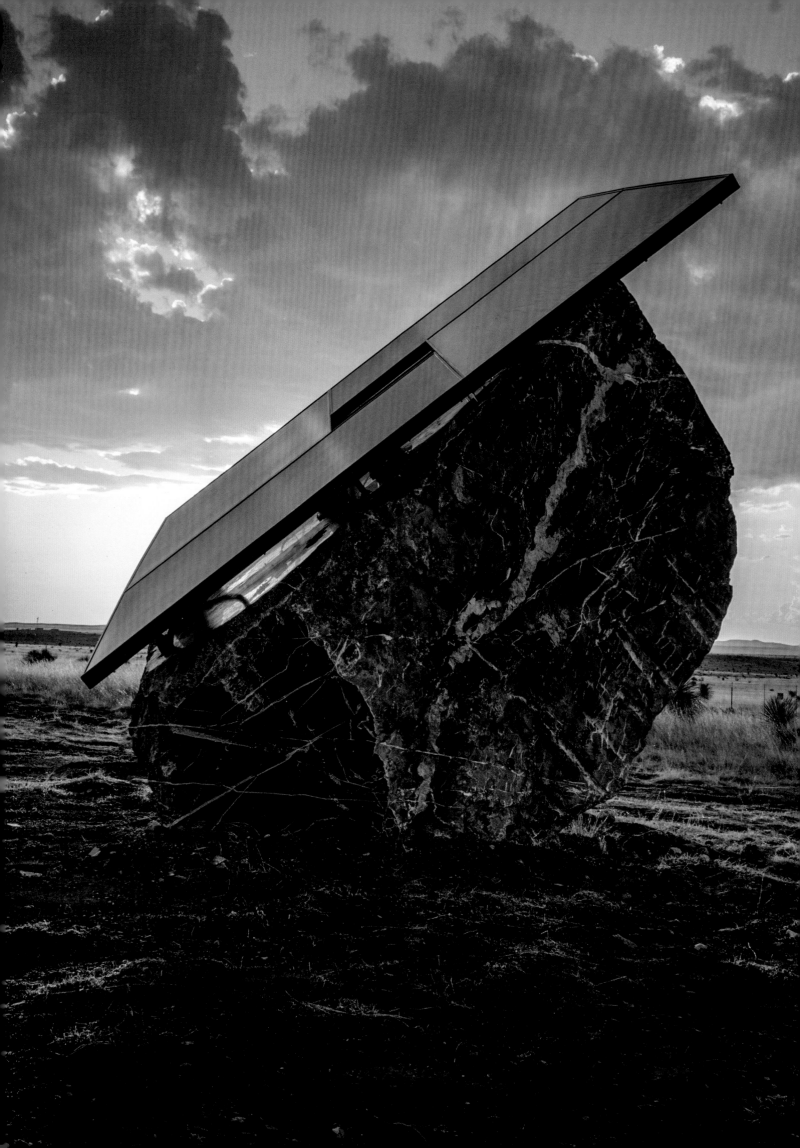

DEEPER CONVERSATIONS WITH THE LAND

2017–2019

Through the foundations that had been established and the continued growth of Ballroom Marfa, big ideas flowed. Artists explored networks, environmental events, technology, and sound in *Strange Attractor*, for example. Philosopher Timothy Morton's ideas about the current ecological crisis were translated to exhibition format through his collaboration with executive director and curator Laura Copelin, *Hyperobjects*. Artist rafa esparza used his solo exhibition *Tierra. Sangre. Oro.* as a laboratory for "dialoguing, thinking, working, and making together with my peers." The musicians in Marfa Myths used the festival as a way to workshop ideas too, with recording, woodworking, and painting residencies. □

STRANGE ATTRACTOR

LAWRENCE ABU HAMDAN, THOMAS ASHCRAFT,
ROBERT BUCK, ALEXANDER CALDER, BEATRICE GIBSON,
PHILLIPA HORAN, CHANNA HORWITZ, LUCKY DRAGONS,
HAROON MIRZA, DOUGLAS ROSS

In 2017, guest curator Gryphon Rue explored the uncertainties and poetics of networks, environmental events, technology, and sound in the exhibition *Strange Attractor*. The term *strange attractor* describes the order embedded in chaos, perceivable in harmonious yet unpredictable patterns. Sound and music pervaded the exhibition, physically or latently, through production or allusion. Visitors were confronted with leitmotifs of capital, transmigration, and asylum. The exhibition opening featured a performance by artist and musician Lonnie Holley and psych duo Tonstartssbandht, with visuals by Benton C Bainbridge. ▷

STRANGE ATTRACTOR
GRYPHON RUE

Strange Attractor begins with the premise that our lived experience and the intimacy, vastness, and interconnectedness of financial, interfacial, and psychological abstractions are intertwined yet irreconcilable. The term originates in the mathematical field of dynamic systems theory and represents the phenomenon of a minute change in a complex behavior that greatly affects the overall pattern (a sparrow in a tornado, fuel sloshing in a tank). The phenomenon is chaotic; the pattern observable yet unpredictable. The poetry and disquiet of a strange attractor indicates an elusive order within our contemporary life.

A strange attractor gives rise or image to something or someone unknown and nearly fictional.

- (A moving target, a magnetic stranger, a parasite posing as a host.)

- *Strange Attractor* composes a poem to the human search for meaning.

- *Strange Attractor* offers strategies for seeking orientation within the world's dislocations through acts of imagination, aiming to reflect the complexities and flaws of this pursuit.

- *Strange Attractor* makes use of the realization that the causes of one's social life are elsewhere, in the processes of extraction, dispossession, and subjugation; it seeks resolution within conditions that are conflicting, opportunistic, and/or programmatic with regard to forms of life.

- *Strange Attractor* privileges ambiguity and indeterminacy, qualities dissonant to the digital mediascape, which enforce a logic of measurements, competence, and functional proficiency.

- Through the facticity, contingency, and ephemerality of matter and sound, *Strange Attractor* probes tensions in our approaches to the identification of strains and conflicts within nature and society, cosmos, and capital. ▷

Excerpt, exhibition catalog essay. Rue is an artist, composer, and musician.

ORBITS AROUND THE GALACTIC CENTER. To understand the trajectories of the stars through a galaxy, Michel Hénon computed the intersections of an orbit with a plane. The resulting patterns depended on the system's total energy. The points from a stable orbit gradually produced a continuous, connected curve (*left*). Other energy levels, however, produced complicated mixtures of stability and chaos, represented by regions of scattered points.

6.3 Principles of nonlinear dynamics

Figure 6.9 The Ueda attractor (from Capra, 1996)

itself. Thus we see that the mathematics underlying the Ueda attractor is that of the "baker transformation."

One striking fact about strange attractors is that they tend to be of very low dimensionality, even in a high-dimensional phase space. For example, a system may have 50 variables, but its motion may be restricted to a strange attractor of three dimensions, a folded surface in that 50-dimensional space. This, of course, represents a high degree of order.

It is evident that chaotic behavior, in the new scientific sense of the term, is very different from random, erratic motion. With the help of strange attractors a distinction can be made between mere randomness, or "noise," and chaos. Chaotic behavior is deterministic and patterned, and strange attractors allow us to transform the seemingly random data into distinct visible shapes.

GEOLOGY SKY OF GEOLOGY NIGHT
BERNADETTE MAYER

The nuclear cooking of free electrons creates spirals
Oolitics or pisolitic, it's a stalactitical wheat sheaf
I vanish into the universe like a wave, cosmologically
while you are a crenellated coxcomb, let's be twinned
rolling into a ball of wind & water, made out of time
crystals all have symmetry, stars'd quickly be damaged
if worn as jewelry, Jupiter's magnetism conducive to the heat
unlike a ruby or sapphire, a painted ball, a Saturnian system
such a topaz is not a potato but a potato can be like a heart
the night geology sky, bye bye, the night pigeon sky
the pearly silky luster of your opalescent heart glimmers
like a sequel to a night sky, the prequel being splendent
like an opera in a small hall, the pyramids are closed
Desdemona will collide with Cressida or Juliet in 100 million
atomic structures like a bird of geologic light years
superstring theory might be astrology, the plump indigo fruit
of a crystal system, falling hail of telepaths, it's so unlikely
we'd be here, flat lustrous surfaces orthorhombically
or just minerally archetypes, complex or simple in the breezeway
every specimen can be cut by a knife or corundum till
political spirit fuses with shamanic allies, it's all good
all forms are pinacoids like ice cream cones, the ice cream
takes a chance with absence of meaning through goblins
rather oolitic if not massive. If you drop it though
like tomato plants told eons ago to slow down In 2013
it becomes mammillary, even reniform, then hackly or blocky
copernican modernity swelled with Homer & the Basques
but when it refreezes, it grows splintery or botryoidal
Oh the way a mineral fractures
Can sometimes help identify it
equal areas equal spaces equal times equal rights for women
their beautiful & often elegant crystal form
universal gravitation has a slow cadence when rolling down a hill
regular geometric shape & smooth crystal surfaces
Melville's whale is elohim to some, dark matter to my twin
Easily broken into a powder by cutting or hammering
I'm in love with the great attractor, my dog hector
sectile: can be cut by a knife into thin shavings
his free-streaming length determining the size of his grave
malleable: can be hammered into thin sheets like gold or copper
from which hector could become another agglomeration &
stretching credulity till the zodiac devours transduction
minerals with a hardness exceeding that of the streak plate
boll weevils eat the vine that annihilates native plants by growing
too fast, luster is modified by transparency
they float into the sky, ammonia is methane, carbon oxygen
may seem softer than they actually are, or as hard as quartz
in the orgone envelope of the world are flying chariots
the hardness of a fingernail, a penny, an emery board
looms until rewoven as all other mammals, I love you, what's my name?

Excerpt, exhibition catalog. Mayer was a poet, writer, and artist.

Bottom: Thomas Ashcraft, Detail, *Transient Luminous Events in the Mesosphere*, 2014. Top: Installation view, Thomas Ashcraft, *Transient Luminous Events in the Mesosphere*, 2014.

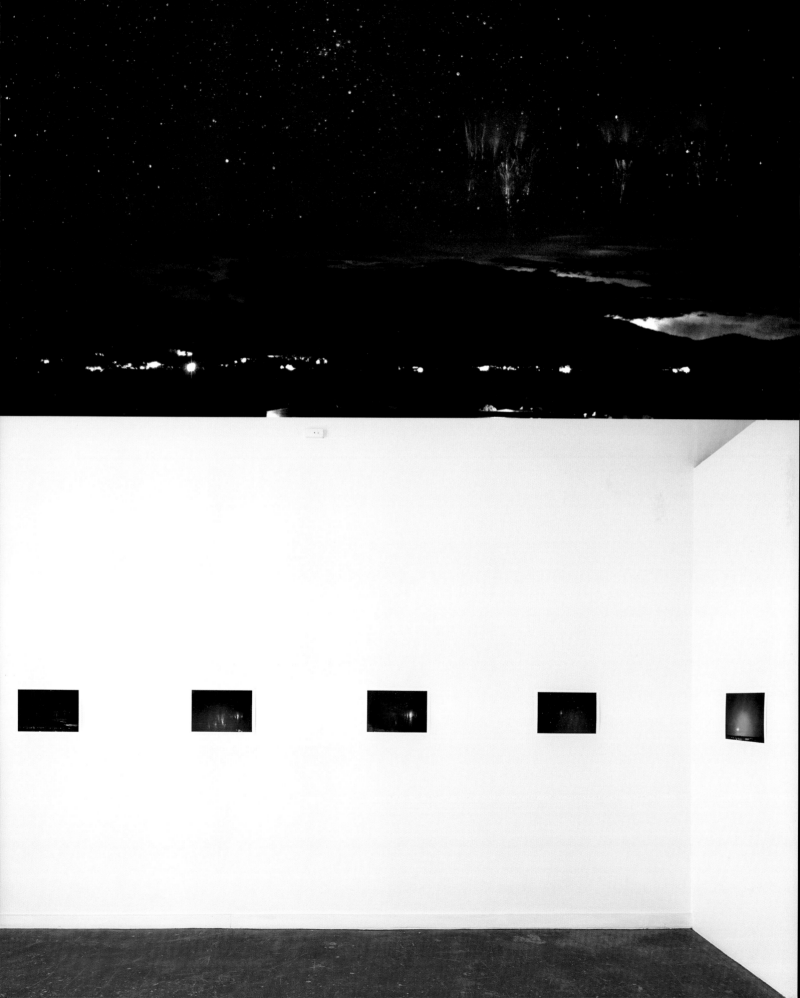

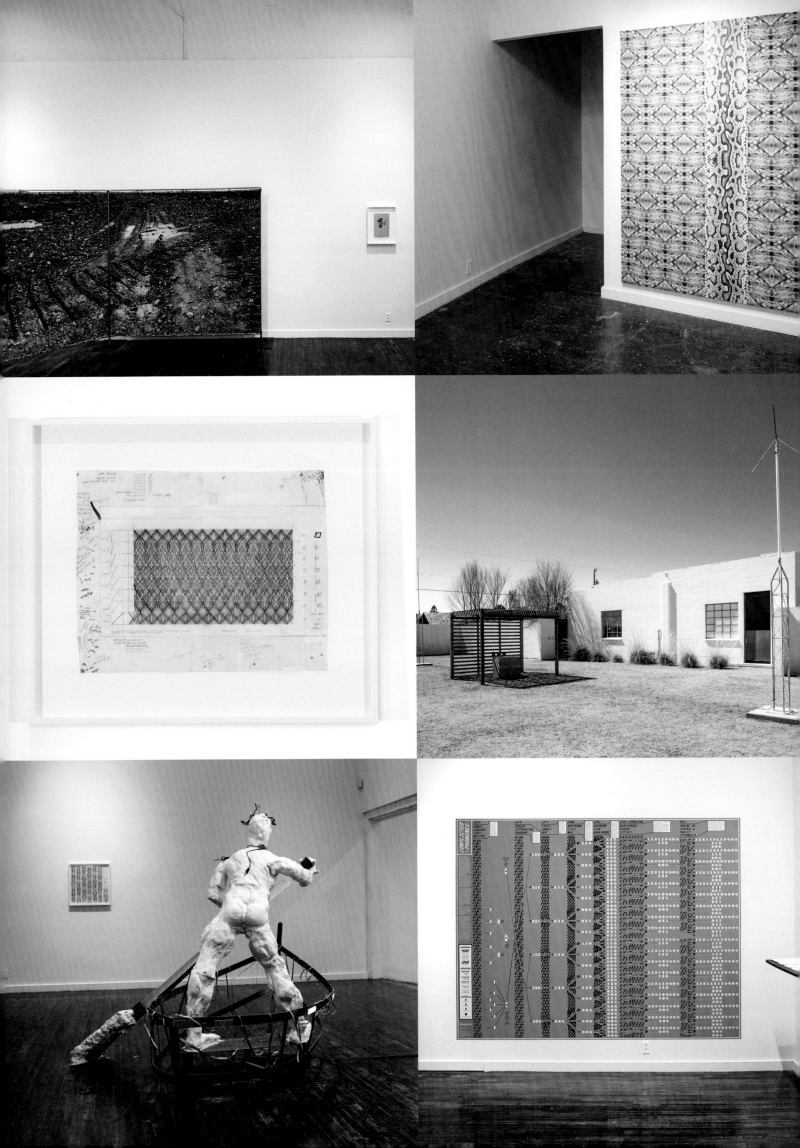

"One day in Marfa, [we] started talking about chaos theory, the birth of crystals, and the physics of music. The seeds for an exhibition germinated."

VISIBLE AND INVISIBLE: THE ONGOING EVOLUTION OF *STRANGE ATTRACTOR*
FAIRFAX DORN

Like so many extraordinary projects, *Strange Attractor* evolved from a conversation. One day in Marfa, Gryphon Rue and I started talking about chaos theory, the birth of crystals, and the physics of music. The seeds for an exhibition germinated, and these ideas continued to resonate with me long after we spoke. Considering these dynamical systems, artist Haroon Mirza's works played a critical role as examples of entropic networks in our early conversations. Both Gryphon and I were drawn to Haroon's work, and soon Haroon and I were in touch, hatching a plan for his *stone circle* (2018), a cosmic megalith for Marfa.

Haroon mentioned he had been visiting and researching stone circles in the United Kingdom, and that he wanted to create something that would speak not only to these mysterious Neolithic monuments but also to present-day technology. Haroon and Gryphon visited Marfa several times and found inspiration in the vast grasslands and alternating dark and sun-drenched skies. Over the course of these early explorations, *stone circle* emerged alongside the concept for *Strange Attractor,* with Haroon's megalith coming to life a year after the exhibition closed.

stone circle represents the resonance that continues to echo out from the exhibition Gryphon conceived for Ballroom Marfa. It embodies many of our early ideas and conversations about the unforeseen dimensional actions we witness in nature and those forms that bring us together as humans. Haroon's large-scale public sculpture produces patterns of electronic sound and light from energy generated by solar panels. The work is about sound, space, energy, and the chaos that shapes the beauty of the surrounding land, sky, and weather. Informed by Gryphon's compelling research into the sonic elements and musical connections of his great-grandfather Alexander Calder's sculptural work, *Strange Attractor* speaks directly to these soundings of the visible and invisible. I was amazed to see artworks for *Strange Attractor* converge through Gryphon's intuitive curatorial process. His background as an experimental musician, as well as his curiosity and knowledge, allowed him and the artists he selected to address dissonant, vast, and interconnected abstractions and mythologies that transformed the exhibition space into a lived experience.

Soon, Lawrence Abu Hamdan, Thomas Ashcraft, Robert Buck, Beatrice Gibson, Phillipa Horan, Channa Horwitz, Lucky Dragons, and Douglas Ross were set into conversation, each of them posing a particular reply to the question of how to clearly perceive and interpret the world in all its order and chaos. Sound and music, and their attendant harmonious yet unpredictable patterns, emerged as a pulse of the show. As *Strange Attractor* continued to evolve, the project began to traverse time. When the opportunity arose to include one of Calder's previously unseen noisemaking hanging mobiles, *Clangors* (1942), we had to answer the call. The power of our early conversations and their concepts continued to grow in magnitude and complexity. □

Excerpt, exhibition catalog.

STONE CIRCLE

HAROON MIRZA

In 2018 Ballroom Marfa commissioned *stone circle* from Haroon Mirza. Inspired by ancient megaliths, this large-scale sculpture was installed in the grasslands east of Marfa and remains today. Eight stones in the circle integrate LED lights and embedded speakers. The ninth stone, the "mother," sits apart, and is mounted with solar panels that power a sound and light score that is activated with each full moon. Among Ballroom's most ambitious public commissions, *stone circle* is the second major movement from Mirza's *Solar Symphonies* series.

A REFLECTION BY HAROON MIRZA

I first heard about Ballroom Marfa because of *Prada Marfa*, but I didn't know much else about it until I met with Gryphon Rue in the fall of 2014 in New York. He had an idea for a show, *Strange Attractor*, that would be staged at Ballroom Marfa during the Marfa Myths festival. Initially, the conversation revolved around mycelial networks and solar works, but quickly segued into stone circles during a conversation with Gryphon, Susan Sutton, then the director of Ballroom, and Laura Copelin, the curator. We all got super-excited about the idea of a black stone circle in the Texan desert. The show was scheduled for nine months from the day of the meeting. Had we known the project would take five years and cost what it did, our enthusiasm may have been somewhat curbed. Luckily, we were all young, slightly naive, and energetic enough not to think too much about the practicalities.

Marfa is, to me, a contemporary oasis. Three hours of nothing but desert, and then suddenly you arrive in a highly concentrated mix of cowboys, Indigenous communities and histories, border politics, Judd, hipsters, art, literature, music, and culinary delights—all within three square miles! The area is so incredibly biodiverse with rattlesnakes, horned lizards, tarantulas, raptors, and an abundance of mesquite; it's the only place in the world where peyote grows natively. I remember finding it unusual that given the combination of vast open space and excessive sunlight, there was not one solar panel to be seen on my lengthy journey from El Paso.

The entire project resonated with so many magical moments. Looking for the Marfa lights, foraging for peyote, Rocky Barnette's mesquite bean ice cream, seeing the Milky Way. One of my most vivid memories is a bittersweet one. An hour before we unveiled the stone circle, we were hit by a spectacular flash storm with massive balls of ice falling out of the sky. It was very unusual for Marfa. Matt Grant, Ballroom's head technician, went on-site to ensure that the stone circle was in order, and it fired up fine. With the tests done, everyone arrived at sunset to witness the first official activation. We watched the sun drift and leave an epic sky to the west, while the storm and its lightning moved onward to the north, it was truly beautiful. A women grabbed my arm and told me this was the land of her ancestors. She asked if I knew what it was used for, and in response to my ignorance she simply said, "Time travel," and walked away. The full moon rose, and the stones' activation was imminent. But, instead of coming to life, they hummed quietly and glowed meagerly. The stones have activated as normal every full moon since. To this day, we have never worked out why they malfunctioned that night; it makes no technical sense! It's as if the stones made a pact with nature and told us, "We're in control."

There is an unavoidable engagement between land and cosmos that courses through the veins of Ballroom Marfa's ethos. Marfa is a staggering place, which is likely the reason Ballroom is there in the first place. The town is a community made up of individual hubs that are rooted locally but face outward, making Ballroom's reach international, and they get behind the idea of an ambitious project and work so hard to find reasons to make it happen. It's in a class of its own. Ballroom Marfa is an inspiration for making things happen against the odds. Having an internationally relevant and diverse program in such a remote place is a real achievement and shows a real commitment to art, artists, and the creative process. ☐

Haroon Mirza, *stone circle*, 2018. Overleaf: Haroon Mirza, *stone circle*, 2018.

Correspondence, Haroon Mirza to Alexann Susholtz, August 3, 2022.

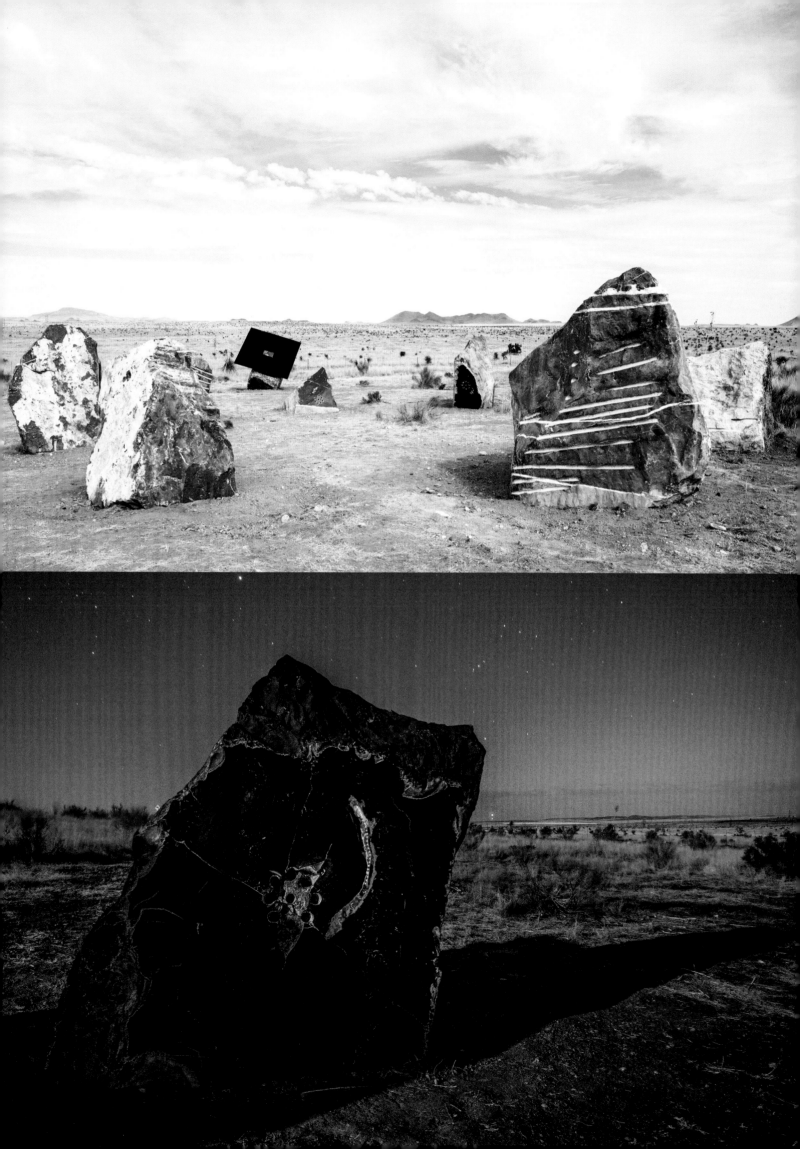

HYPEROBJECTS

DAVID BROOKS, MEGAN MAY DAALDER, TARA DONOVAN,
RAFA ESPARZA, RAVIV GANCHROW, PAUL JOHNSON,
NANCE KLEHM, CANDICE LIN, IVÁN NAVARRO,
OSCAR SANTILLÁN, EMILIJA ŠKARNULYTĖ,
SISSEL MARIE TONN AND JONATHAN REUS

The 2018 group exhibition *Hyperobjects*, which confronted the overwhelming scale of today's ecological crisis, was co-organized by philosopher Timothy Morton and then–Ballroom Marfa director and curator Laura Copelin. Morton defines *hyperobjects* as entities that are bewilderingly huge—global warming, plastic in the ocean, nuclear waste—and seemingly incomprehensible. But, he writes, "They are like titans, not gods. They are huge, but they can be defeated and dismantled." In his treatise "Hyperobjects and Creativity," Morton suggests three questions we might pose "about these strange gigantic beasts":

1. We have suddenly become aware of the Anthropocene, the geological period brought about by human carbon emissions. But how does the Anthropocene affect human society, thought, and art?

2. How can humans think about and plan for the scales sufficient to take global warming and radiation into account, scales that are measured in tens of thousands of years?

3. We often think and act toward the environment as if a horrifying cataclysm is about to take place. But what if the problem were precisely that the cataclysm has already occurred?

The exhibition created encounters with artworks and non-art objects that decenter and expand human perception through their experimentation, immersion, and wild fluctuations in scale and volume. In addition to contemporary art, the *Hyperobjects* exhibition included objects sourced locally from the fields of botany, geology, and astronomy. Exhibition partners included the Center for Big Bend Studies, the Center for Land Use Interpretation, the Chihuahuan Desert Research Institute, Earthworks, the Long Now Foundation, Postcommodity, the Rio Grande Research Center, Sul Ross Herbarium, the University of Texas at Austin McDonald Observatory. ▷

Nance Klehm. *Free Exposure (3 Holes, 5 Heaps), Soil Cubby: A Hole for Listening*, 2018.

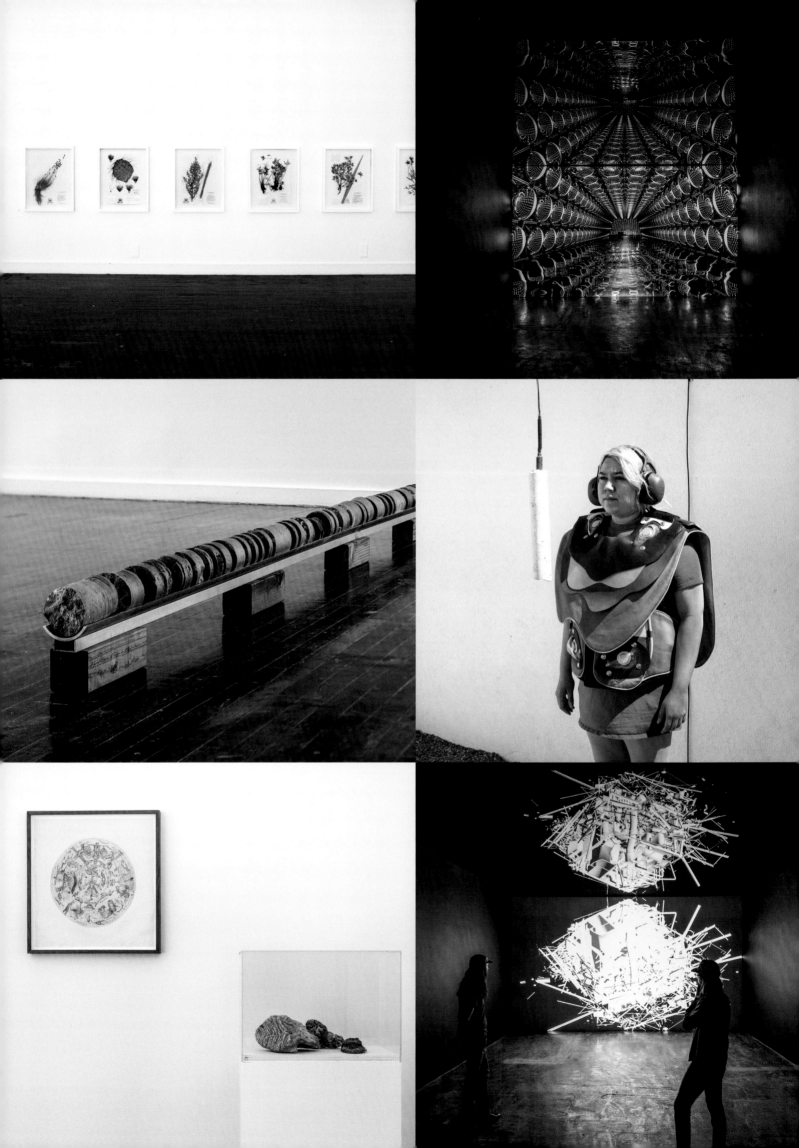

A REFLECTION BY LAURA COPELIN

"If you do not know the names of things, the knowledge of them is lost, too."
—Carl Linnaeus, taped to a wall of Sul Ross State University's A. Michael Powell Herbarium, Alpine, Texas

In 2015 I invited Timothy Morton to speak at Ballroom's symposium Marfa Dialogues/Houston. This was the beginning of a conversation that turned into a multiyear collaboration and, more importantly, a friendship. I was already a fan of Tim's writing; I liked his lyrical and undogmatic approach, and had been particularly inspired by *Hyperobjects*, a ranging and kaleidoscopic book that outlines key components of his ecological theory. The word itself helped me. Tim, a scholar of romantic poetry, conjured up a name for a massive and ineffable kind of thing.

In Tim's words, hyperobjects are "things that are massively distributed in time and space relative to humans."

It is *almost* a relief to have a word for these huge things, which emit a relentless subsonic anxiety: global warming, the threat of nuclear catastrophe, widespread systematic oppression and injustice, etc., etc. The word—*hyperobject*—is a cipher, meaning everything and nothing, but weirdly it is also a handrail, something to hold on to as things go wonky, or a net that is cast out at something huge and unknown and allows you to sense, however tenuously, THERE'S A THERE THERE, I CAN FEEL ITS SHAPE AND MAGNITUDE!

Tim and I wanted to engage artists who confront these vast, unknowable scales and issues daily in their practices. This manifests in myriad forms throughout the exhibition, but each artwork points to something that stretches and expands our sense of time and space, and also, perhaps, our sense of empathy and connection and imagination.

Many are works that you sense even more than you see: a beckoning whisper from over your shoulder, an intimate earthquake, the sound and smell of soil all around you. A hyperobject, after all, is often so large it is invisible or only obliquely perceptible. When talking about the paralyzing grief of confronting our role in global warming, Tim says in his book, "We need art that does not make people think (we have quite enough environmental art that does that), but rather that walks them through an inner space that is hard to traverse."

It also felt important to point to the ecological particularities of the dizzyingly deep "gazing hole" of this place. "This place," meaning the Trans-Pecos region, a sublime and incredibly biodiverse landscape that somehow connects (as many deserts do) our sense of the distant past and the far-flung future. Here there are rocks dating back 1.4 billion years, plant species that are still hanging around from the glacial ages, a profusion of arid-adapted ferns, telescopes that see so far into space that they look back in deep time and a clock being built into mountains that used to be coral reefs, which will ring ten thousand years in the future.

And so, we put together an exhibition that heaps different kinds of objects together, art and non-art and some things in between, creating relationships between scales and sensations and fragments of the ecology of the Trans-Pecos, which is altogether redundant because of "the simple fact that existence is coexistence." ☐

Excerpt, exhibition essay.

Installation views with, clockwise from top left: Herbarium specimens; Emilija Škarnulytė, *Sirenomelia*, 2018; Sissel Marie Tonn and Jonathan Reus, *The Intimate Earthquake Archive*, 2016–ongoing; Emilija Škarnulytė, *Sirenomelia*, 2018; Candice Lin, *5 Kingdoms*, 2015; David Brooks, *Repositioned Core (byproduct)*, 2014–2018. Overleaf, top to bottom: Installation view, Tara Donovan, Untitled *(PLASTIC CUPS)*, 2006/2018; Geological samples from the Big Bend region, from the collection

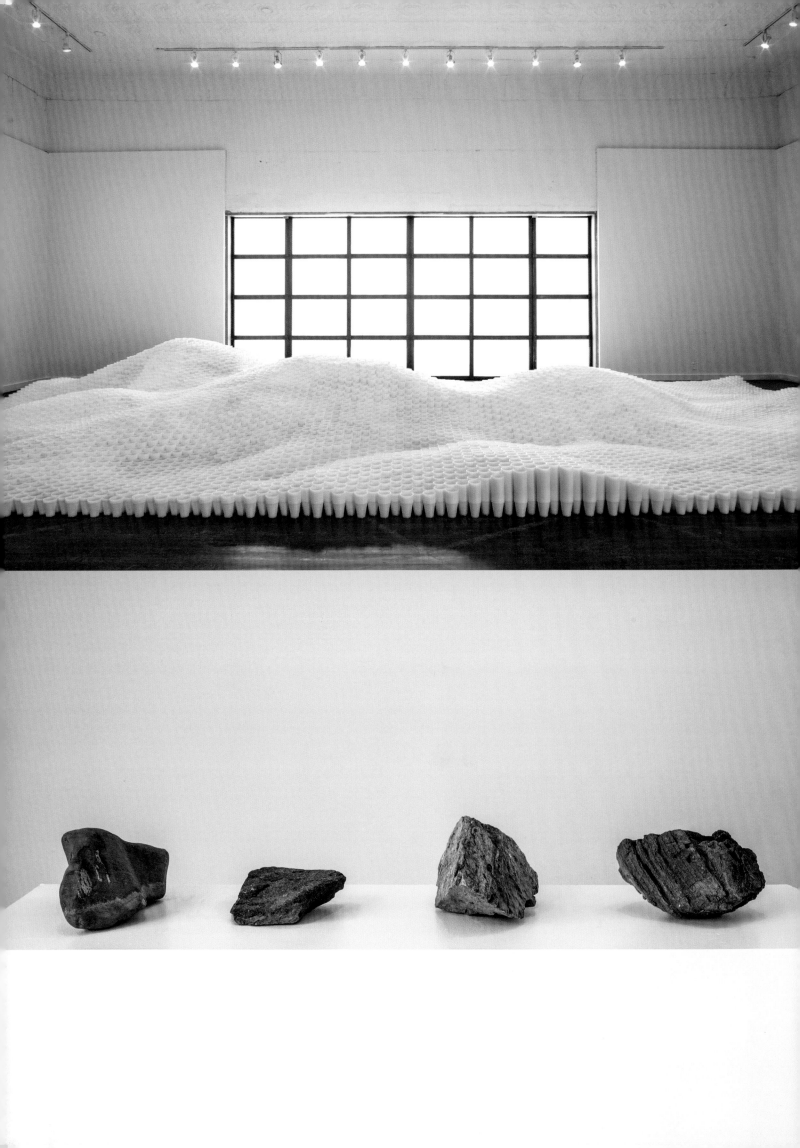

TIERRA. SANGRE. ORO.

RAFA ESPARZA WITH CARMEN ARGOTE, NAO BUSTAMANTE, BEATRIZ CORTEZ, TIMO FAHLER, EAMON ORE-GIRON, STAR MONTANA

Eamon Ore-Giron, *Talking Shit with Quetzalcoatl/I Like Mexico and Mexico Likes Me*, 2017.

In 2017 Ballroom Marfa presented *Tierra. Sangre. Oro.*, an exhibition envisioned by artist rafa esparza. Organized by then curator and interim director Laura Copelin, the project included new installation, performance, and sculptural work from esparza alongside collaborations and contributions from other artists.

In his practice, esparza addresses and excavates the histories of colonialism, labor and economic value scales, and queer culture and masculinity, as well as personal and familial legacy. He sets traditional materials, inherited processes, and ephemeral choreographies up against institutional structures and the historical narratives of Western sculpture, land art, and performance. esparza's work manifests primarily through performance and sculpture, in a territory where the two mediums combine and hybridize. The artist uses adobe brick–building as a process-centered site for personal, cultural, ecological, and political investigation.

While in residence in Marfa from June to August 2017, esparza produced new work and conceived of a site-specific installation particular to the landscape and cultural context of the Big Bend region and Northern Mexico where adobe building is prevalent. For *Tierra. Sangre. Oro.*, esparza transformed Ballroom's architecture using the adobe bricks that are central to his work. While making these interventions, the artist explored, in his words, "the visibility of Brown people in Marfa." esparza worked with his father, who taught the artist how to make adobe, as well as with people from his community, Marfa Independent School District high school students, and local adobe artisans to produce bricks and install the project.

esparza's adobe architecture provided the ground for presentations by the artists he invited to join him in Marfa as he "expanded the idea of a Brown laboratory." New and existing work was presented amid structural additions to Ballroom's facade, galleries, and courtyard, creating spaces for the artist's "laboratories for dialoguing, thinking, working, and making together with my peers." ▷

215

"I had been working with adobe for years and it's evolved into this process of working with the group of people...always the process being this vehicle that holds a space for bonds to be made, for relationships to be made."

A REFLECTION BY RAFA ESPARZA

It was a collaborative exhibition. I think of it as a conversation that's site-specific, but that's also a very intimate engagement. I had been working with adobe for years and it's evolved into this process of working with the group of people. Sometimes people that I know, sometimes strangers, but always the process being this vehicle that holds a space for bonds to be made, for relationships to be made. And then the other layer of bricks made is to engage with—with a community of artists whose work I follow that I highly regard and an artist that I want to sort of physically engage in conversation with. And so that's what this exhibition became. I extended the invitation to six different artists—most of whom reside in Los Angeles, one from Guadalajara—to come and spend some time in Marfa and think about this idea.

I had the idea of using the material of adobe to bond or rekindle a relationship with my father that had been broken, knowing that my father had grown up being a brickmaker in Mexico—in Durango, Mexico, where he migrated from in the 1970s. I asked him if he would teach me how to make adobe. It was before I had these grand ambitious ideas of asking him to teach me how to make bricks, and we're going to bond and it's going be beautiful, and he's going to talk to me about home. And he agreed to teach me how to make adobe. And the conversations didn't happen then. It was very quiet; the entire conversation revolved around the task at hand, what we were doing, just him teaching me how to work with this material. But it was a first step and sort of like mending that relationship. And years later the conversations were had while making the first project that I had where we made a mass of bricks. I think we made like fourteen hundred.

And so, since then I've worked with adobe in different contexts: in outdoor public spaces and traditional art spaces and museums. And every context and every situation is very different. But I like to think of adobe as a platform that [situates you in the] land. And every iteration speaks to the ideas of space. It's charged with a lot of ideas of land, but also bodies. It's a material that I feel comes with, when I think about land, a history that's in conflict with art history or the history of white spaces. And it is an inherently Brown material that, when I'm building structures in these spaces, I feel like we are pushing away the white space or maybe turning it into itself to create a new space. ▷

Interview, rafa esparza, Sarah Melendez, and Alexann Susholtz, April 25, 2023.

Installation views with, clockwise from top left: Nao Bustamante, *Soldadera*, 2015; Nao Bustamante, *Tierra y Libertad—Kevlar 2945*, 2010; Carmen Argote, *Oh wow...The Marfa Sky*, 2017; Nao Bustamante, *Chac-Mool*, 2015; rafa esparza, *Adobe Ground for Hunting and Gathering*, 2017; Timo Fahler, *la basqueda del oro (the search for gold)*, 2017.

216

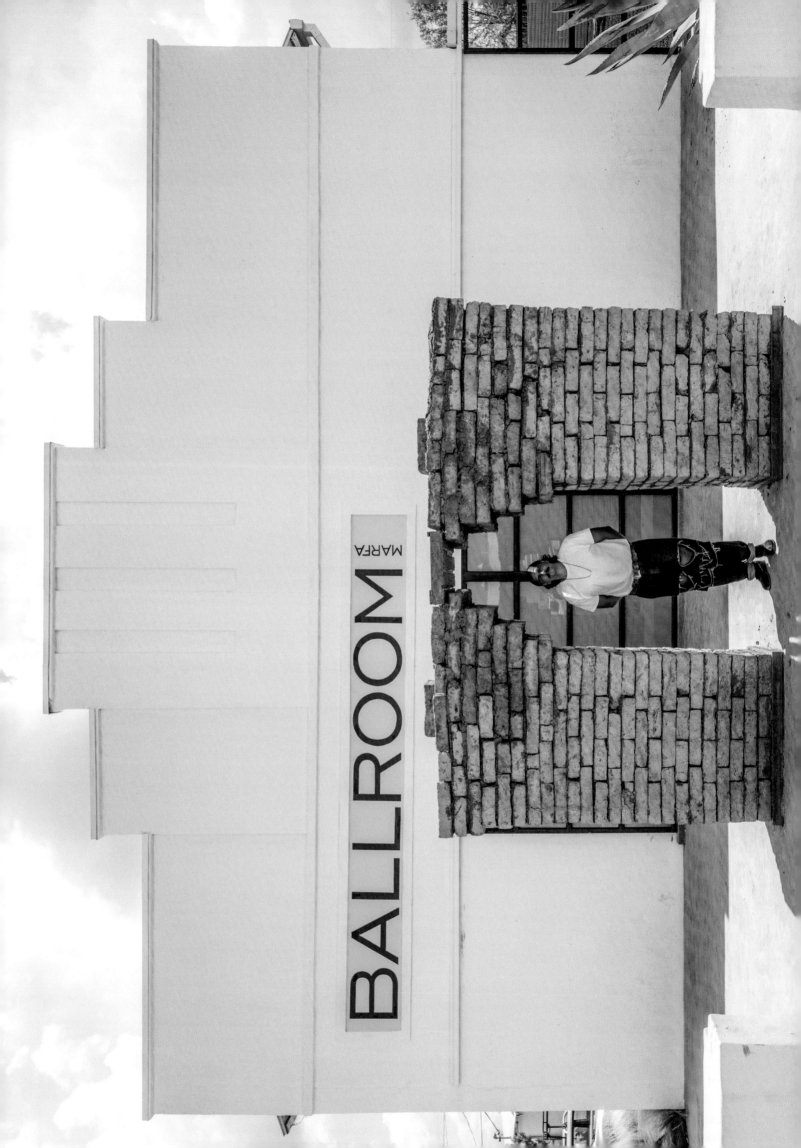

"I wanted to imagine Indigenous people in the cosmos, flying in space capsules, and living in the future.... I want to imagine a garden, like a piece that I have—a gardening spaceship flying around growing quinoa in the cosmos—for the humans of the future."

A REFLECTION BY BEATRIZ CORTEZ

I find it really rewarding to see the conversation that the pieces have with each other, with each other's pieces, and the conversations that connect our work through ideas about immigration, about class, about labor, about materials, about forms of construction. We are building this portal, for example, to enter a space that has a different modernity, but that coexists. And we're doing it in a space like Marfa that's filled with all these beautiful buildings made of adobe. So, we also have the opportunity to call attention to the fact that we're bringing something that may be foreign to the space of the gallery, but it's not foreign to Marfa. It's everywhere. And that opportunity to see the works connected and think about how they talk to each other and they reference different types of labor: the labor of the people who deliver boxes, the labor of the people who sew and stitch and make outfits, the labor of people who work in construction, the labor of people who fought in wars, the labor also of people who are forced to work in ways that are foreign to them, even though they have these magnificent ways of building themselves that are maybe not appreciated all the time in other cultures.

And the importance of seeing the border present. There are all these borders and borders and these opportunities for speculative thought for moving through portals through time. All the work in the exhibition is collaborative in this way: it's referencing labor or class or immigration or alternative identities or future imaginaries or nonhuman identities in different ways. As you move through the space, you might get what one piece was saying by looking at the other one. And I think that that's really beautiful.

Some of the adobes that are in the space came from the Whitney [Museum of American Art] and

were made by some of these youth, and also some of these came from brown, queer collaborators who work with rafa in Los Angeles. But also, one important component of that is that soil from Los Angeles was moved to New York and then was moved to Texas. And it's soil that's an immigrant soil, that's moving around; and soil contains dormant seeds, contains memories, contains the blood and spit and semen of people. You know, it's not just some kind of dust that we pick up. It's God, the memories of everyone who has gone, walked through that space. And so, there's something really beautiful about that.

There's soil from Marfa, from Texas, that was used here to make other adobe, made here. Then there are some of the adobes that were made in Mexico by Manuel Rodriguez, another collaborator that is a master adobe maker, who lives on the other side of the border, that has a life condition that we wish he didn't have because he's a great master and we have learned so much from him and from his practice. He's one of the collaborators who made the adobe bricks for the portal that we entered through. So these bricks have the soil from south of the border and soil from the West Coast that has been also in the East Coast and that has also come to Texas. In that sense, the history of the country, the other part of us that's south of the border, is all brought together in this space in the gallery. And I think that's really important.

My practice is about the experience of immigration and the experience of growing up in a war in El Salvador. (I'm from El Salvador.) And I think that that experience was a shared experience that my parents and I have in common. In many ways when I'm talking about it, I don't talk about it necessarily as something that happened to me personally but something that happened to my family. What became really important was to think about how to talk about the ▷

"I started building a portal to a world where Indigenous aesthetics and technologies are celebrated."

Installation views with, clockwise from top left: Timo Fahler, *la basqueda del oro (the search for gold)*, 2017; Timo Fahler, *aqui con mi sangre (here with my blood)*, 2017; Star Montana, *Maria*; *Krystal*; *Ruby*; *Sarah*, 2017.

TIERRA. SANGRE. ORO.

memory of growing up in a war without making that the one thing that was most important in my life, the thing that solidified my identity. Because then there wouldn't be any reason to keep making works or keep thinking about, keep reinventing myself.

The most important thing in my life already happened. And so, my biggest question to myself and through my work is: How do I deal with that memory in a way that's relevant to the future, in a way that it constructs the future? How do I construct a memory that's as nomadic as my family and as myself? How do I push those experiences from the past to an imaginary that's part of the future? Eventually I began making spaceships and space councils, and then I needed to weld. I needed to make spaceships and I needed to make them in a way that would speak about a spaceship to myself. Also, I became very interested in the labor because the labor of welding, of programming all these things, of working as an electrician, of building things with wood, also related to the different jobs that immigrants do. So, to me, even though my pieces are playful, they also have that very visible labor. So how to push those experiences?

The other important thing for me was how to imagine Indigenous aesthetics in the future so that I would have a chance—because as an immigrant, I feel that I have a right to imagine myself within a space that's not necessarily nationalistic. So instead of imagining a nation that's moving toward progress and leaving Indigenous people in the past, I wanted to imagine Indigenous people in the cosmos, flying in space capsules, and living in the future. That's what I want push toward the future. I want to imagine a garden, like a piece that I have—a gardening spaceship flying around growing quinoa in the cosmos—for the humans of the future.

The experiences that I have are not part of my past but part of the future. And that's why, for me, building

this piece with rafa made of adobe was a natural thing. This piece needed to be made of adobe. It didn't need to be made of steel. I'm not a welder. I weld when I need to weld, and I work with adobe when I need to work with adobe now. I needed to work with adobe, and it was my first time working with the material. From there I started building a portal to a world where Indigenous aesthetics and technologies are celebrated. ▷

220

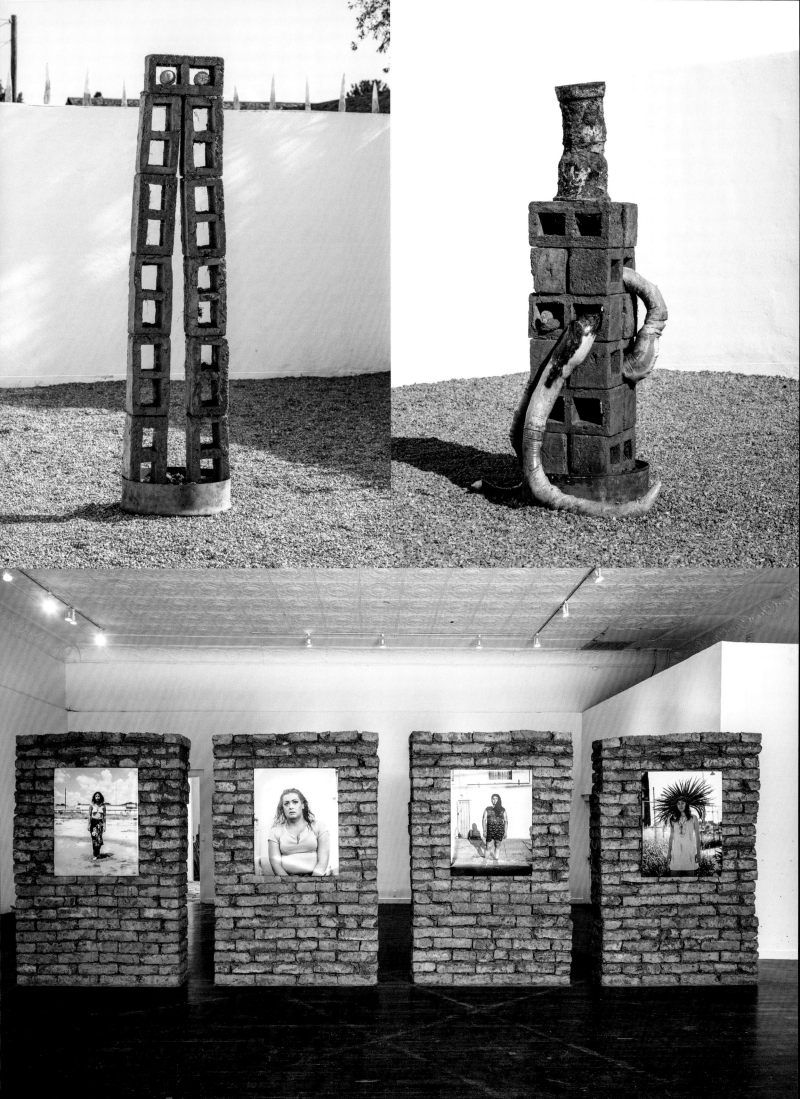

"My father wasn't an artist, but he could build a home. And I think that's a fine art."

A REFLECTION BY TIMO FAHLER

My experience working with rafa, and specifically this experience, is all of the different artists doing their own work but seeing the adobe as a conduit. And that's been really beautiful. All of these different artists are translating these ideas and concepts and theories into works utilizing this earth material. Collaboration is not something that is celebrated as an art practice. And I think that's something beautiful that I've found in working, and in this experience. You're involving six artists, and we've started to maintain a dialogue; we continued talking and communicating. And we're utilizing adobe that I work with, which is mainly plaster. Plaster is gypsum, which is also from the land, but it's a very refined material that is used to make drywall. Adobe is like the classic, almost antiquated drywall.

It's a beautiful conversation. We have gotten to have back-and-forth about the modern material versus the classic material and this juxtaposition of an adobe wall. Like rafa, I grew up and my father taught me everything that I know about building and working with things and working with my hands. And so those materials that I work with— whether it's finding a scrap 55-gallon barrel and cutting it down or bending rebar or pouring different things and welding things together—a lot of that I learned from my father. And I utilize a lot of that stuff in my practice too. There's something to working with my hands in a very kind of pragmatic way, this kind of constructive mind versus the eventual integration of concept in theory, to be part of or the whole of my practice.

But I think that there is an art behind anything that you do, that you love doing. You know, my father wasn't an artist, but he could build a home. And I think that's a fine art—you know what I mean?

Anything that you truly love doing, if you're putting your love into doing that, I feel like there's art there. I like that art exists outside of the galleries. There is a world there, but there are so many other worlds of art that make this world a better place, whenever we're putting our love into it. □

CANDELILLA, COATLICUE, AND THE BREATHING MACHINE

BEATRIZ CORTEZ, CANDICE LIN, FERNANDO PALMA RODRÍGUEZ

Organized by Laura Copelin, *Candelilla, Coatlicue, and the Breathing Machine* was a 2019 Ballroom Marfa exhibition that featured new work by three artists: Beatriz Cortez, Candice Lin, and Fernando Palma Rodríguez. The title refers to a facet of each artist's contribution to the show, which ranged from wax pours and robotic storytellers to provisional shelters and beyond.

Together, the varied installations and objects from these three artists generated a conversation about the animate qualities of land, human and nonhuman migrations and cross-pollinations, and the simultaneous existence of past, present, and future. Each artist spent time in Marfa and around the Big Bend region, and their experiences were reflected in the commissioned works.

Candelilla, Coatlicue, and the Breathing Machine included new drawings from Lin, who explored common species around Marfa—cholla, creosote, ocotillo—and were produced after the artist ingested tinctures she made of each of these plants. Lin also created an immersive new installation from her research on the biopolitics of the candelilla plant, which is harvested and utilized on both sides of the nearby United States–Mexico border. Palma Rodríguez created new "mechatronic" sculptures that speak to intersecting lands, myths, and histories in Texas and Mexico through choreographed spatial storytelling. The kinetic works responded to algorithms from nature and to the movements of bodies throughout the gallery. A new installation from Cortez in Ballroom's courtyard explored modernity, nomadic architectures, and the oppressive structures of Donald Trump's family separation policy via geodesic domes constructed from chain link, Mylar, folded metal, and scrapped car hoods. Cortez also engineered a new machine titled *Infinite Mixture of Things, Past, Present, and Future* that used a hypocycloidal gear to mix air and move a small garden of native crops, referencing the generosity of plant respiration and universal exchange of breath. ▷

Top: Installation view, Fernando Palma Rodríguez, *Ahuaxtli*, 2019. Bottom: Installation view, Fernando Palma Rodríguez, *Xipetotec*, 2018. Overleaf: Installation view, Candice Lin, *On the back of syphilis mountain candelilla grows*, 2019.

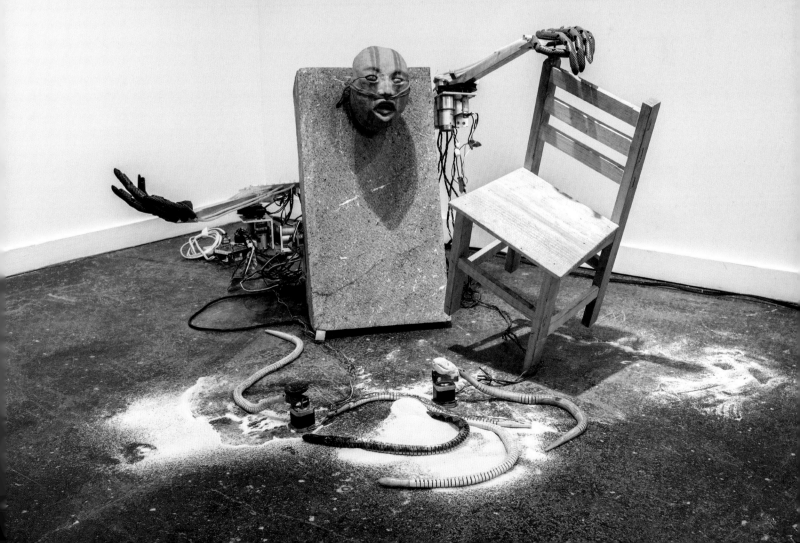

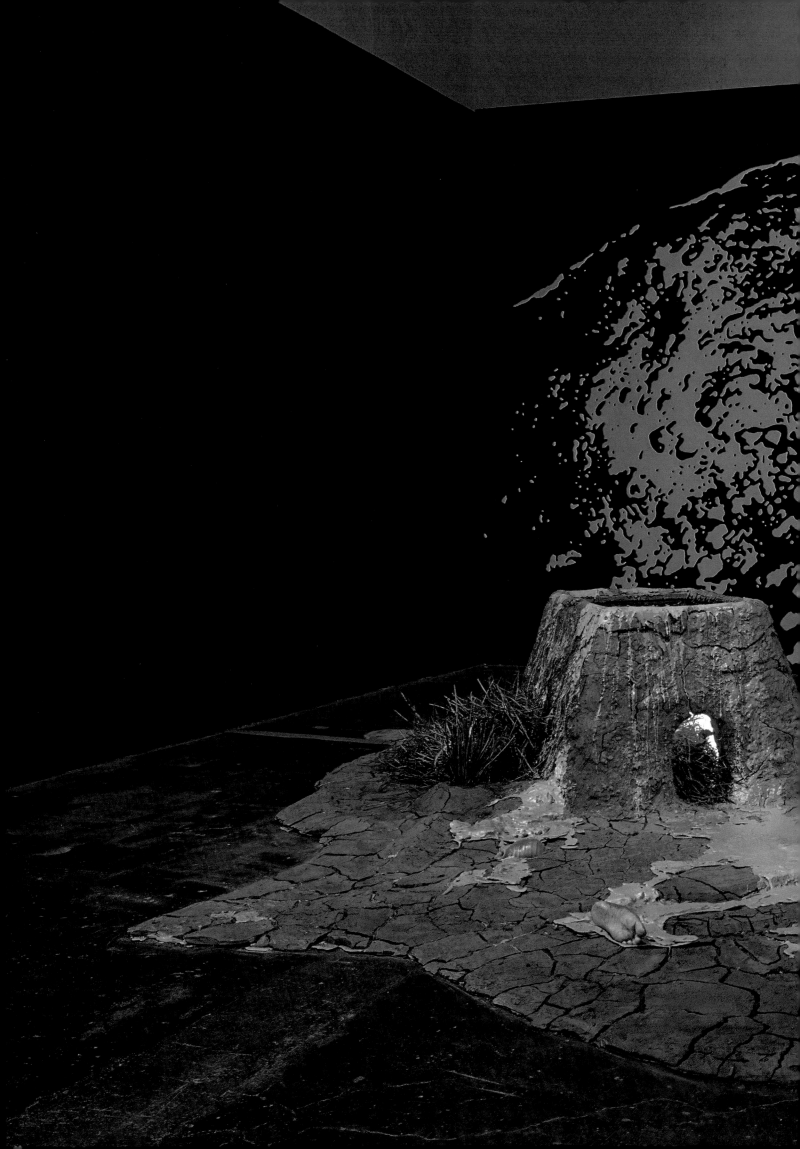

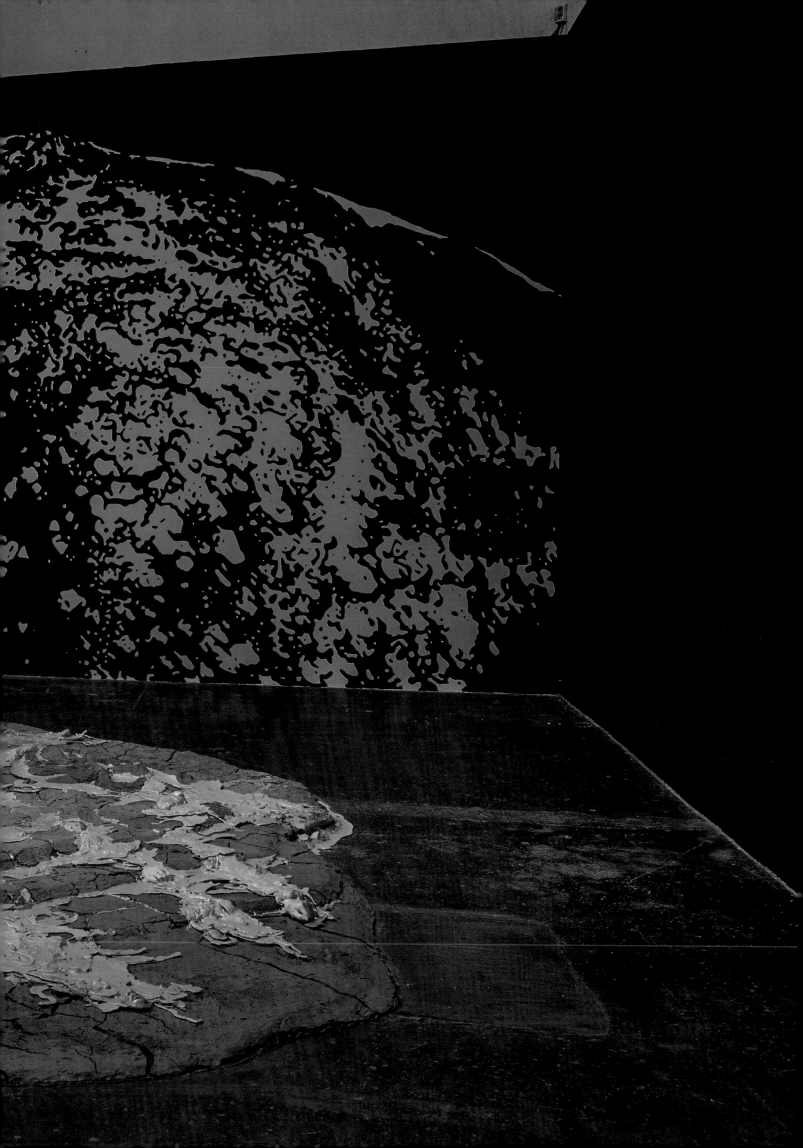

"When I come to a space like this, I feel celebrated as an artist and I feel intimidated as an immigrant all at once. That's important to tackle."

A REFLECTION BY BEATRIZ CORTEZ

I think the exhibition was interesting because it brought together the work of three artists who are very different artists and at the same time that explore concepts that are so similar, like simultaneity and crossing through time and space, and the ideas about land and borders, and also imagining possible futures, the lives of objects and the lives of plants. What I can tell you is that in many ways, the work that I have here explores ideas about imagining possible futures.

The five different new works I made for the show also respond to Marfa as a concrete space. And they enter conversation, in my opinion, with many things that are around, iconic spaces in Marfa. There's the idea, being a nomad idea about migration, and it's a reaction also to the presence of all these immigrants that are being held under the bridge in the most inhumane conditions. All those things come together to me. Marfa has been a great source of inspiration to make all the works that I have made in the exhibition. I am also an immigrant who is traumatized by the experience of immigration. I am also a person who grew up in a war and was kicked out of her own country: my country, El Salvador. Migration has been the most important experience in my life. The one that has taught me to question ideas about racism and classism in my own country, in my own home country, and here. It has also been an experience that has enriched me culturally, and really formed me into a multicultural being who understands the crossing of borders and existing in different temporalities and different times and spaces. When I come to a space like this, I feel celebrated as an artist and I feel intimidated as an immigrant all at once. That's important to tackle as a source of this gut feeling of making art about that. □

228

ARTISTS' FILM INTERNATIONAL

2017–2019

Beginning in 2016, Artists' Film International established an annual theme to create a framework for the films. The theme is intended to help focus the selection of works, yet remain expansive enough to allow each partner to interpret it freely.

ARTISTS' FILM INTERNATIONAL 2017:
COLLABORATION
DENISE FERREIRA DA SILVA AND ARJUNA NEUMAN

In honor of the tenth anniversary of the series and its partnerships, the theme for AFI 2017 was collaboration. Ballroom nominated *Serpent Rain* (2016) by Denise Ferreira da Silva and Arjuna Neuman. The film is as much an experiment in working together as it is a film about the future. The collaboration began with the discovery of a sunken slave ship and an artist (Neuman) asking a philosopher (da Silva), "How do we get to the posthuman without technology?" And the philosopher replying, "Maybe we can make a film without time." The result is a video that speaks from inside the cut between slavery and resource extraction, between Black Lives Matter and the matter of life, between the state changes of elements, timelessness and tarot.

ARTISTS' FILM INTERNATIONAL 2018: TRUTH
JIBADE-KHALIL HUFFMAN

Jibade-Khalil Huffman's *First Person Shooter*, the video nominated by Ballroom Marfa for the 2018 season of AFI, was featured in *The Way You Make Me Feel*, a solo exhibition of his work organized by Laura Copelin. *First Person Shooter* is a complex visual collage that layers digital animation, video, bold text, and multichannel audio. Overlaid onto the imagery, a libretto-like text applies lyricism to collaged episodes that intentionally frustrate conventional narrative expectations. Stock audio and digital animation combine with Huffman's footage of actors who can't help but fall asleep midsentence. The artist calls into question the labor of consciousness and the anxious ennui of the internet age. The piece continues

Huffman's exploration into the formal qualities of video as a medium, while weaving themes of anxiety, race, violence, overstimulation, and boredom from a fractured palette of source material. ☐

LONGILONGE

SOLANGE PESSOA

Curated by Laura Copelin, *Longilonge* was the first solo museum exhibition in the United States of Brazilian artist Solange Pessoa. For *Longilonge*, Pessoa recreated a seminal installation originally staged in Brazil in 1994—an immersive sculpture composed of suspended tiers of coffee bags filled with fruit, flowers, seeds, bones, earth, and poems—and debuted new commissioned works that responded to the cultural and natural landscape of West Texas. In *Longilonge*, she gathered materials and iconography from distant but similar environments, creating conversations between shared forms and interwoven cosmogonies.

A REFLECTION BY LAURA COPELIN

I serendipitously encountered Solange Pessoa's momentous work after a trip to the Lower Pecos Canyonlands to see the ancient rock art there— one of the densest and most diverse bodies of pictographs and petroglyphs in North America. In these prehistoric rock shelters just hours from Marfa, complex patterns, figures, and relationships were rendered with mastery and devotion, and have endured for thousands of years. Below the murals, mortar holes dot the cave floor, some shallow, some smooth and deep enough for my entire hand to fit inside. It was transporting and transformative to feel the grooves in the stone and to be in the presence of such powerful cosmological paintings. A few weeks later, I saw Pessoa's work in person and felt an immediate, visceral connection between the art in the Lower Pecos and her pitted soapstone sculptures and paintings rendered in mineral pigments.

Working from her own dreams and intuitions as well as an encyclopedic knowledge of art history and her personal collections of plants, fossils, and minerals, Pessoa has devoted her life to the organic processes that beget her installations, sculptures, and paintings. Over three decades, she has built a significant and internationally recognized body of work that spans diverse media and multidisciplinary reference points. Deeply studied yet fresh and spontaneous, her work spirals out from inchoate, primeval forms into evolving biomorphic apes, distinct species, and intricately complex patterns. Pessoa's art-making is consciously situated at the confluence of many forces, from Tropicalia to land art, Brazilian modernism and the Baroque, Surrealism, natural history, and poetry, which the artist transmutes into her singular two- and three-dimensional objects.

When we invited Pessoa to West Texas to see the Lower Pecos rock art, the Fossil Discovery Exhibit in Big Bend National Park, the biodiverse plant specimens in the Herbarium at Sul Ross State University, the Chinati Foundation, and the Judd Foundation, she absorbed the landscape with wide eyes and acute curiosity. This exhibition is the result of these manifold meetings, divergent disciplines, and time periods and places, where connections were found and followed despite great difference. From the alchemy of her experiences in Marfa new arcs of work were created, commissioned specifically for our space at Ballroom. These new pieces converge and coexist within five distinct bodies of work, displaying touchpoints in the artist's practice and establishing a connective tissue of imagery, ideas, and relationships between two distant places in North and South America.

The word *longilonge* crystallizes the spirit of this project: It is an invented word found in the poetry of Carlos Drummond de Andrade that Pessoa repurposes to evoke, in her words, "a distant space or time, a longing for the unreachable, a sort of mythical place for feelings and memories, a region of temporal textures." For me, it means longing as well, but for a connectivity and solidarity with each other and the natural world of which we are all a part. □

Excerpt, exhibition catalog.

Installation views with, clockwise from top left: Solange Pessoa, *Longilonge*, 2019; Solange Pessoa, detail, *Untitled (Version Minas-Texas)*, 1994–2019; Solange Pessoa, *Untitled*, 2019; Solange Pessoa, detail, *Mundao I & Mundao II*, 2019; Solange Pessoa, *Mundao I & Mundao II*, 2019. Overleaf: Solange Pessao, *Untitled* from the *Caveiras* series, 2016; Solange Pessoa, *Mundao I & Mundao II*, 2019. Pages 236–37: Solange Pessoa, *Untitled (Version Minas-Texas)*, 1994–2019. Installation view, *Longilonge*, 2019.

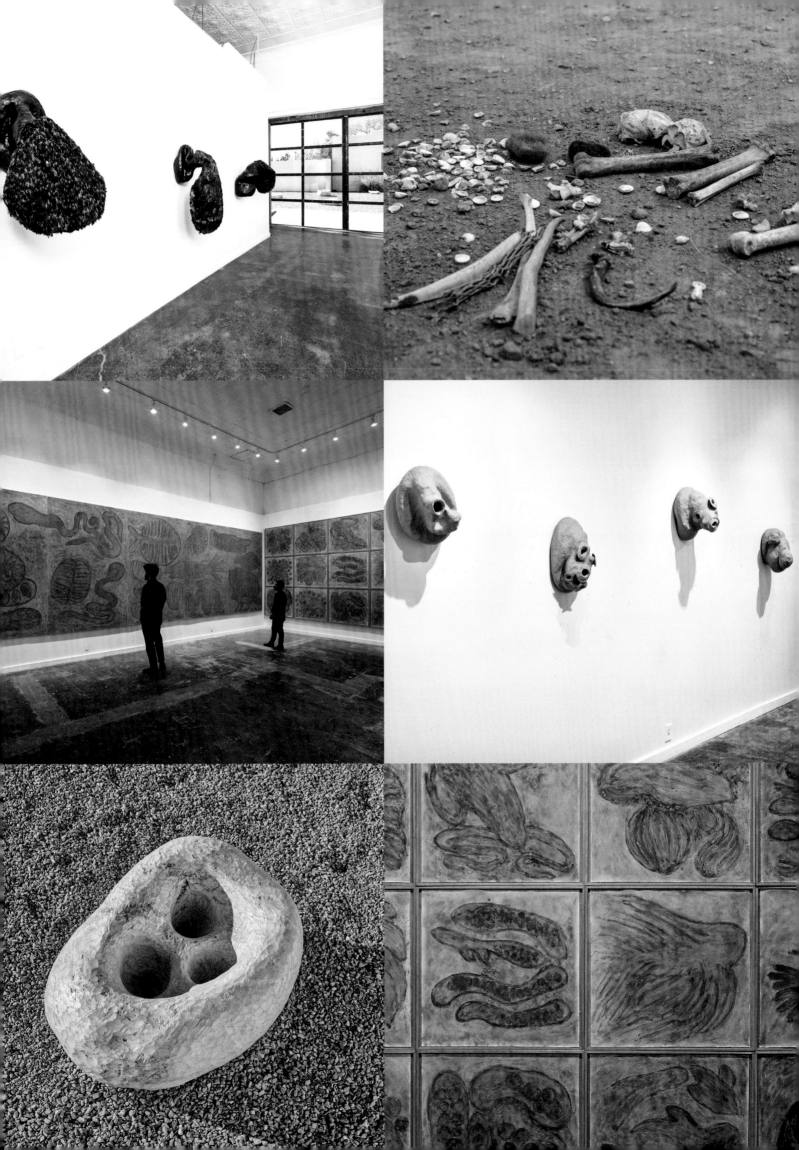

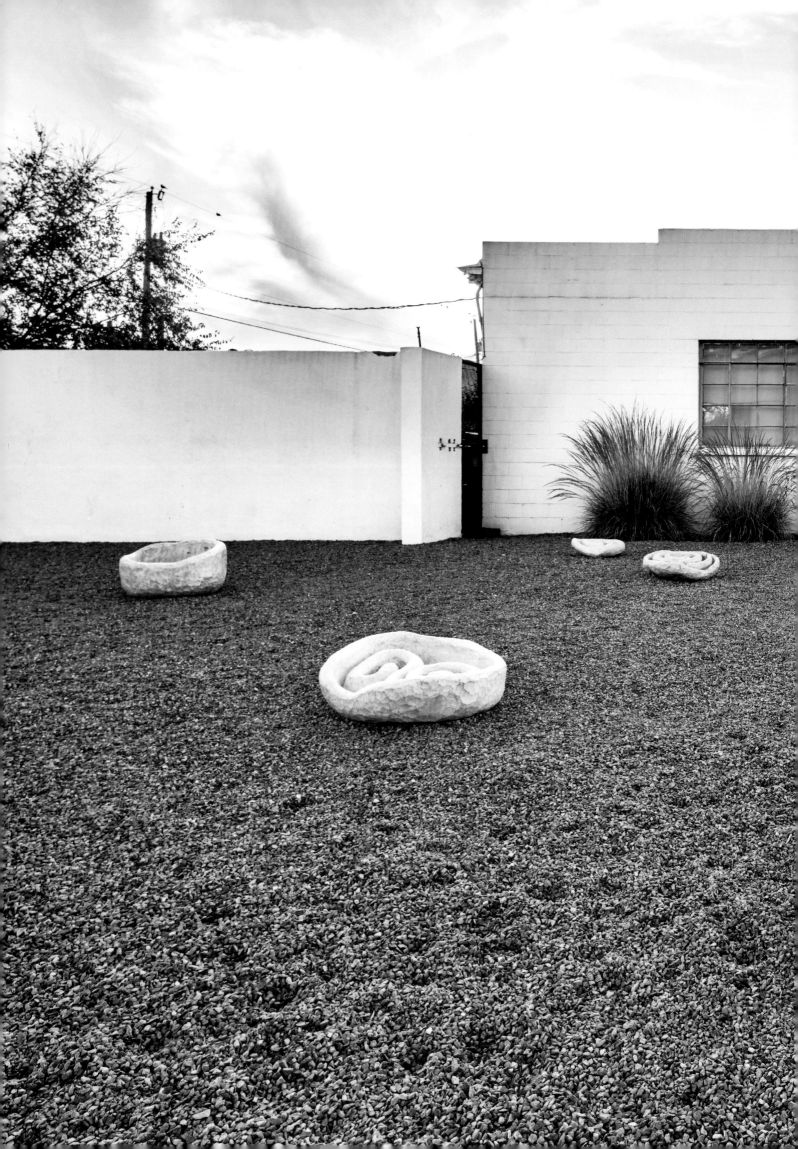

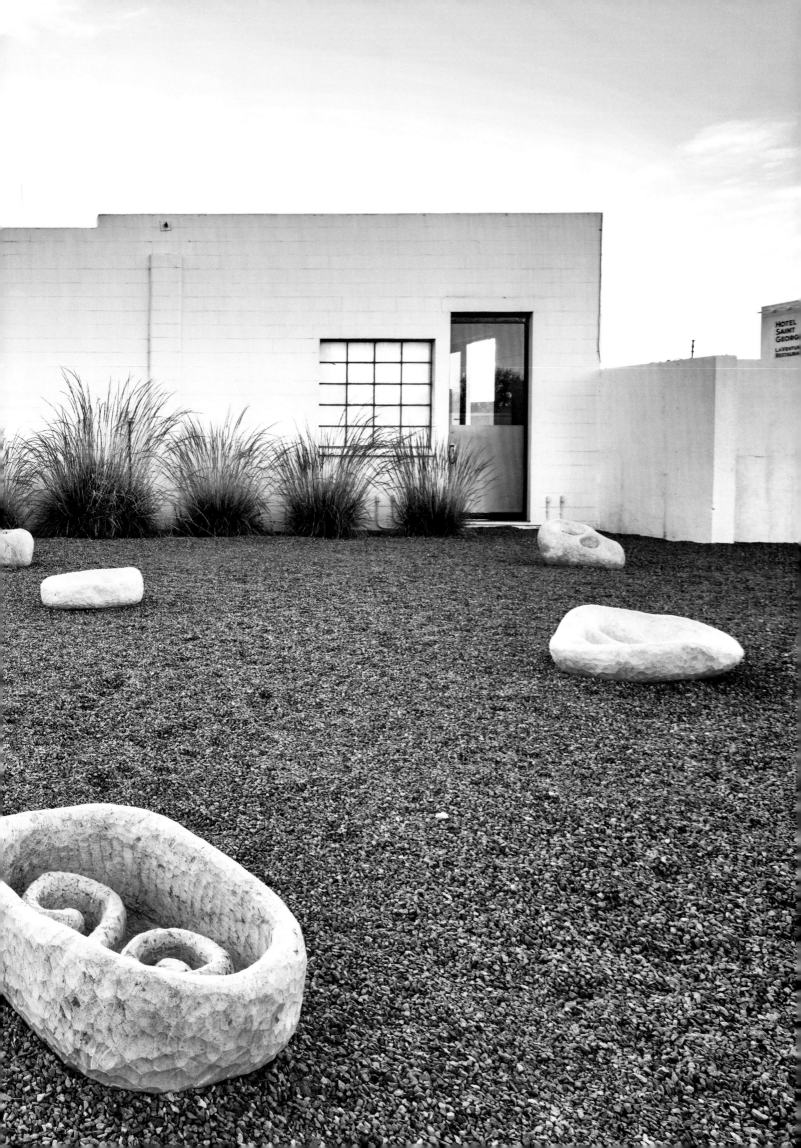

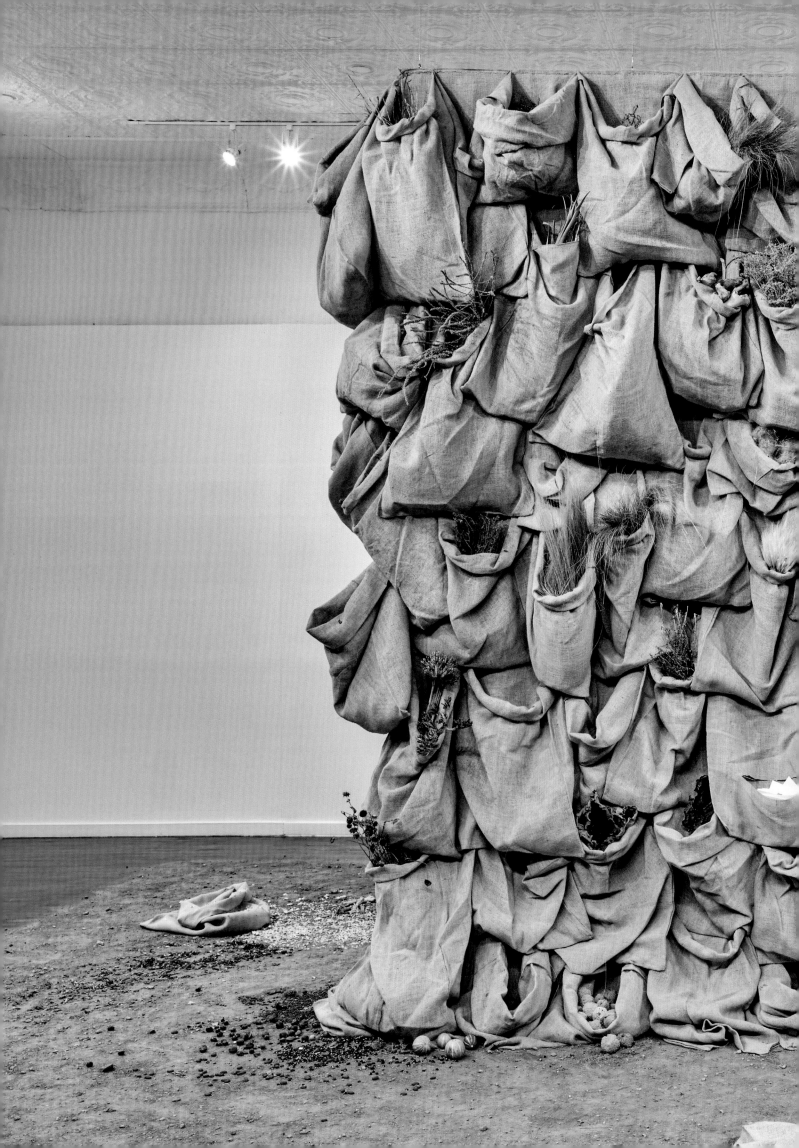

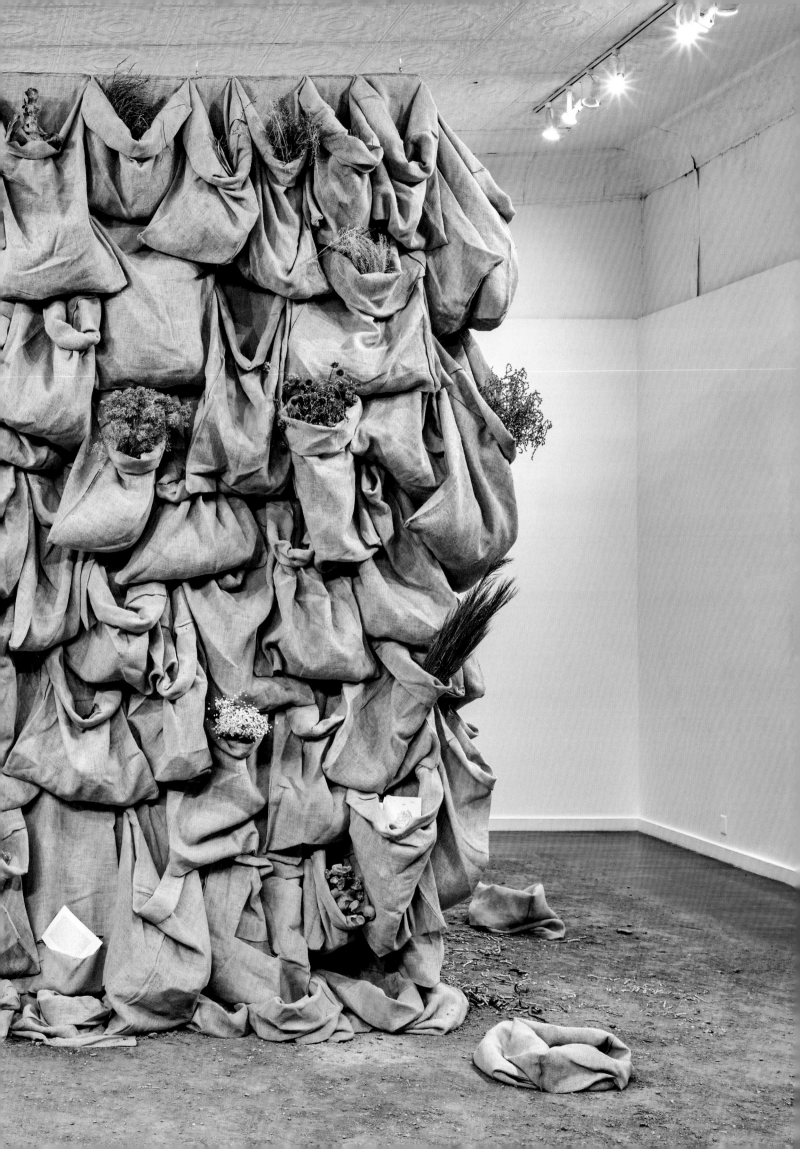

CHAPTER FIVE

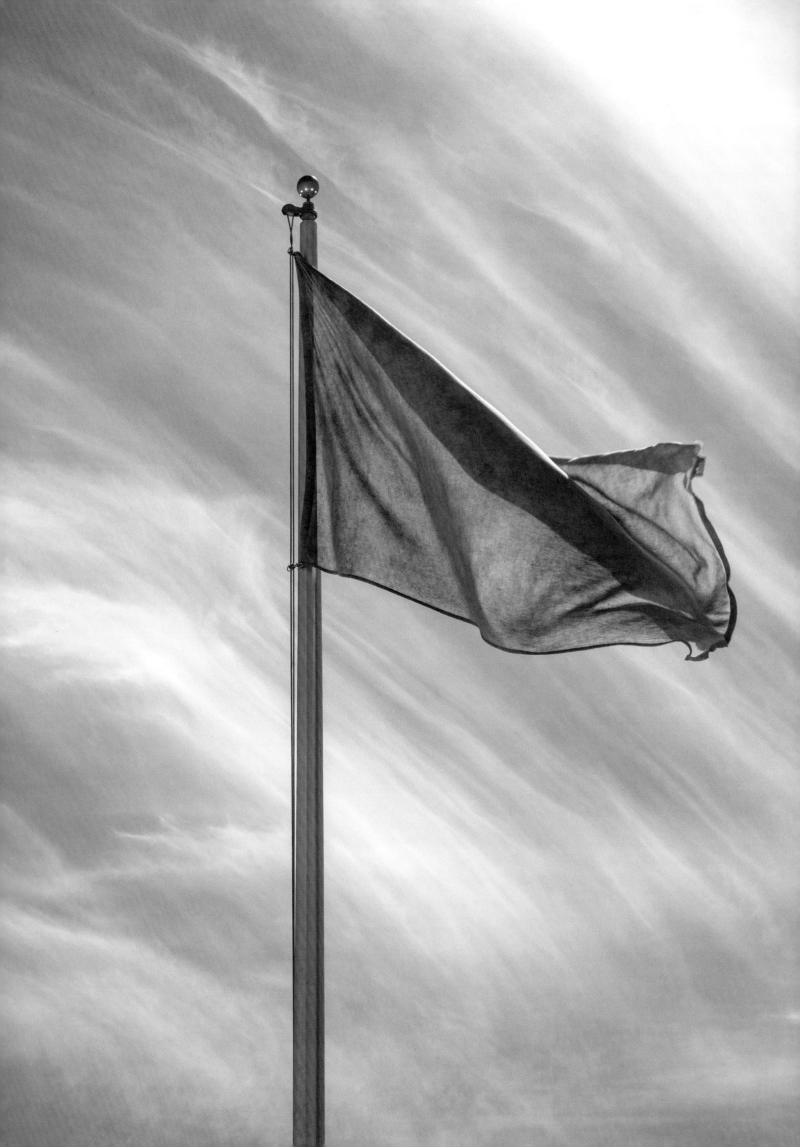

A NEW AND FARTHER PLACE

2020–2023

The pandemic changed everything. When the world shut down in 2020, Ballroom Marfa, too, temporarily closed its doors—for the first time since its opening in 2003. Marfa's businesses, restaurants, and art spaces were all closed in order to discourage tourism to the town. Marfa is rural and remote; the nearest full-size hospital is three hours away, and in the spring of 2020, it was already overflowing with COVID-19 patients. It was the time to evaluate whether running a contemporary art space was necessary while mass illness and death were spreading across the globe.

During this period, the cornerstone of Ballroom since its inception was reaffirmed: its dedication to living artists and musicians. In the wake of the pandemic, many of them were forced to pause their tours, teaching jobs, or upcoming exhibitions and projects. And while Ballroom had always invited artists to come and stay in Marfa for research, site visits, and installations, a formalized residency program was initiated. Through Ballroom Sessions—The Farther Place, artists were given space and resources to carry on their practices. And, once the world began to open up again, the act of sharing art took on even greater significance. What's more, we could process and experience the lessons learned during that difficult time through the work that was made. □

UNFLAGGING

LISA ALVARADO, PIA CAMIL, JEFFREY GIBSON, BYRON KIM, KAMEELAH JANAN RASHEED, HANK WILLIS THOMAS, NAAMA TSABAR, CECILIA VICUÑA

In response to the global pandemic, Ballroom Marfa presented an outdoor exhibition, *unFlagging*—curated by Laura Copelin, Sarah Melendez, and Daisy Nam with Gabriela Caballo—that featured new commissions from eight artists. Each artist created a flag accompanied by a sound-based work. During the exhibition, the commissions rotated every two weeks from October 2, 2020, through January 21, 2021.

unFlagging reconsidered the symbolic meaning of flags in our collective consciousness and in the United States today. Flags communicate beliefs and values in the public landscape. They are inherently performative—they declare, demarcate, and signal. As citizens, we learn to raise them, lower them, fold them, sing to them, and respect them. But the customary use of flags as vehicles to uphold and perform established principles can be challenged. The ruling to remove and reexamine Mississippi's state flag, which displays confederate iconography, for example, reveals not only the power and importance of these symbolic objects, but a shift in how they are received.

In this time of social transformation, Ballroom Marfa invited artists to rethink the immutability and nature of flags. How is meaning constructed, produced, and perpetuated? Can we invent new ways to make symbols and communicate meaning? Animated by the wind, rain, and light of West Texas, these artists' flags reflected change and challenged constancy. Visual elements of design, color, and shape were considered in each flag to generate a multiplicity of readings.

Additionally, the accompanying sound works were not a singular anthem sung in allegiance; rather, each artist created a sonic environment that further activated Ballroom's courtyard to engage with their particular flag. There is a shared experience around sound, reminding us of the multitude of voices that create space for public discourse. ▷

Naama Tsabar, Untitled *(Without)*, 2020.

242

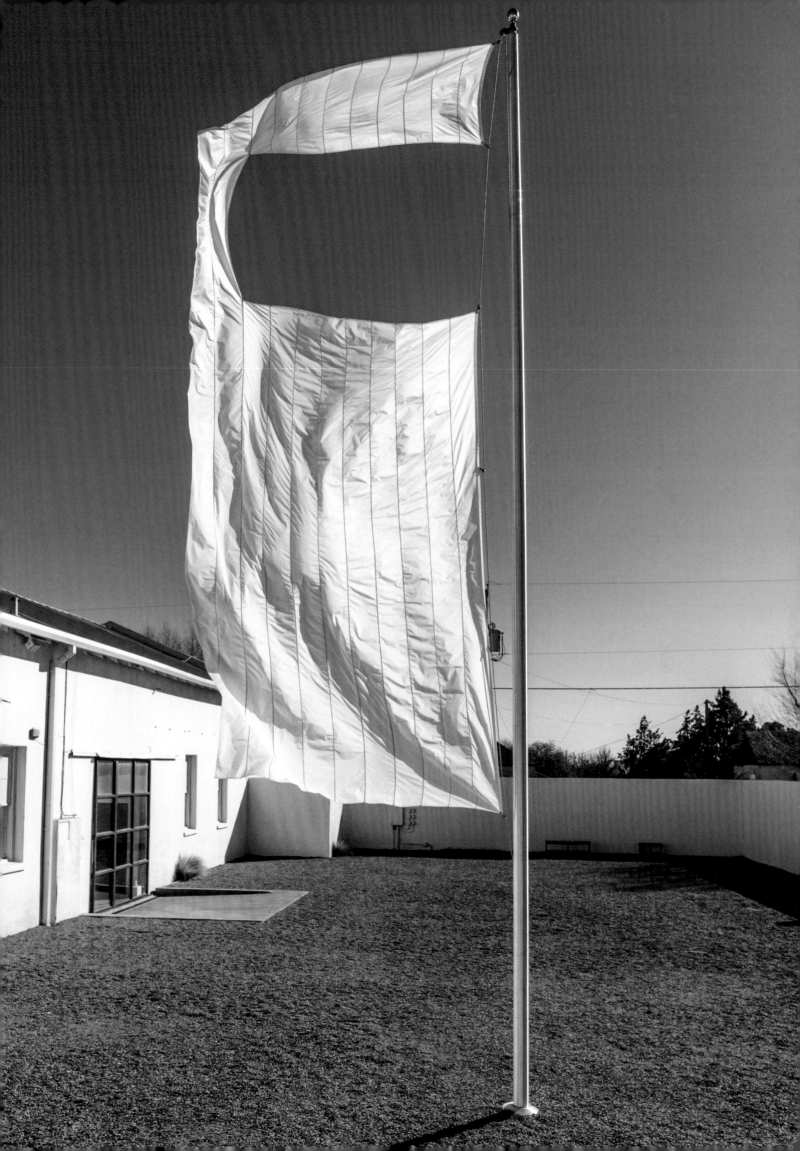

CECILIA VICUÑA WITH RICARDO GALLO

Cecilia Vicuña's flag *Ver Dad* (1974/2020) and sound work *Que despierte la verdad* (2020), made in collaboration with Ricardo Gallo, were the first iterations of the exhibition. The flag's powerful imagery and vibrant colors originate from a 1974 drawing made while the artist was living in London, after fleeing Pinochet's Chile. The drawing is part of a series, *PALABRArmas*, a word invented by Vicuña, which translates to "word weapons" or "word arms."

The flag is an offering for us to see the truth of this moment. Placed at the center of an eye is the word *ver*, which translates to "to see," alongside the word *dad* in the palm of a hand. Put together, *verdad* means "truth" in Spanish. The accompanying sound work invited visitors to feel, as Vicuña's haunting incantation awakens the senses.

BYRON KIM

With the *Sky Blue Flag* series, Byron Kim attempts a nearly impossible task: making a flag disappear in the sky. In the vein of abstract painting, the work complicates the relationship of image, object, and ground, while also deconstructing the symbolic weight borne by flags, as Jasper Johns did with his *Flags* series.

Kim's *Sky Blue Flag* (2020) uses the 4:7 ratio of the Mexican flag rather than the American flag's 4:6 ratio. The flag's color was matched to the skies of Ciudad Juárez, Mexico, where it was fabricated in collaboration with NI EN MORE, a women's activist network and sewing studio. The particular shade of blue was achieved using natural indigo dye and intended to fade over the duration of the flag's installation. The resulting white flag perhaps signals a challenge to fixed claims of nationhood and territories.

HANK WILLIS THOMAS

Hank Willis Thomas appropriated the design and form of a shipping label for his work in *unFlagging*, titled *Life, Handle with Care*. Thomas altered the customary text by replacing "Fragile" with "Life" so that it reads: "This Side Up LIFE Handle with Care." In doing so, Thomas shifted symbols and language and reintroduced them into contexts that created new readings and meaning.

Shipping labels are ubiquitous within art institutions, affixed to every crate transporting artwork. In this context, extreme care is given to inanimate objects as they circulate around the world. Thomas's flag urges us to question whether the well-being of the people living in our communities receives as much consideration. Can we give our neighbors as much care as we do to art objects? How do we attend to the needs of our fellow citizens? The red-hot color of the flag is a searing call to reconsider what care looks like today.

Ballroom Marfa took the cue from Hank Willis Thomas's flag to consider care in the gallery's immediate surroundings. On Election Day 2020, we and our community partners *Big Bend Sentinel*, Communitie Marfa, Convenience West, the Judd Foundation, KMKB, and Marfa Steps Up served free barbecue to voters. Marfa had a historically high turnout.

PIA CAMIL WITH AUDIO FOR MARFA LOCALS

With her commissions, Pia Camil broke the conventional form and function of a flag, asserting that applying abstract symbols to rectangular fabric is inadequate in representing a group of people. For *AIR OUT YOUR DIRTY LAUNDRY*, Camil instead makes a portrait of Marfa using residents' laundry. The artist asked the people of Marfa to donate personal items of clothing or linens, which she hung along a clothesline stretched from the flagpole in Ballroom's courtyard to the building's facade. Audio recordings of participants sharing the meaning of their donated items accompanied the outdoor installation. In exchange, participants received a voucher for a free load of laundry at Tumbleweed, Marfa's local laundromat.

For Camil, intimate items that live close to our bodies contain our sweat and secrets; they bear witness to our moments of joy and sadness. The dirty laundry in this exhibition was foregrounded and celebrated rather than hidden.

JEFFREY GIBSON

Two eight-pointed stars, with concentric diamond patterns radiating from their centers, appear on Jeffrey Gibson's flag *one becomes the other*, 2020. When the flag is still, the stars never quite touch, but as the flag waves and flaps with the wind, they appear to merge. Their interplay is further animated by music from Laura Ortman, which emanated from Ballroom's courtyard.

The flag's symbols are a nod to the exhibition's site in Texas, the Lone Star State. More notable is the influence of the Lone Star quilts made by Indigenous peoples, in which intricately sewn pieces of fabric form an eight-pointed star. These quilts are made to honor individuals at milestones throughout their life. Gibson's introduction to these aesthetic and ritual traditions came through observing his own grandmothers' quilting. His flag foregrounds the geometric abstraction of Native American women quilters, expanding viewers' knowledge of craft and conception of modernism. ▷

"Flags communicate beliefs and values in the public landscape. They are inherently performative—they declare, demarcate, and signal."

Pia Camil, *AIR OUT YOUR DIRTY LAUNDRY*, 2021.

LISA ALVARADO WITH NATURAL INFORMATION SOCIETY

A thalweg is the lowest elevation in a river, a pathway of shifting water and sediment. It is also the median that defines international borders in a waterway. It traces the divide between the Rio Grande and Río Bravo, for example, on the politicized Mexico–United States border.

Thalweg Flag, by artist and musician Lisa Alvarado, demarcates an intervening space for healing physical, psychological, and spiritual borders between people. The flag recognizes borderland waterways as vital arteries of converging multiplicity. The yellows of the flag recall the yellow bracelets imposed on families separated at the border. The flag's symbology acknowledges the power of transformation and intercedes to overcome artificial boundaries and forced separations in favor of unification.

"Sounds for Thalweg Flag" by Natural Information Society, an ensemble founded by Joshua Abrams that features Alvarado on harmonium, played alongside the installation. The sound work includes newly composed, improvised, and found sound. Through it, Alvarado considers a liminal space, a shifting pathway, where layers of memory continuously mix and reconfigure.

NAAMA TSABAR

From a distance, Tsabar's flag Untitled *(Without)* (2020), is a long piece of fabric with a rectangular cutout. Where we expect to see a flag, we instead see empty space. In the courtyard, the flag's details were experienced on a more intimate scale: composed of white strips of fabric sewn together with thread in colors derived from the LGBTQIA+ progress pride flag, its full meaning could only be registered with close inspection. Untitled *(Without)* suggests that identity is far subtler than the bold symbols and objects that attempt to represent us.

Tsabar's installation included a sonic work titled *Ruptures (Opus 1)*, featuring the voices of women singing, sighing, groaning, and breathing. *Ruptures (Opus 1)* explores the female musical voice as a "historically expressive anomaly, a place where a disruption of the patriarchal order happens under the cover of beauty and melody." As the voices reverberated throughout the courtyard alongside the flag, we were reminded to recognize the unseen and undefined.

KAMEELAH JANAN RASHEED

With each passing breeze, Rasheed's *words on all things are organized as uncertainty* (2021) reshuffles and recombines meaning, a reminder that flags are inherently mutable. On one side of the work we read the phrases "all things are organized," "as strange flutters of uncertainty," and "time is structured thick," each enclosed in a white circle. On the reverse we see "strange," "flutters," "*behind* this," "cosmic," "verse." These words and speech bubbles float atop graphics reminiscent of geological or cosmic renderings. Black and white strokes gesture toward movement and gather form with layers of pink and fuchsia circular patterns. These changing arrangements present a poetic gesture in motion, allowing us to read the flag in different ways and reveal new meanings. □

246

NOSOTROS QUEREMOS ATRAPAR A LOS INMIGRANTES ILEGALES Y NARCOTRAFICANTES

ARTISTS' FILM INTERNATIONAL

2020–2021

While the pandemic shifted the ways that audiences could engage with film, the AFI series persevered. Because the partnership was global, each venue had different capacities, resources, and regulations, but all of them participated to the degree that they were able. Ballroom hosted online screenings in 2020 and outdoor screenings in 2021.

ARTISTS' FILM INTERNATIONAL 2020: LANGUAGE
MIGUEL FERNÁNDEZ DE CASTRO

For AFI 2020, Ballroom Marfa selected Miguel Fernández de Castro's film *Grammar of Gates / Gramática de las puertas* (2019). In the film, de Castro traces the overlapping territories, languages, and conflicts that mark the United States–Mexico border within the sovereign Tohono O'odham Nation. The film weaves excerpts from the 1970 film *Geronimo Jones*, surveillance-like drone imagery of the landscape, and an affectless recitation of phrases drawn from *A Practical Spanish Grammar for Border Patrol Officers*.

Ballroom hosted two online screenings and an interview with de Castro and Ballroom curator Daisy Nam on its website. The first screening showcased de Castro's film and was followed by Raqs Media Collective's *Passwords for Time Travel* (2017). The second online screening featured Rhea Storr's *Junkanoo Talk* (2017) and Lisa Tan's *My Pictures of You* (2017–19), and was followed by an online Q and A with Tan and Nam.

ARTISTS' FILM INTERNATIONAL 2021: CARE
PATTY CHANG

In 2021, Ballroom Marfa presented Patty Chang's *Invocation for a Wandering Lake: Part 1 & 2* (2016), curated by Daisy Nam. Ballroom projected the film onto the gallery's facade, as all indoor spaces remained closed.

As a response to COVID-19, the AFI theme for 2021 was care. Chang's work calls for contemplation of human and nonhuman lives, the natural environment, and destructive geopolitical forces, as we witness the artist in ritual acts of care and mourning. In the film, the lifeless body of a whale floats off the coast of Newfoundland's Fogo Island, a former fishing hub. The artist is seen meditatively washing the deceased animal. With similar attention, she scrubs the shell of an abandoned ship in the desert of Muynak, Uzbekistan, a defunct seaport on the receded Aral Sea. Despite the absurdity of her compassionate efforts toward entities that could never be revived, she continues, perhaps as a way to process their fateful ends.

The film was an offering to Marfa. The town had collectively experienced extreme loss during the ongoing pandemic. If we are to create new ways of living, perhaps we first need to practice ways of mourning and mending through acts of care, as the film suggests. ▷

"It's at least ironic that such a powerful telescope, a device strategically designed to facilitate the colonization of new outer space frontiers, is precisely located on a land that was itself the location of a series of colonial occupations."

Installation view, Patty Chang, *Invocation for a Wandering Lake: Part 1 & 2*, 2016.

A REFLECTION BY MIGUEL FERNÁNDEZ DE CASTRO

My practice as a visual artist developed from a deep rootedness in the Sonoran Desert borderlands in Northern Mexico. My ancestry, as that of most people in the region, results from the intermarriage of small ranchers who arrived as settlers and the local Indigenous population. I came to learn about this as a boy when a number of people in the region got into researching their O'odham ancestry with the purpose of acquiring a tribal ID, which they saw as a means to gaining US citizenship. Even though the IDs were validated by O'odham authorities in Sonora, tribal authorities in Sells, Arizona, considered them fraudulent and discarded them—at least initially.

As I began developing my work as an artist, I became involved in the social dynamics of this territory, especially because my studio is located along one of the region's main rural smuggling trails, a few miles south of the border. These experiences had led me to think about the territory in a critical way, and to question the political and poetic implications of an arbitrary border.

As Mexicans living in the borderlands, we began to feel the effects of Nixon's war on drugs back in 1971—as did the black and brown minorities in America's inner cities. This was way before the war on terror and the US's current anti-immigration rhetoric.

I have a profound—and perhaps nostalgic—interest in the local stories about life in the borderlands during the '60s and '70s. I like listening to people who lived in Sonora or Arizona back in those days. From what they said—and I think oral traditions are essential knowledge—there used to be entire outdoor markets with food and music at the O'odham traditional border gates way out in the desert. None of that is left today. The links between the Arizona O'odham and the Sonoran rural communities were closer in terms of kinship, trade, and, of course, smuggling. The forces unleashed by the initial war on drugs in the '70s are key to understanding the current struggles and conflicts of these lands.

My practice as an image-maker sometimes deliberately mimics the state and government's ways of seeing. This is my way of foregrounding the extent to which our gaze has been militarized. That is, it has been trained by devices and expectations of military origin. By combining this type of imagery, such as the drone's omnipresent eye, with footage resulting from a closer and more rooted engagement with this land, I intend to undermine the undisputed power of the former and create a form of resistance counter-gaze. During the conceptualization of the video, I kept drawing a telescope on a mountain looking simultaneously toward outer space and the ground. It's at least ironic that such a powerful telescope, a device strategically designed to facilitate the colonization of new outer space frontiers, is precisely located on a land that was itself the location of a series of colonial occupations. □

Interview, Miguel Fernández de Castro and Daisy Nam.

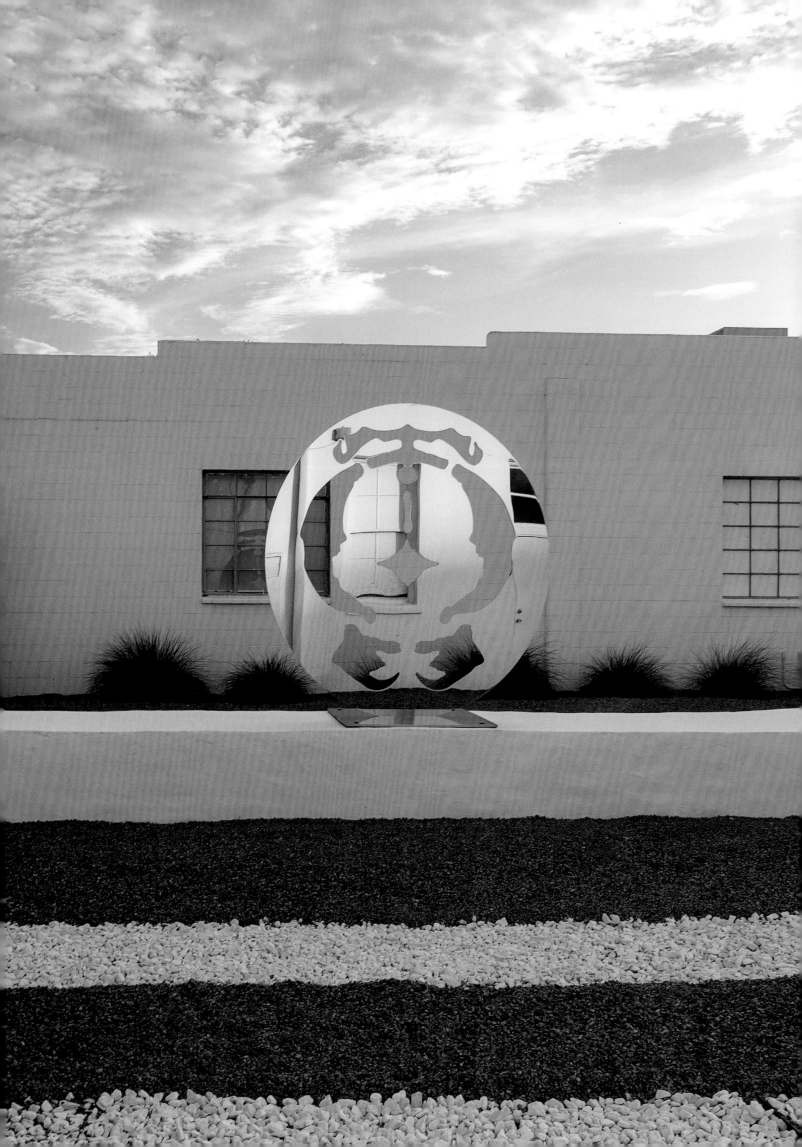

ESPEJO QUEMADA

DONNA HUANCA

Installation view, Donna Huanca, *SCRYING CON DIOS(A)*, 2021.

Stepping into Donna Huanca's exhibition *ESPEJO QUEMADA*, mounted at Ballroom Marfa in 2021, visitors were transported through distinct installations within the gallery spaces. Organized by Daisy Nam, it was the first exhibition since the beginning of the pandemic. Huanca's environments contain elements of color, light, scent, sound, and materials such as the sand and oil paint found in her paintings, and the metal in her sculptures. The immersive installations attuned viewers' senses and attention to material shifts. There were temporal shifts, too, with a sensation of time spanning past, present, and future. Within the installations, each of the artworks was singular, yet they interacted with one another to form an ecosystem. Huanca's presentation at Ballroom, in some ways, was a return to the beginning. She first visited Marfa in 2005, and returned to install *ESPEJO QUEMADA* in 2021—closing the circle to form an organic whole.

World-building is not only an aspect of Huanca's process—it is also physically and materially the construction of a particular space. Huanca *world builds*, conceptually and formally. Creating new worlds feels necessary. The exhibition's title *ESPEJO QUEMADA*, which translates as "burnt mirror," alludes to the need for change. Mirrors offer reflection, and fire has the ability to reshape and recreate—together, they are catalysts for combustion and evolution. During the period of the exhibition, we were still processing the effects of the pandemic, changes to our social norms, and even a new sense of our own bodies. Daily skin-to-skin contacts—hugs, kisses on the cheek, and handshakes with colleagues, friends, and loved ones—had been altered. We were immersed in digital landscapes and metaverses, in some ways allowing us to deal with fragmentation and separation from one another on a global scale. Doomscrolling flattened our experience of the physical world as well as our sense of scale and embodiment. But within Huanca's installations and works, atrophied senses come alive. She invited us to be touched by the work, to pause and feel, reminding us that the sentient body is a potent source and repository of memory, intuitive knowledge, imagination, emotion, and desire. ▷

ESPEJO QUEMADA: A LOOK INTO DONNA HUANCA'S WORLD-BUILDING PRACTICE
DAISY NAM

ESPEJO QUEMADA (RUBBING)

When visitors first enter *ESPEJO QUEMADA*, they encounter Ballroom's Center Gallery and see the "rubbings" on both sides of the wall that comprise the work *ESPEJO QUEMADA (rubbing)* (2021). Smudges and traces of blue paint capturing wisps, strokes, and other bodily movements have been left behind from a private performance. Huanca offers her own perspective on art spaces: "When you think about entering an art space, we never think about rubbing or touch. You're not supposed to touch anything. You're supposed to walk really stiffly and properly. Art is not allowed to be touched. But I like the idea of breaking the etiquette of how you behave in a gallery or museum."[1] For this piece, Huanca invited Cassandra Momah to perform in private. As she did, she left markings on the wall. Momah, the *model* (Huanca's preferred term for performer), was not "on view" for an audience. Huanca offers agency and power to Momah, and all of her models, who move freely as they wish.[2] In preparation, Huanca hand-painted water-soluble paint onto Momah's body with a makeup brush, as well as applied pigment from a spray gun to create an even coating of color.[3] The artist asked for curtains to be installed for Momah's privacy while she performed. There were only a few select moments when Momah was joined by Huanca and a photographer to document her movements and interactions with objects in the show. Momah spent a few hours creating the "rubbing" by dancing, moving, and pressing her body directly against the surface of the wall. Her performance will also forever be present on the wall. Even after the show's de-installation and the rubbing is painted over, there will be traces of the private performance underneath, as well as in our imaginations. The body rubbings are imbued with a sense of curiosity, probing more questions from viewers: What happened here? Who has been here? Was it a week ago, a lifetime ago? Where did they come from? Where are they going?

PAINTINGS

In Huanca's paintings at Ballroom, we also see the past, present, and future occurring simultaneously. For this exhibition, due to global lockdowns, Huanca was unable to return to Marfa for a site visit (she was able to come for the installation in June 2021). From her Berlin studio, over 5,000 miles away, she relied on her memories of Marfa. As perhaps the title of one of her paintings, *MUSCLE MEMORY (BLUR)* (2021), suggests, the act of painting allowed her to remember and connect to the deserts of West Texas. Her memories not only return to 2005, her first trip to Marfa, but even further back—millions of years ago. Some of her paintings in *ESPEJO QUEMADA* evoke ancient landscapes forming fissures in the Earth's crust, geological shifts, moving tectonics, and molten magma. With this series, the artist reveals, "I wanted to record the different landscapes that you encounter when you're driving in the desert and how the colors are shifting and changing as you continue onward into the different conditions of the weather."[4] Geological records show that cataclysmic changes of volcanic eruptions, floods, and tidal waves occurred in West Texas over 30 millions years ago. Huanca also references eruptions in South America, as seen in the work *COTOPAXI SWEAT* (2021), which perhaps refers to a volcano in the Andes Mountains. One can't help but think of Earth's current and future drastic ecological changes. Scientists predicted many such changes already occurring: decreased sea ice; increased permafrost thawing, heat waves, and heavy precipitation; and decreased water in semiarid and arid regions.

With Huanca's abstract paintings, there are layers of materials that awaken the senses. The first layer in the composition is not canvas; rather, it is a digital print of a close-up photograph of one of her model's painted bodies. The next layer is oil paint, applied with her own body's movements. We see gestures and marks made by her hand, and feel them, too. As we follow the traces of her gestures, we are entranced. There are scratches, swirls, dips, all in the paint. There is an immediacy and rawness to the motions, as if there is something that needs to be communicated and transmitted through her body. Huanca says of her process, "I always think of the paintings as an opportunity to create and contain emotions, or a record of time and movement."[5] The paintings engage viewers' entire bodies as well. Each work standing at six and a half feet and hung low to the ground, it is as if one could step into the works themselves, the worlds she has created.

GUERRERA PROTECTORA (PACHA) AND SCRYING CON DIOS(A)

In the North Gallery, visitors encounter *GUERRERA PROTECTORA (pacha)*, 2021, a six-and-a-half-foot tall circular metal sculpture, as she emerges from white sand. The title translates to "protective warrioress" in Spanish, plus "cosmos" in Quechua, the Indigenous language Huanca heard spoken by her father and grandmother. The sculpture is anthropomorphic and truly embodies the presence of a being. As a note of context for this exhibition, live public performances with models were not possible (large gatherings indoors were still unsafe), so the artist had to reevalute the ways in which her sculptures functioned in the space. In this instance, her sculptures' formal qualities evolved to embody a powerful presence. There is a concision of form and material, and a succinct visual language in the new ▷

Top: Installation view, Donna Huanca, *ESPEJO QUEMADA (Video)*, 2021. Bottom: Installation view, Donna Huanca, *ESPEJO QUEMADA*, 2021. Overleaf: Installation view, Donna Huanca, *ESPEJO QUEMADA*, 2021.

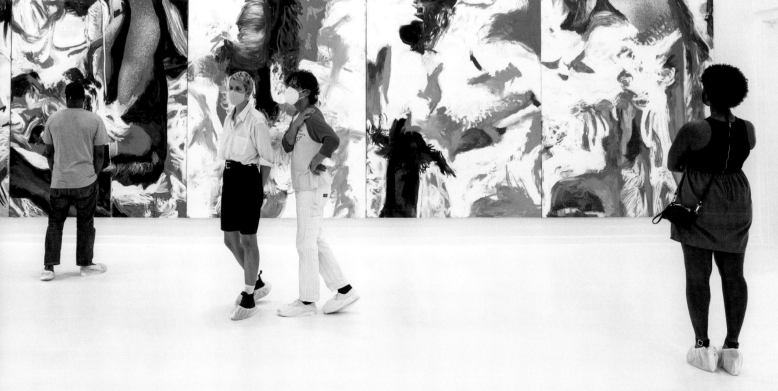

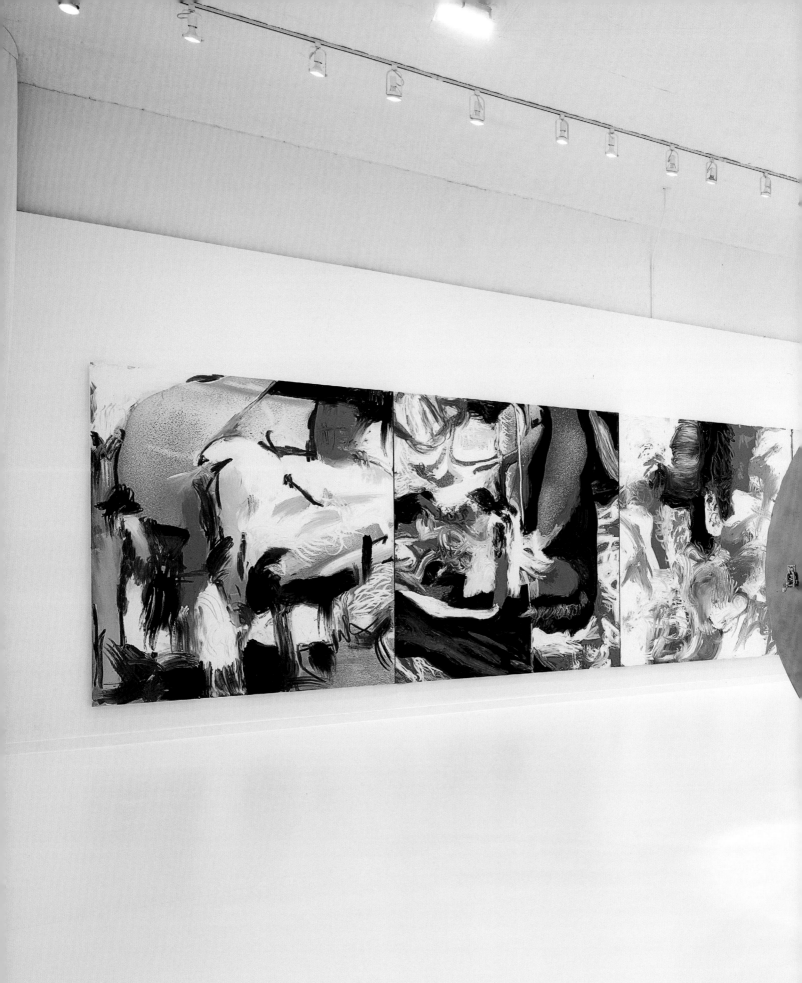

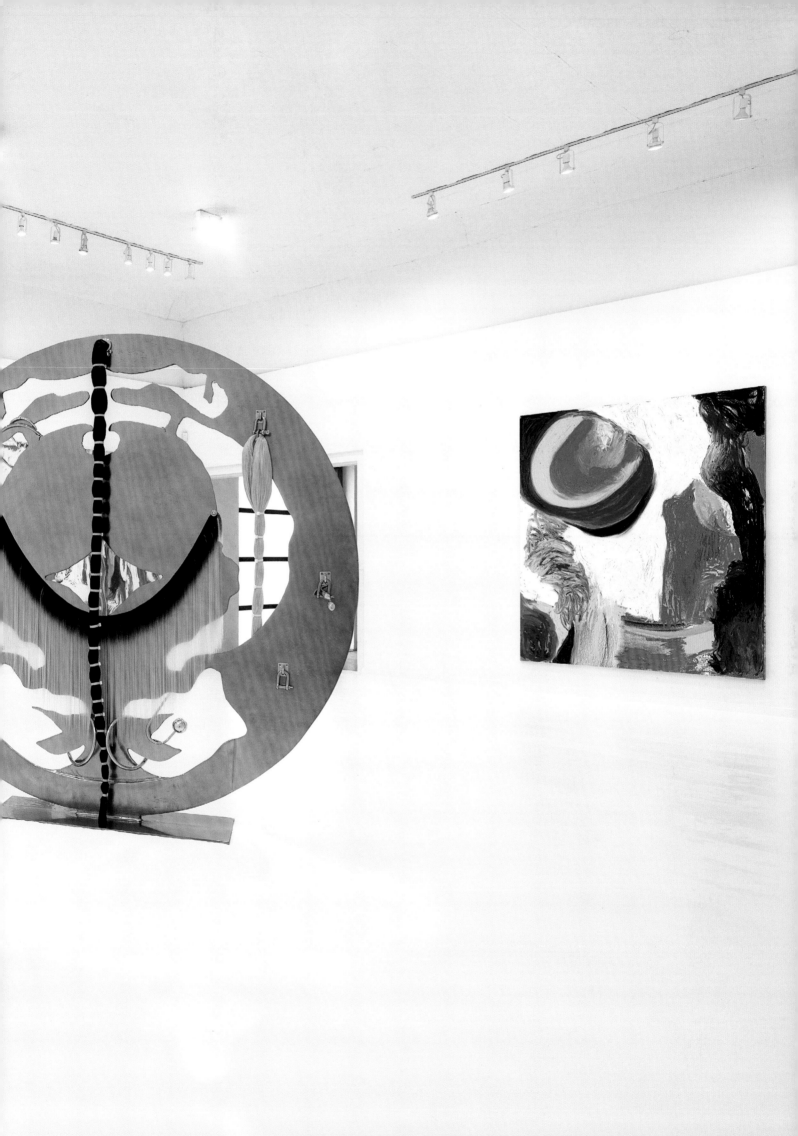

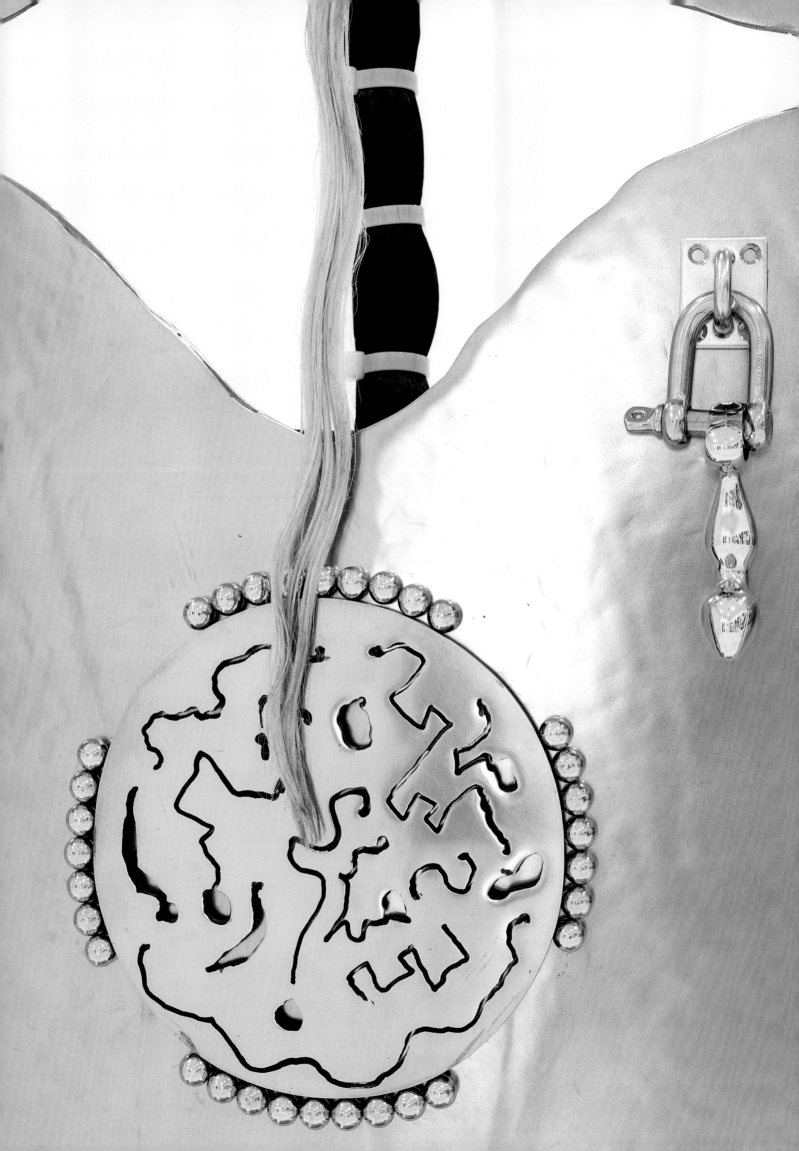

sculptural work. Huanca's new sculptures are made of metal with uniform finishes, as if formed like a singular body.

With *GUERRERA PROTECTORA (pacha)*, time moves fluidly back and forth: there are elements that recall ancient histories, while the material brings us back into our own bodies and present moment. The form purposefully adopts several connotations—mirror, shield, globe, maps, orbiting planets, the cosmos. She is circular like a clock; where the hours should be indicated, however, there are metal clasps. She does not tell chronological time yet nonetheless communicates information. Her commanding, warrior-like presence is adorned with hoops, clasps, rings, prayer beads, and sex toys that invoke flesh of the body. The cutout patterns can be Rorschach tests or MRI scans of organs. The indecipherable lines etched into the surface of the smaller circles resemble a map or maze, or some unknown script. Hair holds power, as seen in her multiple braids and hair pieces. Our DNA is embedded in each strand, holding an individual's genetic makeup, which can reveal our ancestral lineages.[6] The knotted ponytail also alludes to Indigenous forms of communication, such as *khipu* (or quipus), the strings and cords used by Andean cultures that kept records, dates, and communicated information through knots. Knowledge and information from the past are imbedded in material, and can be activated in the present through the reader.

SCRYING CON DIOS(A) (2021), Huanca's first outdoor sculpture, located in Ballroom's courtyard, echoes its double, *GUERRERA PROTECTORA (pacha)*, indoors. She sits atop a plinth that also functions as a bench for visitors. Surrounding the sculpture is a geoglyph formed with chips of white marble, referencing the Nazca Lines—ancient, monumental Andean earth drawings. Not only are there historical references that evoke the past, there are elements that aspire to "elongate time," as Huanca says about her installations. The rock pathways encourage visitors to walk around the sculpture and the courtyard space. Arising from the rocks are four speakers that stand at human height, which additionally pull visitors in to listen. *SCRYING CON DIOS(A)*, similar to the indoor sculpture, has a circular shape and cutout patterning, but the steel has been machine-polished to a mirror surface. The reflection allows us to see ourselves and perhaps even visions into the future, as the title suggests. Scrying is a form of divination and seeing visions of or messages from the future. The future is suggested not only in the title but also the doubling effect of the two sculptures. There's a suggestion of multiplication, replication, and proliferations, as if they were cells. There may be a potential sibling sculpture created and installed elsewhere in the future. Time is captured by the sculpture and its

relationship with the natural world. The sculpture and its shadow become a sundial, as the sun and the moon transit throughout the day. Like the indoor sculpture that seems to tell time, this work, too, offers its own way of reading past, present, and future.

During Huanca's first experience of West Texas, the sky was especially striking for her. The natural movements and rhythms of the sun, moon, stars, planets were more apparent in the wide expanse of a desert sky. It felt alive and animated with cosmic and extraterrestrial forces. Her upward and outward looking is replicated in *SCRYING CON DIOS(A)*—her first outdoor sculpture to date. This work's reflective surface mirrors the world above and around us, shifting our perception. In that shift toward the otherworldly, Huanca's outdoor work, and exhibition as a whole, allows us to form new practices of seeing, feeling, and being as we attempt to form new worlds and realities. □

Excerpt, exhibition essay.

1 Conversation with the artist, June 24, 2021.
2 Even in public performances, Huanca gives little instruction except to move slowly and not speak verbally but through the body and eye contact. "It's not about performing for someone else. It's about [one's] own experience." See Donna Huanca and Jamillah James, *Donna Huanca: Obsidian Ladder* (Los Angeles: Marciano Art Foundation, 2021), 65.
3 Sometimes Huanca will also use turmeric, clary, coffee, and other natural healing elements on the model's bodies.
4 Donna Huanca, from transcript of exhibition walkthrough video, 2021.
5 Conversation with the artist, June 24, 2021.
6 The hair pieces used in this sculpture are synthetic; for ethical reasons, the artist does not use human or animal hair (though horse hair was previously featured in her work).

A WALKTHROUGH OF ESPEJO QUEMADA

ROBERTO TEJADA

Due to the ongoing pandemic, many audiences could not visit Donna Huanca's powerful presentation of new paintings and sculptures, *ESPEJO QUEMADA*. In the fall of 2021, art historian and poet Roberto Tejada shared his insights on the exhibition during a filmed walkthrough that was then offered as part of Ballroom's online programming.

It's interesting to hear Huanca talk about her work—because a very early impression and an early model for her were the folk festivities around the Virgen de Urkupiña in Bolivia. These are a mix or syncretism between precolonial ceremony, Catholic pageantry, and contemporary forms of parade or carnival in which the Virgin is carried through the streets.

[Huanca's] paintings involve all kinds of "chaotic forces," as [she] calls them, but also include her interest in bodies. One of the things that really captivates me about her work is this interest in the blending between the female and the male, the femme and the masculine, as we have at the center of this room with *[GUERRERA PROTECTORA (pacha)]*. I'm also drawn to the way in which Huanca fuses two different elements: the backdrop that strikes me as one from a television studio or a performance or theatrical space, and then the other element—a very purified silence of the white space that she has built for this exhibition, what I consider to be a ceremonial space. She's looking at how contemporary art has a kind of ceremonial practice to it in the same ways that other forms of ritual or ceremonies elevate a kind of central object. In this case, it's the *GUERRERA PROTECTORA (pacha)*, one of the female deities in the Andes cosmovision. Huanca's works' sense of materiality [is evident here]. We have the stainless steel with the hair, mounted on this white sand. It's almost as if the paintings that surround this work are being performed for the powerful femme presence of the Pacha deity. . . . Some of the paintings have to do with melanin, which evokes the idea of pigment—both the pigment of the painting and the pigment of a body's skin. . . .

One of the things that I'm struck by in Huanca's practice is the centrality of the model she uses and the body as the essential unit in collage practice. She will often have models . . . who have been painted with certain kinds of paint, very often this cobalt blue and magma orange, and she then takes photographs of the remnants of those performances. These become the constituent elements in a kind of collage practice that she then uses to establish these very large format paintings. Again, the word "chaos" that Huanca often uses can describe this kind of tension between what is a chaotic field of colors that represent both bodies (skin pigment) and magma as they're being witnessed by this very strong, iconic or monumental precolonial figure here in the center. We're getting to the sound design as well, which is important. The sound has a certain frequency, and we'll also hear voices, often female, or sounds from nature that kind of orchestrate and pull the various elements together. It's as if viewers themselves are the activators of this ceremony and performance as we move through this space. . . .

There's a sense that there are two different elements that don't seamlessly come together into a whole. I think this is what Huanca wants to do, to keep things in suspense. . . . Her model occupied the space during a performance that was not available to the public. If you hear Huanca talking about her relationship to her models, it's really one of care and trust. These are experiences that are meant for the model. . . . What happens is that the model, with her body covered in this pigment, has a kind of choreography that included [pressing against] the walls and therefore imprints, while listening to her own music. These were really drawings or monotypes in a sense of a particular body in a moment in time, leaving a trace of an existence of an experience.

Excerpt, edited transcript of walkthrough, October 2021; a version of this text was published for the exhibition catalog copublished with Inventory Press, 2022. Roberto Tejada is an art historian, poet, critic, and a distinguished professor at the University of Houston.

Cassandra Momah during the creation of Donna Huanca, *ESPEJO QUEMADA*, 2021.

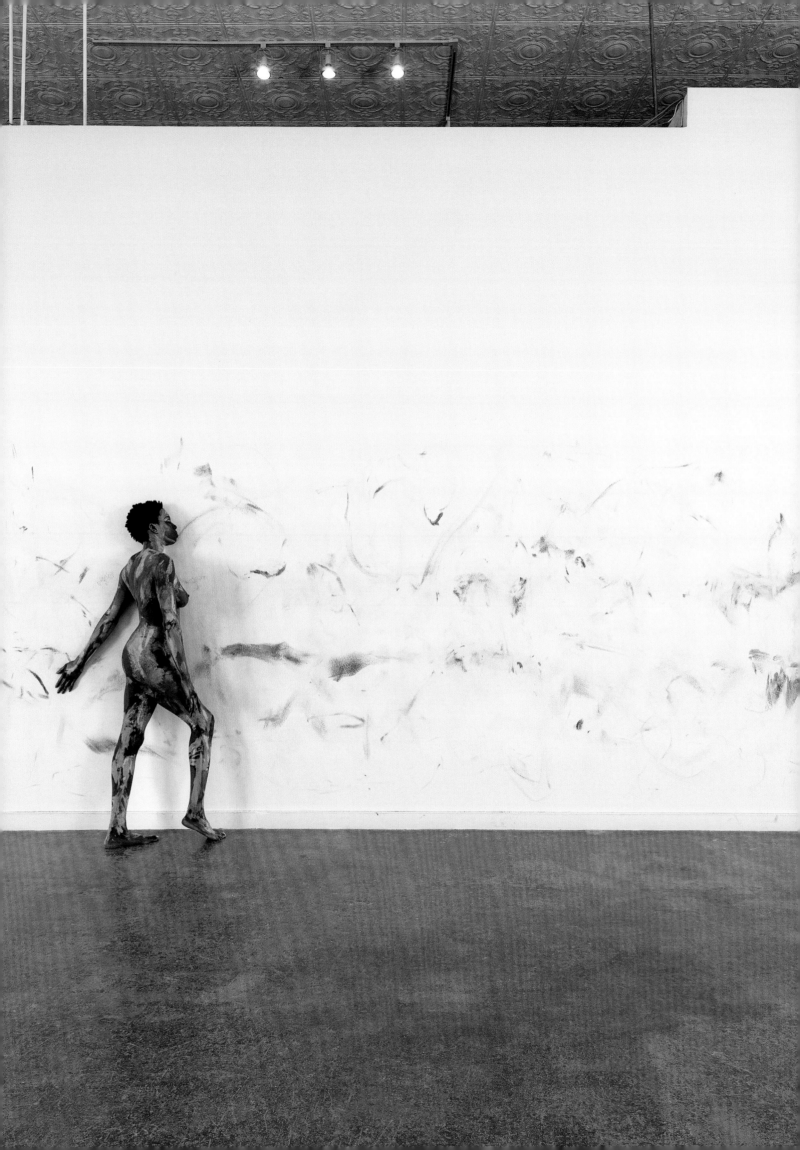

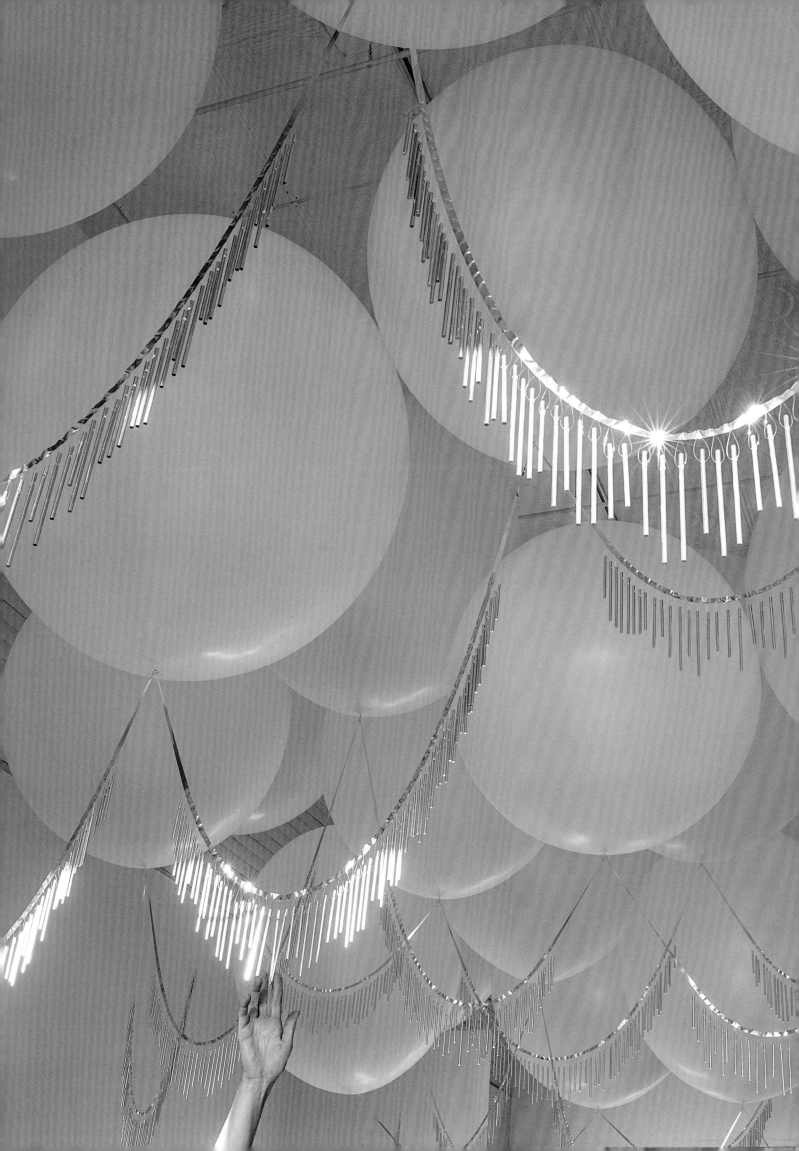

KITE SYMPHONY

ROBERTO CARLOS LANGE AND KRISTI SWORD

Roberto Carlos Lange and Kristi Sword, *Curious Hue In My Ear*, 2022.

Invited by Ballroom in March 2020 for a production trip for *Kite Symphony*, then a short film with a live score, musician Roberto Carlos Lange (widely known as Helado Negro) and visual artist Kristi Sword found themselves in West Texas at the onset of a global pandemic. The artists chose to remain in Marfa and, with Ballroom's support, extended their short visit into a six-month residency. Over the course of that time, *Kite Symphony* expanded into a full-scale exhibition, curated by Sarah Melendez, that included new installation works, a community sound piece, performance, and four new experimental compositions featuring noted local musicians Jeanann Dara and Rob Mazurek, led by Sword's meditative and meticulous visual scores. The compositions formed the album *Kite Symphony: Four Variations*, which was released through Ballroom's Bandcamp.

During their residency, Lange and Sword were guided by the wind and inspired by their day-to-day experiences with the local landscape. To produce new work, they centered a practice of listening: they utilized forms of meditation to tune their bodies into the sonic environment; they employed field recording to capture and amplify barely audible sounds, such as insects' wings; and they launched an open call to the community in order to hear the town through the ears of locals. Said Lange, "When you have your headphones on and a microphone pointing out to the expanses surrounding Marfa, you're surprised with the density of the air. It's like a big blanket wraps your head and you're invited into another world."

The exhibition featured an impressionistic film exploring the forces that shape the West Texas landscape and documenting the artists' experiments with wind and light interacting with kites, handmade Mylar instruments, found objects, and native plant materials. *Star Scores*, a piece of visual music, reflected on the region's dark skies through animations of galaxies orbiting, multiplying, and expanding. Adjacent were Sword's ink drawings of rhythmic and repetitive brush marks. Ballroom's courtyard was transformed into a listening space where Lange presented a sonic installation composed of the sounds collected from the community. These newly commissioned works heightened the audience's sense of space, attuning us to expansive new sonic geographies, helping us to listen in diverse ways, and reminding us of our presence in a living world. ▷

"It touches you, touches your skin and your hair, and carries dust through the air and it carries sound. It's moving sound everywhere. Our constant, invisible collaborator was the wind."

A CONVERSATION WITH ROBERTO CARLOS LANGE AND KRISTI SWORD

Roberto Carlos Lange: Something really poetic that kept coming up for me was just thinking about what the wind carries and what it does and how it interacts with you and how it touches you, touches your skin and your hair, and carries dust through the air and it carries sound. It's moving sound everywhere. Our constant, invisible collaborator was the wind. What initially brought us out was we were invited by Sarah Melendez, the music curator, to try an idea that we had talked to her about, which was making music with kites and interacting with the wind. And Kristi . . . was making these Mylar pieces that were like abstract ideas on kites, so something that interacts with the wind.

Kristi Sword: My first collaborative experience working with another artist was working with Roberto on *Kite Symphony*. It challenged my process of making and forced me to let go and to open up to small experiences that didn't have to be fine-tuned or monumental.

Lange: So we came and had this long list of ideas that we wanted to try out. Like every day. The first week that we arrived to Marfa, the whole world started to shut down. So we tried to find our way with it, and luckily Marfa is isolated and so we were able to be in a place that was quiet, so we would just roam around town and try these little experiments with the kites. Kristi was creating these graphic scores, which are like an abstract idea on music notation. So instead of traditional notes on a paper, they're more like drawings, and musicians can interpret them as they wish. So that's what we did. We were able to collaborate with local musicians here, Rob Mazurek

and Jeanann Dara, and interpreted and created this album called *Kite Symphony: Four Variations*.

Sword: The graphic scores became a visual dialogue between Roberto and me. An idea that expanded from the graphic scores was the *Star Scores*. They're a version of the graphic scores in motion.

Lange: *Star Scores* is an animated film that projects onto two different screens and there's eight speakers. The intention is to maybe have an experience as if you were looking at the stars or as if you were in a star, or as if you were at the beginning of the creation of the star.

Sword: Working with Mylar 16 mm film and office stickers lent itself well to my meditative process.

Lange: The conversation ended up expanding even more where we were able to create an exhibition out of all these small ideas that have just bloomed a little bit. □

Excerpt, transcript of exhibition video.

Clockwise from top: Roberto Carlos Lange and Kristi Sword, *Kite Symphony*, 2022; Installation view, Roberto Carlos Lange and Kristi Sword, *Kite Symphony*, 2022; Kristi Sword, *Visual score for Kite Symphony, Four Variations*, 2020; Kristi Sword, *Drawings for Radio Telescope*, 2021; Kristi Sword, *Visual score for Kite Symphony, Four Variations*, 2020; Installation view, Roberto Carlos Lange and Kristi Sword, *Kite Symphony*, 2022. Overleaf: Helado Negro, *Music for Earth Day*, April 22, 2022. Page 268, top to bottom: Lisa E. Harris, *Music for Earth Day*, April 22, 2022; Lori Scacco and Newman Taylor Baker, *Music for Earth Day*, April 22, 2022; top to bottom: Jace Clayton, *Music for Earth Day*, April 22, 2022; Jamire Williams, *Music for Earth Day*, April 22, 2022.

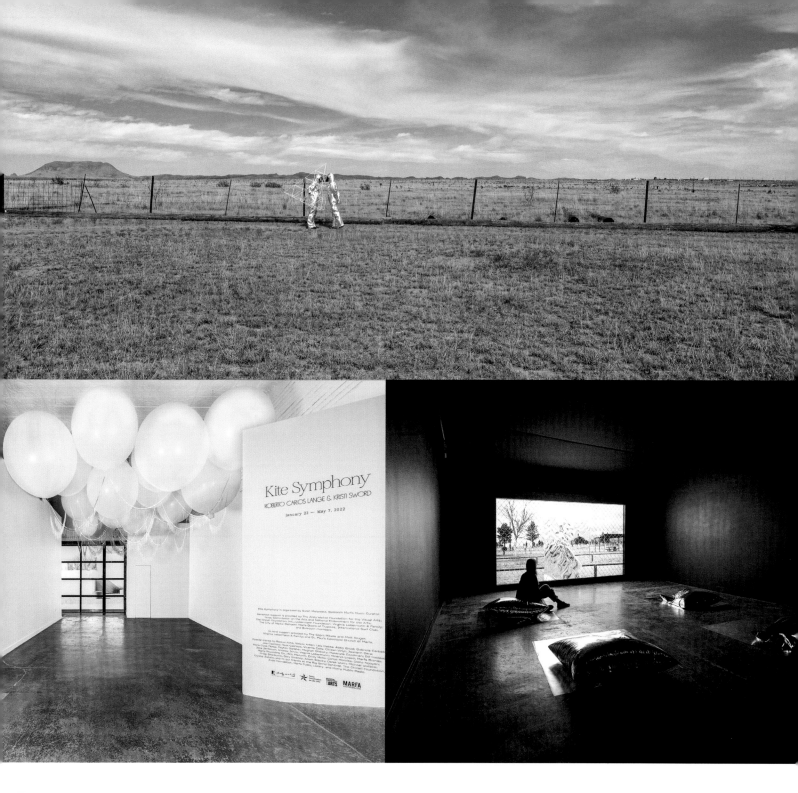

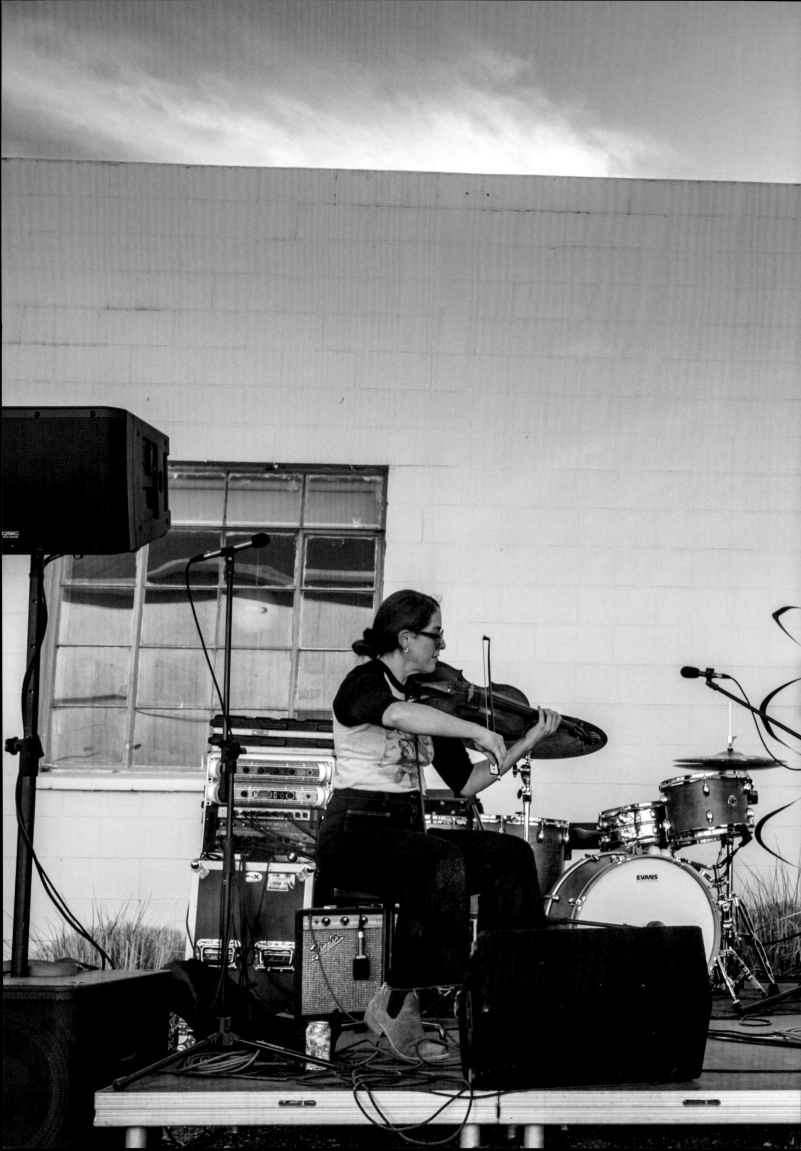

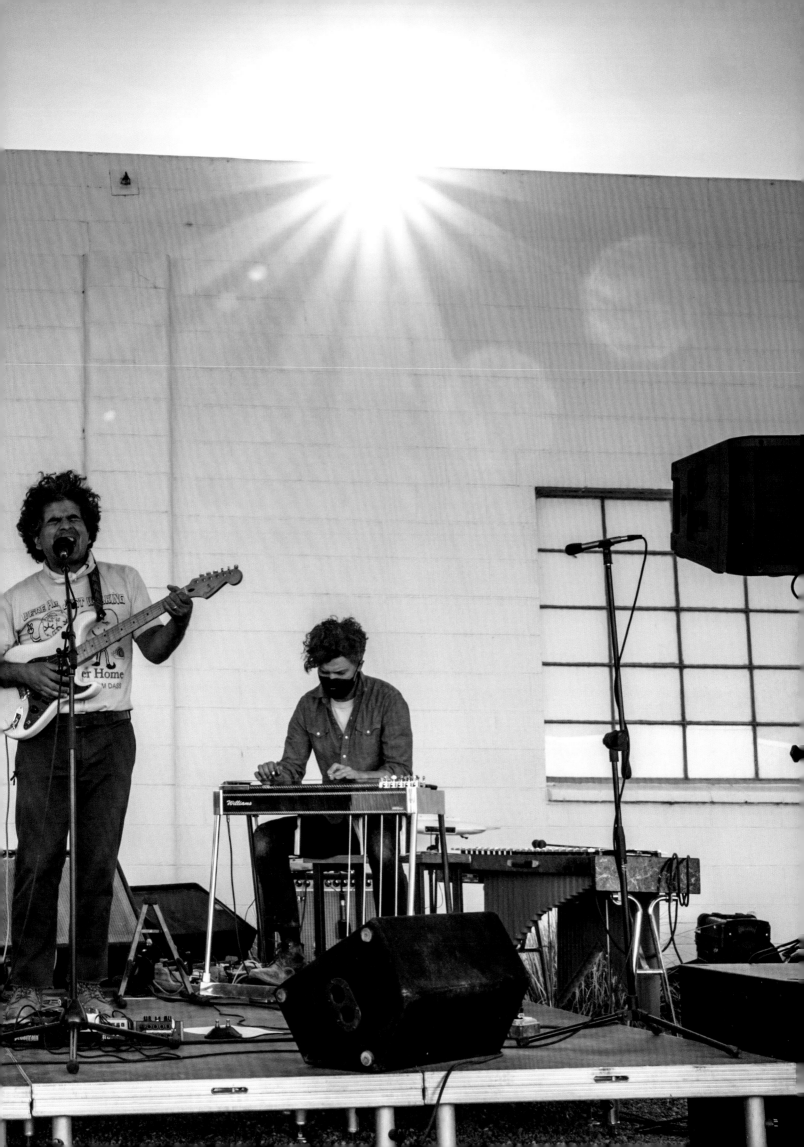

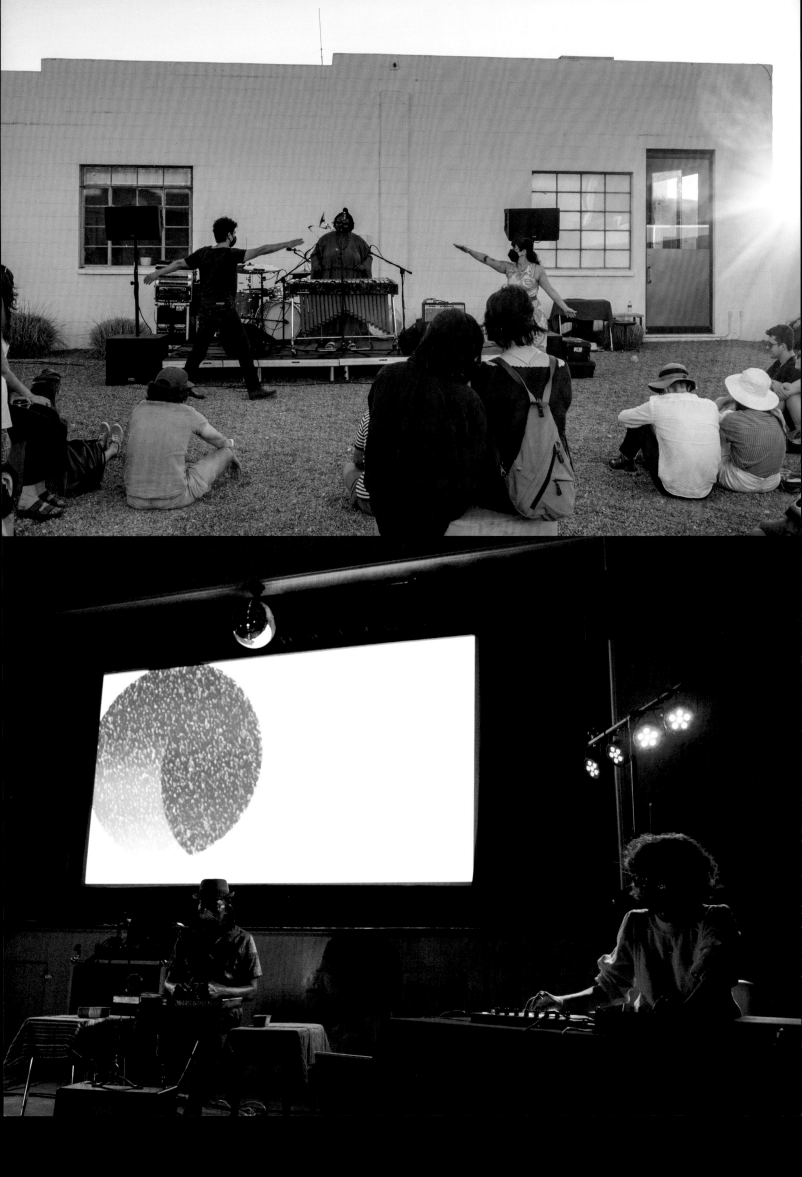

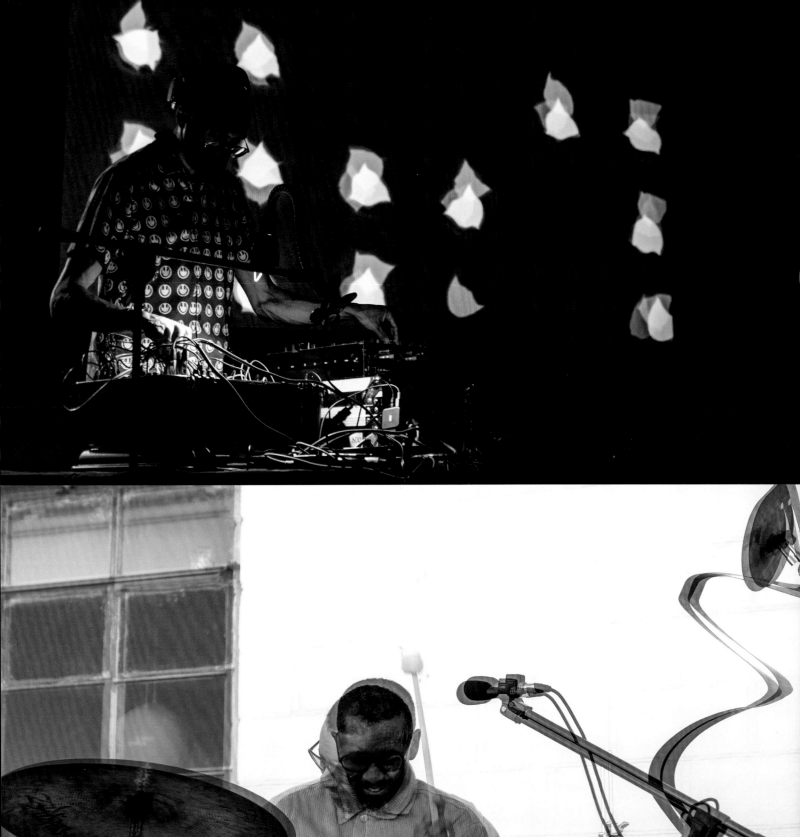

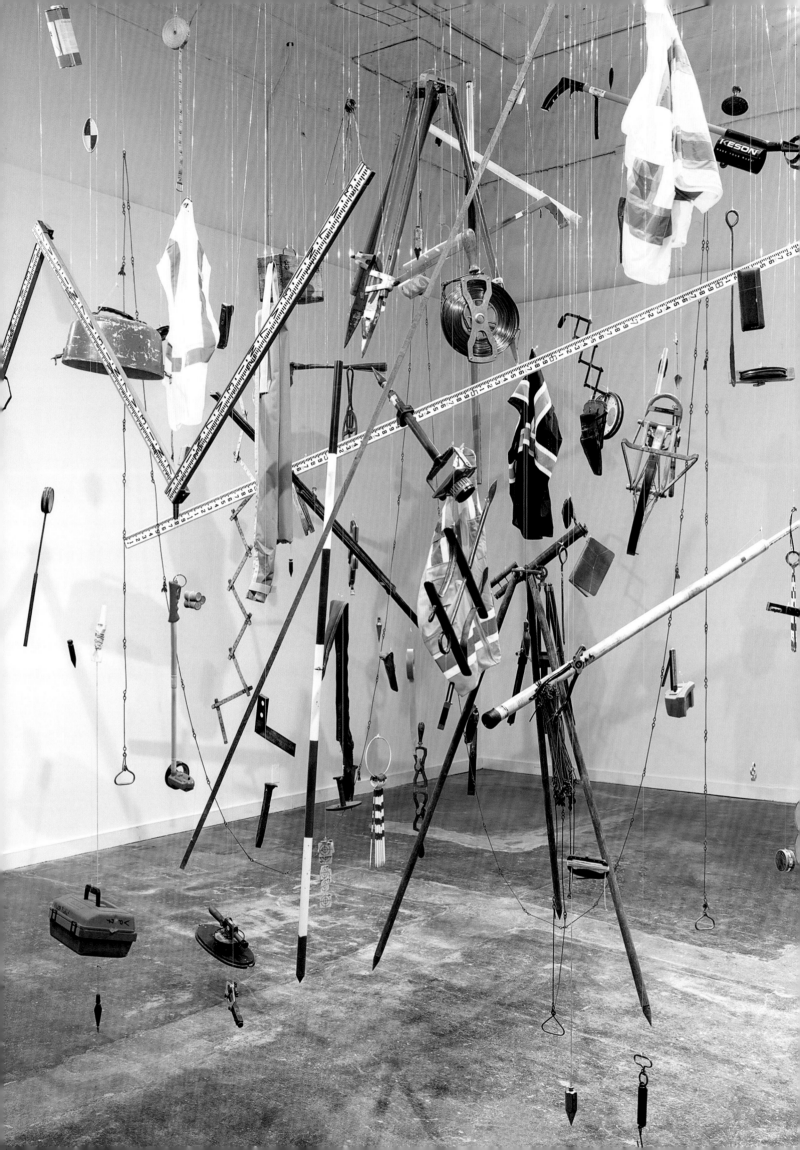

THE BLESSINGS OF THE MYSTERY

CAROLINA CAYCEDO AND DAVID DE ROZAS

Installation view, Carolina Caycedo and David de Rozas, *Measuring the Immeasurable*, 2020. Overleaf, top to bottom: Installation view, Carolina Caycedo and David de Rozas, *Halving and Quartering*, 2020; installation view, *The Blessings of the Mystery*, 2022. Page 273, top to bottom: Installation view, *The Blessings of the Mystery*, 2022; Carolina Caycedo and David de Rozas, detail, *Somi Se'k (The Land of the Sun—La Tierra del Sol)*, 2020.

In May 2022 Ballroom Marfa presented the exhibition *The Blessings of the Mystery*, featuring work by Carolina Caycedo and David de Rozas, and curated by Laura Copelin. The project crystallized the artists' research into the connections and tensions between the cultural, scientific, industrial, and sociopolitical forces across locations in West Texas. The exhibition traveled to the Visual Arts Center (VAC) at the University of Texas at Austin in September 2021 and to the Rubin Center for the Visual Arts at the University of Texas at El Paso in January 2022. The VAC presentation was organized by MacKenzie Stevens, director, and the Rubin Center presentation was organized by Kerry Doyle. An iteration of the exhibition was also on view at the Museum of Modern Art, organized by Anna Burckhardt.

The presentation centered on *The Teachings of the Hands*, a single-channel film that depicted the region's complex histories of colonization, migration, and ecological precarity from the perspective of Juan Mancias, chairman of the Carrizo/Comecrudo Tribe of Texas. The video installation combined observational and experimental documentary with oral histories, reenactments, and archival footage. The film's narrative grew out of the land where both Indigenous and settler knowledge has been historically produced. Weaving together scenes from the present day to four thousand years in the past, the film highlights the environmental memories and cosmologies of these interconnected places.

The artists drew from different materials and sources to expand on the concepts in the film. They created immersive installations of surveying flags and tools, made series of drawings and collages, and included a collection of watercolors from the 1930s by artists and amateur archaeologists Forrest and Lula Kirkland that depict the ancient rock art of the Lower Pecos. On loan from the Texas Archeological Research Laboratory at the University of Texas, these rarely seen paintings document the original forms and vibrant colors of murals that were still visible in the 1930s, before flooding, erosion, and human interaction damaged them. ▷

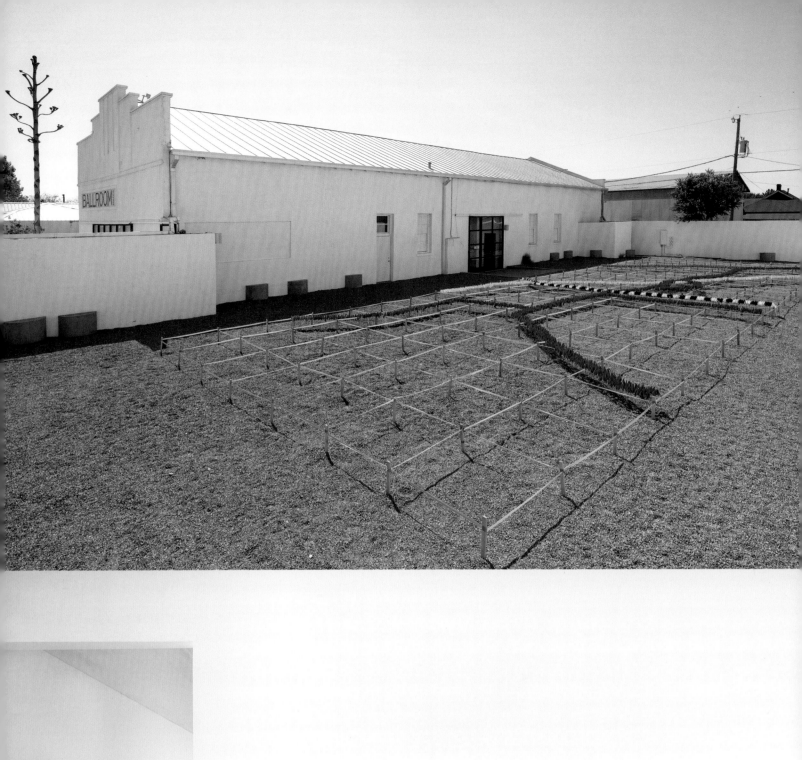

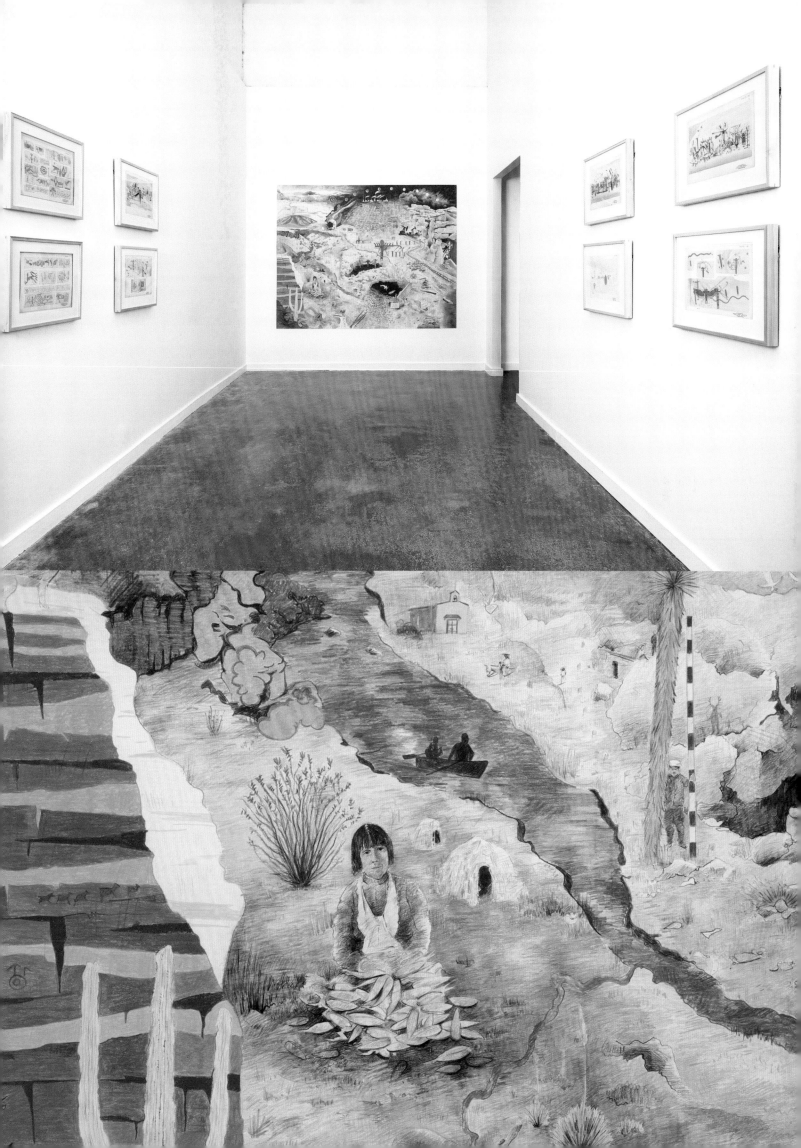

A REFLECTION BY LAURA COPELIN

In *The Blessings of the Mystery*, artists Carolina Caycedo and David de Rozas presented new work made in and about West Texas. The project began with a conversation about dams. I was familiar with Carolina's ongoing project *Be Dammed*, which investigates the socioeconomic and environmental effects of dams across the Americas, and was eager to talk to her about the Amistad Dam in Del Rio, the largest dam on the Rio Grande, which is managed jointly by the United States and Mexico. The seed of this conversation blossomed into a body of work that looks at Amistad and other contested sites across the region, unspooling histories, and forging connections within *Somi Se'k*, which translates to "Land of the Sun" and is the way the Carrizo/Comecrudo Tribe from the Rio Grande delta refers to the land known as Texas.

Together, Carolina and her partner, David, a multidisciplinary artist and filmmaker himself, collaborated on a series of major new commissions for Ballroom. The two artists embarked on many trips to Texas where they researched and filmed, forming countless connections and relationships across the region. They spent time with scientists at the McDonald Observatory near Fort Davis, visited the Permian Basin oil fields and the Permian Basin Petroleum Museum in Midland, dove into the archaeological archives and biological collections at the University of Texas at Austin, and witnessed what remains of the ancient Lower Pecos rock art near the Amistad Dam. On their journey they met Juan Mancias, the chairman of the Carrizo/Comecrudo Tribe, who became the voice and heart of their film *The Teaching of the Hands*. This piece is the center point of the exhibition, stretching like the horizon across Ballroom's former dance floor. In this film the artists synthesize their research to create an experimental meditation on the region's histories of colonization, migration, and ecological disaster.

The piece, narrated by Chairman Mancias, layers oral histories, speculative reenactments, and observational and found footage, weaving together scenes from the present day to thousands of years in the past. *The Teaching of the Hands* highlights the environmental memories and divergent cosmologies within *Somi Se'k*, where both Indigenous and settler knowledge coexist.

Rippling out from the film, drawings, collages, installations, and sculptures expand on elements of the narrative. Diagrammatic drawings of fence patents and installations like *Measuring the Immeasurable* and *Halving and Quartering* investigate the practices of land surveying, which led to the displacement of people and the privatization of vast swaths of land. The series *Los Nudos Fuertes* ("The Strong Knots") and the large drawing *Somi Se'k* counter typical forms of mapping by connecting diverse species and stories through collage or lush illustration.

The artists have conceived of an expansive body of work that constellates unexpected relationships among stars and galaxies, rivers and aquifers, oil and gas infrastructure, invasive and native species, flooded pictographs and rock shelters, and a state-of-the-art observatory. Taken together, the works speak to the multidimensional confluence of cultures and cosmologies held by the surrounding land. □

Excerpt, exhibition catalog.

Top: Installation view, Carolina Caycedo and David de Rozas, *The Teaching of the Hands*, 2020. Bottom: Film still, Carolina Caycedo and David de Rozas, *The Teaching of the Hands*, 2020.

BALLROOM SESSIONS— THE FARTHER PLACE

NEWMAN TAYLOR BAKER, MORGAN BASSICHIS, JIBZ CAMERON/DYNASTY HANDBAG, JESSE CHUN, ROB FRYE, LISA E. HARRIS, EJ HILL, ROBERTO CARLOS LANGE AND KRISTI SWORD, GUADALUPE MARAVILLA, ELLE PÉREZ, LORI SCACCO, JOHANNA UNZUETA, JAMIRE WILLIAMS

Roberto Carlos Lange and Kristi Sword in Big Bend National Park, 2020. Overleaf, clockwise from top: Rob Frye binocular photos, 2020; Jibz Cameron, 2023; Jamire Williams recording in the Arena at Chinati Foundation, 2023. Page 279, top left: Newman Taylor Baker recording at Sonic Ranch in Tornillo, Texas, 2023; top right and bottom: Lisa E. Harris, 2021. Page 280, clockwise from top: Studio of Elle Perez at Ballroom Marfa, 2021; Lori Scacco recording in Big Bend Ranch State Park, 2023; Guadalupe Maravilla, 2023. Page 281,

The artist-in-residence program Ballroom Sessions—The Farther Place began in 2020, during the onset of the COVID-19 pandemic, to support artists and musicians. It is organized by music curator Sarah Melendez and curator Daisy Nam. Through in-depth site visits, residencies, research, studio space, or production, artists can explore nascent ideas in their practice. Ballroom Sessions prompts questions such as: How do artists think and make work in these times? How can an arts organization serve artists? What kind of support is most generous to artists and musicians right now, especially if they experiment between mediums and forms?

Ballroom Sessions encourages cross-disciplinary processes, facilitates research of the culture and landscape of the region, and connects artists to local partners and experts. During and after these residencies, participating artists present their new works to the public in a number of ways, ranging from releasing music and film to giving audio lectures, interviews, and more, through Ballroom's unique channels.

"The *Farther Place*" connotes not only a physically distant location but also a zone for experimentation. Through incubation and production, artists can go deeper into a farther place within their practices. Their ideas and artworks move out into the world beyond Far West Texas. As a point of inspiration, Sun Ra conjures us to move beyond our (earthly) limits in his poem "The Farther":

> Get over into the spirit of things
> Thus the movement is on. . . .
> Ever moving toward
> The farther place or the
> Place of the farther . . . ☐

TENDER IS THE HAND WHICH HOLDS THE STONE OF MEMORY

KENNETH TAM

Clockwise from top left: Kenneth Tam in West Texas, 2021; installation view, *Tender is the hand which holds the stone of memory*, 2022; Kenneth Tam, *Why do you abuse me*, 2022; Kenneth Tam, *Silent Spikes*, 2021; Kenneth Tam, *At night we talk of home*, 2022. Overleaf: Installation view, Kenneth Tam, *Silent Spikes*, 2021.

In 2022, Ballroom Marfa presented a solo exhibition by Kenneth Tam, organized by Daisy Nam. In *Tender is the hand which holds the stone of memory*, Tam unearths forgotten histories in order to reimagine our own identities and to challenge dominant myths that shape and govern our bodies. The exhibition questioned Manifest Destiny and the conquest of the American West, one of the most enduring myths that still haunts our nation. This ideology has circulated and remain embedded in popular culture through Westerns and advertising, embodied in tropes and figures such as the Marlboro Man. These images reified claims to Indigenous land as well as distorted Indigenous histories, while also enforcing stereotypes of Anglo-American masculinity that remain pervasive.

Tam's examination of American westward expansion is rooted in the unrecorded lives of nameless Chinese laborers, who toiled under the most arduous conditions in the late nineteenth century. The exhibition title selected by the artist is taken from a line of poetry that was used for a monument in memory of these laborers. *Silent Spikes*, the video installation on view at Ballroom, weaves together improvised dialogue and movement sequences from a group of participants, along with semifictional scenes of a Chinese worker from inside the tunnels of the Transcontinental Railroad. During Tam's site visit to Ballroom and West Texas in 2021, his encounter with artifacts and objects left at workers' camps along the railroad led him to consider how physical remnants function as stand-ins for the disappeared histories of laborers. Tam's sculptures suggest other ways of thinking about these men. His use of archaeological fragments as visual and material language complicates the simple narratives that have been constructed about migrant lives. In their lifetimes, Chinese laborers were reviled for their race but praised for their industriousness, their worth as people always tied to their ability to work. Bits of dried food, broken jewelry, and other personal items are integrated into the sculptures to point to experiences of precarity, but also of tenderness and care. Physical traces—and even the sounds of the railroad passing through Marfa today—can serve as reminders of how this nation was built, and by whom. As Tam has said, "It's not about filling the void, but making the void felt." □

283

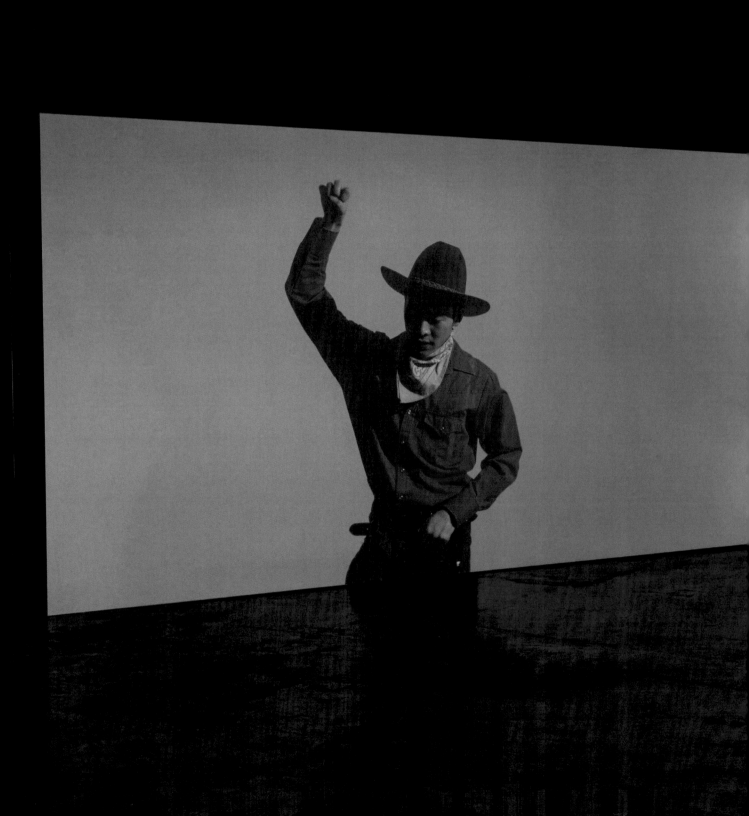

PERHAPS THE TRUTH

ALEJANDRO PIÑEIRO BELLO, JES FAN,
JOEL GAITAN, FLORIAN KREWER, REBECCA MANSON,
RUBEN ULISES RODRIGUEZ MONTOYA, JESSE MURRY,
ROBERT NAVA, ILANA SAVDIE, KIKI SMITH,
ASTRID TERRAZAS, LUCÍA VIDALES, ISSY WOOD

To celebrate Ballroom Marfa's twentieth anniversary, Fairfax Dorn returned to curate a group exhibition, *Perhaps the Truth*. The exhibiting artists suggested that truth is not fixed or absolute, but rather something that is shaped by experiences and shifting perceptions. *Perhaps the Truth* was inspired by the writings of Wallace Stevens and the painter and poet Jesse Murry. The opening included poetry readings by Arden Wohl and Emmy Pérez. The celebrations continued with a blowout concert by Dos Santos, a Chicago-based quintet propelled by Latin rhythms fused with cumbia, salsa, funk, jazz, surf rock, and psychedelia.

The title *Perhaps the Truth* comes from a line in Stevens's long-form poem *Notes Toward a Supreme Fiction* (1942): "Perhaps / The truth depends on a walk around a lake." The act of walking around the lake, like the process of making and viewing work, leads to various interpretations of truths and helps us make sense of the world and our place within it. Influenced by Stevens's poetry, Murry also believed in painting as a "supreme fiction"—that through acts of disbelief and imagination we can save ourselves. He writes, "What has prompted this effort toward humanity is a necessary belief in art's saving powers of address."

The paintings and sculptures included in *Perhaps the Truth* reveal expansive definitions of truths. Some create dreamscapes that are surreal, hallucinogenic spaces that transcend boundaries. Others look beyond our earthly imaginations to broaden notions of the self. Classifications of human, animal, and spirit are blurred. Gender binaries are dismantled. Biological, organic, and artificial life are merged. The artists mine ancestral histories and folklore to form new mythologies for the future.

Much like Murry's landscape paintings, in which he created an "inwardness" and "poetic dimension" through "extra-visual content," many of the artists in *Perhaps the Truth* use saturated color, rich textures, and varied materials to create a visceral experience. Their works are imbued with a feeling of freedom and transformative capacities—a world free of fixed identities and singular experiences. *Perhaps the Truth* is a tribute to the spirit and legacy of both Stevens and Murry, whose works, like the works in the exhibition, are in the process of searching for what makes us who we are. □

Rebecca Manson, *Moth Wing*, 2023. Overleaf: Installation view, *Perhaps the Truth*, 2023. Page 290, top to bottom: Installation view, *Perhaps the Truth*, 2023; Alejandro Piñeiro Bello, *Desapareció Entre Los Árboles*, 2023. Page 291, top to bottom: Jesse Murry, *Nocturnal Umber*, 1989; Joel Gaitan, *Face, Style, and Grace*, 2023; Astrid Terrazas, *Su estómago canta canciones de búsqueda*, 2023.

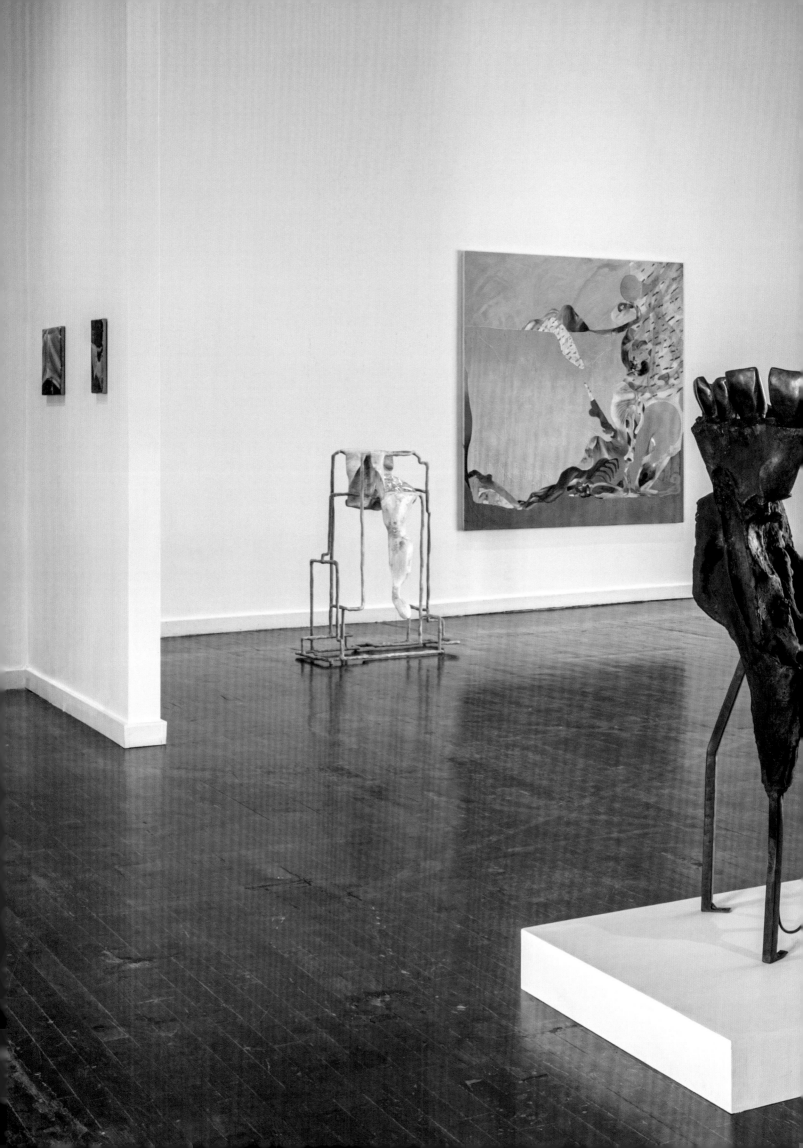

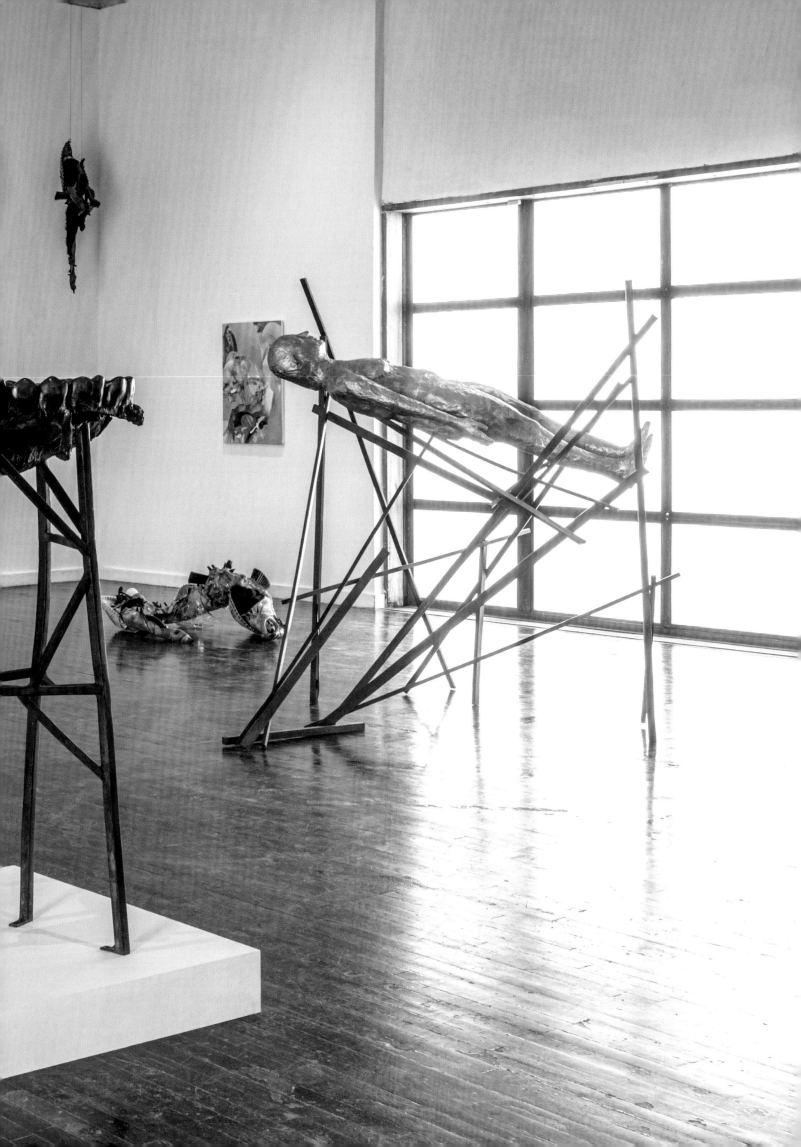

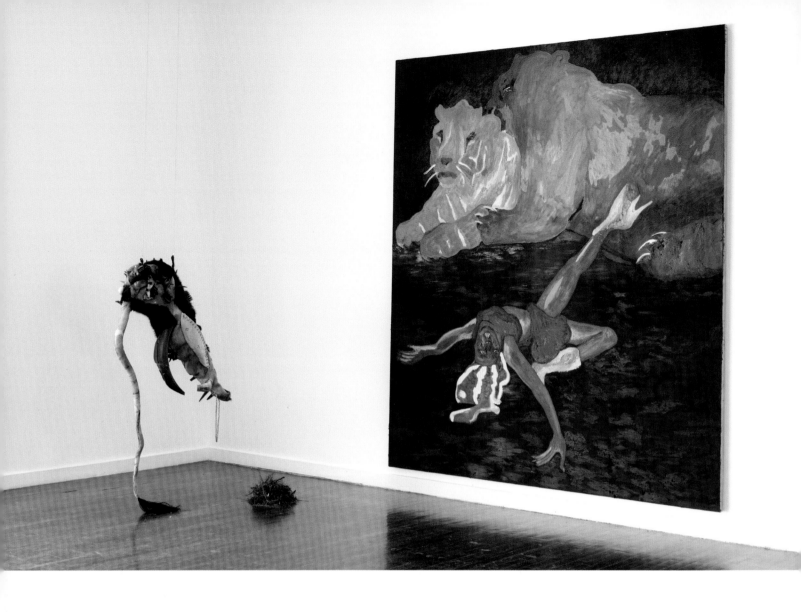

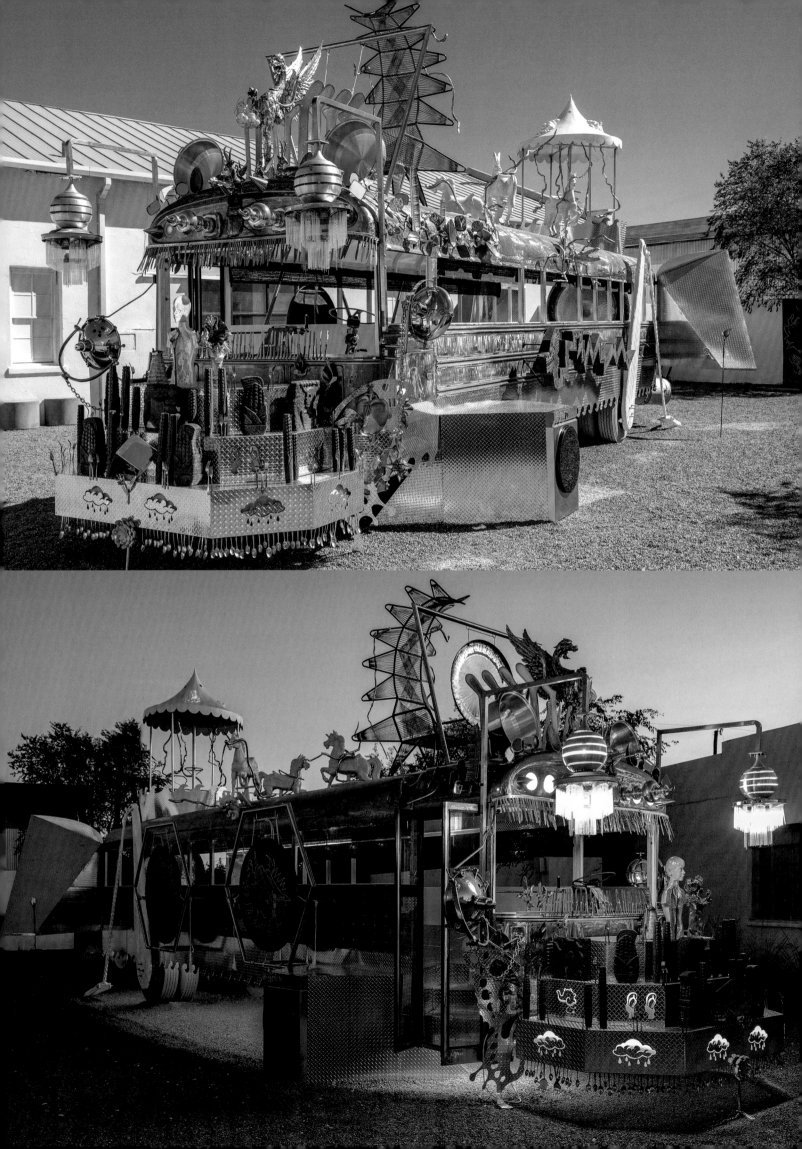

MARIPOSA RELÁMPAGO

GUADALUPE MARAVILLA

As part of its twentieth-anniversary festivities, Ballroom Marfa presented Guadalupe Maravilla's monumental sculpture *Mariposa Relámpago* in the courtyard. Ballroom's installation and its accompanying public programs were organized by Daisy Nam, Sarah Melendez, and Alexann Susholtz. Maravilla was a Ballroom Sessions—The Farther Place artist-in-residence in 2021 and 2022.

Maravilla grounds his practice in activism and healing, informed by his personal story of migration, illness, and recovery. In 1984, at age eight, Maravilla fled El Salvador's civil war as an unaccompanied minor; he made a perilous journey through Central America to reunite with family in the United States. In the 2010s, Maravilla was diagnosed with colon cancer—an illness he links to generational trauma and the stresses of being undocumented—and during the recovery process, he was introduced to ancient methods of healing, including the use of sound. This life event shifted Maravilla's practices, and he has since worked tirelessly to raise awareness of trauma and expand access to healing, nurturing collective narratives with a sense of perseverance and humanity.

Mariposa Relámpago, which translates to "lightning butterfly," is the artist's largest sculpture to date. Maravilla's sculptures known as *Disease Throwers* incorporate natural materials, handmade objects, and items collected while retracing his migratory route. Every sculpture includes metal gongs that are activated by the artist during public sound baths to deploy the powers of vibrational sound as a form of healing. His artworks also contain a cosmology of potent symbols and objects that connect the artist's personal journey with ancient practices of the indigenous Mayan peoples, diverse spiritual and folk beliefs, and the contemporary crises of disease, ecology, and war. *Mariposa Relámpago* functions as a sculpture, shrine, and healing instrument.

The sculpture was commissioned by ICA Boston but launched its "Texas Tour" at Ballroom. It came at a time when the state was confronted with its own deep-seated sociopolitical issues surrounding border control and immigration. Ballroom, the Contemporary Austin, and the Blaffer Art Museum in Houston collaborated to take Maravilla's powerful installation across the state and invite visitors to explore notions of displacement and recovery. □

EPILOGUE

STATES OF DREAMING
VIRGINIA LEBERMANN AND FAIRFAX DORN

We take pause, a long pause, when thinking about all the artists, musicians, filmmakers, curators, philanthropists, seekers, travelers, and friends who have passed through the halls of this iconic space on the high plains of the Chihuahuan Desert, fifty-seven miles from the Mexican border.

Jonathan Mergle, a former member of the Ballroom Marfa team, was once asked how one makes things happen in such a remote and isolated place. He responded, "You really have to know how to dream."

Ballroom Marfa has become a space for artists, visitors, staff, and the town of Marfa—all of us together—to dream. We honor those teams of people, directors, staff members, coordinators, helpers, and volunteers who have made magic inside these walls and beyond them. It has taken not just a village but a global community of inspired, courageous, diligent souls with varied backgrounds, passions, and expertise. Those that came before us, as well, when this building was built in 1927, and those who will come after us, are all an integral part of this story set on East San Antonio Street in Marfa, Texas.

To all of them we owe our deepest gratitude.

Marfa and our stewardship of Ballroom has now defined a majority of our adult lives. It has been an adventure beyond any we could have imagined. For twenty years we have been steeped in deep honor of the creative process we call life.

TIMELINE

1927

Construction of the dance hall that now houses Ballroom Marfa.

2002

Virginia Lebermann and Fairfax Dorn purchase the former dance hall and begin renovation. The space will include two galleries totaling 4,500 square feet and a 6,000-square-foot courtyard.

2003

Ballroom Marfa opens its doors on October 10 and hosts its first concert, featuring Spoon.

Ballroom Marfa's first feature in the national press appears in *Vanity Fair*'s December issue.

October 10
Spoon

October 10–January 12
Vault (pp. 26–27)
María José Arjona
Organized by Fairfax Dorn

2004

Ballroom Marfa receives 501(c)(3) status.

Ballroom officially opens with the exhibition *OPTIMO.* The opening attracts over a thousand visitors from around the world to Marfa and garners the attention of *Texas Monthly*, the *New York Times*, *W Magazine*, *Art in America*, and *ARTnews*.

Four of the world's top jazz improvisers, including Jemeel Moondoc, unite for a high-energy performance in the courtyard. Ballroom issues a limited-edition vinyl recording of the event, *Fire into Music*.

Ballroom collaborates with the Chinati Foundation to present Samuel Beckett's *Endgame* directed by acclaimed theater director André Gregory and featuring local talent.

January 17–March 16
The Paper Sculpture Show
Janine Antoni, The Art Guys, David Brody, Luca Buvoli, Francis Cape and Liza Phillips, Seong Chun, Minerva Cuevas, E.V. Day, Nicole Eisenman, Spencer Finch, Charles Goldman, Rachel Harrison, Stephen Hendee, Patrick Killoran, Glenn Ligon, Cildo Meireles, Helen Mirra, Aric Obrosey, Ester Partegàs, Akiko Sakaizumi,

David Shrigley, Eve Sussman, Sarah Sze, Fred Tomaselli, Pablo Vargas Lugo, Chris Ware, Olav Westphalen, Allan Wexler, Paul Ramírez Jonas
Co-organized by *Cabinet* magazine, Independent Curators International (ICI), and SculptureCenter.
Organized by Mary Ceruti, Matt Freedman, and Sina Najafi

March 26
Dominic Welhouse: In My Room
Dominic Welhouse
Organized by Fairfax Dorn

April 23
Stereo Total

April 23–June 27
OPTIMO: Manifestations of Optimism in Contemporary Art (pp. 28–31)
María José Arjona, Takashi Murakami, Polly Apfelbaum, Martin Creed, Karen Finley, Forcefield, Emily Jacir, Beatriz Milhazes, Adam Pendleton, Leo Villareal
Co-organized in conjunction with Alexander Gray (Guest Curator)

July 3–December 12
Sarah Morris
Organized by Fairfax Dorn

July 3–December 12
Franco Mondini-Ruiz
Organized by Fairfax Dorn

August 6–15
**Kino-Eye: Approaches to
Documentary Film Making**
Organized by Don Howard
(Guest Curator)

October 8
Fire into Music
(Ballroom Beat, vol. 1)
Jemeel Moondoc, Steve Swell,
William Parker, Hamid Drake

October 8–April 10
Noel Waggener and Satch Grimley
Organized by Fairfax Dorn

October 23
An Evening with John Waters
(pp. 36–37)
John Waters

2005

Erika Blumenfeld is Ballroom's
inaugural artist-in-residence. She
creates the video work *Moving Light:
Lunation 1011.* Ballroom commissions
the first limited edition work from her.

Ballroom realizes its first significant
architectural and artistic achievement
by completing *Prada Marfa*, a site-
specific, permanent public art
project by Elmgreen & Dragset, in
cooperation with Art Production Fund.

January 29–April 10
Moving Light: Lunation 1011
Erika Blumenfeld
Organized by Fairfax Dorn

January 29–May 15
The Folding Nose and Other Works
Richard Erickson
Organized by Fairfax Dorn

February 11–12
Music on Film I
Michael Snow, Shirley Clarke,
Melvin Van Peebles
Organized by Vance Knowles
and Noel Waggener

February 25
Music on Film II
Gabriella Cardazzo and Duncan
Ward, Mark Moorman
Organized by Vance Knowles

and Noel Waggener

February 26
SOUNDteam

March 26
Matt Haimovitz

March 30
André Gregory
Organized with the Chinati
Foundation and Lannan Foundation

May 27–September 18
Treading Water
(pp. 50–61)
María José Arjona, James Benning,
Agnes Denes, Matthew Goulish,
Sigalit Landau, Michael Phelan
Organized by Fairfax Dorn

July 29
Nikolai Haas
(Ballroom Beat, vol. 1)

September 20
Magnolia Electric Company

October 1
Prada Marfa (pp. 38–49, 182–85)
Elmgreen & Dragset

October 6–February 27
You Are Here (pp. 32–35)
SunTek Chung, Larry Bamburg,
Deborah Grant, Andrew Guenther,
Hilary Harnischfeger, Adam
Helms, Matthew Day Jackson,
Karyn Olivier, Blake Sandberg,
Sigrid Sandström, Allison Smith,
Ian Sullivan, William Villalongo,
Roger White, Raphael Zollinger
Organized by Fairfax Dorn

October 8
Yo La Tengo

November 11
Be Here to Love Me
Margaret Brown

December 15
The Audible Picture Show
Organized by Matt Hulse
(Guest Curator)

December 17
Terry Allen
(Ballroom Beat, vol. 1)

2006

The concept for the Drive-In is born
and grows from discussions between
Virginia Lebermann, Fairfax Dorn,
and Josh Siegel, a film curator at the
Museum of Modern Art, New York.

Ballroom Marfa hosts a solo
exhibition by Peter Doig, one of
the world's foremost painters. To
open the exhibition, artist Jonathan
Meese is commissioned and
performs live in the courtyard.

March 25
*The Art and Architecture of
Anstis and Victor Lundy*
Organized by Suzanne
Dungan (Guest Curator)

May 25
Adam Bork

May 27
Schuyler Fisk

September 15
Fire Into Music LP Release
Jemeel Moondoc, Steve Swell,
William Parker, Hamid Drake

September 29–February 28
Peter Doig: STUDIOFILMCLUB
Peter Doig, Jonathan Meese
Co-organized by Che Lovelace

September 30
Film Screenings with Peter Doig
Peter Doig

October 26
Jenny Lewis

December 1
Independent Film Month
Keven McAlester, Nevie Owens
and Buckner Cooke, Kyle Henry

December 14
Joanna Newsom

2007

In collaboration with the Chinati Foundation, the Judd Foundation, and Ballroom Marfa board member Charles Attal, Ballroom hosts Sonic Youth for the 2007 Open House weekend.

Ballroom Marfa collaborates with artist and former board member Matthew Day Jackson to create a site-specific project at the NADA Miami art fair. Ballroom commissions from Jackson its second limited edition: the iconic silver knuckles *Sculpture for My Right Hand*.

Ballroom receives its first grants from the National Endowment for the Arts and the Andy Warhol Foundation for the Visual Arts in support of the Visual Arts Program.

January 20
Zykos

January 21
Jeff Tweedy

February 24
Grizzly Bear

March 14
The Watson Twins with CB Brand

March 23–July 30
Deep Comedy
(pp. 66–69)
Fischli/Weiss, Isa Genzken, Jef Geys, Rodney Graham, Christian Jankowski, Japanther, Julia Scher, Roman Signer, Michael Smith, William Wegman, John Wesley, Joshua White, Elin Wikström
Co-organized by Dan Graham and Sylvia Chivaratanond (Guest Curators)

March 24
Sam Prekop

April 1
Richard Buckner with Six Parts Seven

April 26
José González

April 28
Mingo Saldivar

May 11
GLORIA
(pp. 70–72)
Maria Hassabi, Hristoula Harakas, David Adamo

May 12
Angela McCluskey & Paul Cantelon

May 25
Animal Collective with Sir Richard Bishop

July 7
Terry Allen with the Panhandle Mystery Band

September 22
New Humans/Mika Tajima

September 22
Every Revolution Is a Roll of the Dice
(pp. 62–65)
Barry X Ball, Huma Bhabha, Carol Bove, Trisha Donnelly, Gardar Eide Einarsson, Jason Fox, Wayne Gonzales, Robert Grosvenor, Guyton\Walker, Adam Helms, Corey McCorkle, John Miller, Wangechi Mutu, Haim Steinbach, Mika Tajima/ New Humans, Joan Wallace
Organized by Bob Nickas
(Guest Curator)

October 4
Bruce Levingston

October 6
Sonic Youth with Black Leather Jesus
(Ballroom Beat, vol. 1)

October 7
Medicine Show: The Poster Art of Ballroom
Jaime Cervantes, Decoder Ring, Fairfax Dorn, Essen Film School, Dirk Fowler, Hatch Show Print, Kathleen Judge, Dan McAdam, Erick Montes, Jason Munn, Kelly O'Connor, Obsolete Industries, Todd Slater, Studio Zeds Design, Noel Waggener

October 18
Boris with Damon & Naomi and Michio Kurihara

December 5–9
NADA Miami
Matthew Day Jackson

December 14–15
film.text.performance. film (Parts I and II)
Bruce McClure, Jennifer Reeves, Sandra Gibson, Luis Recoder, David Gatten, Michael Tracy, The Speculative Archive
Organized by Ralph McKay

2008

Ballroom hosts its most transformative exhibition to date, *Hello Meth Lab in the Sun*, by Jonah Freeman, Justin Lowe, and Alexandre Singh. It garners important critical response from *New York Times* art critic Roberta Smith.

Art in the Auditorium debuts as the first installment in an ongoing annual monthlong film and video series presented in partnership with Whitechapel Gallery, London, and ten international institutions.

January 10
The Big Read
Leah McWilliams, Azul
Organized in conjunction with National Endowment for the Arts and Marfa Public Library

January 19–20
Two Evenings with Robert Earl Keen

February 2
Running After Disaster
Mel Chin
Organized by Fairfax Dorn

February 22
Keren Ann with Dean & Britta

March 22
The Dodos with Silje Nes

April 5
Psychic Ills

April 11–12
film.text.performance.film
Michael Tracy, Christopher
Rincon, Julia Meltzer, David
Gatten, Christian Gerstheimer
Organized by Ralph McKay

May 5–August 4
Hello Meth Lab in the Sun
(pp. 82–95)
Jonah Freeman, Justin Lowe,
and Alexandre Singh
Organized by Fairfax Dorn

May 6
Beethoven: The Last Piano Sonatas
Sarah Rothenberg
Organized in conjunction with
Jeff Fort & Marion Barthelme,
the Chinati Foundation, and the
Goode-Crowley Theater

May 18
The Havels

August 7
Balmorhea with Bexar Bexar

September 27–February 28
The Marfa Sessions (pp. 96–99)
Emily Jacir, Nina Katchadourian,
Christina Kubisch, Louise Lawler,
Iñigo Manglano-Ovalle, Kaffe
Matthews, neuroTransmitter,
Dario Robleto, Steve Roden,
Stephen Vitiello, Steve Rowell,
SIMPARCH, Deborah Stratman &
Steven Badgett, Julianne Swartz,
Angel Navarez, Valerie Tevere
Organized by Regine Basha,
Rebecca Gates, and Lucy
Raven (Guest Curators)

September 27
Kurt Wagner of Lambchop

October 31
Japanther and Killer Dreamer
Japanther, Killer Dreamer,
and Gorgamoth

November 11
Art in the Auditorium
(pp. 116–17)
Cornelia Parker, Leandro Erlich, Ali
Kazma, Readjustment of Clocks,
Shahryar Nashat, Lene Berg, Ryan
Trecartin, Wang Jianwei, Diego
Perrone, Nathalie Djurberg
Organized in conjunction with
Whitechapel Gallery, London

November 23
Conor Oberst and the
Mystic Valley Band

2009

Ballroom Marfa hosts its first
benefit, a concert with performances
by Lyle Lovett and His Acoustic
Group at the Crowley Theater.

Ballroom publishes its first printed
catalog, for *Hello Meth Lab in the Sun*.

With the support of a grant from
Green Mountain Energy Company,
Ballroom installs solar panels
to produce more than 10,000
kilowatt hours of electricity per
year and offset up to 13,700 pounds
of carbon dioxide annually.

January 31
Yacht with White Rainbow
(Ballroom Beat, vol. 1)

February 15
Billy Joe Shaver with Adam Carroll
and Scrappy Jud Newcomb

March 14–April 16
Emergency Response Studio
Paul Villinski

April 5
*Wild Combination: A Portrait
of Arthur Russell*

May 15
Paradise and Back:
Michael Almereyda
Michael Almereyda

May 29
Esteban Jordan

May 29–December 13
Two Face (pp. 100–105)
Aaron Curry, Thomas
Houseago, Robert Arber
Organized by Fairfax Dorn

May 30
Lyle Lovett and His Acoustic
Group with Michael Almereyda
and Prince Klassen
(Ballroom Beat, vol. 1)

June 24
*No Soul for Sale, A Festival of
Independents at X–Initiative, New York*
Kaffe Matthews

August 13
*Hello Meth Lab in the
Sun* catalog launch
Jonah Freeman, Justin
Lower, Alexandre Singh

August 14
Quintron and Miss Pussycat

October 1
Bon Iver with Megafaun

October 8
The Marfa Sessions catalog launch
Josh Kun, David Toop, Emily Jacir,
Nina Katchadourian, Christina
Kubisch, Louise Lawler, Iñigo
Manglano-Ovalle, Kaffe Matthews,
neuroTransmitter, Dario Robleto,
Steve Roden, Stephen Vitiello,
Steve Rowell, SIMPARCH,
Deborah Stratman & Steven
Badgett, Julianne Swartz

October 31
Marfa Masquerade
Heloise and the Savoir Faire

2010

Ballroom Marfa launches the first
in its ongoing biennial symposium
series The Marfa Sessions in
collaboration with Hamilton Fish
and the *Washington Spectator*.

Ballroom is awarded $140,000
by the Warhol Foundation's
Warhol Initiative to expand its
organizational infrastructure.

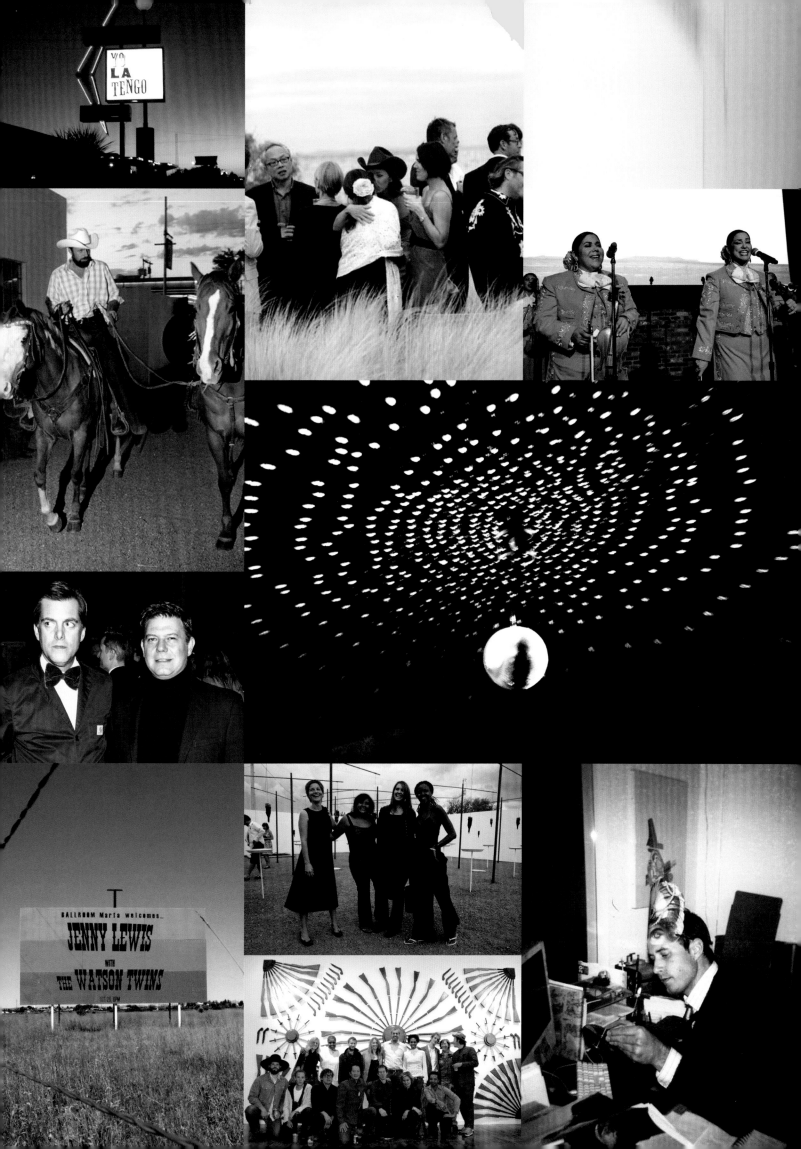

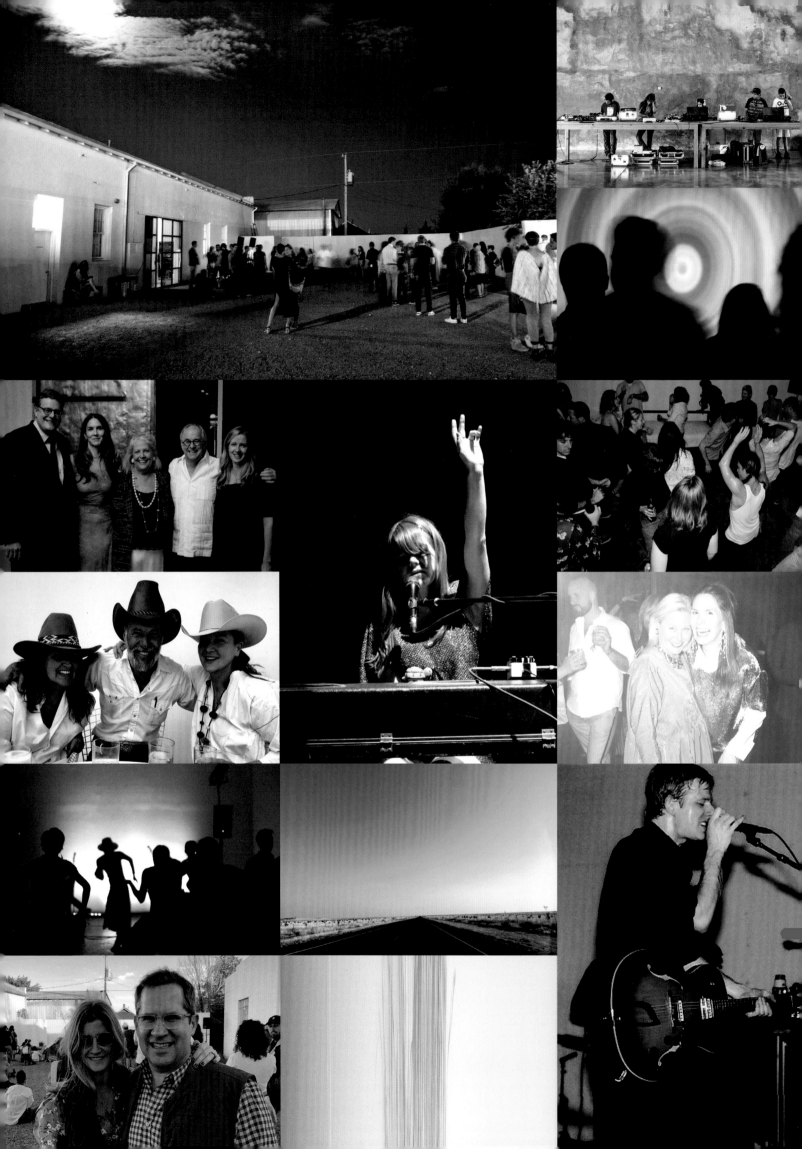

Thanks to a collaborative National Endowment for the Arts grant, Ballroom donates a kiln to the Marfa Independent School District. It is accessible to both the elementary and secondary campuses.

January 2
The Wind with live score by Brian LeBarton
Brian LeBarton, Ira Blanton, Joel Nelson
Organized in conjunction with Marfa Public Radio

January 15
White Denim

January 29
Art in the Auditorium 2
(pp. 116–17)
Aïda Ruilova, Ursula Mayer, Charly Nijensohn, Nova Paul, Lars Laumann, Inci Eviner, Patrizio di Massimo
Organized in collaboration with Whitechapel Gallery, London

January 29
Haiti Relief Benefit Raffle
Matthew Day Jackson

February 5
Robinson Jeffers Poetry Slam
Jennie Lyn Hamilton
Organized in conjunction with the Marfa Public Library

February 9
Chicago Underground Duo

February 27
Fundred Dollar Bill Project
(pp. 76–81)
Mel Chin

March 10–September 19
In Lieu of Unity/En Lugar de la Unidad (pp. 118–25)
Eduardo Abaroa, Margarita Cabrera, Livia Corona Benjamin, Minerva Cuevas, Mario García Torres, Máximo González, Paulina Lasa, Teresa Margolles, Pedro Reyes, Tercerunquinto
Organized by Alicia Ritson

March 28
Mexican Institute of Sound

April 13
Making Art Work: Yaesayer
Yaesayer

April 17
Sarah Rothenberg

May 4
Marfa Student Poetry Book Launch

May 14–16
No Soul for Sale, A Festival of Independents at the Tate Modern
Erika Blumenfeld
Organized in conjunction with the Tate Modern

May 30
Grouper with Adam Bork

July 19–23
DJ Camp 2010 (pp. 106–9)
Javier "DJ Bigface" Arredondo

September 17–19
Marfa Dialogues/Diálogos en Marfa (pp. 132–33)
Cecilia Ballí, Charles Bowden, Mark Danner, Robert Halpern, Dahr Jamail, Sandra Rodríguez Nieto, Hamilton Fish, Laura Flanders, Kathleen Staudt, Luis Carlos Davis, David Taylor
Organized in collaboration with the *Washington Spectator*

September 18
La Santa Cecilia

October 1, 2010–
February 20, 2011
Immaterial
(pp. 110–15)
Barbara Kasten, Rachel Khedoori, Esther Kläs, Liz Larner, Erlea Maneros Zabala, Linda Matalon, Julie Mehretu, Charline von Heyl, Rosy Keyser, Laleh Khorramian, Heather Rowe, Erin Shirreff
Organized by Fairfax Dorn

October 2
Ty Segall

November 1
The Rat Trap Ball with the Royal Butchers

2011

January 1
The Blood of a Poet with live score by Eluvium
Eluvium (Matthew Cooper)

January 10
Red-Haired Stepchild: Making Visual Art in New Orleans
Dan Cameron, Skylar Fein, Srdjan Loncar, Dan Tague

February 14
Making Art Work: Sharon Isbin
Sharon Isbin

March 15
Student Haiku Workshop
Dan Tague, Mallory Jones

March 18
Little Freddie King

March 18–August 14
The World According to New Orleans
Jules Cahn, Bruce Davenport Jr., Dawn Dedeaux, Courtney Egan, Skyler Fein, Roy G. Ferdinand, Srdjan Loncar, Deborah Luster, Sister Gertrude Morgan, Gina Phillips, Noel Rockmore, Michael P. Smith, Dan Tague
Organized by Dan Cameron (Guest Curator)

March 26
The Reading 2011–*The Jumper of Maine* by Andrew Lanham
Andrew Lanham, John S. Davies, Carolyn Pfeiffer, Nancy Sanders, Drew Wall, Angie Bolling, Harry Hudson, Susannah Lipsey, Camille Willaford, Felix Benton, Cory Van Dyke, Jennie Lyn Hamilton, Steve Holzer, Sam Schonzeit, James Rodewald
Organized in conjunction with the Academy Nicholl Fellowships in Screenwriting

April 18
Making Art Work with Alyce Santoro
Alyce Santoro

April 25–May 1
Texas Biennial with Alyce Santoro
Alyce Santoro
Organized by Fairfax Dorn
and JD DiFabbio

July 8
Cass McCombs Band with Pink Nasty

July 11
Grouper 7-inch release
Grouper (Liz Harris)

July 11–15
Grouper (Liz Harris)

July 12
**Lecture Series: "Art,
Airfields & Airspace"**
Kathleen Shafer

July 18
DJ Camp 2011
Faith Gay

August 8
Eets Feats with Solid Waste

August 26
Art in the Auditorium 3
Niles Atallah, Joaquín Cociña and
Cristóbal León; Elodie Pong; Rachael
Rakena; Stephen Sutcliffe; Marthe
Thorshaug; Huang Xiaopeng;
Giorgio Andreotta Calò; Ergin
Çavuşoğlu; Dinh Q. Lê; Kelly Nipper;
Elodie Pong; Stephen Sutcliffe;
Jalal Toufic; Alicia Ritson
Organized by Alicia Ritson in
conjunction with Whitechapel
Gallery, London

September 15
**Explosions in the Sky
with Mr. Twin Sister**

September 30
Mariachi Las Alteñas and Mick Barr
(Ballroom Beat, vol. 1)

September 30–February 12
AutoBody (pp. 128–31)
Meredith Danluck, Liz Cohen,
Matthew Day Jackson,
Jonathan Schipper
Organized by Neville Wakefield

October 10
**Ballroom at the High
Line: Atom Fables**
Laleh Khorramian, Shahzad Ismaily
Organized in conjunction with
Friends of the High Line

October 14–16
Chalk the Block, *Irrigación*
(pp. 126–27)
Teresa Margolles
Organized in conjunction
with Kate Bonansinga

October 20
Texas Contemporary Art Fair

November 3
Tinariwen
Tinariwen, Sophie Hunger

December 15, 2011–
February 12, 2012
Autobody **Film Program**
David Cronenberg, Matthew
Barney, Claude Lelouch, Kevin
Jerome Everson, Asif Kapadia
Organized by Neville Wakefield

December 30
The Kid **with live score
by Shahzad Ismaily**
Shahzad Ismaily, Meshes
of the Afternoon
Organized by Josh Siegel

2012

Ballroom Marfa is awarded
$75,000 by the Robert
Rauschenberg Foundation in
support of visual arts programs

March 1
Making Art Work: Jennifer Dalton
Jennifer Dalton

March 2
R. Luke DuBois and Bora Yoon

March 2–July 8
Data Deluge
Rebeca Bollinger, Jon Brunberg,
Anthony Discenza, Scott Hug, Loren
Madsen, Michael Najjar, Adrien Segal
Organized by Rachel Gugelberger
and Reynard Loki

March 24
Eleanor Friedberger

March 24
**Lecture Series:
"Remembering Istanbul"**
Jens Hoffman

April 12
At the Drive-In with Zechs Marquise
April 21
The Reading—*Cutter* by Dion Cook
Andrew Lanham, John S. Davies,
Carolyn Pfeiffer, Nancy Sanders,
Drew Wall, Angie Bolling, Harry
Hudson, Susannah Lipsey,
Camille Willaford, Felix Benton,
Cory Van Dyke, Jennie Lyn
Hamilton, Steve Holzer, Sam
Schonzeit, James Rodewald

April 25
Feist

May 27
CSS
CSS, Foundation for
Jammable Resources

June 1
Kimball Gallagher Children's Concert
Kimball Gallagher

July 16
DJ Camp 2012
DJ Bigface, Faith Gay

July 20
Artists' Film International—Dan Finsel
Dan Finsel
Organized in conjunction with
Whitechapel Gallery, London

July 31
Dirty Projectors

August 7
Book and a Movie: *Never Let Me Go*
Elizabeth Redding, Dirk
Vaughn, Renee Mick
Organized in conjunction with
the Marfa Public Library

August 18
Piano Lessons with Kimball Gallagher
Kimball Gallagher

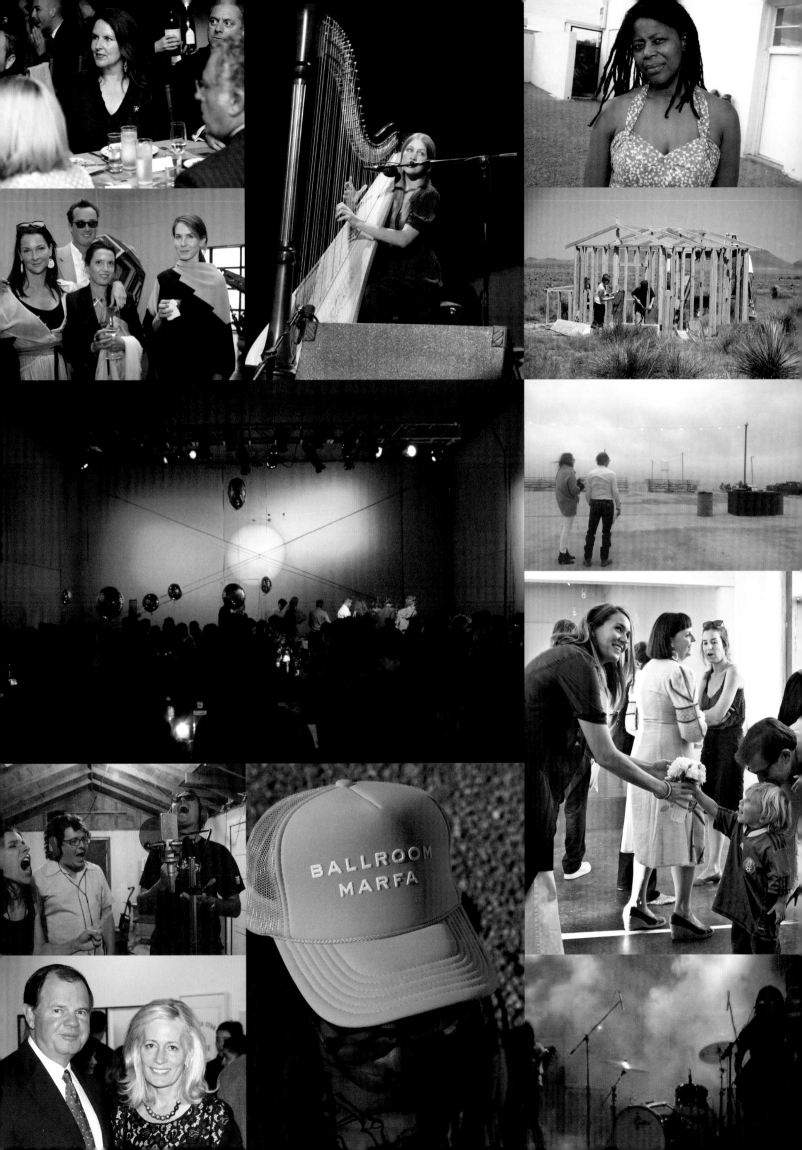

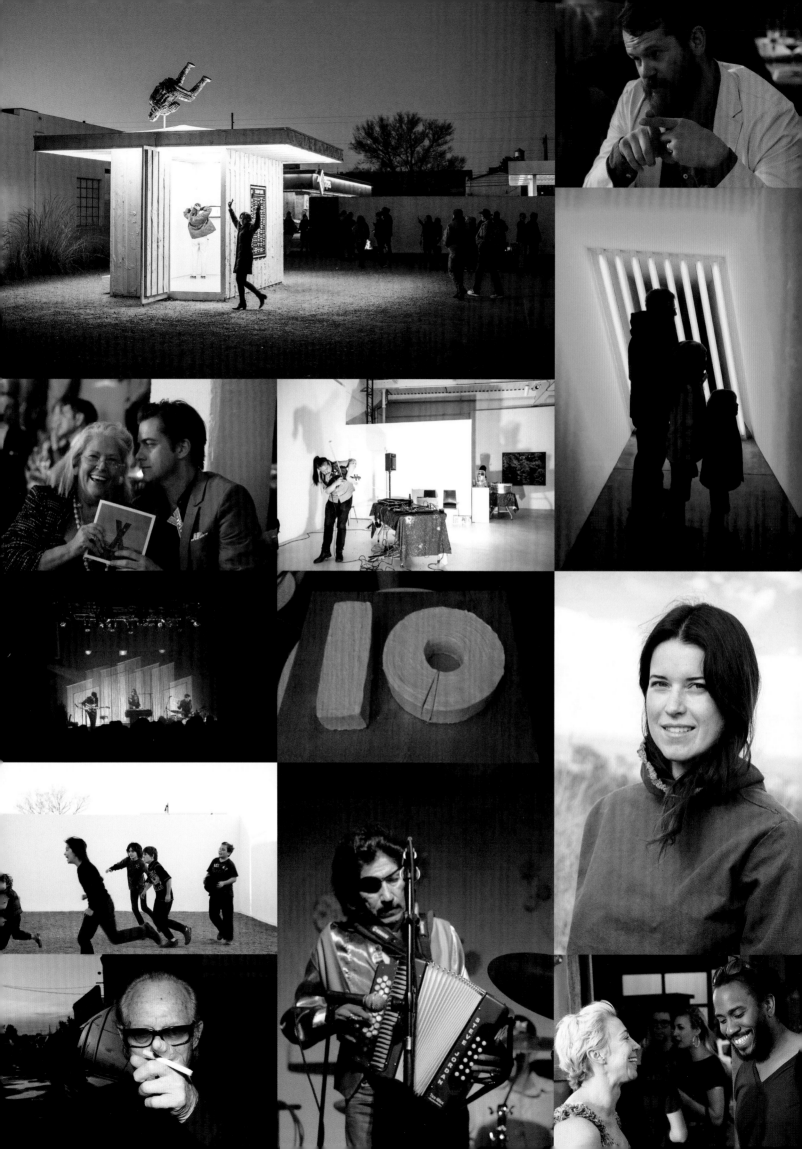

August 30
Making Art Work: Adriane Colburn and David Buckland
Adriane Colburn and David Buckland

August 31
Marfa Dialogues 2012
(pp. 132–33)
Michael Pollan, Rebecca Solnit, David Buckland, Hamilton Fish, Cynthia Hopkins, Diana Liverman, John Nielsen-Gammon, Robert Potts, Tom Rand, Bonnie J. Warnock, Co-organized by Fairfax Dorn and Hamilton Fish

August 31, 2012–February 3, 2013
Carbon 13
Ackroyd & Harvey, Amy Balkin, Erika Blumenfeld, David Buckland, Adriane Colburn, Antony Gormley, Cynthia Hopkins, Sunand Prasad
Organized by David Buckland
September 18

Peter Brötzmann and Jason Adasiewicz

September 19
Making Art Work: Jason Adasiewicz
Jason Adasiewicz

October 12
Lee Fields & the Expressions with the Honeybears

October 18
Texas Contemporary Art Fair

November 27
Book and a Movie: *The Godfather*
Organized in conjunction with Marfa Public Library

December 12
Children's Film Series: *Princess Mononoke*
Organized in conjunction with Marfa Public Library

December 30
***The Phantom Carriage* with live score by Noveller**
Noveller (Sarah Lipstate)

2013

January 5
The Sebastian Ensemble

February 15
Valentine's Dance with Gary P. Nunn
Gary P. Nunn, Primo Carrasco & Friends

March 8–July 7
New Growth (pp. 140–47)
Rashid Johnson
Organized by Fairfax Dorn

March 8
Kahil El'Zabar and Hamiet Bluiett

March 13
Jeff Mangum

March 21
Eleanor Friedberger 7-inch Release

April 4
Lecture Series: Anthony Elms
Anthony Elms

April 21
Beach House

May 1
New Growth **Film Program**
John Coney / Sun Ra's *Space Is the Place*, John Sayles, Van Peebles
Organized by Rashid Johnson and Josh Siegel

May 18
The Reading—*Devils at Play*
James DiLapo, Julia Dyer, Drew Wall, Chuck Huber, Carolyn Pfeiffer, Nancy Sanders

June 24
DJ Camp 2013
DJ Bigface, Faith Gay

July 19
Artists' Film International 2013–Alix Pearlstein
Alix Pearlstein
Organized in conjunction with Whitechapel Gallery, London

August 6
William Tyler with $3.33

August 31
AJ Castillo with The Resonators at Marfa Lights

September 14–November 9
Open Studio: Every Person is a Special Kind of Artist, with Baggage
Dallas Collective (Michael Corris, William Binnie, Soraya Abtahi, Jenna Barrois, Ellen Smith, Alexandra Monroe, Dylan Wignall, Rhyanna Odom, Nina Davis, Elainy Lopez, Hannah Tyler, Michael Deleon, Braeden Bailey, Kelly Kroener, Travis LaMothe, Michael M. Morris, Melissa Tran)
Organized in conjunction with the 2013 Texas Biennial Commissioned Project

September 27
Devin Gary & Ross
Devin Flynn, Ross Goldstein, Gary Panter, Kramer

September 27, 2013–February 2, 2014
Comic Future (pp. 154–57)
Walead Beshty, Liz Craft, Aaron Curry, Carroll Dunham, Arturo Herrera, Mike Kelley, Paul McCarthy, Erik Parker, Sigmar Polke, Peter Saul, Dana Schutz, Michael Williams, Sue Williams
Organized by Fairfax Dorn

October 1–November 30
Marfa Dialogues/NY (pp. 148–49)
Carbon Tax Center, Miriam Simun, Miriam Songster, Rosa Barba, Neïl Beloufa, Camille Henrot, Basim Magdy, Nora York, Mary Miss/City as Living Laboratory, Maya Lin, Frances Beinecke, Center for Social Inclusion, Tue Greenfort, David Brooks, Toshihiro Oki, Wangechi Mutu
Organized by Fairfax Dorn and Hamilton Fish

October 9
Autre Ne Veut

October 13–November 30
Quiet Earth (pp. 150–53)
Amy Balkin, Larry Bamburg,
Agnes Denes, Hans Haacke,
Donald Judd, Maya Lin, Trevor
Paglen, Robert Rauschenberg
Organized by Fairfax Dorn
at the Robert Rauschenberg
Foundation Project Space

November 2
Laura Marling with Willy Mason

November 16
*The Marfa Triptych–The Country
and Western Big Band Suite*
(pp. 162–69)
Graham Reynolds
Organized by Fairfax Dorn
and Virginia Lebermann

November 21
C. Spencer Yeh and Messages

December 3
Julianna Barwick

December 30
Le Révélateur with live score by
Mary Lattimore and Jeff Zeigler
(Ballroom Beat, vol. 1)
Mary Lattimore and Jeff Zeigler
Organized by Vance Knowles

2014

February 28–October 24
Sound Speed Marker
(pp. 158–61)
Teresa Hubbard, Alexander Birchler
Organized by Fairfax Dorn

March 1
The Tish Hinojosa Band

March 8
Marfa Myths 2014
(Ballroom Beat, vol. 2)
Connan Mockasin, No Joy,
Weyes Blood, Quilt, Arp
Organized by Nicki Ittner

March 11
New Bums

April 12
The Doodlin' Hogwallops

April 21
Marisa Anderson

May 5
Avery Tare's Slasher Flicks
Avey Tare, Angel Deradoorian,
Jeremy Hyman, Party With Death

June 17–19
Music Moves U
Kahil El'Zabar & the Ethnic
Heritage Ensemble

June 30–July 5
DJ Camp 2014
DJ Bigface, Faith Gay

July 12
Bonnie "Prince" Billy

July 12–19
Vidas Perfectas
Alex Waterman, Robert Ashley,
Javier Sinz de Robles, Ned Sublette,
Elio Villafranca, Peter Gordon,
Elisa Santiago, Raúl de Nieves
Organized by Fairfax Dorn

July 30–August 3
Marfa Dialogues/St. Louis
(pp. 148–49)
Organized in conjunction with
the Pulitzer and the Public
Concern Foundation

October 4
The Marfa Triptych–The Desert
(pp. 162–69)
Graham Reynolds
Organized by Fairfax Dorn
and Virginia Lebermann

**Artists' Film International
2014–Nicole Miller**
Nicole Miller
Organized in conjunction with
Whitechapel Gallery, London

2015

March 13–15
Marfa Myths 2015
(Ballroom Beat, vol. 2)
Iceage, Grouper, Tamaryn, Steve
Gunn, Weyes Blood, Suicideyear,
Gabi, Co La, Thug Entrancer,
Jefre Cantu-Ledesma, Bitchin
Bajas, Gregg Kowalsky, Dev
Hynes, Connan Mockasin
Organized by Nicki Ittner

March 13–August 15
Sam Falls
Organized by Fairfax Dorn

June 14–15
Steve Earle and the Dukes
Organized by Nicki Ittner

June 19–July 3
DJ Camp 2015
DJ Bigface
Organized by Nicki Ittner

August 28–29
Desert Surf Films (pp. 170–73)
Alby Falzon, David Elfick,
Sam Falls, Ian Lewis, Joe
Zorilla, Daniel Chamberlin
Organized by Susan Sutton

September 25, 2015–
February 14, 2016
Äppärät (pp. 174–81)
Ed Atkins, Trisha Donnelly, Melvin
Edwards, Cécile B. Evans, Jessie
Flood-Paddock, Roger Hiorns,
Sophie Jung, Lee Lozano, Marlie
Mul, Damián Ortega, Charles
Ray, Shimabuku, Paul Thek
Organized by Tom Morton
(Guest Curator)

September 25
Mike Simonetti
Organized by Nicki Ittner

November 14
**Artists' Film International
2015–Brigid McCaffrey**
Brigid McCaffrey
Organized in conjunction with
Whitechapel Gallery, London

2016

March 10–16
Marfa Myths 2016
(Ballroom Beat, vol. 2)
Parquet Courts, No Age, Connan
Mockasin's Wet Dream, Dungen,
Emitt Rhodes, Fred and Toody, Quilt,
William Basinski, Hailu Mergia,
Awesome Tapes from Africa,
Raum with Paul Clipson, Heron
Oblivion, Mary Lattimore, Maria
Chavez, Sheer Mag, Pill, Weyes
Blood, Ariel Pink, Real News
Organized by Nicki Ittner

March 11–August 16
After Effect
(pp. 186–91)
Dan Colen, Loie Hollowell, the
Transcendental Painting Group,
Arturo Bandini, Oscar Fischinger
Organized by Fairfax Dorn

March 24–26
Marfa Dialogues/Houston
(pp. 148–49)
Rev. Lennox Yearwood Jr., MPA, Dr.
William Stefanov, Jamey Stillings,
Dr. Trevor Williams, Center for Land
Use Interpretation, SIMPARCH, Dr.
Geof Rayner, Gina Glover, Dornith
Doherty, Juan Parras, Sarah
Rara, Timothy Morton, Mandy
Barker, Erik Davis, Rachel Rose
Organized by Fairfax Dorn and
Hamilton Fish in conjunction with
FotoFest International and the
Public Concern Foundation

March 24
Lucky Dragons at Marfa Dialogues

April 15
Bitchin Bajas
Cooper Crain, Dan Quinlivan,
Rob Frye, Mellow Arms
Organized by Sarah Melendez

May 21
"Agnes Pelton and the American
Transcendental: A Lecture by
Artist Mary Weatherford"
(p. 192)
Mary Weatherford

June 17
DJ Camp 2016
DJ Bigface
Organized by Sarah Melendez

September 23, 2016–
February 19, 2017
This is Presence: Artists' Film
International 2016–The Institute for
New Feeling with Arturo Bandini
Institute for New Feeling, Scott
Andrew, Agnes Bolt, Nina
Sarnelle, Arturo Bandini
Organized by Laura Copelin

November 11–12
*The Marfa Triptych–Pancho
Villa from a Safe Distance*
(pp. 162–69)
Graham Reynolds, Lagartijas
Tiradas al Sol, Shawn Sides, Paul
Sanchez, Adrian Quesada
Organized by Fairfax Dorn
and Virginia Lebermann

December 9, 2016–
February 19, 2017
*Arturo Bandini–Vapegoat
Rising and Dengue Fever*
Kelly Akashi, Edgar Bryan, Josh
Callaghan, Jason Roberts Dobrin,
Michael Dopp, Marten Elder,
John Finneran, Kathryn Garcia,
Sonja Gerdes, S Gernsbacher, Liz
Glynn, Chanel Von Habsburg-
Lothringen, Ed Fornieles, Kate
Hall, Mark Hagen, Rick Hager,
Drew Heitzler, Julian Hoeber,
Joel Holmberg, Yanyan Huang,
Whitney Hubbs, Dwyer Kilcollin,
Sofia Londono, Anna Mayer, Nevine
Mahmoud, Sarah Manuwal, Calvin
Marcus, Thomas Mcdonell, Isaac
Resnikoff, Roni Shneior, Mungo
Thomson, and Barak Zemer.
Organized by Michael Dopp
and Isaac Resnikoff

2017

March 10–August 6
Strange Attractor (pp. 196–203)
Lawrence Abu Hamdan, Thomas
Ashcraft, Robert Buck, Alexander
Calder, Beatrice Gibson, Phillipa
Horan, Channa Horwitz, Lucky
Dragons, Haroon Mirza, Douglas Ross,
Lonnie Holley, Tonstartssbandht,
Benton C. Bainbridge
Organized by Gryphon
Rue (Guest Curator)

March 9
Dirty Gay Movie Night featuring
Bijou and *Community Action Center*
Eileen Myles, Rae Anne Hample,
Natalie Melendez, Tim Johnson

March 9–12
Marfa Myths 2017
(Ballroom Beat, vol. 2)
Roky Erickson, Perfume Genius &
Weyes Blood, Pharoah Sanders,
Julia Holter, Idris Ackamoor &
The Pyramids, Jenny Hval, Kaitlyn
Aurelia Smith, Allah-Las, Cate Le
Bon, Connan Mockasin, Bostyn 'n
Dobsyn, Zomes, Lonnie Holley, Rose
Kallal, Tonstartssbandht, Botany &
Shingetsu Billy White, Chulita Vinyl
Club, Matt Craven, Dungen, Woods,
Johan Kugelberg, Paul Drummond
Organized by Nicki Ittner
and Sarah Melendez

March 23
Tower
Keith Maitland, Sarah Wilson

June 19–23
DJ Camp 2017
DJ Bigface, Chulita Vinyl Club
Organized by Sarah Melendez

July 6
Maria Minerva with W.
Creeves, VJ Mellow Arms
Organized by Sarah Melendez

July 20
*Through the Repellent
Fence*: A Land Art Film
Sam Wainwright Douglas, Raven
Chacon, David Hartstein

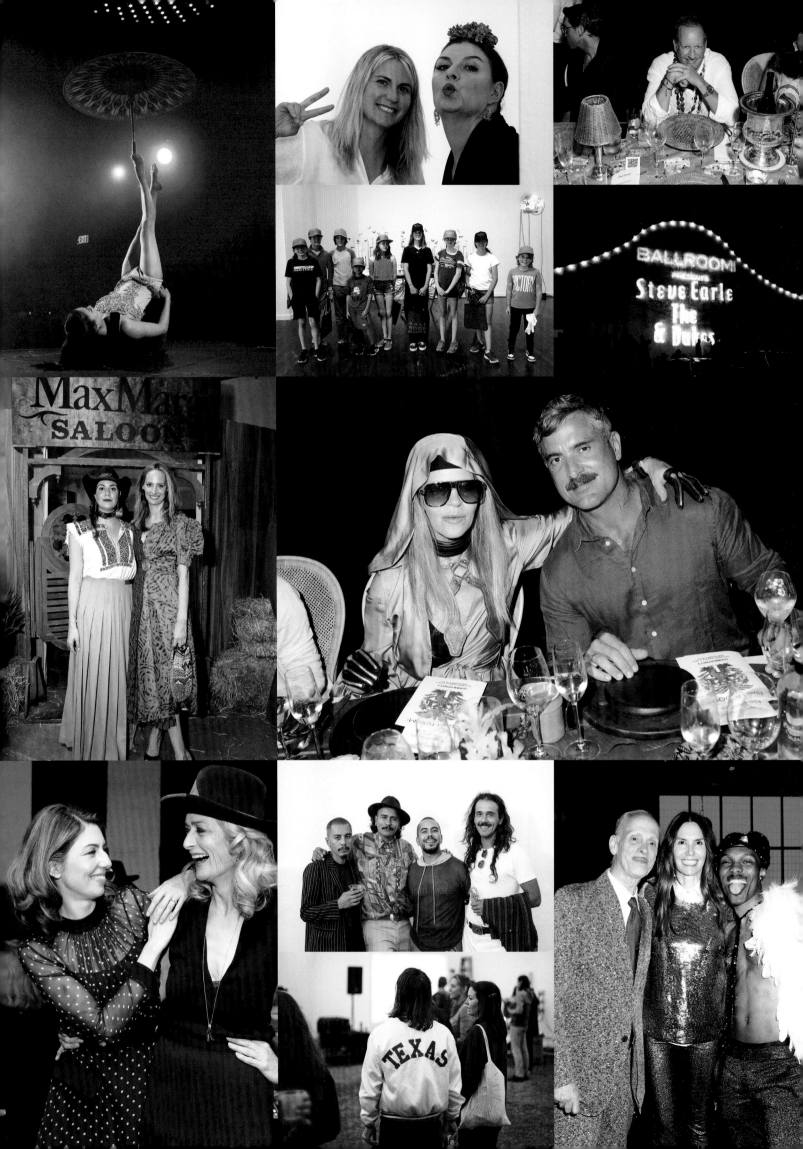

August 4
Marfa Solar Social
Freedom Solar Power, Judd
Foundation, Marfa Solar System

August 25, 2017–March 18, 2018
Tierra. Sangre. Oro.
(pp. 214–23)
rafa esparza with Carmen
Argote, Nao Bustamante, Beatriz
Cortez, Timo Fahler, Eamon
Ore-Giron, Star Montana
Organized by Laura Copelin

August 25
JD Samson and MEN
Organized by Sarah Melendez

November 13–14
Tierra. Sangre. Oro. Adobe Workshop
rafa esparza
Organized by Sarah Melendez

November 18
Artists' Film International 2017–
Denise Ferreira da Silva and
Arjuna Neuman (pp. 230–31)
Denise Ferreira da Silva
and Arjuna Neuman
Organized in conjunction with
Whitechapel Gallery, London

2018

February 15
San Cha—Tragame Tierra
San Cha, Ashley Hicks, Mamis
Organized by Sarah Melendez

April 4
Marfa Myths 2018
(Ballroom Beat, vol. 2)
Wire, Tom Zé, Jessica Pratt, Circuit
des Yeux, The Weather Station,
Drugdealer, Terry Allen, Ryley
Walker, Omar-S, Innov Gnawa, Thor
& Friends, Helado Negro Ensemble,
Suzanne Ciani, Laraaji with Arji
OceAnanda, Gravity Hill, Sound
+ Image, Amen Dunes, Kelsey Lu,
Equinoxx, Cate Le Bon, Bradford
Cox, Connan and Ade Mockasin
Organized by Sarah Melendez

April 13–November 4
Hyperobjects (pp. 208–13)
Center for Land Use Interpretation,
Megan May Daalder, Tara Donovan,
Nance Klehm, Postcommodity,
Emilija Škarnulytė, Sissel Marie Tonn,
Jonathan Reus, David Brooks, Center
for Big Bend Studies, Chihuahuan
Desert Mining Heritage Exhibit,
Earthworks, rafa esparza, Raviv
Ganchrow, Paul Johnson, Candice Lin,
Long Now Foundation, Iván Navarro,
Sul Ross State University Herbarium,
Rio Grande Research Center, Oscar
Santillán, University of Texas at
Austin McDonald Observatory
Co-organized by Timothy Morton
(Guest Curator) and Laura Copelin

April 29
stone circle first activation
(pp. 204–7)
Haroon Mirza

June 6
Mary Lattimore with
Julianna Barwick
Organized by Sarah Melendez

June 11–14
DJ Camp 2018
DJ Bigface, Si Mon' Cecilia Emmett
Organized by Sarah Melendez

August 5, 24, & 26
Hyperobjects–Animal,
Vegetable, Mineral
Denis Perez, Mieke Titulaer,
Nance Klehm, Charlotte Reemts
Co-organized by Timothy Morton
(Guest Curator) and Laura Copelin

September 15
Nostalgia for the Light and Star Party
Patricio Guzmán
Organized in conjunction with
the University of Texas at Austin
McDonald Observatory

September 30
Ranch Day | Botanical
Collage Workshop
Jeff Keeling, Sandra Harper

October 24
stone circle - PASSAGE
Jennifer Lane, Haroon
Mirza, William A. Cloud

November 16
def.sound

November 16
The Way You Make Me Feel:
Artists' Film International
2018–Jibade-Khalil Huffman
(pp. 230–31)
Jibade-Khalil Huffman
Organized in conjunction with
Whitechapel Gallery, London
Organized by Laura Copelin

2019

April 5–October 20
Candelilla, Coatlicue, and the
Breathing Machine (pp. 224–29)
Beatriz Cortez, Candice Lin,
Fernando Palma Rodríguez
Organized by Laura Copelin

April 25–28
Marfa Myths 2019
(Ballroom Beat, vol. 2)
Khruangbin, OG Ron C & The
Chopstars, Jon Bap, Money Chicha,
Annette Peacock, Träd, Gräs och
Stenar, Vivien Goldman, Jess Sah
Bi & Peter One, The Space Lady,
Deerhunter, Nadah El Shazly, Tim
Hecker & the Konoyo Ensemble, Cass
McCombs, Makaya McCraven, Jerry
Paper, Photay, Josey Rebelle, Emily
A. Sprague, Jess Williamson, Kate
Berlant and John Early, Superstar
& Star, Drugdealer, Tim Presley,
Cate Le Bon, Connan Mockasin
Organized by Sarah Melendez

June 5
Tlacuilcopa–a workshop and
exploration of Nahuatl
Fernando Palma Rodríguez

June 17–21
DJ Camp 2019
The Chulita Vinyl Club ATX
Organized by Sarah Melendez

July 19
The River and the Wall
Nancy Sanders, Hillary
Pierce, Katy Baldock

August 9
Cassandro, The Exótico!
Marie Losier, Cassandro,
Sauvignon Blanca, Tokyo Bois
Organized by Sarah Melendez

September 5–7
A Triptych of Films about Migration—
El Mar La Mar, Island of the
Hungry Ghosts, **and** *Capernaum*
Joshua Bonnetta, J.P. Sniadecki,
Gabrielle Brady, Nadine Labaki

September 19
Mdou Moctar
Organized by Sarah Melendez

September 23
rafa esparza–bust:
indestructible columns
rafa esparza, Patrisse Cullors, Timo
Fahler, Raquel Gutiérrez, Sebastian
Hernandez, Risa Puleo, Yosimar Reyes
Organized by Laura Copelin with
Performance Space New York

November 15
Violin Phase **by Steve Reich**
Jeanann Dara and Ben Russell
Organized by Sarah Melendez

November 15
UJI
Luis Maurette
Organized by Sarah Melendez

November 19 2019–May 24 2020
Longilonge (pp. 232–37)
Solange Pessoa
Organized by Laura Copelin

November 22
Artists' Film International
2019–Carolina Caycedo
Carolina Caycedo
Organized in conjunction with
Whitechapel Gallery, London

2020

2020 Ballroom Sessions–The Farther
Place (pp. 276–81) Roberto Carlos
Lange and Kristi Sword, Rob Frye
Organized by Sarah Melendez
and Daisy Nam

May
Transmissions
Graham Reynolds, Carolina Caycedo,
David de Rozas, Elmgreen & Dragset
Organized by Sarah Melendez

May 16
Landscape Roberto Burle Marx
João Vargas Penna

July 2020
DJ CAMP 2020–Ten-
Year Anniversary!
With DJ Bigface and DJ Dada
Organized by Sarah Melendez

August 22 & 29
Artists' Film International 2020:
Miguel Fernández de Castro
(pp. 248–51)
Miguel Fernández de Castro
Organized in conjunction with
Whitechapel Gallery, London

October 2, 2020–February 18, 2021
unFlagging (pp. 242–47)
Lisa Alvarado, Natural Information
Society, Pia Camil, Jeffrey Gibson,
Laura Ortman, Byron Kim, Kameelah
Janan Rasheed, Hank Willis Thomas,
Naama Tsabar, Cecilia Vicuña
Organized by Sarah Melendez
and Daisy Nam

October 23–November 1
Chihuahuan Desert Birdscapes
+ Hearing Hidden Melodies
Rob Frye, Martín Kaulen, Edbrass
Brasil, Cristian Pinto, Martin
Frye, Satya Gummuluri
Organized by Sarah Melendez

2021

2021 Ballroom Sessions–The Farther
Place (pp. 276–81) EJ Hill, Elle
Pérez, Lisa E. Harris, Rob Mazurek
Organized by Sarah Melendez
and Daisy Nam

Knowledge of Wounds 2021
SJ Norman, Joseph Pierce

January 27
Milk Fountain–A Conversation
with Loie Hollowell
Loie Hollowell
Organized by Laura Copelin
and Daisy Nam

April 9–25
Artists' Film International 2021:
Patty Chang (pp. 248–51)
Patty Chang
Organized in conjunction with
Whitechapel Gallery in London

June 26–December 31
ESPEJO QUEMADA (pp. 252–59)
Donna Huanca
Organized by Daisy Nam

June 28–July 1
DJ Camp 2021 with Chulita
Vinyl Club ATX
Organized by Sarah Melendez

October 27
Arttable Talk: Marcela
Guerrero and Daisy Nam
Marcela Guerrero
Organized by Daisy Nam

2022

2022 Ballroom Sessions–The
Farther Place (pp. 276–81)
Jesse Chun, Guadalupe Maravilla,
Morgan Bassichis, Johanna
Unzueta, Jamire Williams
Organized by Daisy Nam
and Sarah Melendez

January 22–May 7
Kite Symphony (pp. 262–69)
Roberto Carlos Lange
and Kristi Sword
Organized by Sarah Melendez

April 22
Music For Earth Day
Newman Taylor Baker, Jace Clayton,
Lisa E. Harris, Roberto Carlos Lange,
Lori Scacco, Jamire Williams
Organized by Sarah Melendez

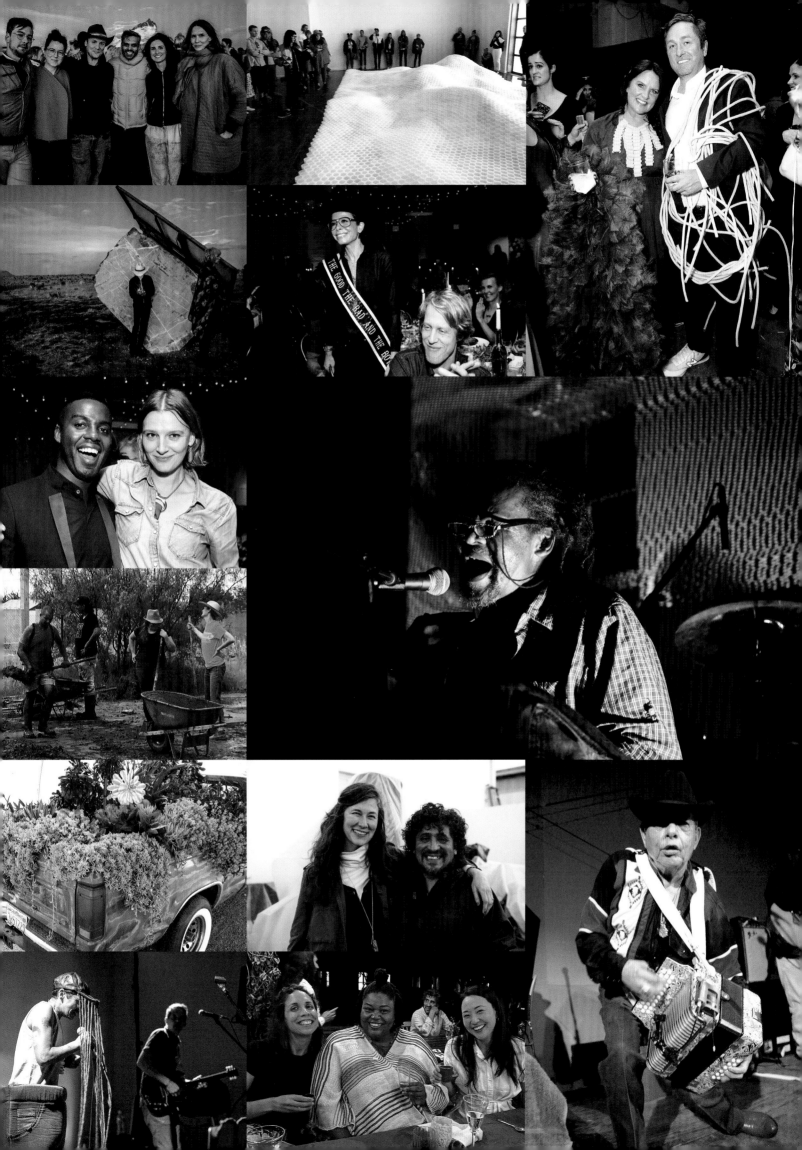

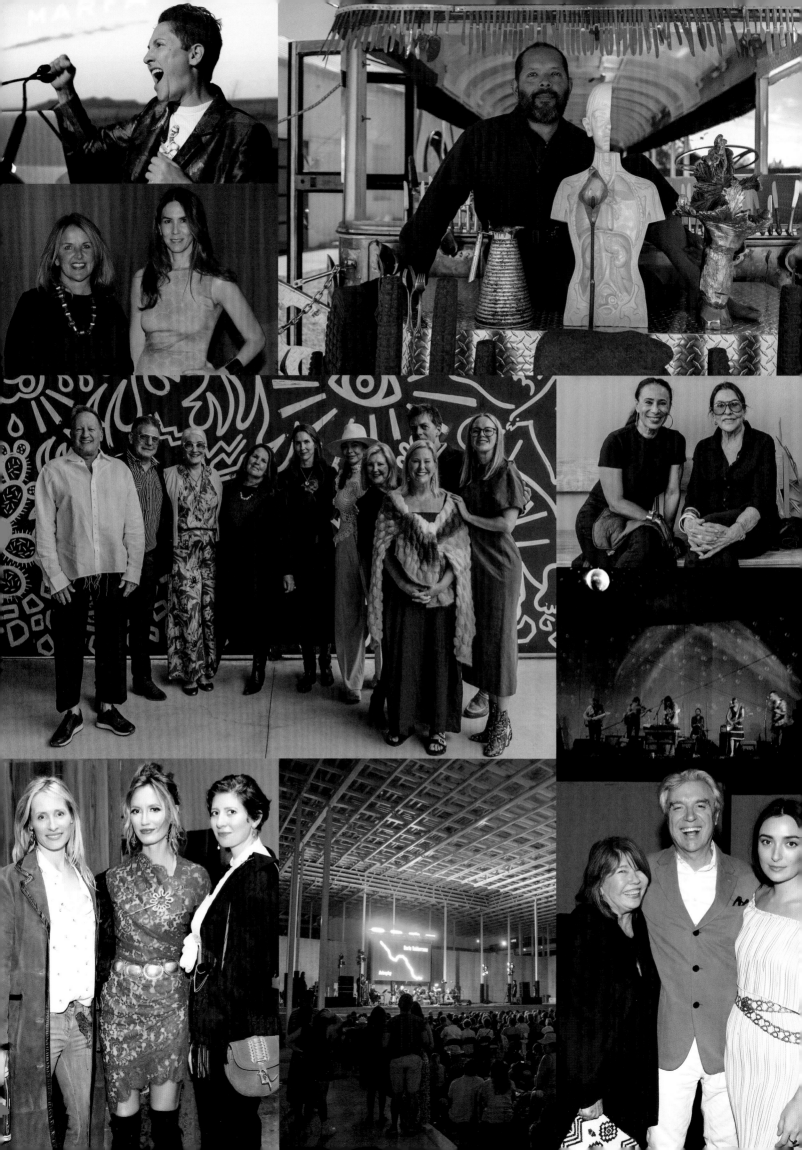

May 26–October 9
The Blessings of the Mystery
(pp. 270–75)
Carolina Caycedo and David de Rozas
Organized by Laura Copelin
and Daisy Nam

June 20–June 24
DJ Camp 2022 with Chulita
Vinyl Club ATX
Organized by Sarah Melendez

September 4
MXTX–A Cross-Border Exchange
Mexican Institute of Sound, Toy
Selectah, Paulina Sotomayor,
Murcof, Valentina Moretti, Pablo
Borchi, Naerlot, Concepción Huerta,
Microhm, NurryDog, Felipe Pérez
Santiago, Alina Hernández Maldonado,
Dario González Valderrama, Sabina
Cobarrubias, César Juárez-Joyner,
Mabe Fratti, Juan Felipe Waller,
Libertad Figueroa, Jean Angelus
Pichardo, Gibrana Cervantes Chavela,
Orión García, Saint Spicer, George
West, Jane Claire Hervey, NJUNE,
Noise Traveler, Alfredo Rios, Natalia
Rocafuerte, Tednoir Martinez,
Vanessa Burden, Adrian Quesada,
Laura Brackney, Carl Thiel, Jessy
Eubanks, Peter Stopschinski, Henna
Chou, José Martínez, Amanda Ekery,
Graham Reynolds, Kenzie Slottow
Organized by Sarah Melendez

October 26–May 7, 2023
Ecstatic Land
Laura Aguilar, Genesis Báez, Teresa
Baker, Dineo Seshee Bopape, Christie
Blizard, the Duncan Archive, Nancy
Holt, Katherine Hubbard, Isuma,
Benny Merris, Alan Michelson,
Laura Ortman, Elle Pérez, Sondra
Perry, David Benjamin Sherry
Co-organized by Dean Daderko
(Guest Curator) and Daisy Nam

October 26–May 7, 2023
*Tender is the hand which
holds the stone of memory*
(pp. 282–85)
Kenneth Tam
Organized by Daisy Nam

2023

2023 Ballroom Sessions–The
Farther Place (pp. 276–81)
Jamire Williams, Jibz Cameron,
Lori Scacco, Newman Taylor
Baker, Michelle Lopez
Organized by Daisy Nam
and Sarah Melendez

May 24–September 16, 2023
unlit: sof landin
Lisa E. Harris
Organized by Sarah Melendez

May 24–September 16, 2023
Tongues of Fire
Jorge Méndez Blake, Jesse Chun,
Adriana Corral, JJJJJerome
Ellis, Nakai Flotte
Organized by Daisy Nam

June 5–June 9
DJ Camp 2022 with Chulita
Vinyl Club ATX
Organized by Sarah Melendez

September 2
D.R.E.A.M= A Way to AFRAM
Lisa E. Harris
Organized by Sarah Melendez

September 25, 2023–
September 29, 2024
unFlagging: Futures
Kira Dominguez Hultgren,
Adriana Corral, María de los
Angeles Rodríguez Jiménez
Organized by Alexann Susholtz

October 4, 2023–March 31, 2024
Perhaps the Truth (pp. 286–91)
Alejandro Piñeiro Bello, Jes Fan, Joel
Gaitan, Florian Krewer, Rebecca
Manson, Ruben Ulises Rodriguez
Montoya, Jesse Murry, Robert Nava,
Ilana Savdie, Kiki Smith, Astrid
Terrazas, Lucía Vidales, Issy Wood
Organized by Daisy Nam

October 6
Dos Santos
Organized by Sarah Melendez

November 4, 2023–March 16, 2024
Mariposa Relámpago (pp. 292–93)
Guadalupe Maravilla
Organized by Daisy Nam, Sarah
Melendez, and Alexann Susholtz

November 9
Silent Spikes Screening & Discussion
Kenneth Tam, Daisy Nam, and Maggie
Dethloff, Curator of Photography
and New Media, Cantor Arts Center
Organized in conjunction
with the Cantor Arts Center
at Stanford University

2024

2024 Ballroom Sessions–
The Farther Place
Adriana Corral, Janaye
Brown, San Cha
Organized by Daisy Nam
and Sarah Melendez

February 17
Artist Talk with Adriana
Corral and Daisy Nam
Organized by Daisy Nam
and Alexann Susholtz

April 20–September 9, 2024
Steady
Michelle Lopez and Ester Partegàs
Organized by Daisy Nam
and Sarah Melendez

Ongoing
Prada Marfa
stone circle
DJ Camp
Artists' Film International
Ballroom Sessions–The Farther Place
Transmissions
Marfa Dialogues

ACKNOWLEDGMENTS

VIRGINIA LEBERMANN AND FAIRFAX DORN

We would like to acknowledge how thankful we are to our families for their kind and persistent support. We are specifically grateful to Louise S. O'Connor, Henry Wotowicz Lebermann, Marc Glimcher, Gage Dorn Glimcher, and Lisa and John Dorn.

Additionally, we are forever indebted to our founding and current board members: Charles Attal, Sara Story, Allison Sarofim, Molly Kemp, Mary Robbins, Leo Villareal, Phillip Solms de Graf, Charles Ruger, Sue Hostetler, Maria Giulia Prezioso Maramotti, Gordon VeneKlasen, Anne-Cecilie Engell Speyer, Suzanne Deal Booth, Deborah Green, Elle Moody, Arden Wohl, Nancy Sanders, Matthew Day Jackson, Rashid Johnson, Abdullah Al-Turki, Liana Krupp, and Vance Knowles. Every single board member has been integral to the growth and evolution of Ballroom Marfa. Their dedication and commitment continue to be the foundation on which Ballroom's ability to serve artists and the community relies.

Many thanks to the Monacelli/Phaidon team—Keith Fox, Jenny Florence, Carla Sakamoto, Michael Vagnetti, and Laura Mintz—as well as to designer Su Barber and co-editors Daisy Nam and Jessica Hundley.

We also want to recognize our editorial friends who stepped in at the last hour helping us to complete the book: Lachlan Miles, Sean Daly, Jonathan Mergele, and Vance Knowles.

And a final thank-you to Holly Harrison, Ballroom Marfa's current director, for bringing this book to the finish line.

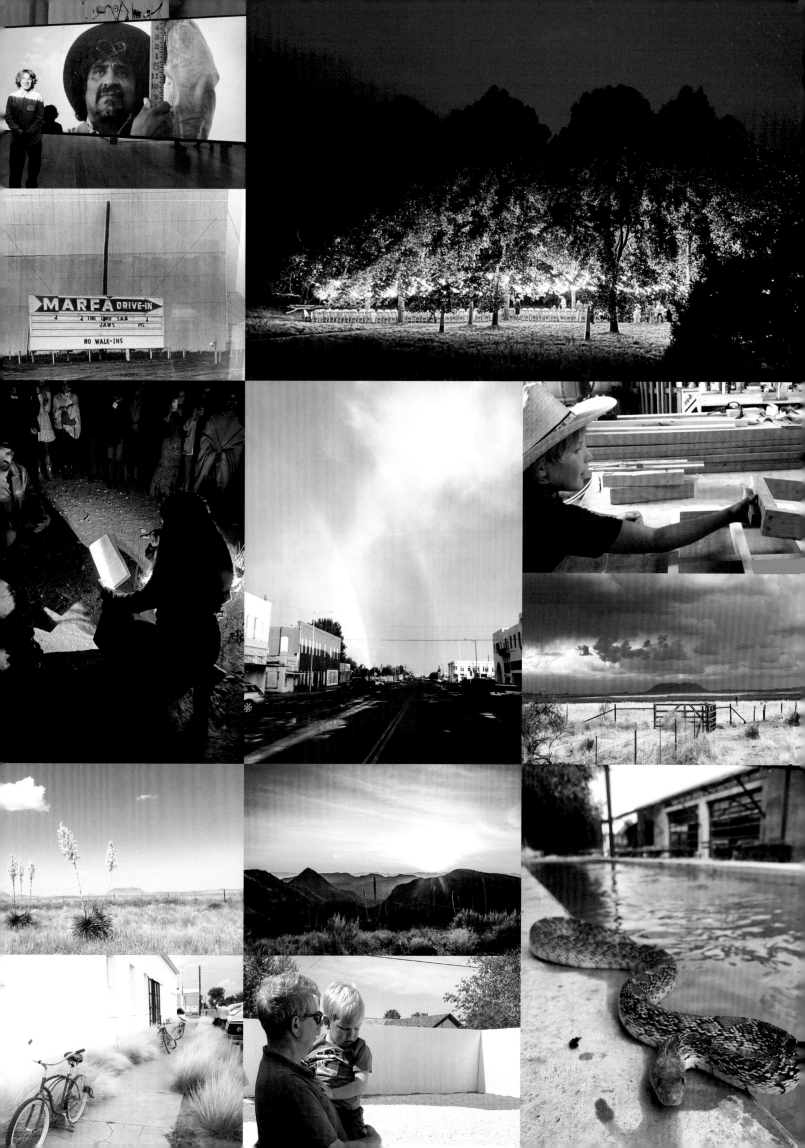

Editors:
Daisy Nam and Jessica Hundley

Special thanks to:
Sarah Melendez, Alexann Susholtz, and Britney Bass

Library of Congress Control Number: 2024939980
ISBN 9781580936262

Design by Su Barber

Printed in China

Monacelli
A Phaidon Company
111 Broadway
New York, New York 10006
monacellipress.com

All images courtesy the artist and Ballroom Marfa unless otherwise noted.

Photo Douglas Friedman Photography, LLC. 10, 16–17; Courtesy Gardar Eide Einarsson and Team Gallery, New York, Photo Fredrik Nilsen 22, 64 bottom left; Photo John Huba 24–25; Photo Ezra Gregg 27; © 2003 Takashi Murakami/Kaikai Kiki Co., Ltd. All Rights Reserved, Photo George O. Jackson 28, 31 center right; Takashi Murakami/Kaikai Kiki Co., Ltd. All Rights Reserved 31 top left background; Courtesy Forcefield and Electronic Arts Intermix, Photo George O. Jackson 31 top left foreground; Courtesy Adam Pendleton and Shane Campbell Gallery, Photo George O. Jackson 31 top right; Courtesy Martin Creed, Photo George O. Jackson 31 bottom right; Courtesy Leo Villareal, Pace Gallery, and Blanton Museum of Art, The University of Texas at Austin, Photo George O. Jackson 31 bottom left background, 31 center left; Courtesy Polly Apfelbaum and Frith Street Gallery, Photo George O. Jackson 31 bottom left foreground; Photo George O. Jackson 32, 35 top left; Courtesy Alison Smith and Bellwether Gallery, New York, NY, Photo George O. Jackson 35 top right; Courtesy the Artist Pension Fund of New York, Photo George O. Jackson 35 center left; © John Waters. Courtesy the artist, Marianne Boesky Gallery, New York and Aspen, Sprüth Magers, and Artforum Media, LLC. 36; Courtesy Elmgreen & Dragset, Art Production Fund, and Ballroom Marfa, Photo James Evans 39; Photo Lizette Kabré 45; Photo Ronald Rael 46; Photo Boyd Elder 49; Courtesy Agnes Denes and Leslie Tonkonow Artworks + Projects, Photo Paul Bardagjy 50; Photo Vicente Celis 53, 59, 77, 79; © Sigalit Landau 56–57; Courtesy Agnes Denes and Leslie Tonkonow Artworks + Projects, Photo Fredrik Nilsen 60; Courtesy John Miller and Metro Picture New York, Photo Fredrik Nilsen 63 top; Courtesy Carol Bove, Maccarone Inc., New York, and Galerie Dennis Kimmerich, Düsseldorf, Photo Fredrik Nilsen 63 top; Courtesy Barry X Ball and Salon 94, New York, Photo Fredrik Nilsen 63 top; Courtesy Huma Bhabha and ATM Gallery, New York, Photo Fredrik Nilsen 63 top; Courtesy Robert Grosvenor and Paula Cooper Gallery, New York, Photo Fredrik Nilsen 63 bottom; Courtesy Guyton\Walker and Greene Naftali, New York, Photo Fredrik Nilsen 63 bottom; Courtesy Jason Fox and Feature Inc., New York, Photo Fredrik Nilsen 63 bottom; Courtesy Wangechi Mutu and Sikkema Jenkins & Co., New York, Photo Fredrik Nilsen 64 top; Courtesy Guyton\Walker and Greene Naftali, New York, Photo Fredrik Nilsen 64 bottom right; Courtesy Julia Scher and Ortuzar Projects, Photo Fred Covarrubias 67; Courtesy Rodney Graham and Donald Young Gallery 68 top; Courtesy Christian Jankowski and Maccarone, Inc., Photo Fred Covarrubias 68 bottom; Photo Fred Covarrubias 69; Photo Fredrik Nilsen 74, 102 top and right, 111, 112 center right, 115 bottom, 118, 120–21, 123 top right and bottom right, 158 top, 191; Courtesy Jonah Freeman, Justin Lowe, Alexandre Singh and Andrew Krepps Gallery, Photo Tom Jenkins 83, 84, 87, 88, 90–91, 92 top left; Courtesy Jonah Freeman, Justin Lowe, Alexandre Singh and Andrew Krepps Gallery, Photo Alicia Ritson 92 top right, bottom right, and bottom left; Photo Sally Coleman 97, 98 center right; Photo JD DiFabbio 98 top left, top right, bottom left; Courtesy Dario Robleto and Inman Gallery, Houston, Photo Alicia Ritson 98 center left; Courtesy Aaron Curry, Thomas Houseago and Michael Werner Gallery, Photo Fredrik Nilsen 101, 105; Courtesy Aaron Curry and Michael Werner Gallery, Photo Fredrik Nilsen 102 left; Photo Alex Marks 106, 108, 109 top left, center left, and bottom, 163, 164, 201 bottom, 202, 209, 210, 212 bottom, 214, 217, 218, 221, 230; Photo Faith Gay 109 top right and center right; Courtesy Barbara Kasten and James Fuentes Gallery, New York, NY, Photo Fredrik Nilsen 112 top left; Courtesy Laleh Khorramian artist and Salon 94, New York, NY, Photo Fredrik Nilsen 112 top right; Courtesy Heather Rowe and D'Amelio Terras, New York, NY, Photo Fredrik Nilsen 112 bottom right; Courtesy Erin Shirreff and Lisa Cooley, New York, NY, Photo Aurora Tang 112 bottom right; Courtesy Charline von Heyl and Friedrich Petzel Gallery, New York, NY, Photo Aurora Tang 112 bottom left; Courtesy Rosy Keyser and Peter Blum Gallery, New York, Photo Aurora Tang 112 center left; Courtesy Kelly Nipper 117; Courtesy Sul Ross State University Herbarium, Photo Alex Marks 210 top left; Courtesy Eduardo Abaroa and Kurimanzutto Gallery, Mexico City, Photo Fredrik Nilsen 123 top right; Courtesy Pedro Reyes and The Coppel Collection 123 bottom left; Courtesy Liz Cohen and Salon 94, New York 129 top; Courtesy and Giraud Pissarro Segalot, New York, NY, Photo Fredrik Nilsen 129 bottom; Courtesy Jonathan Schipper and The West Collection, Oaks, PA, Photo Fredrik Nilsen 130–31; Photo Lesley Brown 132; Courtesy Arturo Herrera and Sikkema Jenkins & Co., New York, NY, Photo Fredrik Nilsen 138; Courtesy Rashid Johnson and Hauser & Wirth, Photo Fredrik Nilsen 141, 142–43, 144–45, 147; Courtesy Trevor Paglen, Metro Pictures, Altman Siegel Gallery, and Galerie Thomas Zander 152 top; Courtesy Maya Lin and Pace Gallery, Photo Fredrik Nilsen 152 bottom right; Courtesy Larry Bamburg and Simone Subal Gallery, Photo Fredrik Nilsen 152 bottom right; Courtesy Agnes Denes and Leslie Tonkonow Artworks + Projects, Photo Fredrik Nilsen 153; Courtesy Aaron Curry and Michael Werner Gallery, New York and London, Photo Fredrik Nilsen 155; Courtesy Peter Saul and Mary Boone Gallery, New York, and VW (VeneKlasen/Werner), Berlin, Photo Fredrik Nilsen 156 top; Courtesy Dana Schutz and the collection of Alan Hergott and Curt Shepard, Photo Fredrik Nilsen 156 top; Courtesy the Mike Kelley Foundation for the Arts, Photo Fredrik Nilsen 157 top; Courtesy Carroll Dunham and Gladstone Gallery, New York and Brussels, Photo Fredrik Nilsen 157 bottom; Courtesy Hubbard/Birchler and Lora Reynolds Gallery, Photo Fredrik Nilsen 158 bottom, 160–61; Photo Jennifer Boomer 167; Hilary duPont, Liz Janoff, and Ian Lewis 170; Courtesy Roger Hjorns and Corvi-Mora, London, Photo Thierry Bal 174; Photo Thierry Bal 177 top left; Courtesy Ed Atkins and Gavin Brown's Enterprise, New York, Photo Thierry Bal 177 top right; Courtesy Melvin Edwards and Alexander Gray Associates, New York 177, Photo Thierry Bal center right; Courtesy the Watermill Center Collection, the Estate of George Paul Thek, and Alexander and Bonin Gallery, Photo Thierry Bal 177 bottom left; Courtesy Lee Lozano, Hauser & Wirth, and Matthew Marks Gallery, Photo Thierry Bal 177 center left; Photo Thierry Bal 178–79, 180; Courtesy Lacey Dorn 185 top left; Courtesy Jonathan Mergele 185 top right and middle left; Courtesy Sean Daly 185 bottom right; Courtesy Nathalie Kaplan 185 bottom left; Courtesy Loie Hollowell and Jamie and Adam Altman, Photo Fredrik Nilsen 186; Courtesy Dan Colen and VENUS, Photo Fredrik Nilsen 188–89; Courtesy Haroon Mirza, Lisson Gallery, and Ballroom Marfa, Photo Rowdy Lee Dugan 194, 205 bottom; Courtesy the Calder Foundation, Photo Alex Marks 196; Courtesy Lawrence Abu-Hamdan and Mor-Charpentier, Photo Alex Marks 202 bottom right; Courtesy Haroon Mirza, Lisson Gallery, and Ballroom Marfa, Photo Alex Marks 205 top; Courtesy Haroon Mirza, Lisson Gallery, and Ballroom Marfa, Photo Emma Rogers 206–7; Courtesy Candice Lin and Ghebaly Gallery, Photo Alex Marks 210 bottom left; Courtesy Tara Donovan and Pace Gallery, Photo Alex Marks 212 top; Courtesy Iván Navarro and Paul Kasim Gallery, Photo Alex Marks 213; Photo Sarah Melendez 222, 276, 279 top left, 278 bottom left, 280 bottom right; Courtesy Fernando Palma Rodríguez and House of Gaga, Photo Alex Marks 225; Courtesy Fernando Palma Rodríguez, François Ghebaly, and Ballroom Marfa, Photo Alex Marks 226–27; Courtesy Beatriz Cortez and Commonwealth and Council Los Angeles, Photo Alex Marks 229; Courtesy Solange Pessoa, Ballroom Marfa, Mendes Wood DM, Blum & Poe, Photo Alex Marks 233, 234–35, 236–37; Photo Makenzie Goodman 243, 244, 247, 251, 252, 255 top, 256–57, 258, 261, 262, 265, 270, 272, 273, 275; Photo Sarah Vasquez 255 bottom, 266–67, 268–69; Photo Lisa E. Harris 279 top right and bottom; Photo Daisy Nam 278 bottom right, 281 bottom left, 280 bottom left, 282 top left; Photo Elle Perez 280 top, 281 bottom right; Photo Jesse Chun 281 top right; Photo Heather Rasmussen 282 top right, center right, bottom right, and bottom left; Courtesy Kenneth Tam and Queens Museum 284–85; Courtesy Rebecca Manson and Josh Lilley Gallery, Photo Sandy Carson 287; Photo Sandy Carson 288–89, 290; Courtesy the Jesse Murry Foundation, Photo Sandy Carson 291 top; Courtesy Joel Gaitan and KDR305, Photo Sandy Carson 291 bottom; Courtesy Guadalupe Maravilla, P.P.O.W, New York, and Institute of Contemporary Art/Boston, Photo Makenzie Goodman 292 ; © BFA 2024, Photo Yvonne Tnt/BFA.com 304 right second from bottom, 312 bottom left, top left, bottom right, 315 top right; © BFA 2024, Photo Rommel Demano/BFA.com 312 middle right; © BFA 2024, Photo Leandro Justen/BFA.com 316 bottom right.